HUMAN NATURE

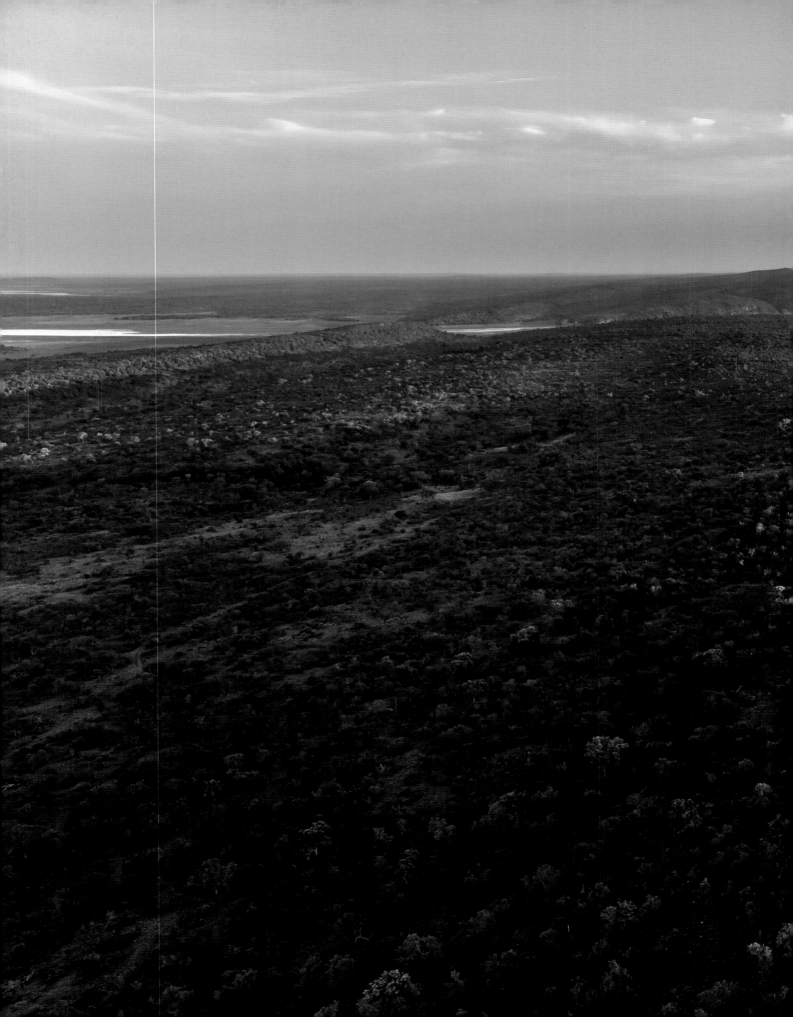

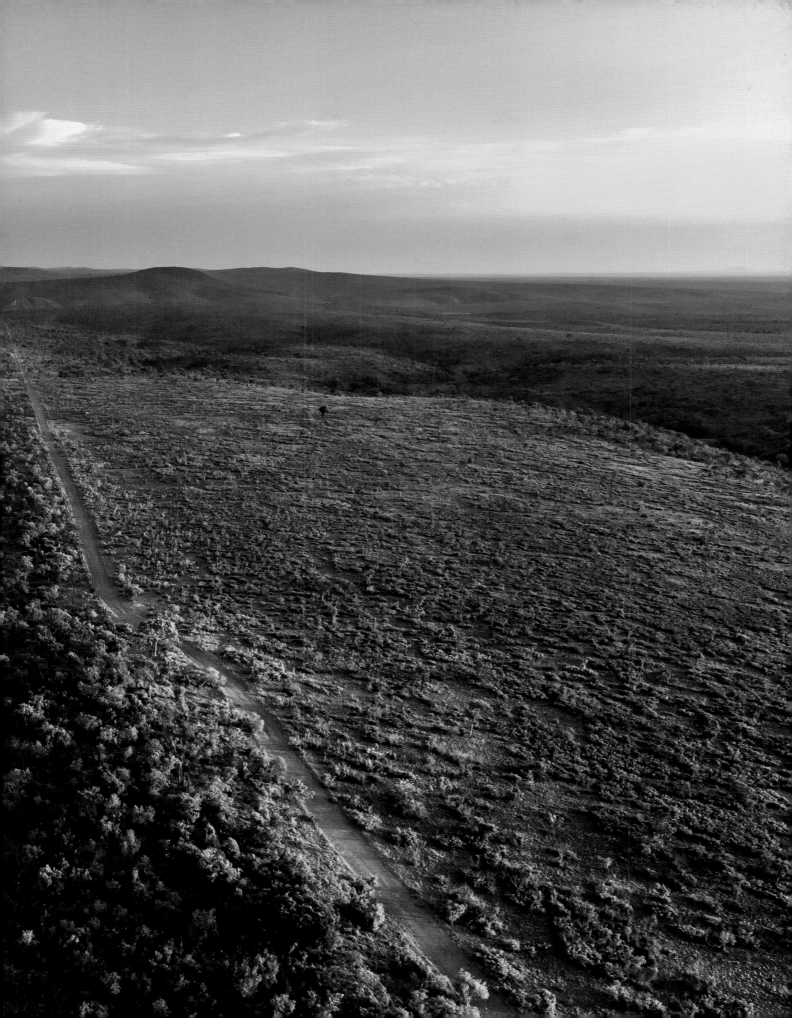

Twelve photographers address
the future of the environment

HUMAN NATURE

PLANET EARTH IN OUR TIME

Created by Geoff Blackwell and Ruth Hobday

Edited by Nikki Addison

CHRONICLE BOOKS
SAN FRANCISCO

in association with

Blackwell&Ruth.

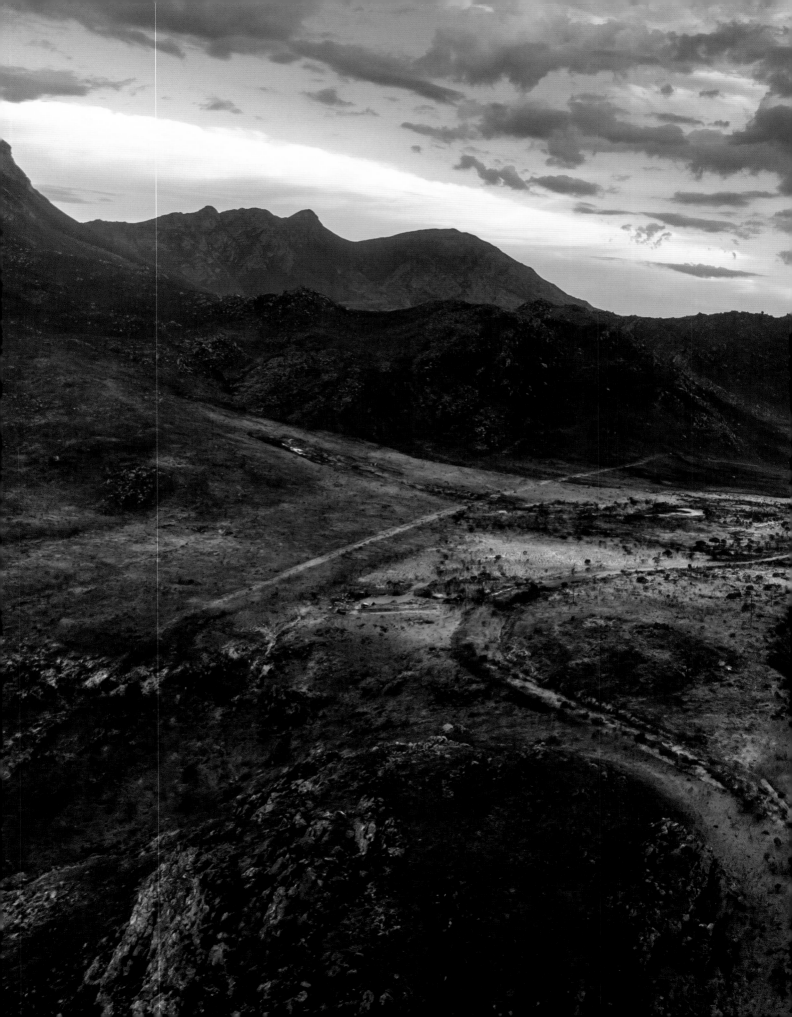

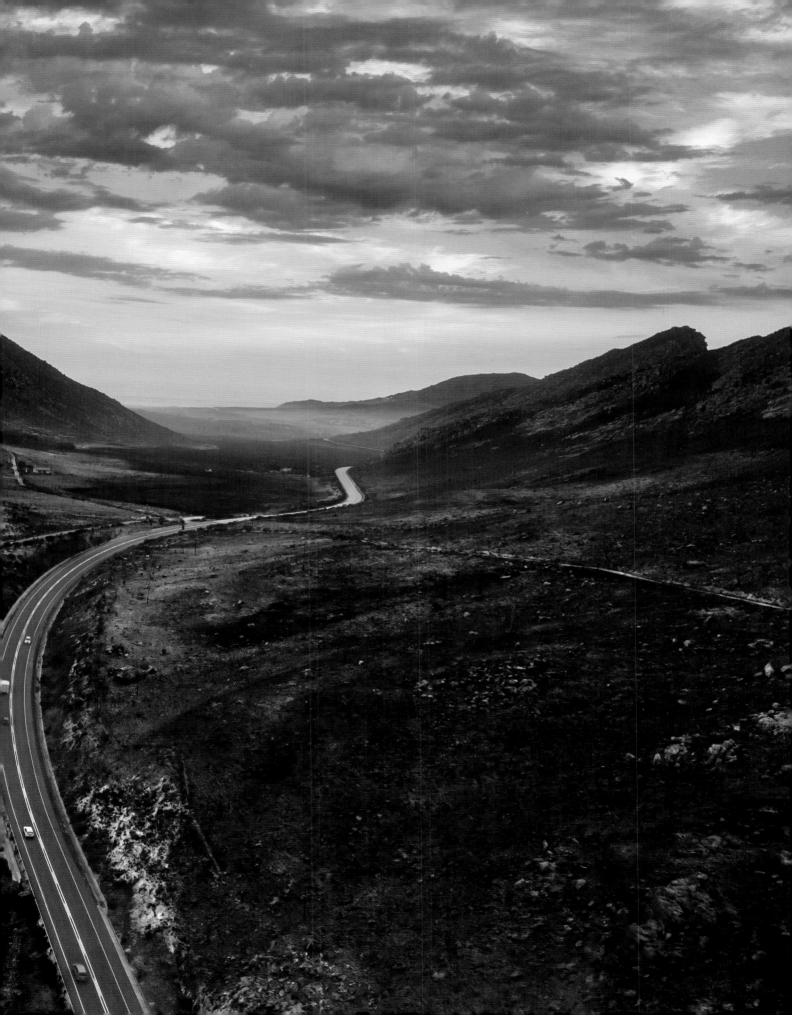

In 2019, the United Nations declared that the natural world was declining at an unprecedented rate. At the time, approximately three-quarters of the earth's land mass, two-thirds of its oceans and eighty-five per cent of crucial wetlands had already been extremely altered or lost. Waters were suffocating with pollution from the 300 to 400 million tons of heavy metals, toxic sludge and solvents that were dumped every year. More plant and animal species were threatened with extinction than at any other period in the history of humanity. Urgent change was needed, to not just protect and restore the planet, but secure the future of human life. It is still needed.

As scientists have posited, we have entered a new geological epoch driven by human impact: the Anthropocene. This new geological era is the result of the drastic and now irreversible, influence that human actions have had on the global environment and its species.

Realizing that we have arrived at an unparalleled moment in the history of human life on earth, we wanted to do something to respond positively to the challenges we all now face, so we turned to perhaps the most powerful form of communication: photography. We decided to engage with twelve of the world's most respected and influential contemporary photographers working at the intersections of humanity and nature today – photographers who are documenting some of the key issues affecting our planet: species extinction; deforestation; ocean degradation; human migration, poverty and conflict; industrial pollution; food supply chains; mass consumption; and globalization.

The twelve photographers in this book were each chosen for a reason. That they are experts in their fields and that they have produced extraordinary, compelling and unique images is clear. But equally, their commitment to and passion for, their work struck a chord. These photographers have dedicated their lives to capturing the crisis our planet faces, they are front-line witnesses to what is happening. They are out there now, in the deserts and the forests, on the mountain tops and the ocean floor, under the ice and in the air above our land and cityscapes, chronicling, writing and sharing their stories. It is thanks to them that we can both admire the magnificence of nature and understand the reality of what we need to do if we want to save it – and ourselves.

Through first-person original interviews, we asked each photographer to address the biggest issues of our time: what really matters now for humanity and the planet? What do we have? What do we stand to lose? And what we must change in order to create a better, brighter future for all species on earth?

Their answers, combined with their powerful images, are at once confronting and illuminating but, ultimately, provide us with an inspiring call to action.

Brian Skerry captures the richness of marine life and emphasizes the importance of protecting our oceans; Frans Lanting illustrates the interconnectedness of all species through sweeping landscapes and raw portraits; J Henry Fair captures the astounding effects of industrial pollution through aerial photography; Paul Nicklen documents the heartbreaking effects of global warming on wildlife in the polar regions; Cristina Mittermeier underscores the critical conservation issues impacting oceans and indigenous cultures; Brent Stirton, with devastating clarity, provides an urgent wakeup call to address animal poaching; Ami Vitale encapsulates the fundamental connection between human communities and wildlife; Steve Winter documents the magnificence of big cats and why preserving their habitats is as important to us, as it is to them; Tim Laman reminds us of the beauty of the natural world and all its creatures; George Steinmetz goes behind the scenes of industrial food supply chains and explores the pressing issue of feeding the world's population; Richard John Seymour reveals the widespread repercussions of consumerism and opens our eyes to the vast economies behind the global dependence on plastic; and Joel Sartore highlights the astonishing vastness of the world's animal species and their intrinsic value.

These photographers all share one important similarity: they remind us that each and every one of us holds the power to create change through the everyday choices that we make: what we choose to eat, what we purchase, how we get to work, who we vote for, which businesses we support. We all have a role to play. But, we all must begin to act and act now.

It is our hope that these stories and images will not only educate and move you, but inspire you to take action. One person can make an incredible difference. The remarkable movement inspired by climate activist Greta Thunberg began as a one-person protest with a hand-painted sign and has become of beacon of hope in times that have often seemed hopeless. With a simple school strike, she has succeeded in mobilizing millions of people around the world to fight and care for the planet. As she says, 'You are actually capable of making a difference. The step from one to two is always the hardest and once you have passed that step, you're not far from creating movement.'[1]

Geoff Blackwell and Ruth Hobday

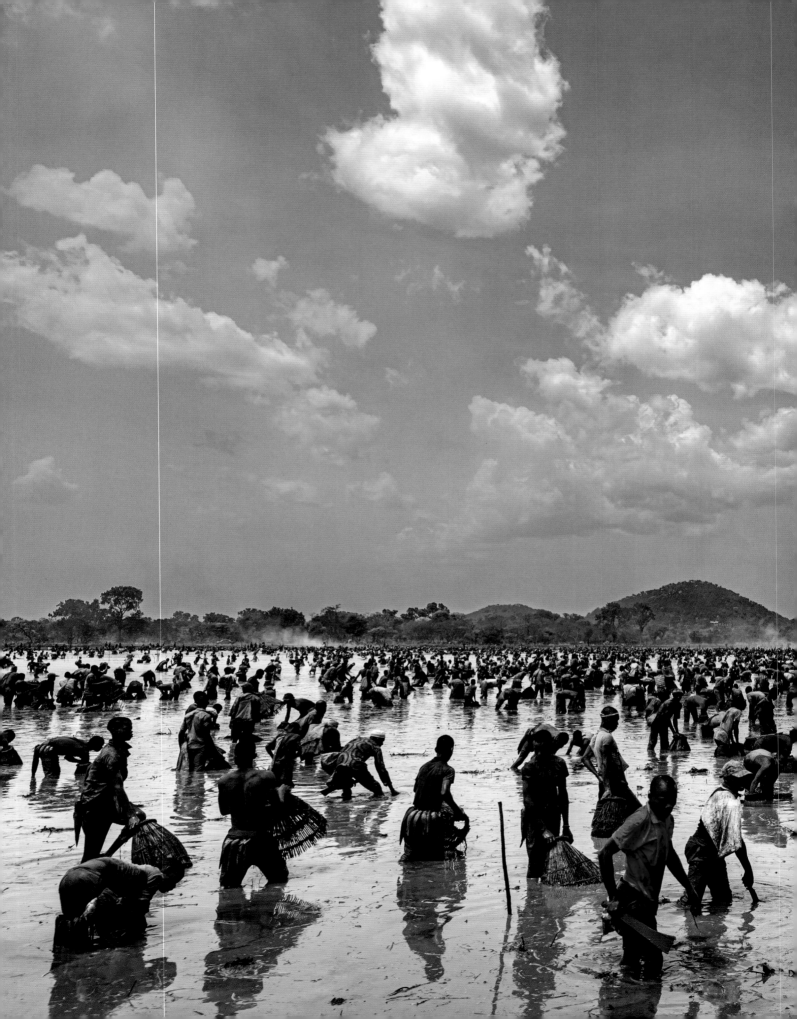

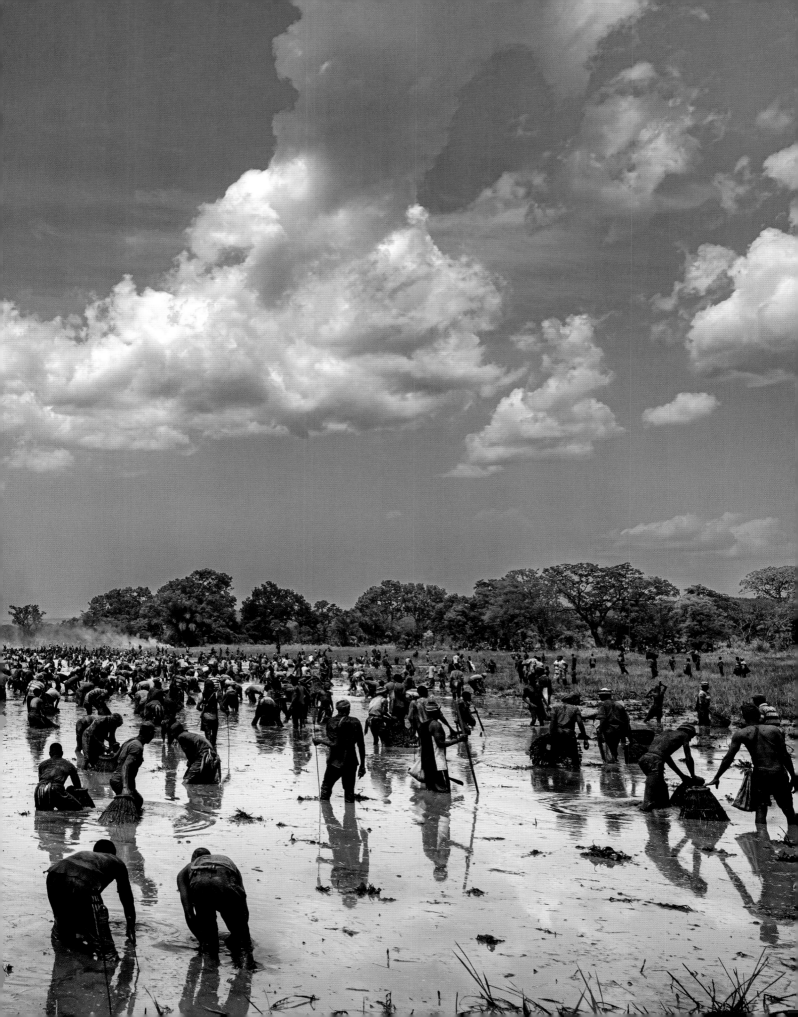

'WE ARE LIVING AT THIS VERY SPECIAL AND PIVOTAL MOMENT IN HISTORY WHERE, MAYBE, FOR THE VERY FIRST TIME, WE ACTUALLY UNDERSTAND BOTH THE PROBLEMS AND THE SOLUTIONS. AND THE QUESTION IS, WILL WE DO THE RIGHT THING AND WORK ON THOSE SOLUTIONS, OR WILL WE SIMPLY BEAR WITNESS TO THE DESTRUCTION? THE DECISIONS THAT WE MAKE TODAY ARE GOING TO DETERMINE THE FUTURE OF THIS PLANET AND THE FUTURE OF OUR SPECIES. IT'S A TIME FOR TRUTH; IT'S A TIME FOR SCIENCE AND STORYTELLING AND JOURNALISM TO WORK TOGETHER COLLABORATIVELY. THE STAKES HAVE NEVER BEEN QUITE SO HIGH.'

– BRIAN SKERRY

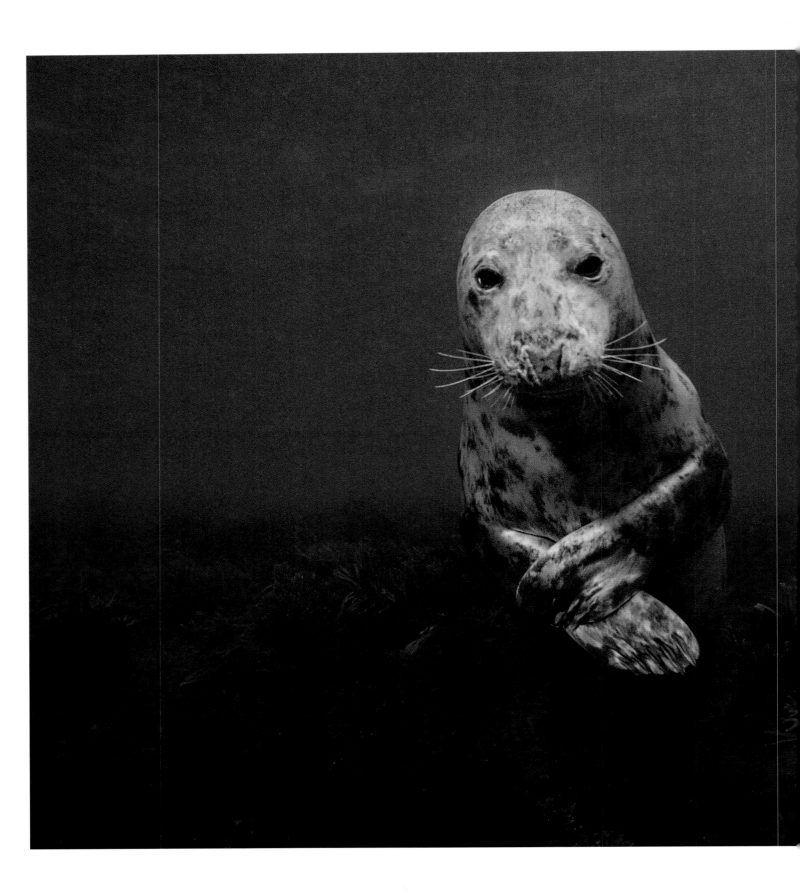

BRIAN SKERRY

BRIAN SKERRY

Brian Skerry is a photojournalist, a fellow of the National Geographic Society and a founding member of the International League of Conservation Photographers. Specializing in underwater and marine photography, his work is centred on promoting awareness about the world's oceans and waterways.

I'm an underwater photographer specialising in marine wildlife and ecosystems in the sea. I've been working for *National Geographic* since 1998 and just began my twenty-eighth story for the magazine. I didn't start out wanting to be a photographer; I just wanted to be an ocean explorer. I can remember reading *National Geographic* as a little boy and watching those old documentaries by Jacques-Yves Cousteau and just being absolutely captivated by the notion of exploring the oceans, so my parents would take me to the beaches in New England in Massachusetts, USA, when I was two, three years old. We had a swimming pool in the backyard and when I was about three, I can remember putting on my little mask and fins and swimming in the pool, pretending I was swimming with sharks and whales and dolphins, exploring shipwrecks.

When I was about fifteen years old, I became a certified scuba diver. I just wanted to find a way to explore the ocean. And it was maybe a year or so after that I was attending a dive show – a conference in Boston – and I remember sitting in the audience and watching the photographers and film-makers present their stories about exploring the ocean, but as visual storytellers. And I often describe it as an epiphany; I just had this moment where I remember saying, 'That's how I want to explore the ocean, I want to do it with a camera.' The notion of being able to travel around the world; to go into these places and be close to these animals, make pictures and then be able to share them – that was something that really appealed to me.

Above: Portrait of a grey seal in the waters off Acadia National Park, Maine, USA.

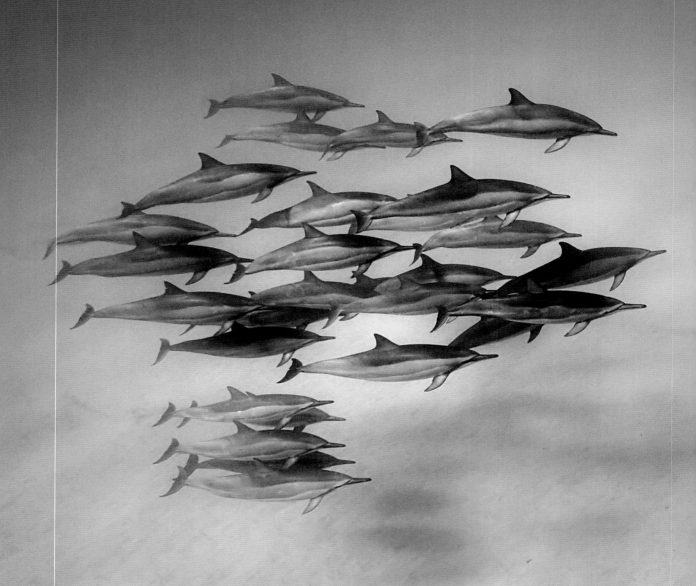

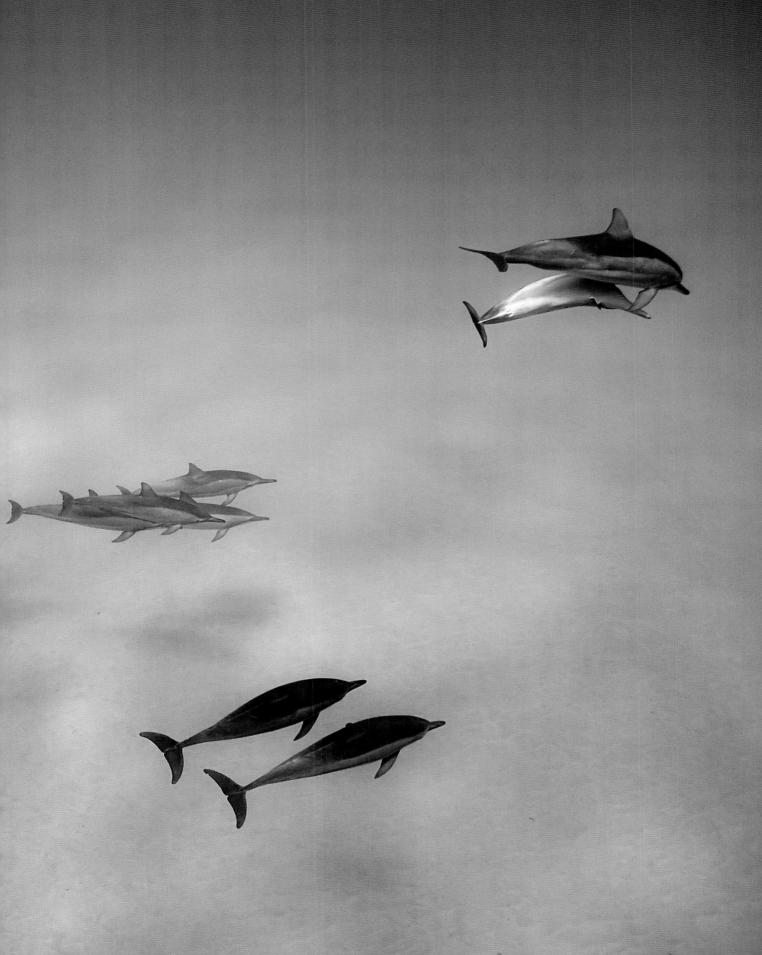

'With the ocean, fighting climate change is really hard because we've removed so many creatures that live there – we've killed off ninety per cent of the big fish – the sharks, the tuna, the bill fish – and we kill more than one hundred million sharks every single year. You can't remove one hundred million apex predators from any ecosystem and expect it to be healthy.'

Previous page: A pod of spinner dolphins swims in a coastal bay in the waters off Kona, Hawai'i, USA. These animals forage in deep, offshore water at night, then move into shallower regions to rest and socialize in the morning.

Right: A school of black margate drift in the water column of Hol Chan Marine Reserve off the coast of Belize. This marine protected area was created in 1987 and has allowed marine life and ecosystems to thrive over the past three decades.

The first time I strapped on a mask and fins and explored underwater, was in a place near Newport in Rhode Island, a very well-known sailing centre. The water was a bit chilly and not particularly clear; there was decent visibility but it's not like the tropics. I didn't feel the cold and was just mesmerized, captivated, by what I was seeing: small fish called cunner [also known as blue perch or sea perch], some crabs walking on the rocks and little snails, sea anemone and other invertebrates. And it's instantly addicting, the moment you have that experience – at least it was for me – there's no going back. I had heard that siren call for a very long time, it was this innate desire within me to do those things and once I started, it didn't disappoint. It was even more than I expected.

I wasn't sure what I needed to do to become an underwater photographer. I was actually interested in both documentary filmmaking and still photography in those days and still am, but I started by buying an underwater camera. Back in those days there was an amphibious camera that Nikon used to make called the Nikonos and I ended up buying a used Nikonos II, one of their early models. I had no idea how to use it – no idea how to even open it, or turn it on – but I figured it out. I belonged to a diving club back then and I used to go out on weekends on a Zodiac boat that friends owned and we'd go diving in the waters off New England. Those early pictures were horrible; I didn't have any idea what I was doing, but it was cool – holding the camera and jumping in the water, I felt like I was a photographer.

I eventually decided that if I was going to do this, I needed some training, so I went to university and majored in communications media which allowed me to build a curriculum around photography and photojournalism, television production, film, animation. I learned about lighting, I learned about F-stops and apertures and shutter speeds and all those technical aspects, but always with the intention of using what I learned underwater; so I would take what I was learning and try to do those things underwater. But then when you graduate – you've gone to school for four years, it's gone well, you've done well in your classes – but I couldn't just come out and hang a sign on the door that says I'm an underwater photographer and expect people to hire me. You have to build your own career, you have to create a niche – and that's what I did. I worked on charter boats in New England. I would do a lot of shipwreck diving; that was something that interested me back then. I loved history – I was always interested in wildlife but there was more opportunity in the shipwreck world – so I linked up with some very experienced divers and I would work on the boat for free. In the wintertime I'd be in the snow, grinding the hull and painting it and doing all kinds of work to pay my dues to get on that boat in the spring and summer for free. We would take people out to dive on German submarines and old World War II shipwrecks. So I became a fairly accomplished diver; I was doing a lot of deep, dark North Atlantic shipwreck diving with many tanks and regulators and dry suits, but was always really fascinated with wildlife and wanting to pivot towards more of that. But it was a long evolution: I sold photos to magazines; I did stories for diving magazines; I wrote a book about shipwreck diving; I did some speaking engagements; all building towards what I really wanted to do.

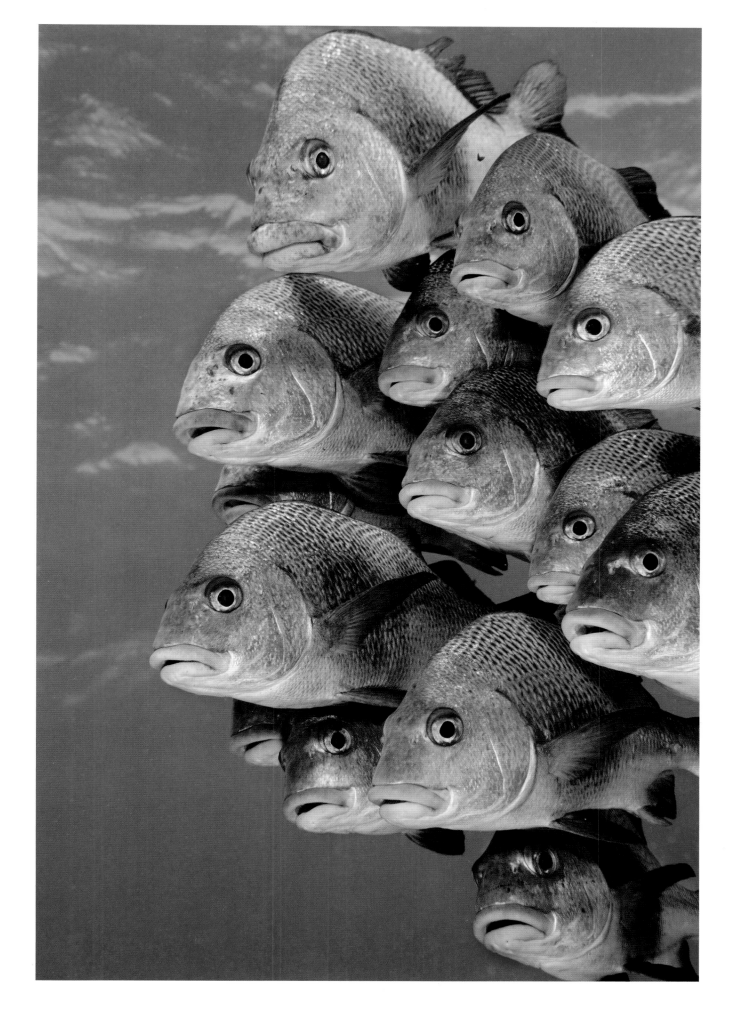

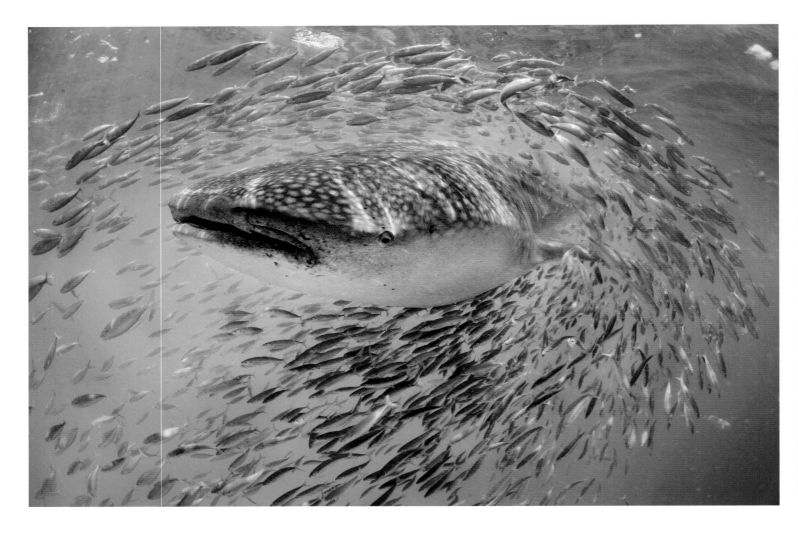

'We can no longer treat nature as something we can abuse; we no longer have the luxury of short-term thinking. If we remove a fish from the sea or an animal from the forest, what are the consequences to our own life? It's about treading lightly. How we can do things better?'

I started out in the mid-eighties and it was about a decade and a half before I got an assignment with *National Geographic*. It could very easily not have happened. It was always the dream, from an early age when I decided that I wanted to be an underwater photographer – that was the Mount Everest. But there were three underwater photographers working for the magazine and they weren't looking to move on anytime soon. Ultimately, I became friends with a veteran *National Geographic* photographer who helped me get that first assignment.

I suppose for most of those early years I saw myself as an underwater photographer and it was probably really only when I started working for *National Geographic* and had exposure to many other photographers and photojournalists, that I started to think of myself as a photojournalist. Their standards were very high in terms of quality, but they also were looking for people who understood journalism. There are a lot of great photographers in the world, there are a lot of people who could take beautiful pictures, but the magazine needed people who could form a story in their mind and then execute it in the field. I was inspired by terrestrial photographers – the nature photographers, or the social documentary photographers, the street shooters. It was another of those epiphany moments where all of a sudden a light goes on and I thought, 'Yes! That's what I need to be doing in the sea.'

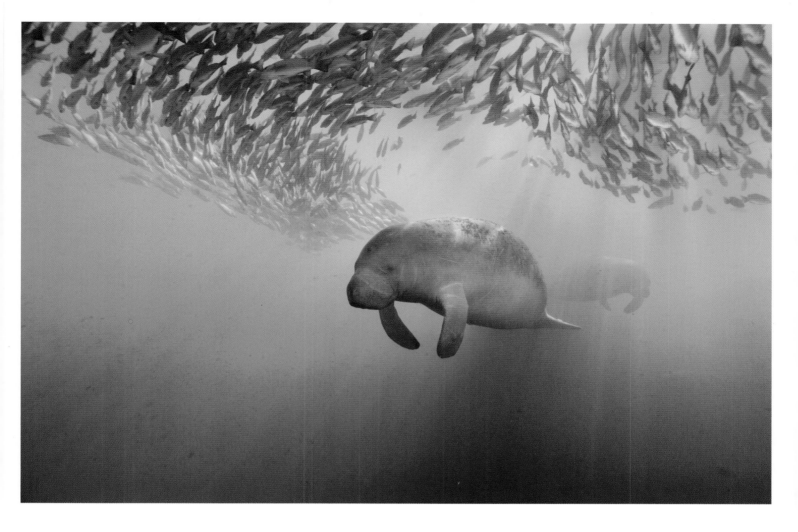

Underwater photography is quite a different beast than traditional wildlife photography on land – terrestrial photography. I don't have the luxury of using a telephoto lens, I can't sit in a camouflaged blind in some remote spot with a tripod and a 600mm lens and wait for weeks on end for some elusive animal to wander by. I can only stay underwater as long as the air supply on my back lasts. Even in the warmest of locations there will be thermal considerations; you will eventually get cold. And even in the places in the world where it's extremely clear, relatively, you still have to get within a few metres of your subject. It's a testament to those animals that allow you into their world.

*

In the beginning I wanted to do stories about animals or places that interested me. I think in many respects it was self-serving – I wanted to do things that I felt were cool. I had to find the story; there had to be some angle, some narrative to that issue, or that subject, or that species, but it really was just about doing things that I wanted to do. That changed. After a few assignments for *National Geographic* I began to see problems occurring in the world's oceans. Now almost all the stories that I do for *National Geographic* are my ideas, but for the first two or three years I was given assignments. The first one I proposed was a story on harp seals and initially I started out

Above left: A whale shark glides amongst a school of fish in the turquoise waters off the coast of Mexico. Whale sharks are currently listed as 'vulnerable' due to human pollution and hunting. Due to their slow reproductive habits, populations remain unstable.

Above right: Florida manatees swim under a school of mangrove snapper fish in the Weeki Wachee River in northwest Florida, USA. Manatees cannot survive in temperatures colder than sixty-eight degrees Fahrenheit [twenty degrees Celsius], so they come into rivers in the winter when ocean waters turn colder.

Following page: An olive ridley sea turtle entangled in a plastic fishing net in the waters off Sri Lanka. Floating debris, such as drifting logs, often attracts fish and other creatures. In this case, a bamboo log was snagged with plastic netting.

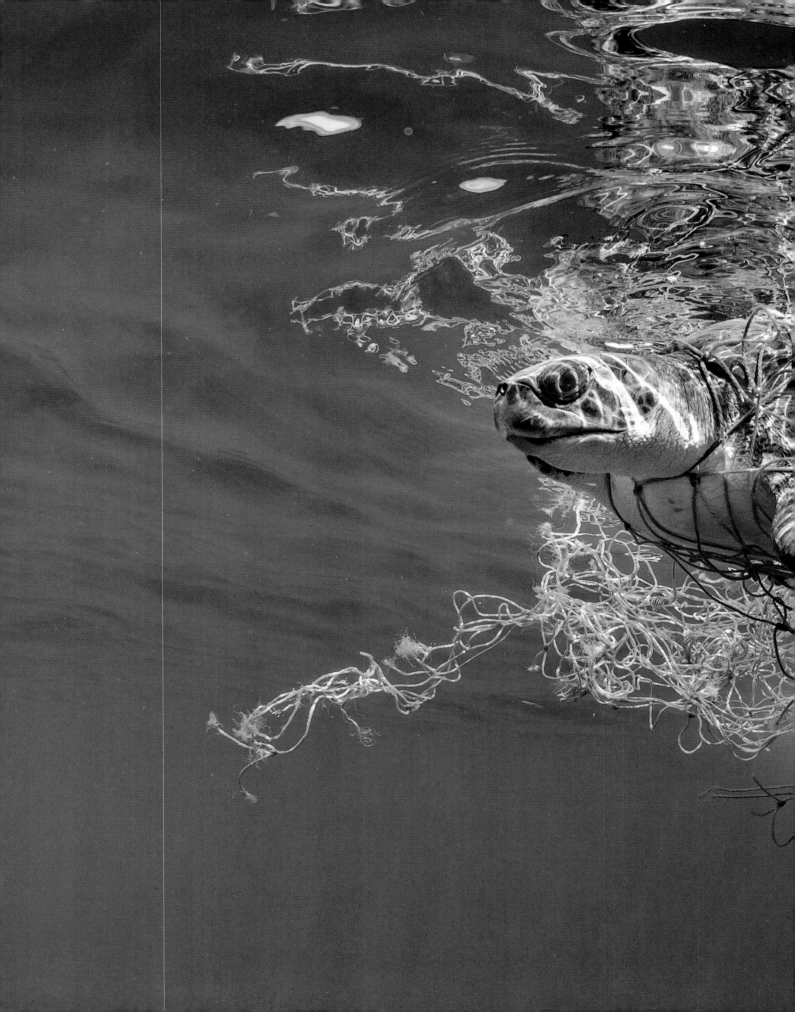

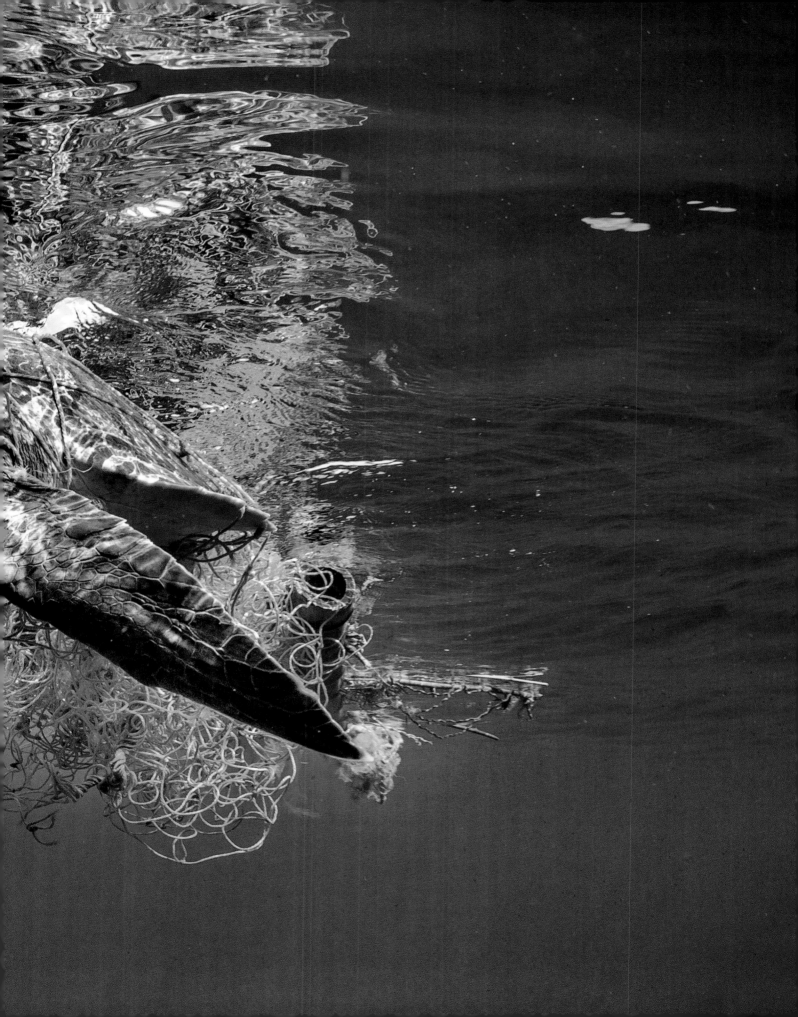

with that same position of just wanting to do something that was interesting to me: going up to the ice in the Gulf of Saint Lawrence in north-eastern Canada and helping readers to see a snapshot of the lifecycle of these animals above and below the ice for the few weeks each year that they migrate down from the Arctic and spend time doing courtship, mating and pupping. I thought that would be a really insightful way to go into these animals' lives and show readers things that they don't often get to see.

It was during the coverage of that story over two years that I began to realize that there were some big environmental issues that needed to be explored if we were going to do this story right. One was that they continued to be hunted. Most folks had no idea that these cute little white baby seals were still being clubbed by hunters – they thought that had ended thirty years ago. It was the biggest slaughter of marine mammals on the planet, but most folks had no idea it was happening. But the bigger problem for harp seals, as I realized, was the decline of sea ice that was occurring due to climate change. I felt strongly that we needed to cover those issues and I think it was that story that really was a pivotal moment in my life and in my career; I realized that through the magazine I had this platform I could use to reach 50 million people around the world each month.

The reaction to that harp seal story was substantial. The magazine made it a cover story in 2004 and it received quite a bit of attention. I actually became the first journalist in seventeen years to get aboard one of those hunting boats. That hunter had no reason to bring me on that boat; there was nothing in it for him, but I had made friends with him the first season I went out, not knowing, at first, that he was a hunter. I chartered his boat because he was a crab fisherman and I needed a platform to break through the ice and live out there with the seals. Nobody had done that. Previous photographers who had done work with harp seals had used helicopters to go out and could only spend a few hours each day, but I wanted to live out there day and night so I hired a fisherman and it was during that first season that he mentioned that he also hunted seals. The next year he initially said no to me coming on the boat, but then changed his mind. And while of course I had

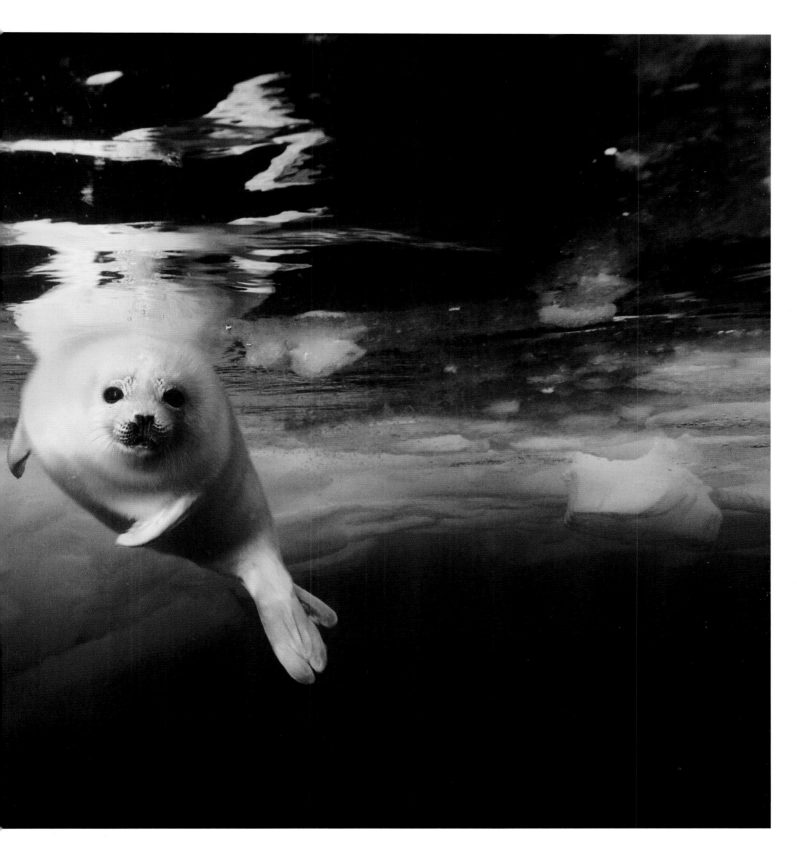

Above: A harp seal pup, about fourteen days old, makes its first swim in the icy waters of Canada's Gulf of Saint Lawrence. The survival of this species is threatened due to declining sea ice in the region.

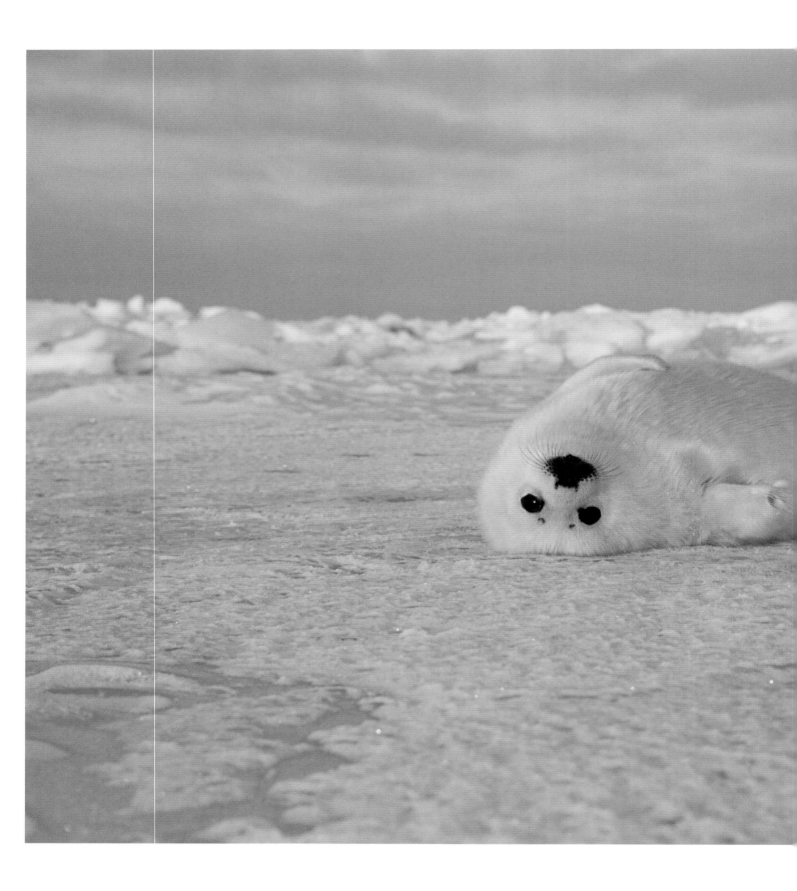

BRIAN SKERRY

Left: A harp seal pup on the ice in the Gulf of Saint Lawrence, Canada. These pups require solid ice as a platform in order to be able to nurse from their mothers. Without this stable platform, the pups will die. Thinning ice, due to climate change over the last decade, has resulted in an increased mortality rate for the pups.

my own opinion of what was happening with the seals, as a journalist I needed to just present the facts and let the readers draw their own conclusions, which they did. And it was because of that story that I began doing other environmental issues.

The hunting, as far as I know, continues though, in a strange twist of irony, climate change has caused the hunting to decline because there's less ice, or sometimes no ice, out there. Despite the decline in hunting, the pup mortality rate has increased due to the lack of sea ice. One of the interesting things about harp seals is that the pups have the second fastest weaning in the animal kingdom. [The fastest weaning is the hooded seal, which also lives in that same area that harp seals do.] Harp seals are born completely helpless; they're born on the ice, but they have almost no insulation – no fat, no blubber – but within two weeks, they have nursed and gotten very chubby. They are known as 'a fat whitecoat' at that point and it's about that time in their life that their mother leaves and they have to go into the water on their own and learn how to fend for themselves. If they happen to fall into the water during those first fourteen days or so, they die. So that's the problem with the decline of sea ice – those pups need the stable platform of ice from which to nurse from their mother. And I saw that when I was up there; pups five or six days old that still had pieces of the umbilical cord on their bellies, that had fallen through that very thin, slushy ice and the mother was frantically trying to push them back up. I saw some that died and I saw some that made it, but it's been worse every year since.

*

One of the great joys and privileges, of my work is being able to spend time out in nature, often in places that are off the beaten track and pretty remote and to see things that even in my wildest dreams I never imagined that I'd get to see. About a decade ago I did a story about the most endangered species of whale in the world, the North Atlantic right whale. These whales live in my native waters in New England and travel from Canada down to Florida each year, but they are urban whales and they get entangled in fishing gear and hit by ships. It's believed that pollution is affecting their reproduction, so there're maybe only four hundred or so of them left on the planet. As part of my story, I wanted to draw a comparison between that beleaguered North Atlantic population by looking at a healthier population of their cousins, the Southern right whales. They're almost identical in species and can be found in places like Patagonia, Argentina and South Africa, with some in Australia. But I had learned about a population in the Auckland Islands, in the sub-Antarctic of New Zealand, that had only recently been discovered and to my knowledge hadn't really been photographed and documented before. So I did a very speculative trip for three weeks in the austral winter. We left on a sailboat out of Dunedin and I didn't know what we would find. I didn't know if the whales would be there, I didn't know if the visibility would be good enough to photograph them, or whether they would let me get close if they were there.

We pulled into a place called Enderby Island and it was one of the rare sunny days and the sand was just glowing below our hull and all these right whales came out to meet us. The scientist that I was working with said these whales likely had never seen a human before, so, for the first few days, I was diving alone; I didn't want to spook them with even one other person in the water. I told my assistant to wait on the boat. And here were these fifty-foot [fifteen-metre] long, seventy-ton [sixty-three-tonne] whales that were extremely curious about me, swimming right up to me and nudging me with their big callosities – which are like barnacles; they could rip your dry suit apart – but it was extraordinary. I couldn't have imagined an experience like that. Here I was, in this remote corner of the world – I didn't see another boat for hundreds of miles around – there were yellow-eyed

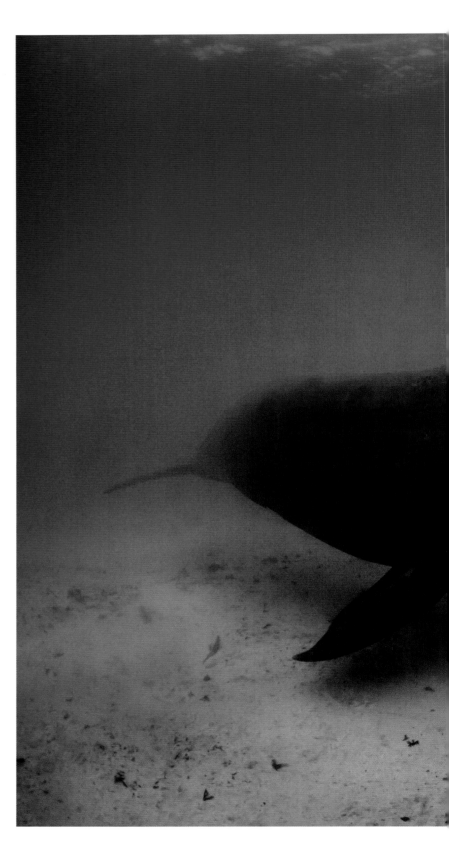

BRIAN SKERRY

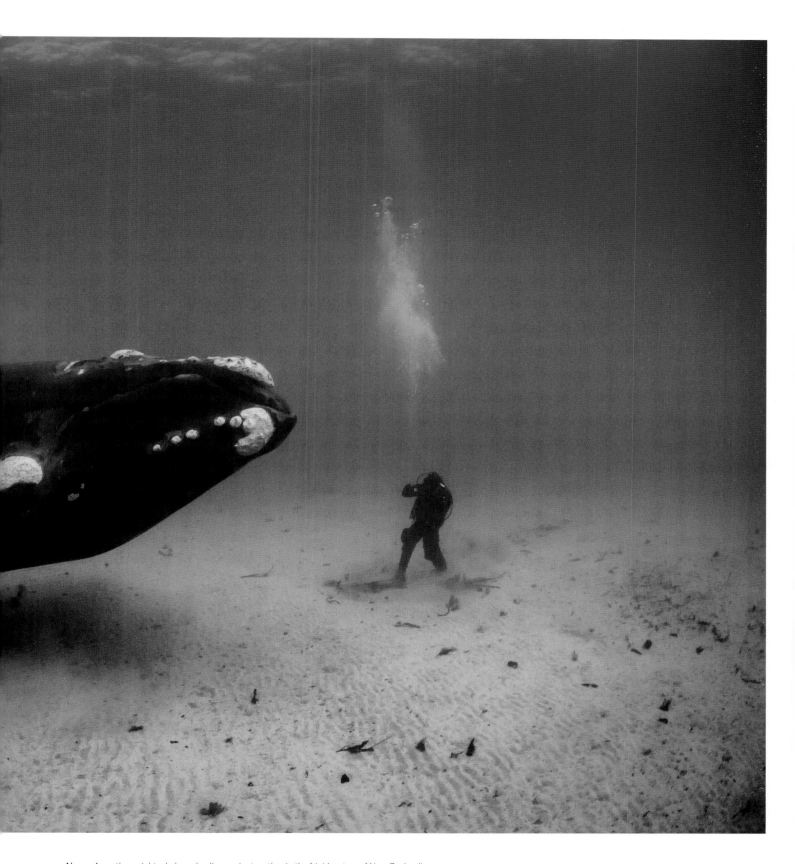

Above: A southern right whale and a diver swim together in the frigid waters of New Zealand's sub-Antarctic Auckland Islands. These enormous whales can reach lengths of forty-five feet [thirteen metres] and weights of seventy tons [sixty-three metric tonnes].

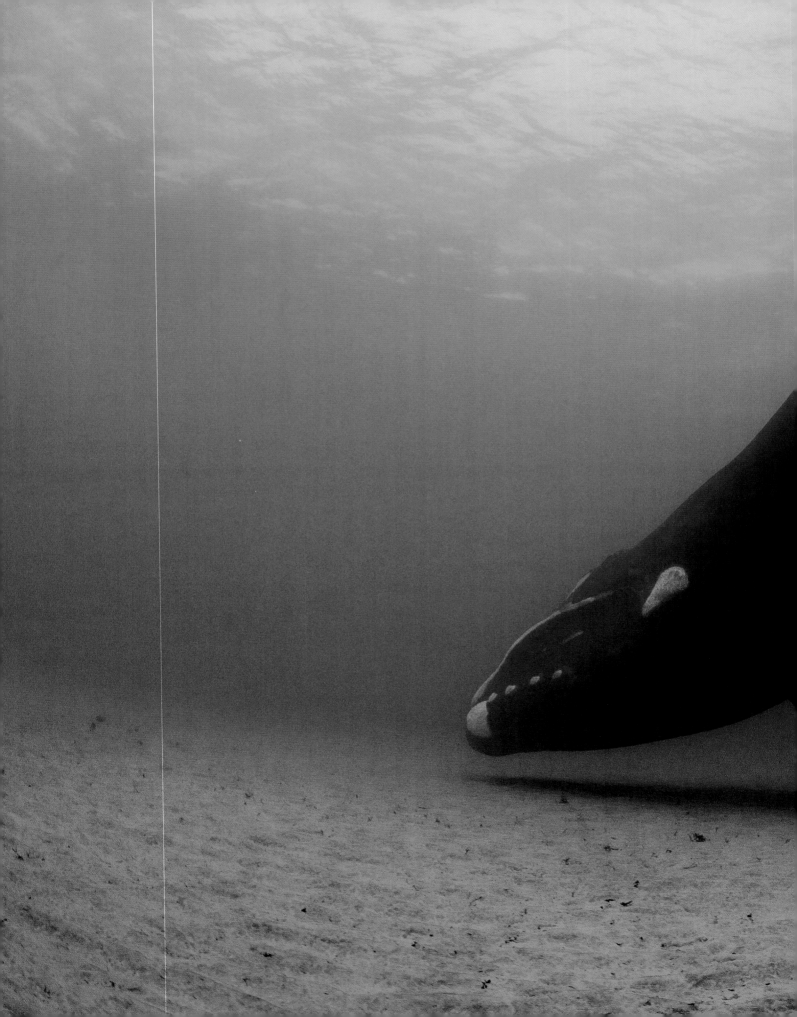

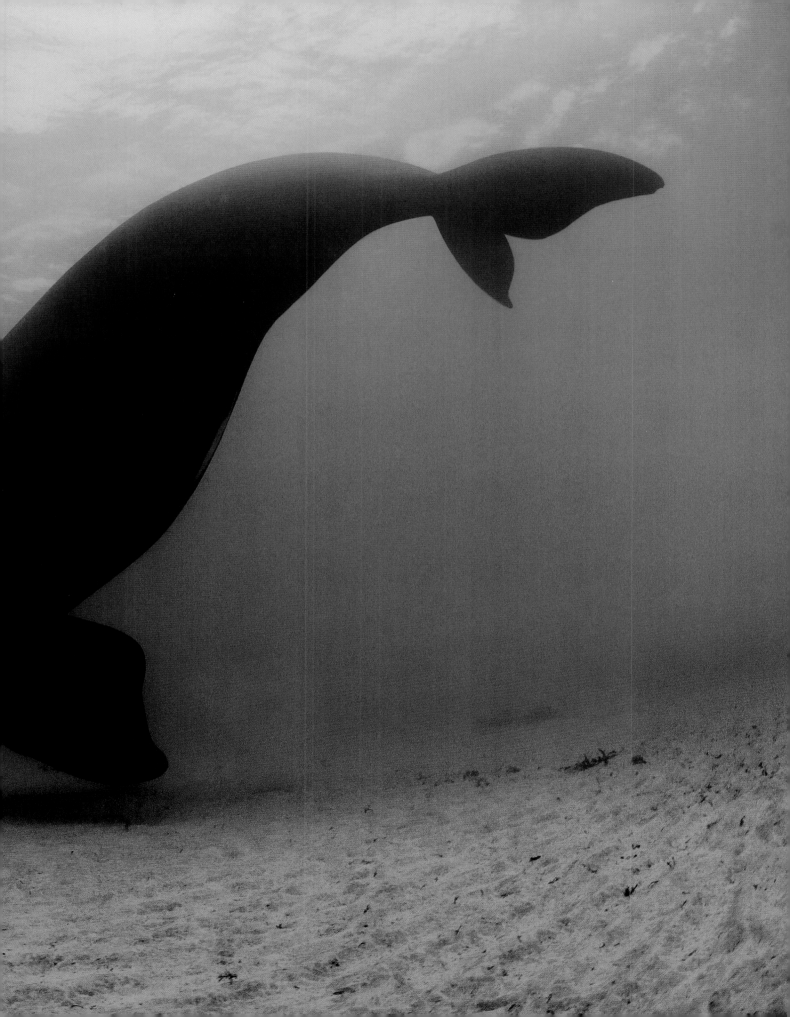

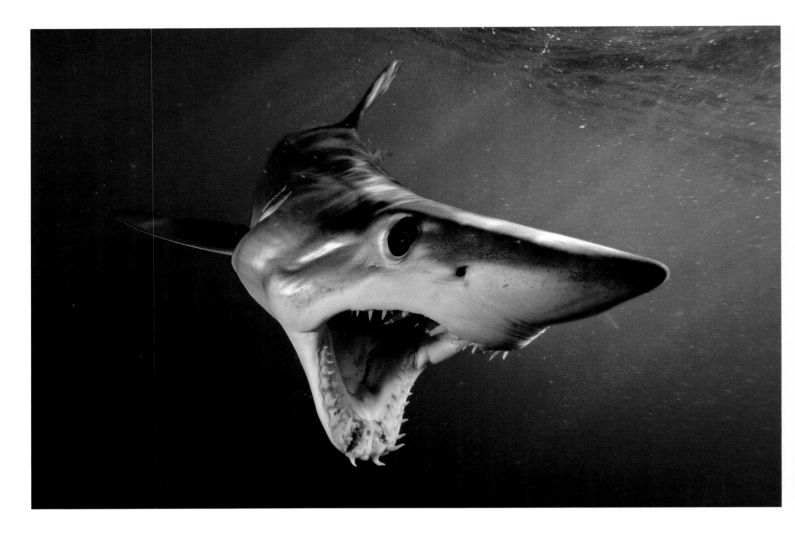

Previous page: A southern right whale swims over sandy sea floor in the sub-Antarctic Auckland Islands off the south coast of New Zealand. Its cousin, the North Atlantic right whale, is the most endangered whale on earth. Although the southern right whale is also endangered, it is geographically farther away from industrialization and less likely to be hit by ships or entangled in marine debris, enabling populations to fare better in this region.

Above left: A mako shark swims in the waters off New Zealand. Mako sharks are one of the fastest in the sea and have one of the largest brains relative to body size. The number of mako has declined worldwide due to overfishing and the demand for shark fin.

Above right: A thresher shark dead in a gill net in the Sea of Cortez off the coast of Baja California, Mexico. Every year over one hundred million sharks are killed as a result of human activity – often for their fins.

penguins swimming underwater and sea lions, it was spectacular. And here were these beautiful whales. I could only imagine that this was what it was like in my home in New England hundreds of years ago. There are stories of the pilgrims who came over from England and settled in Massachusetts in 1620, being able to walk across Cape Cod Bay on the backs of right whales. Whether that's true or not, we know there were a lot of them and those whales have now learned to mistrust humans, but here was a group of animals that hadn't learned to mistrust us yet and were very open and welcoming and friendly. Having an experience like that was just off the scale.

The Southern whales of the Auckland Islands were vastly different from the North Atlantic whale, not morphologically, but from a health standpoint. The researchers that I was working with had a scale of measuring the health index of North Atlantic right whales and it had to do with the amount of fat on their backs and their necks and the amount of scarring from entanglements and so forth. Well, the whales in New Zealand were fat – the scientists didn't even have a category on their index for a whale that chubby! And they had no entanglement scars – something like eighty-plus per cent of North Atlantic right whales have entanglement scars – but none of these ones did. They were healthy and happy, it seemed and living in this icy wilderness down there in the sub-Antarctic, which was spectacular.

*

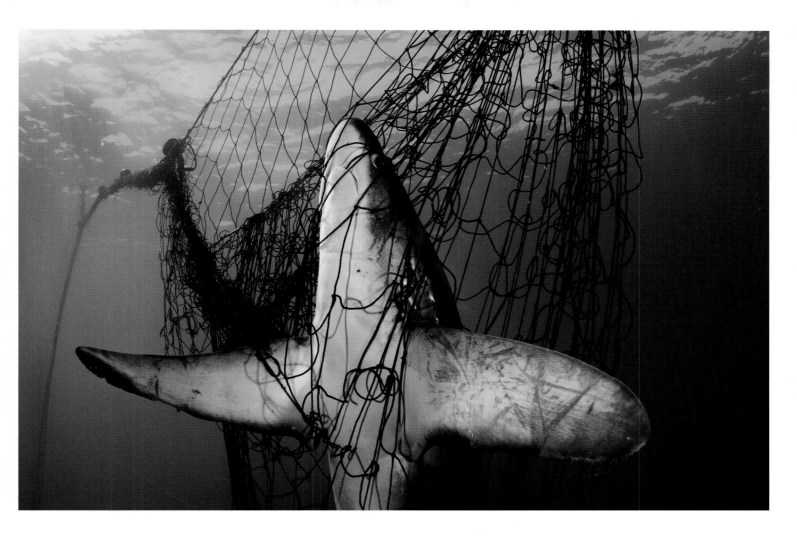

I was not yet a diver when the movie *Jaws* came out in 1975, but I remember being so fascinated with that movie. I remember seeing the trailers. The night that it was released, I was at the movie theatre and I couldn't get enough. I wanted to be Matt Hooper [played by Richard Dreyfuss]; I wanted to be that shark biologist. I was probably one of the few people who saw that movie and was attracted to go into the ocean, as opposed to staying away from it! Sure, I was scared, but I was just blown away by the notion of an animal like a great white shark. So that began my interest in sharks. When I started scuba diving in 1977, only a couple of years after *Jaws* came out, there were very few people who wanted to go in the water with sharks. But the good news is that that has changed; many divers today actually go to great lengths to spend time with sharks. That being said, long before *Jaws*, sharks have been much maligned. They've been given this villainous treatment – so many people out there have this shadowy one-dimensional view of sharks and we only hear about sharks when there is a public safety concern. We think of this creature down there just waiting to bite us the minute we put a toe in the ocean.

For me, sharks represent many things. I see them photographically as an intoxicating subject: they move very elegantly through the water and yet they exude a great confidence. They're perfectly formed, having been sculpted by hundreds of millions of years of evolution that has made them perfect for whatever environment they happen to live in in the ocean, whether it's a reef shark or a pelagic shark. They are symmetrical with their pectoral fins and their

'The ocean is dying a death of a thousand cuts and, unlike in the past, we now understand that the ocean is not too big to fail. It absolutely can and our actions are bringing the sea to her knees.'

'The ocean is becoming acidic. It's taken in so much carbon that it can't function as it needs to anymore and it's changed the chemistry of the ocean.'

dorsal fins. What I couldn't have imagined in those early years was how fragile sharks are. We see them as these big, bad tough guys of the ocean and to some extent of course that's true – they're apex predators – but they are also fragile. These are animals that are being destroyed at an alarming rate by humans and I have come to learn that they play an important role in the health of the oceans, so I think they need some good press; sharks need a bit of a makeover.

Because of my interest in both sharks and in conservation, it was natural to want to do stories that celebrated these animals. I had to do stories that showed the killing of them, sharks in nets and the finning, because we have to understand what's at stake and what's really happening out there. But I also recently did four stories about different sharks for *National Geographic* as a way of celebrating their magnificence, their biology, their morphologies. It was unusual for the magazine to dedicate that much real estate to a single genre of a species like sharks, but I made a case for it and they embraced it because they recognized how important it is. I did stories on tiger sharks, makos, great whites and oceanic whitetips – some of the most dangerous predatory species. And while I think it's important to do stories about sharks, it's also just personally satisfying to be in the water with a shark. It's exhilarating to be in the company of an animal that exquisite.

I've had my share of hairy moments with animals like sharks, but I've made many hundreds, possibly thousands, of shark dives throughout my life and I've probably had only three or four times where I felt unsafe and had to get out of the water. One time I was doing a five-week expedition to a remote series of coral reef islands in the South Pacific. The coral cover in these places was one hundred per cent; in most places in the world you're lucky to see thirty per cent. The biomass of predators and fish was off the scale, truly like travelling back in time. But the biomass of predators included sharks and there were a lot of sharks around. During one dive with my assistant around sunset, I lost track counting about sixty grey reef sharks that were swirling all around us. I was in a little three-sided coral head and one shark would come in and I would bump him in the nose with my camera housing. Normally that deters them, they would usually just swim away, but these guys were doing a tight three-sixty and coming right back in and behind that one were five more and behind them were maybe ten or twelve more and they were all jockeying for position and I knew that if one latched on, it was going to get ugly, quick. But I was able to move into shallow water and then back to the boat, although they pursued us. So that was one of the times that was a little bit dicey, but honestly I think if you told anybody in the world that you've made thousands of shark dives, they'd be looking at your arms and legs and limbs and digits, because they would think you would have had problems. I think it's a testament to the sharks; they're not nearly as bad as they've been portrayed.

*

There's no question that in terms of issues in the ocean, there are many important things going on. I've often said the ocean is dying a death of a thousand cuts and that unlike in the past, we have to understand that the ocean is not too big

to fail. It absolutely can and our actions are bringing the sea to her knees. Without a doubt the biggest problem, I think, is climate; there's too much carbon in our atmosphere. The ocean is the greatest carbon sink on our planet; it takes in carbon and gives us back oxygen. Phytoplankton, coral reefs, all these little creatures that are processing carbon and giving us back oxygen are essential to our kind of life on this planet. But the ocean is becoming acidic. It's taken in so much carbon that it can't function as it needs to anymore and it's changed the chemistry of the ocean – it's pH is decreasing. Anything with a calcium component is beginning to erode – coral reefs, anything with a shell and even small baseline sources of protein like tetrapods and copepods – all these little creatures are sources of protein for whales and other big animals in the ocean. Climate is the five-hundred-pound gorilla in the room. It is going to dictate everything.

Then there are other big problems. A healthy body, a healthy immune system, can fight off infections if it's otherwise intact, but with the ocean, fighting climate change is really hard because we've removed so many creatures that live there – we've killed off ninety per cent of the big fish – the sharks, the tuna, the bill fish – and we kill more than one hundred million sharks *every single year*. You can't remove one hundred million apex predators from any ecosystem and expect it to be healthy. We're also putting eighteen billion pounds of plastic into the ocean every year. I can remember decades ago not really seeing plastic anywhere. Then you began to see it here and there. Now I don't think I ever go on a trip where I don't see plastic on the reef, or in the deep ocean, or in a mangrove. It's inside baby turtles; it's inside fish in the deepest part of the ocean in Marianas Trench in the western Pacific Ocean – samples of their gut contents contain micro-plastics.

So there are all these problems – but there are also solutions. Companies are embracing circular economies, they're finding ways to 'own' plastic from cradle to grave. Consumers need to demand this and companies need to react. Laws need to be created to help shepherd that new frontier in. One area that can make a difference is in fisheries; we don't have to fish for wild fish anymore. I did a story for *National Geographic* about fish farming – aquaculture – and if it's done right it can be sustainable. We can feed, in the not-too-distant future, nine billion people by fish farming, but it has to be done right and it has to give those wild stocks a break. I photographed carp fishing in China and catfishing in the Mississippi Delta and these seemed to work. You can raise tilapia in an industrial park in a factory using a recirculation facility and we can do integrated multi-trophic aquaculture [a system that provides the byproducts, including waste, from one aquatic species as fertilizer or food for another] where you are raising different species that all work in harmony with one another. These methods don't impact negatively on the environment and yet they provide a harvestable product that can be sold so that people can make a living and they create good, low-cost sources of protein to feed the world.

So there are solutions, we just have to move away from being hunter-gatherers of the sea and become farmers. That can be a bad thing too if

'Most scientists would argue for forty or fifty per cent of the oceans being protected, but today we're only at one, or three, per cent.'

Following page: Bluefin tuna inside a purse seine [vertical] net in the waters off of Spain. Bluefin tuna continue to grow their whole lives and can cross entire oceans in the course of a year. They are currently listed as endangered due to overfishing.

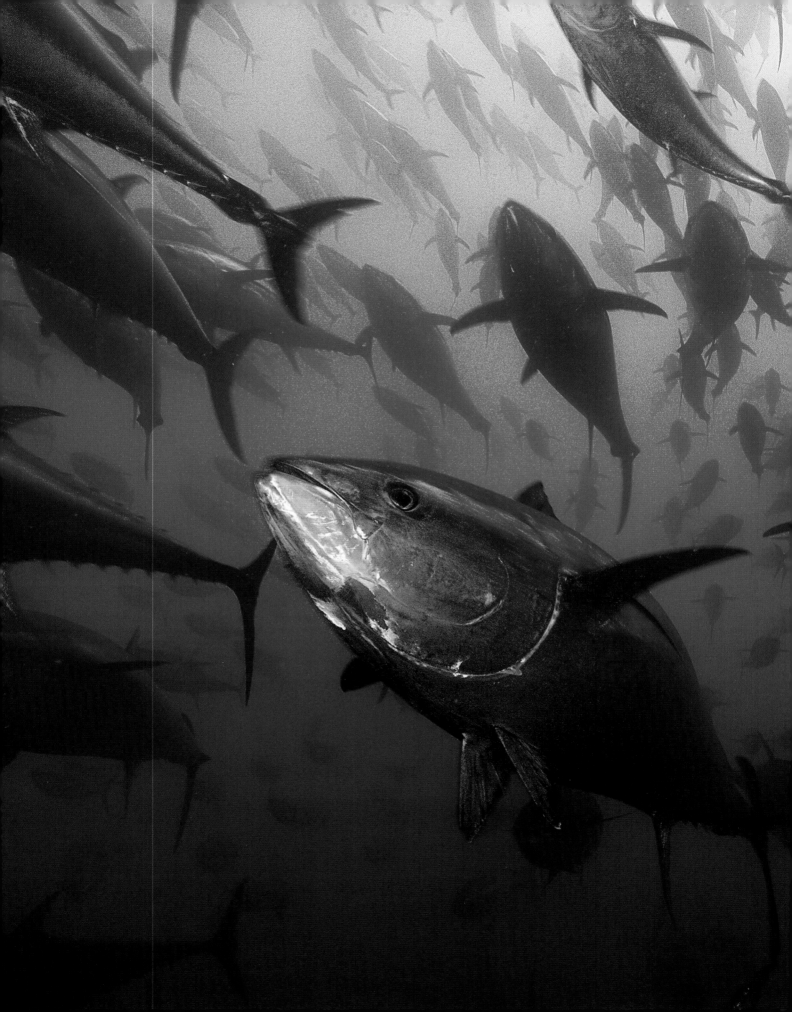

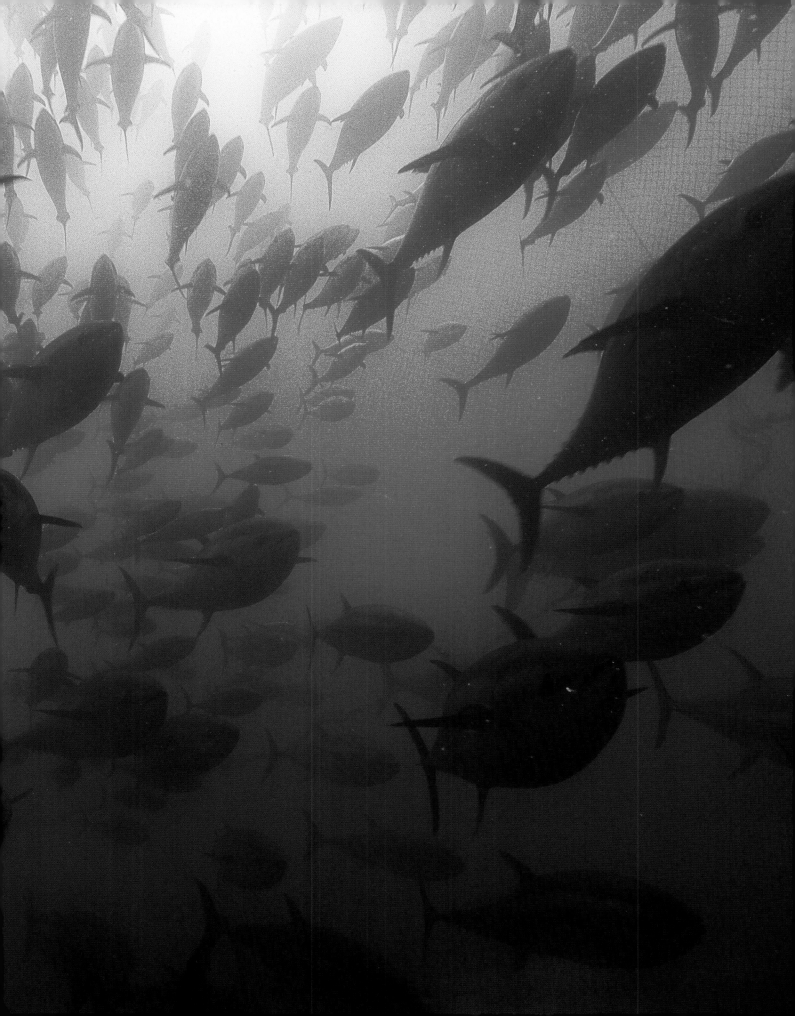

'There are solutions, we just have to move away from being hunter-gatherers of the sea and become farmers.'

we don't do it right, so it's about having an appreciation for our role in the environment; realizing that we wield a very big stick, that unlike any other species, our actions can be devastating. If we're cognisant of our role and of the consequences of our actions, then I think we can proceed methodically and carefully and make it sustainable for a very long time.

I certainly don't know all the answers when it comes to how we proceed, but I do firmly believe that a big part of how we need to do this is to really appreciate our role in the natural world and understand that our actions have direct consequences. We can no longer treat nature as something we can abuse; we no longer have the luxury of short-term thinking. If we remove a fish from the sea or an animal from the forest, what are the consequences to our own life? Every animal on earth plays a vital role at some level, from the tiniest creatures to the largest creatures, so we can't see things in a vacuum. We can't just extract all the codfish from a place and think that that's okay, that somehow they'll replenish. They won't and it will affect the overall ecosystem. I've often described what I've learned about nature in the sea as the gears of a finely-made Swiss watch. They all mesh together and some gears are spinning rapidly and the bigger ones are turning more slowly, but they all play a role. If you begin to remove individual gears, the whole machine breaks down and that's what has happened in nature. So I think it's about treading lightly. How we can do things better? We are a very smart species, we are capable of great things, but we have to have the knowledge and the desire to move in the right direction.

*

These days in my career I just want to do work that I feel really matters. After that light goes on and you realize that there are a lot of problems occurring in the world's oceans, things that are probably not evident to most people, you realize that you've been given this great privilege: I'm able to go out and document these things and then tell a story about them that can reach a lot of folks. I do want to make a difference and I want to do it for a whole host of reasons, not the least of which is my own children. I want them to be able to see a blue-finned tuna; I want them to have a healthy planet.

I feel a great sense of urgency to do this. I think we are living at this very special and pivotal moment in history where, maybe, for the very first time, we actually understand both the problems and the solutions. And the question is, will we do the right thing and work on those solutions, or will we simply bear witness to the destruction? The decisions that we make today are going to determine the future of this planet and the future of our species. I don't think that's hyperbole, I don't think that's an overstatement. So it's a time for truth; it's a time for science and storytelling and journalism to work together collaboratively. The stakes have never been quite so high. I think, ultimately, I'd like to believe that we will do as Cousteau urged a generation ago and that is protect what we love. There is a sense of urgency, but there's also hope.

I believe there are three pieces of the equation in terms of how change will occur: There is the political scene, the legislative scene, the world leaders;

there's industry and business; and there are everyday folks like us. If we don't know there's a problem, we can't fix it. The first step is admitting you have a problem. If we can't admit that climate change is real, if we don't know that we've removed ninety per cent of the big fish in the ocean, or that fifty per cent of the coral reefs are gone, then were not going to fix it.

It's been shown that elected leaders rarely actually lead – instead they follow their constituency, so if there's an educated constituency that wants to do something good, then political laws will get passed. The first step is taking the science and finding a way to make it interesting and palatable to the masses, because if people understand those problems, then there's a will from the people. What matters to me is coming up with a narrative that will grab somebody's attention and help them understand a little bit more about our planet. It's about wanting to share what you've learned. I don't want to beat people over the head with doom and gloom, but the reality is we have to understand what's happening on this planet and that our actions have serious consequences.

Back in the 1960s [American inventor] Buckminster Fuller termed the phrase 'Spaceship Earth' and the idea that we're on this planet with no chance of resupply, so whatever we have here, we need to take care of. We haven't really done that. So I want to do stories that celebrate what still remains, that show why these things matter. We have to understand that, even if you don't particularly care about sharks, maybe you should care that there are sharks swimming in the ocean, because it's directly tied to your own life, no matter where you live. If you care about breathing, then you should care about coral reefs and protecting the ocean. That's the end game: I want people to come away with a better appreciation for the planet, for their connection to it; to see that they are not above or apart from nature, but directly, intricately, tied to it.

A big part of that equation is going to be business: there has to be profitability in sustainability. I do see reasons for hope and some of that comes from businesses and industries who are actually leading, not waiting for governments to lead. I think they acknowledge the fact that that's probably not going to happen. I have talked to people in the plastic industries and chemical industries who could easily be seen as the bad guys, but I've chatted with many of them and they're not bad people at all; they're really good people and they have families and they have children and they care about the future and those are the people that we need to engage. I've done lectures for companies and corporations who have decided that they're going to change the way they do things to become a green company. They may not be sure exactly how they're going to get there, but they set goals and set a mandate. I think that's where change is going to occur. If solutions are going to be found it's going to be because some plastic engineer found a new way to do something, because somebody in one of those companies has a reason to want to do it. Villainizing people and making it more tribal isn't the answer.

I was sitting with an old friend of mine, Dr Bill Ballantine – a great Kiwi [New Zealand] marine biologist who was considered to be the 'father' of

'We are a very smart species, we are capable of great things, but we have to have the knowledge and the desire to move in the right direction.'

'There is a sense of urgency,
but there's also hope.'

marine reserves – one night in his home. He said that
he believed that if you gathered a reasonable group
of people in a room anywhere in the world and you
presented them with the facts – in this case, about the
ocean – and you told them how important the ocean
was to their lives and then you told them that most
scientists would argue for forty or fifty per cent of the
oceans being protected, but that today we're only at
one, or three, per cent, most people would say, 'Well,
that's a no-brainer. Of course, let's protect more of it.'
The problem is that most people don't know about
those things and that's where we need to get. I think
that people do want to be able to do the right thing.
Government and industry can help them with that, but
they need to desire it first and that's where journalism
and science can help; to give people, consumers, an
infrastructure to make good choices.

I would like to see real traction – serious movement – in
terms of protecting this planet. Before I turn that light
out for the last time, I'd like to think that we're on a
good track, that most people in the world 'get it'. There
will always be greed, there will always be self-interest,
but if the work that all of us are doing, everybody who
cares about the planet, to move in that direction, if we
can get people to understand how important protecting
the planet is to our own life, to our children and grand-
children, to all future generations, if we can protect thirty
per cent of nature, especially the ocean, by 2030, I'll feel
pretty good about that. There's an old proverb that says
it is a wise man or a special person that plants a tree
knowing that he'll never benefit from the shade that it
casts and that's what I'm thinking about – I want to see
that we're headed in the right direction.

There are certainly plenty of reasons to be pessimistic
and there's a lot of bad news out there today, but I
remain cautiously optimistic about the future. We don't
have a lot of time – the hourglass is running out of sand
– but yes, I think we can do it.

Above: A tiny yellow goby welcomes us into its
makeshift home – an abandoned aluminium can on
the volcanic, sandy bottom of Suruga Bay, Japan.

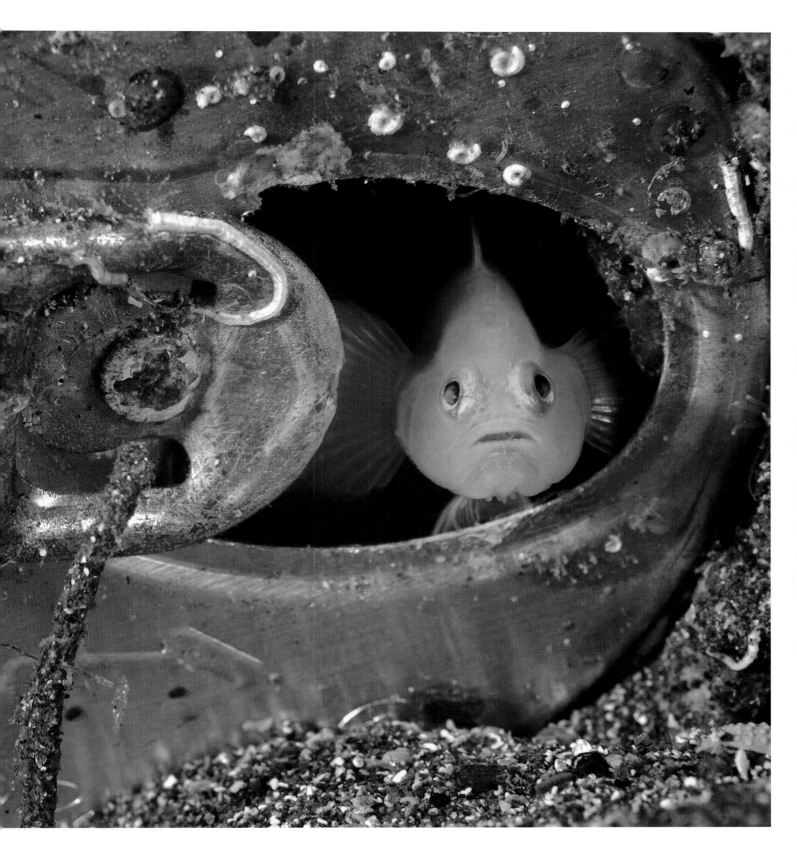

Following page: A sea anemone off Kingman Reef in the North Pacific Ocean provides cover for a transparent shrimp the size of a grain of rice. Kingman Reef became a US wildlife refuge in 2001 and remains a rare, pristine ecosystem as it is largely untouched by humans due to its remote location.

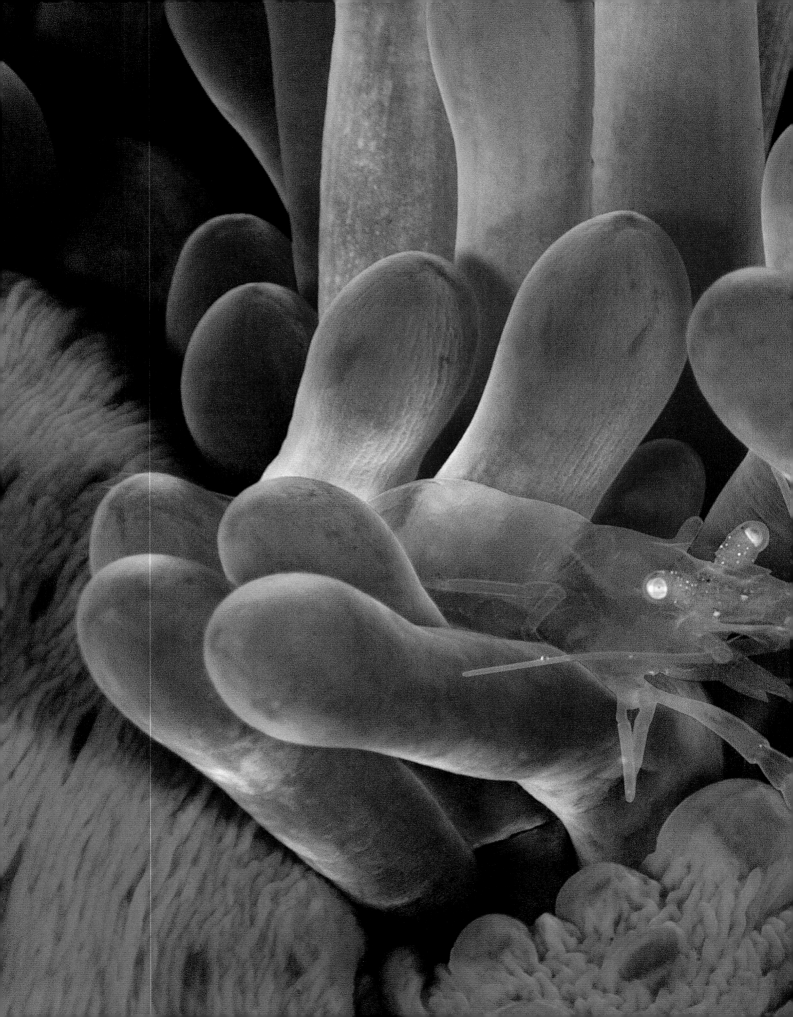

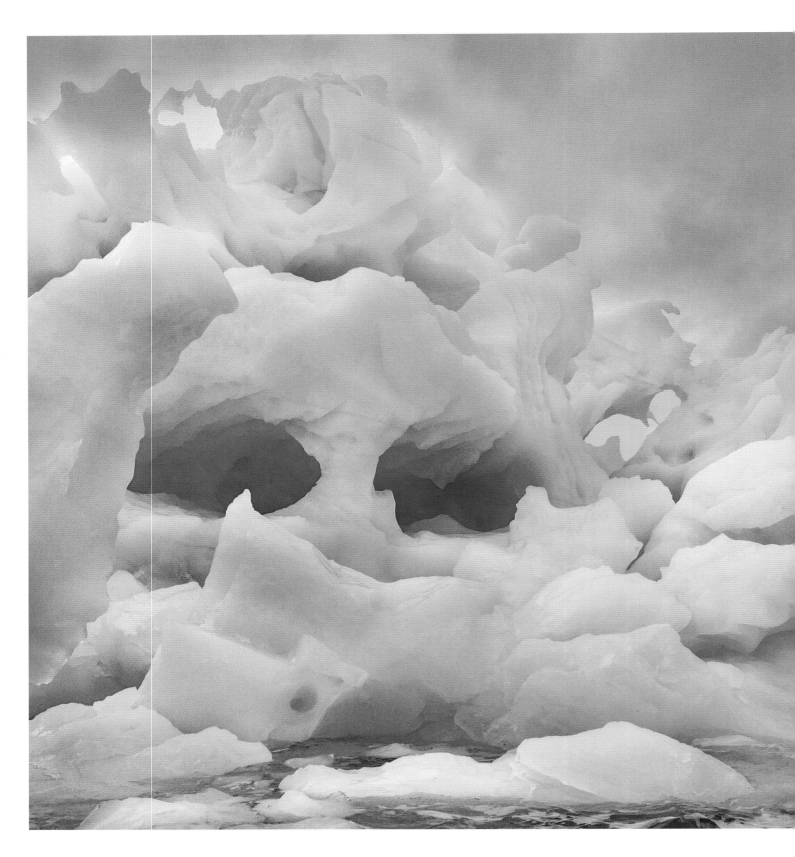

Above: An iceberg floats off the east coast of Greenland. Its contorted shapes indicate that it is melting rapidly and falling apart. Greenland and Antarctica are at the epicentre of global concerns over the effects of climate change because together, they contain ninety-eight per cent of the earth's frozen fresh water.

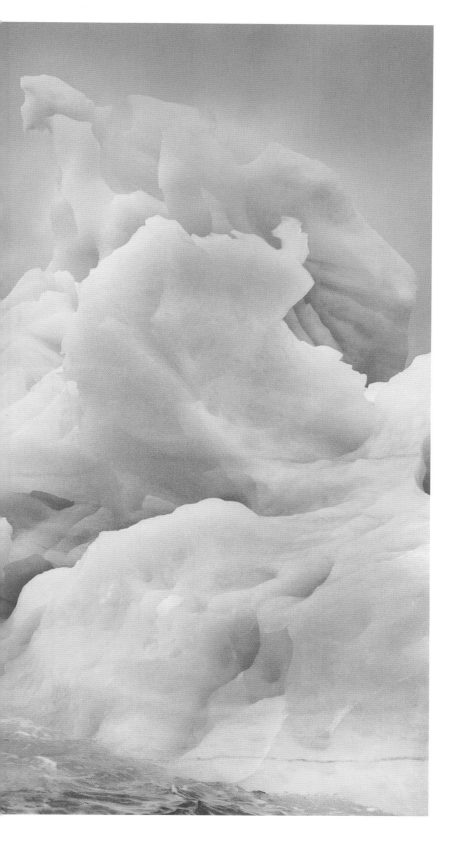

FRANS LANTING

Frans Lanting is an author and activist whose work has been published and exhibited around the world. He photographs wildlife and our relationship with nature to promote awareness and understanding about the planet and the interconnectedness of all life.

I was born and raised in the Netherlands, then I moved to the United States where I became a photographer. Ever since, I've been working around the world to capture its diversity and sharing my experiences with people, to convince them that we all inhabit a living planet and that our future is dependent on keeping it alive.

I've always been interested in photographs, but when I was growing up in the Netherlands, there was no path towards a future as a nature photographer; that model didn't exist at the time. My parents convinced me that I needed to choose a respectable career, so I became an economics student. But that turned into environmental economics, because my heart has always been in nature. Whenever I could, I would go out and wander around nature reserves in the Netherlands. I picked up a camera and began to play with it, because in those days there were no books about nature photography, there was no Internet and there were no people I could ask, 'Can you explain this to me?' I did everything on my own and I made a lot of mistakes. But if you don't know what the rules are, you're not afraid of breaking them. I started as an outsider in the field of photography; I've developed a personal vision about nature and how it can be represented in images. I think that has helped me in my career.

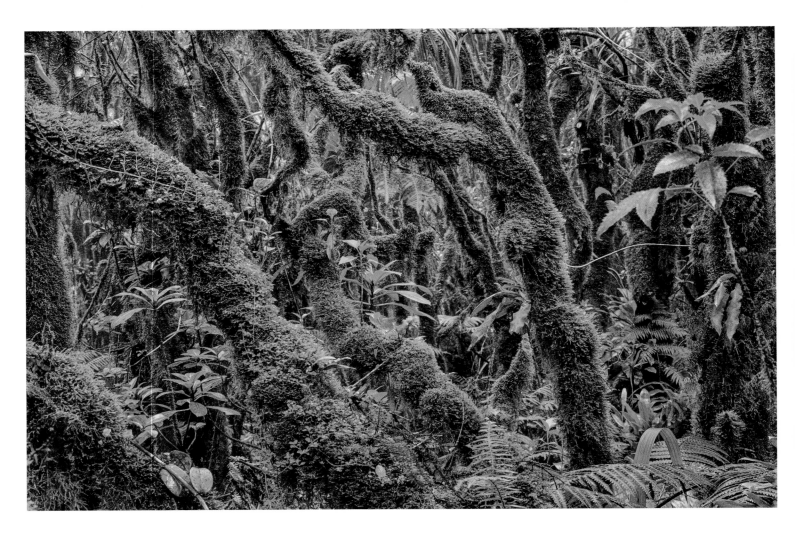

Above left: The lush vegetation in the Kamakou Preserve on the island of Moloka'i in Hawai'i contains more than two hundred species of rare native plants, many of which can only be found here. The Hawai'ian Islands are a hotspot of island biodiversity.

Above right: Botswana's Okavango Delta is one of the largest wetlands in the world. Each year floodwaters that originate as rain over the highlands of Angola spread over an area of up to nine thousand square miles [twenty-three thousand square kilometres], creating an oasis of life in the middle of the Kalahari Desert.

Following page: A jaguar peers from dense vegetation along a riverbank in the Pantanal region of Brazil. The world's largest tropical wetland, the Pantanal also extends into Paraguay and Bolivia. Jaguars have made a comeback here due to new protections introduced after decades of heavy persecution by ranchers, who feared their impact on livestock.

When one of my photographs was published on the cover of *GEO* magazine in the early eighties, I happened to be in New York City during the week that the magazine hit the newsstands. I saw my picture of two albatrosses all over Manhattan and thought I'd really made it and that everything would be easy from then on! That wasn't the case, but it was a pivotal moment because I realized that, with photographs, I could add my voice to the public conversation. I saw my photograph surrounded by fashion magazines with pictures of models, news magazines with pictures of conflict scenes and so on and realized that if I wanted to be effective as a photographer, I needed to cultivate a language for communicating visually with people, to ensure that nature and the environment would end up on the same kind of platform.

*

I've always been passionate about nature, especially about animals. It comes naturally to me, but because of my scientific background – I'm trained in sociology and political social sciences – I can also be analytical about the world of nature and I've long been aware of the conflicts between humans and nature. In the Netherlands there are one thousand people per square mile, so the evidence of this kind of conflict is everywhere. But there is also a coexistence, because in the Netherlands people have figured out that you can't survive forever if you don't respect the environment to a certain degree.

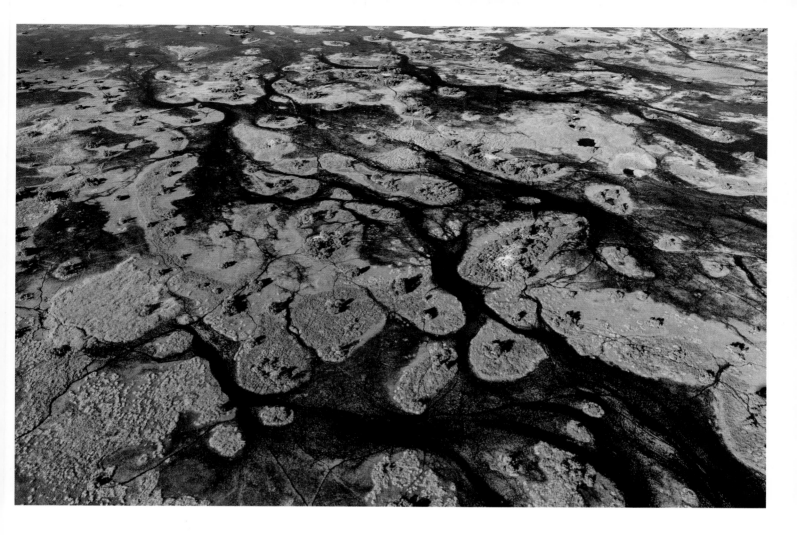

I started photographing nature with that perspective, which was different from the way that many photographers in the United States approached nature. There is so much of an original natural environment in the western parts of North America that it's easy for people to focus their cameras on the purity of nature and leave reminders of the human environment out of their images. You end up with the gorgeous landscape views that the American landscape photographer Ansel Adams practiced and that many other photographers have emulated.

To me, it's always been more about the connections between people and the planet that we depend on – even if there are no people visible in my photographs, there is often a reference to that connection. We now know that we are not that different from our nearest cousins, the great apes. But what's more fascinating is that our deep genetic connections with other life forms are even more profound – we may share ninety-nine per cent of our genes with chimpanzees and bonobos, but we also share fifty per cent of our genes with the lettuce that we eat. There's a kinship to all life on planet earth and we carry that story with us in our own genes. That fascinates me just as much as capturing the diversity of life on this planet.

When I set out to become an environmental economist, my goal was to quantify the value of nature so that decision makers would have better information for making informed decisions that affect our environment.

'Extinction has been part of the story of life since the very beginning, but we are now in the midst of a mass extinction that is unique in the history of our planet because it is caused by humans.'

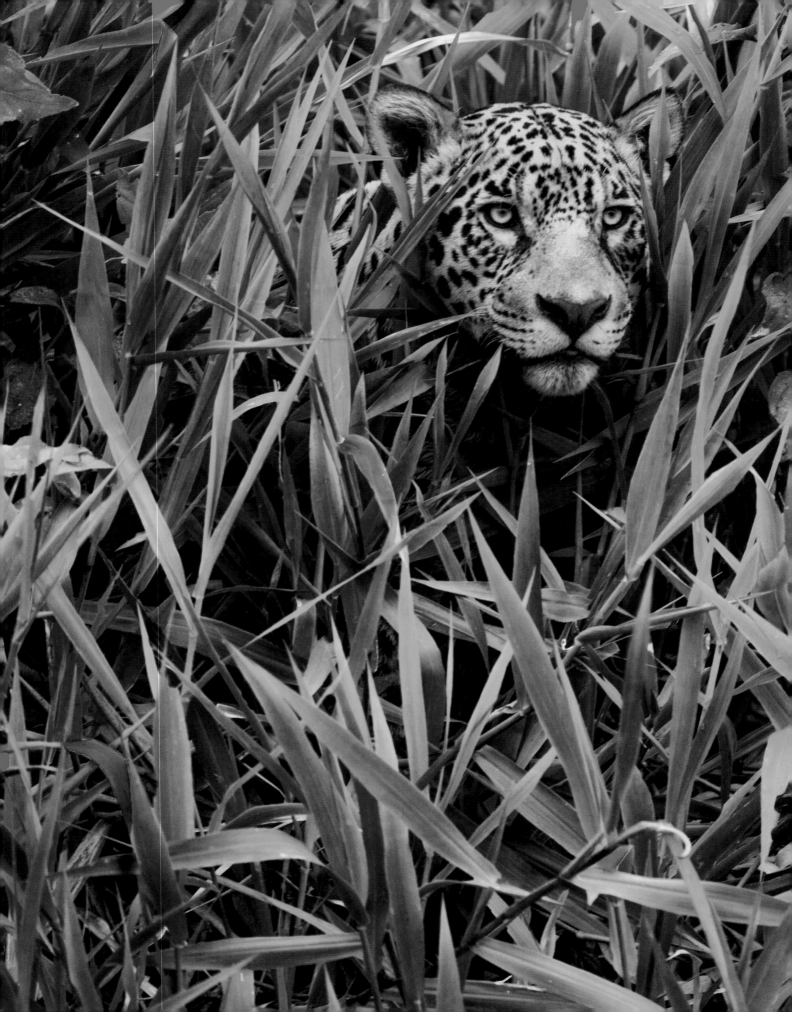

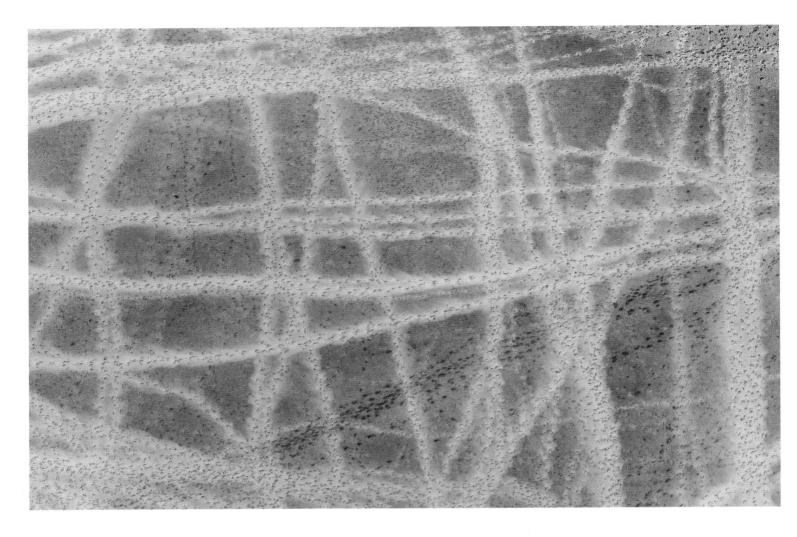

Above left: Animal trails pattern the surface of the Makgadikgadi Pans in Botswana, one of the largest salt flats in the world. The pans are a remnant of a huge prehistoric lake once fed by the Zambezi River. The lake dried up tens of thousands of years ago when the river changed course.

Above right: A flock of greater flamingos nests in the Makgadikgadi Pans, Botswana. The birds are drawn to the pans when seasonal rains raise the water level high enough to protect their nests. For most of the year the pans are bone dry.

But now I'm demonstrating the value of nature through images and stories and through our efforts of siding with people who can effect positive change. I like to think of my photographs as having multiple layers, like Christmas presents with attractive wrappings. The outside has to look good; you need to have the coloured paper and the bows to make people appreciate a gift. In the same way, I want to seduce people with the colours and patterns of nature. But when the outer layer is peeled away, there is another layer – I want people to go deeper into the stories that are embedded in every photograph – the lives of individual animals, how they relate to their environment and how they are part of a planet that we belong to as well. It's not just about the diversity of life in its myriad forms, it's also about the unity of life. Our DNA is an extension of the genetic make-up of all other life forms that we share our planet with. That is an exciting realization. It's not us versus nature; it's us being part of nature.

*

Extinction has been part of the story of life since the very beginning, but we are now in the midst of a mass extinction that is unique in the history of our planet because it is caused by humans. It has been called 'the sixth mass extinction'.[2] This is of great concern to me. I try to capture it in my images, but how do you visualize extinction? How do you capture something that isn't there anymore?

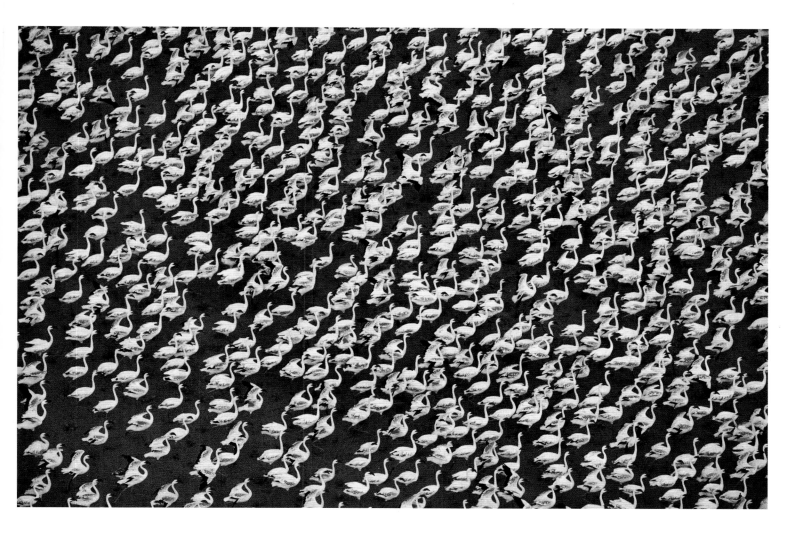

What's most important at this point in time, is for people to realize that there is only one planet and that we are dependent on it, not just for our well-being, but also for our survival. When I started out, there was not much recognition for that notion. A few scientists knew it, but now more people seem to embrace the idea. The world has shrunk because of media and the ease of travel; we now understand that we live on a finite blue marble. That is a vital realization that needs to become the foundation for everybody's actions, whether it is through what they buy, or who they vote for. The tragedy is that many of the people who are most directly affected by global climate change, do not have the ability to vote, or do not have access to information that can help them understand what is happening in their world. I do see change happening. Whether it is happening fast enough is the big question.

We need to work on all fronts to achieve a better balance between people and nature. If I had to pick one thing that I think is important, it is to embrace nature as part of a climate solution strategy. Nature can help us overcome the effects of climate change in a more effective way than virtually anything else we can do. If we invest in nature by protecting habitats like forests, as lungs of the planet, then we can save species that are dependent on those habitats. We will also be able to save ourselves, because we're dependent on those reservoirs of nature that still exist. Economists tell us that this is the most efficient way to spend money when it comes to climate change. Overhauling human infrastructure like our transportation systems and changing the way we build – that will take many

'Nature can help us overcome the effects of climate change in a much more effective way than anything else. If we invest in nature, in protecting nature as habitats, as forests, as lungs of the planet, then we can save species that are dependent on those habitats.'

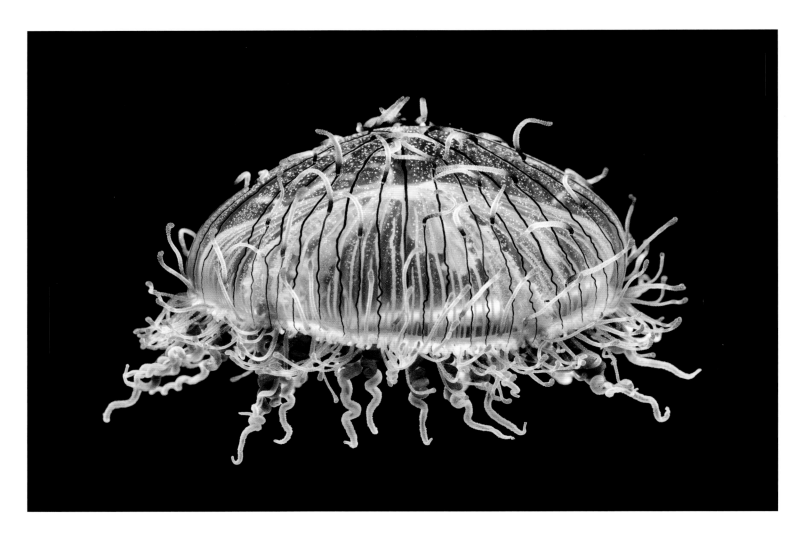

'It goes all the way back to the beginning; the origins of life. There's a unity and continuity to all life on planet earth and we carry that story with us in our own genes.'

trillions of dollars, but we can do a lot more when it comes to protecting the last fortresses of nature. We're still able to preserve biodiversity, but if we don't act soon then we're undermining the biocapacity of the planet to sustain us. If we embrace nature, nature will help us.

Wild animals have shown me how nature works. I'm a naturalist, but I work with them in a different way than scientists, who back off emotionally and accumulate data. To me photography has always been the result of a direct relationship. As a photographer, I am not making photographs of animals collectively; there's usually just one in front of me. What I've tried to do is bring out the identity of individuals and from that realization I've built bigger views of how they relate to their world. I've applied that principle from small shore birds, to elephant seals along the coast of California, USA. Then I started working with other animals – elephants in Africa, polar bears in the Arctic. Every time I embraced an animal it lured me into a world that I didn't know much about initially. From that intimate, one-on-one perspective, I began to learn more about the worlds that animals are part of. That led me to embrace ecosystems and animals became ambassadors for ecosystems. As my understanding grew, my photographs became more layered. It wasn't about animals by themselves anymore; they became part of a bigger view. My work has become more complex over the years because of that.

*

Empathy is important to me. To see yourself in others and vice versa, is essential to my work as a photographer. Instead of looking at animals through a big lens mounted on a tripod, which can emphasize a detached point of view, I prefer to be close, physically and metaphorically. It's fascinating to go back to the same place and reconnect with the same individual animals. Once, when I was in New Zealand, I had the privilege of photographing kakapos. They are large, flightless parrots that occur only in New Zealand. They are one of the symbols of the country and why it is so different from any other place on the planet. At the time, there were fewer than one hundred remaining. Biologists were working hard to save the species, which was on the verge of extinction. A number of kakapos had been released onto a small island and we went there with an assistant, Gideon, who had hand-raised a few of them as part of a repopulation program. One night we were in the forest looking for kakapos and one approached us through the undergrowth. Gideon said, 'I know that bird. That's Hoki.' Gideon had hand-reared this kakapo from the time when she crawled out of her egg and even though she'd been alone in the forest for more than five years, she recognized her former keeper and walked up to him. She reverted to the kind of behaviour that was typical of when she was a young bird; she crawled into his lap, turned upside down and sucked his finger. That was fascinating, because it showed that there was a bond between this bird and the man who had hand-raised her. The connection was instant. It was clear evidence that birds can recognize people as individuals in the same way that we can recognize certain birds

Above left: Multicoloured tentacles wave from the pin-striped bell of a flower hat jelly. This particular jelly drifts in sea currents at night to feed and rests on the ocean floor during the day.

Above right: Steam rises from the Grand Prismatic Spring in Wyoming's Yellowstone National Park, USA. The spring is named for its striking colouration which matches those seen in light prisms (red, orange, yellow, green and blue). The stains along the edges of the boiling blue water in the centre are evidence of primitive bacteria.

as individuals. Hoki passed away a few years ago. Now these precious images are not just a record of a species on the brink of extinction; to me they are portraits of Hoki (see opposite).

Kakapo numbers are increasing now, but the species is still at risk of extinction. There are a lot of problems in New Zealand because native animals evolved there in the absence of mammalian predators but everything changed when people arrived. The natural wonders of New Zealand survive on the fringes of the North and South Islands and on its offshore islands. It's almost like planet earth in a microcosm; what has been happening in New Zealand we're now seeing on other continents. Wherever humans show up, vulnerable species tend to disappear, or are reduced to fractions of their former populations. We need to recognize the fragility of nature, especially on islands.

I have worked extensively in Madagascar off the east coast of Africa, which underwent its own unique evolution – everything there is different from what you find in Africa or Asia. I went there to document its natural history, but I became drawn into the lives of the people and their traditions, because they were just as fascinating. There are nineteen different tribes on the island, but even though people have only been there for two thousand years, there's a conflict between the growing population on the island and its natural environment. I documented that as a microcosm of my interest in the global relationship between people and nature.

We returned to Madagascar recently, to places that I knew well, to document ecological and cultural changes. On the west coast of Madagascar, I once photographed the relationship between people and sea turtles, but that tradition is gone and so are the sea turtles. And that happened in the course of just one generation. We brought photographs from thirty years ago back to a village to share them with local people. They looked at my photos and recognized individuals no longer alive. They still knew the names for the traditions I had photographed, but nobody was practicing them anymore. That was a poignant experience. It's hard for

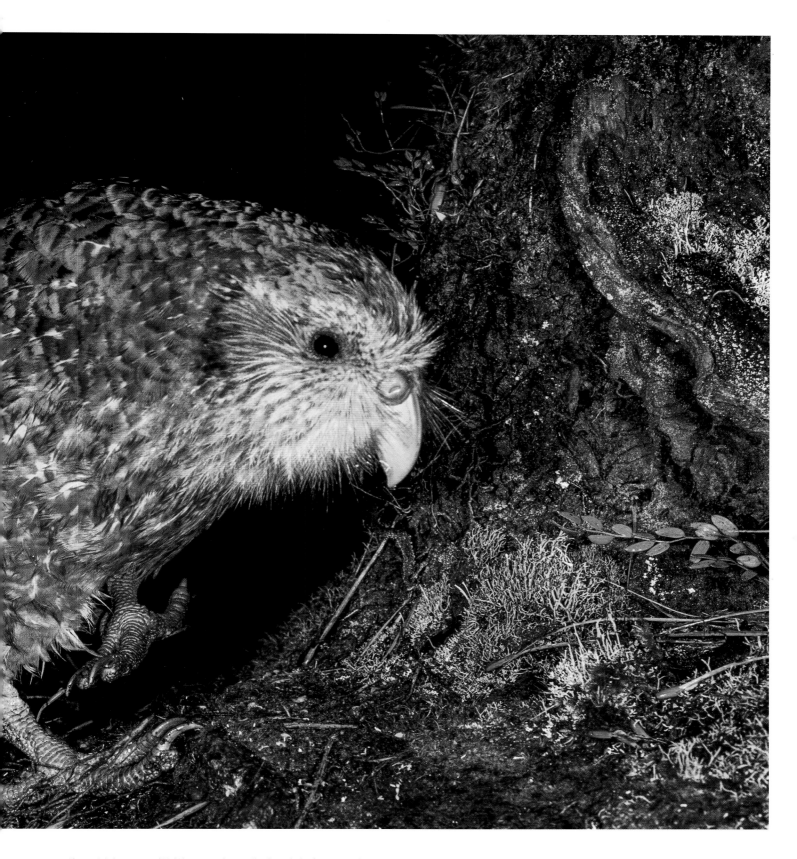

Above: A kakapo named Hoki by researchers walks through the forest at night on New Zealand's Codfish Island, a predator-free bird sanctuary that holds the majority of the world's breeding population of the critically endangered kakapo.

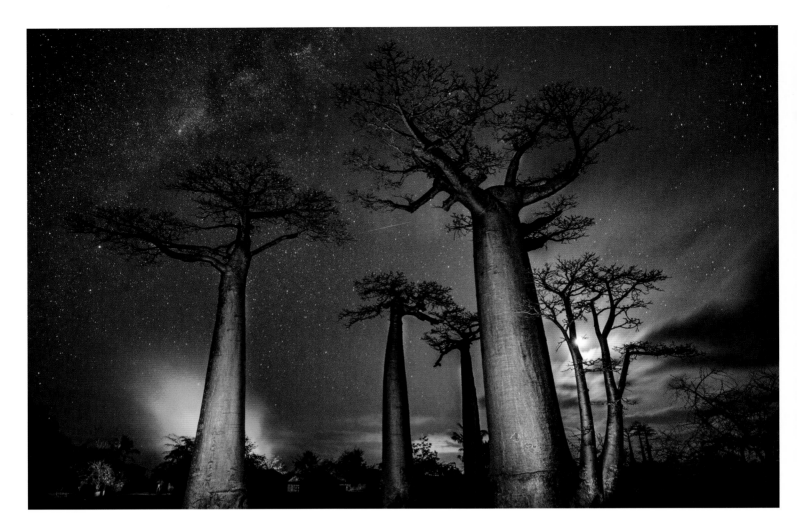

Above left: Backlit by the glow of a rising moon and a bush fire set by villagers, a grove of baobabs in Madagascar is silhouetted by a night sky filled with stars. Baobabs are iconic trees of Africa, but while the continent has only one species of baobab, the island of Madagascar has six.

Above right: An Antandroy tribesman poses with a fossilised elephant bird egg against a background of octopus trees in southern Madagascar. Elephant birds were flightless birds up to ten feet [three metres] tall that became extinct around five hundred years ago as a result of human impact.

nature to thrive unless there is cultural stability. You can't isolate protecting nature from nurturing the lives of people. And when people are poor, it is not easy to ask them to preserve nature.

We did bring back more hopeful stories from that same village in Madagascar as well. There was a small non-governmental organization practicing a different kind of conservation. Instead of putting nature first, they were applying innovative methods of bringing back marine life in the lagoon. After only a couple of years, animals that have a short life span were significantly boosted in numbers. It became evident to people that there is a better way to deal with their resources.

I do believe that a better future is possible in places where nature matters for people in a direct sense. We are blessed that we can go to grocery stores; for many millions of people in the tropics that's not the case. They need nature for daily material needs. If we can help them, then that helps nature and ultimately, it helps all of us on this planet. It has been estimated that if we want to be able to afford all the things that we in modern consumer societies like to have, then we need to set aside half of our planet's natural environment to sustain our lifestyle.[3]

<div align="center">*</div>

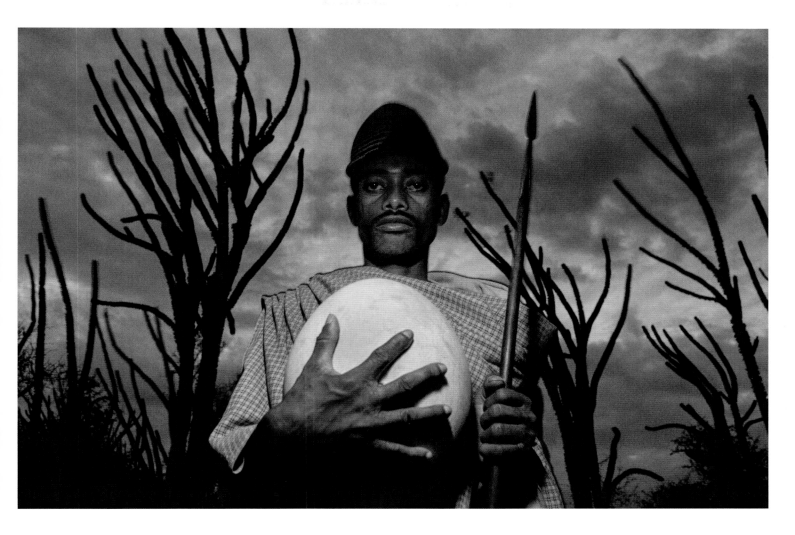

I'm becoming more of an activist as I grow older, not just in how I photograph things, but in what I connect the photographs with. I spend a lot of time supporting causes and organizations that can help turn things around. My wife, Christine Eckstrom, and I are partners in life and work; we collaborate in the field and for our publications and we have a similar view of life on planet earth and what we can do to sustain it. Instead of starting our own foundation, we decided that we could be more effective by lending our support to others who know the pathways towards a more sustainable future for us all. The forces lined up against nature, causing its retreat, are formidable and we don't have a lot of time, so Christine and I pick projects carefully, to make sure that we create images and publications that are connected with causes and can contribute to solutions. That sounds rational, but when you're on location and you see how things have changed – and not for the better – it becomes a more emotional reality. I've been doing this work now for four decades and in the last few years we've started a series of expeditions to places that I know well from earlier projects to document them again. There's a massive retreat of nature, especially in the tropics and sometimes I gasp when I see what has happened in the past few decades.

'The tragedy is, that many of the people who are most directly affected by global climate change, do not have the [ability to] vote, or do not have access to information that can help them understand what is happening in their world.'

'Our DNA is an extension of the genetic make-up of all these other life forms that we are sharing our planet with. That is a really exciting realization. It's not us versus nature; it's us being part of nature.'

We live in a period where pressures are becoming more intense all the time, where you can be worried about everything – every meal you eat, everything you purchase. In Europe there's a new term: 'climate anxiety'. People are beginning to suffer from a mental condition that can lead to depression. We need to turn that around and provide people with positive examples of what we can do. The window for turning things around is shrinking but each trip to the grocery store can be an affirmative act of positive change and we need to take it from there.

It's easy to become cynical and say that nothing can be done, so it's important to tell stories of hope. We are working now on a project to document Monterey Bay in California, USA, where I've lived for decades. There is a rich ecosystem onshore and offshore, with whales in the bay and mountain lions in the forest. But after the Gold Rush, it was plundered. The forests were turned into construction wood for the cities around San Francisco Bay and offshore the ocean was overfished until there was little left. But in the last fifty years there has been a miraculous recovery that may provide some inspiration to other places working to restore their natural resources. What worked was protection of the forests and preservation of critical places such as parks and reserves, with the same ideas applied to the ocean and marine resources. We are seeing whales come back in huge numbers and the mountain lion population is rebounding. I'm not saying that everything is perfect here, but there has been a unique combination of scientists, activists and politicians who were supported by a citizenry that got engaged. That can be a potent formula. These ingredients may exist in different combinations in other parts of the world, but I do believe in the power of artists banding together with scientists and activists to tell stories that can make a difference and give people hope.

Hope matters. And so does action.

Right: An old male chimpanzee drinks from a waterhole in the Fongoli area of southeastern Senegal. Just like humans, chimp hair turns grey with age and their skin can become blotchy, just like ours. Chimpanzees are highly threatened throughout their range in Africa.

Following page: Many frog species are disappearing worldwide at an alarming rate. Scientists consider them to be the 'canary in the coal mine' – warning us of problems that might harm humans as well. In recent years, disturbing mutations have been documented in wetlands around North America and Europe where frogs can now grow six legs or more. Here, at a scientist's lab in Oregon, USA, the photographer arranged these dead frogs to emphasize the eerie effect of their deformations.

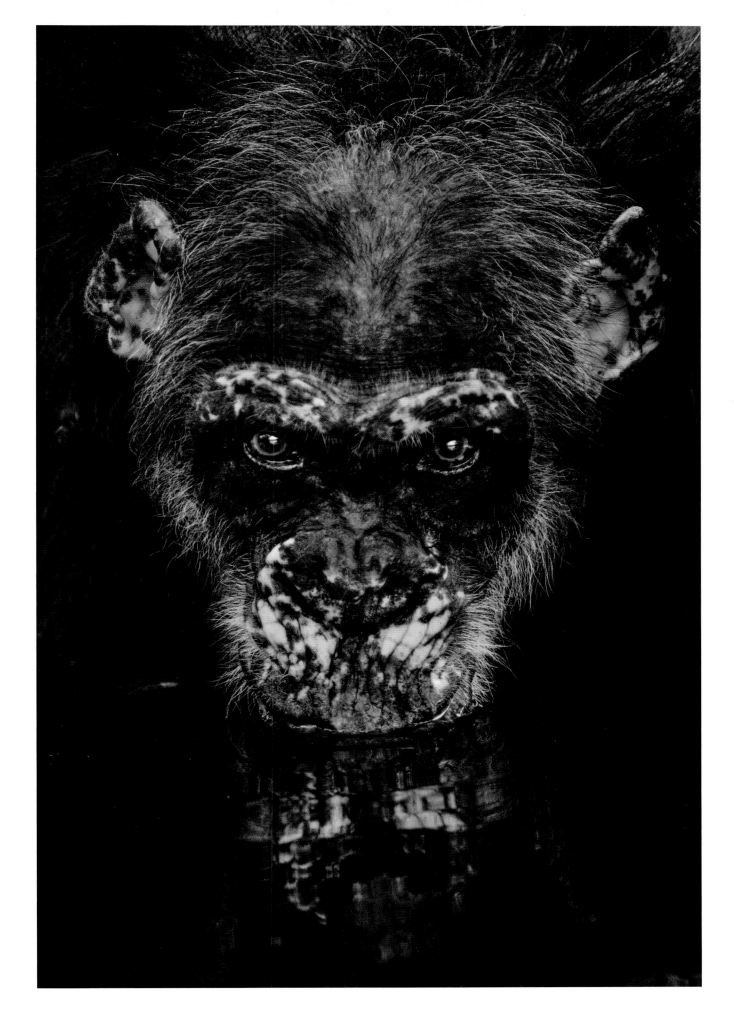

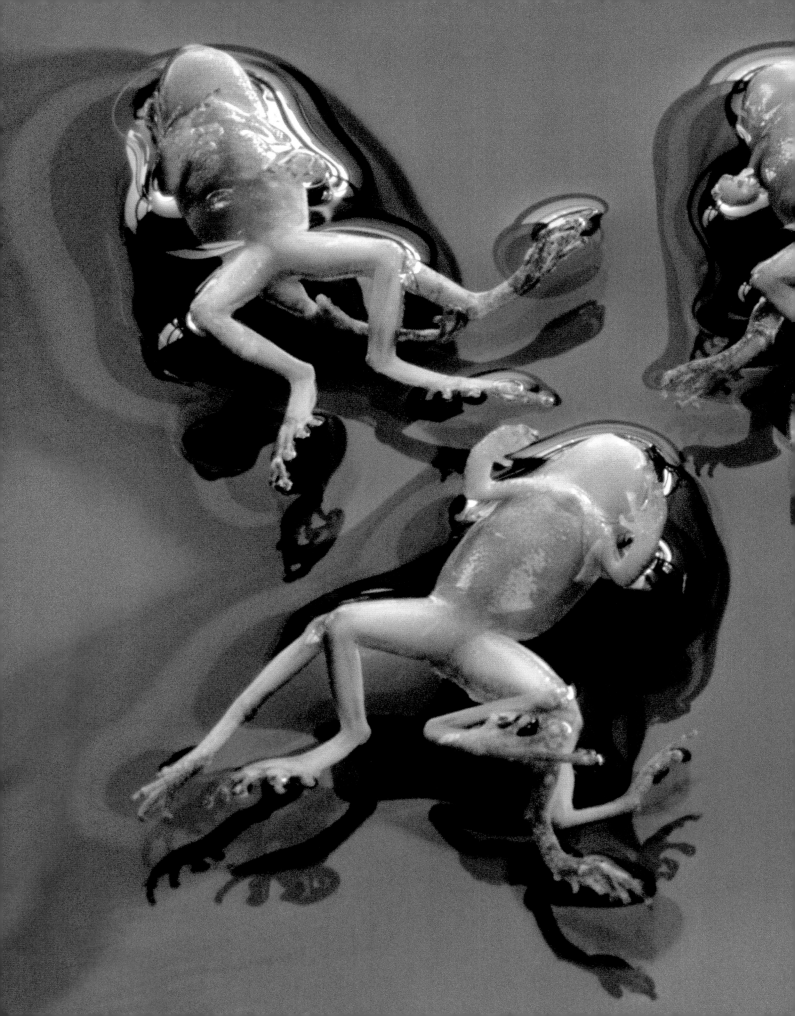

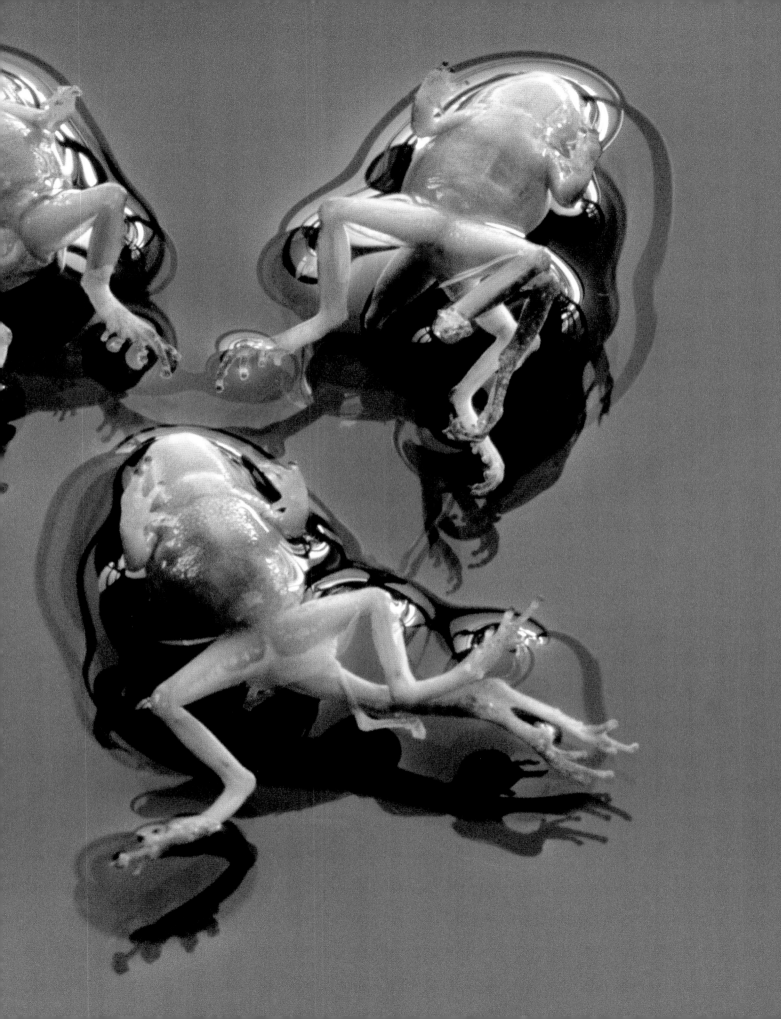

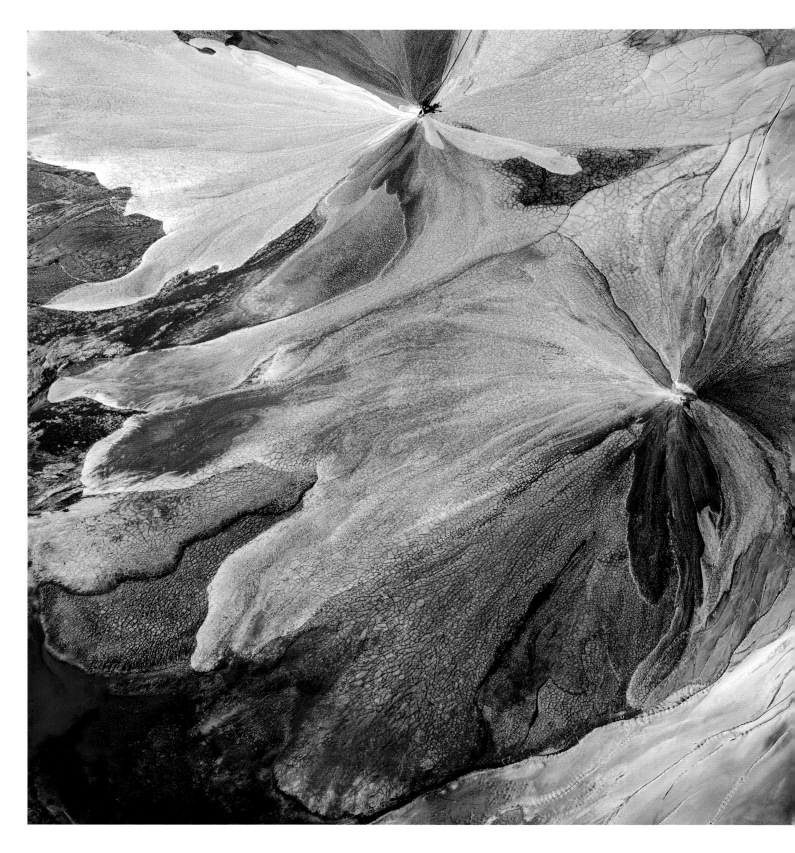

Above: Bauxite waste from aluminium production in Burnside, Louisiana, USA. The red waste is iron oxide, the white waste is aluminium oxide and sodium bicarbonate. Tremendous amounts of caustic (pH 13) 'red mud' bauxite waste is produced in aluminium refining, which also generates other contaminants and heavy metals.

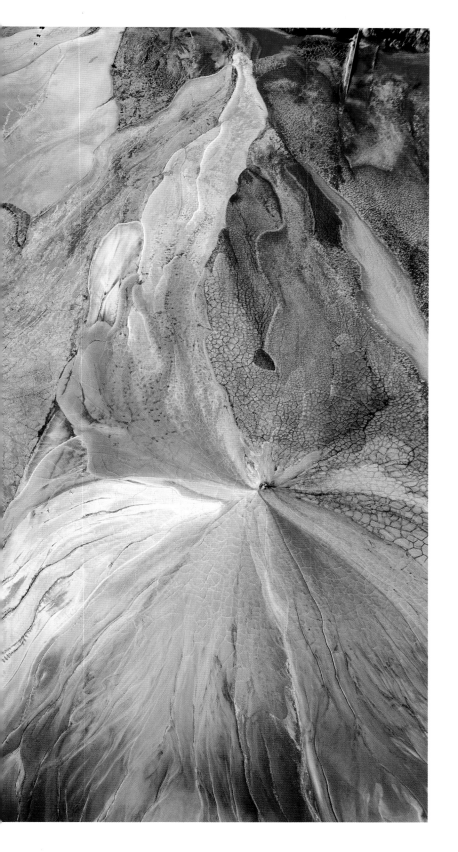

J HENRY
FAIR

J Henry Fair is a photographer and co-founder of the Wolf Conservation Center in South Salem in New York, USA. A self-described environmental activist, his recent work is a large-scale aerial photography project exploring the extreme effects of human and industrial pollution on the planet.

I'm from Charleston, South Carolina, USA, but work out of Berlin and New York, making photographs that are simultaneously art, reportage and activism, the ultimate purpose of which is to explain the science behind complex environmental issues.

After stealing an old Kodak Retina camera from my father when I was eleven years old, I immediately knew that photography was my field. Getting a job in a professional camera store propelled me and gave me access to a higher level of equipment, knowledge and technique. I've always photographed people and the things that they are affected by and have always had a consciousness about nature, our connectedness to it and the damage we are doing to the planet.

Arriving in New York City at the age of eighteen, determined to be a photographer, sounds romantic. But the execution can be bumpy. Carpentry paid the bills as I started to pick up some photo work. I photographed anything for a dollar, from making eight-by-ten transparencies of an original painting by Louis-Jacques-Mandé Daguerre, one of the inventors of photography; to doing portfolio shoots for a fly-by-night modelling agency. I have photographed everything from priceless jewellery to religious tchotchkes, catalogue fashion to opera divas. It seemed that doing commercial photography – fashion, portraits, still life – could segue into doing something more personal that mattered to me.

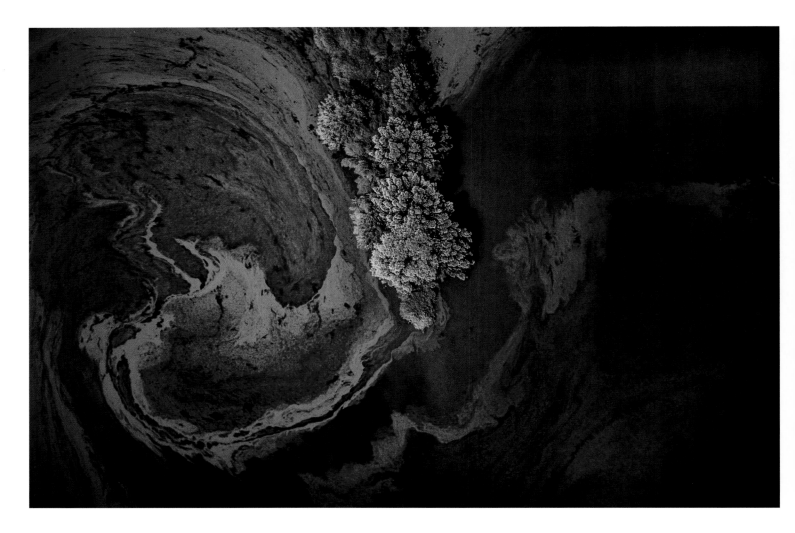

'What we see in these pictures are the hidden costs of mining; the detritus from the production processes that make the things that we buy every day, whether it's electricity, bread or the soda cans we throw away on the street. We are complicit, but it's a complicity of ignorance.'

My enduring fascination with industry and decay led me to photograph ruins, old machines and toxic sites throughout the eighties and early nineties, as I looked for a way to tell a story about the environment. I started to sneak into refineries to make pictures of the inner workings, hoping to highlight the disastrous effect of hydrocarbons on our bodies and the environment. This was before the climate crisis was a worldwide news item and before 9/11, so the level of paranoia in the United States was not so high.

When asked by a press agent some years ago if I saw myself as an artist or activist, my response was: both. He assured me that I would be punished in the art world for that. But my dictum is: art that is beautiful but not meaningful is decoration. Art that is meaningful without beauty is pedantic. A photograph that makes somebody feel has transcended into art. A photograph to which the viewer thinks, 'Oh yes, cut-down trees on a hillside – seen it before', is just a document. Intrinsically I understood that I needed to make art for people to feel my sense of urgency.

I want my photographs to work on multiple layers. They must be beautiful and the irony of making something beautiful out of something terrible comments on the irony of life in the modern world, where each of us, no matter how conscientious, must realize that we're stealing from our grandchildren by not living a sustainable life. The constant study of art

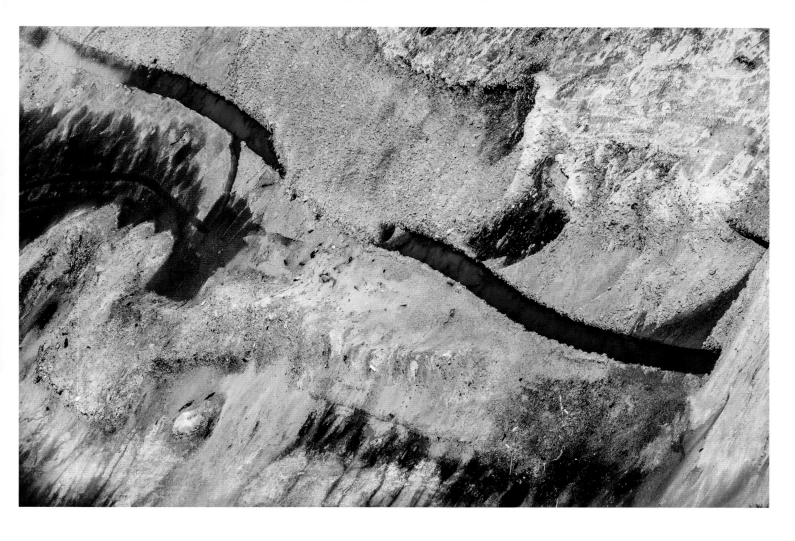

teaches me how the old masters stimulated the emotions of the viewer through lighting, composition and colour. That, for me, is the hallmark of really good art: it manipulates our senses to make us feel something.

*

One day, on a red-eye flight from California to New York, I looked out the window at dawn and saw a serpentine river of fog in a valley, with cooling towers and smoke stacks protruding out of it – and I had a revelation: getting above it could be a way to tell the story I had been trying to tell. Then all that remained were the logistical questions of how to find an aeroplane and where to go to photograph. New Orleans was an obvious answer because of 'Cancer Alley', the industrial corridor of the Mississippi River between New Orleans and Baton Rouge, so-called because of the higher than average cancer rates in these locations. So I went to New Orleans and hired a plane.

Aerial photography allows a lot that can't happen on the ground. Firstly, it allows me to get rid of the horizon and make an abstract composition, the horizon being one of the defining elements in human perception of any scene. And since most of the things I want to photograph are either far from 'civilization', or sequestered behind fences and 'beauty strips' [rows of trees planted to hide something from the road], flying lets me get over the fence.

Above left: A waste pit at a herbicide manufacturing plant in Luling, Louisiana, USA. The world's most widely used herbicide, glyphosate, can be used in conjunction with seeds that have been genetically modified to tolerate its application, but is increasingly applied on non-GM plants, including just before harvest. In August 2018 a court in San Francisco found that glyphosate manufacturer Monsanto, was liable for the cancer of a California school groundskeeper and ordered it to pay the man US$289,000,000.

Above right: Waste from phosphate fertilizer production in Huelva, Spain. The phosphorous component of fertilizer used in industrial agriculture is obtained from the refining of phosphate rock, which contains traces of naturally occurring radioactive material which are concentrated during the treatment of the crushed rock with sulfuric acid. The waste, shown here, is both radioactive and very acidic.

'Our consumer disposable lifestyle is destroying this very complex natural system on which we depend.'

Flying also allows me to go big distances and look for stuff. A perfect example is the tar sands in the far north of Alberta, Canada; being in a small plane allows you to cover that distance, which you could not do with a drone. Over the years, a network of pilots around the world have become friends and essential collaborators on this aerial photography project. Aside from the support of donating their aircraft and flying time, they bring a wealth of local knowledge and experience to my 'grand wiki'.

Right after Hurricane Katrina in 2005, my life was in a bit of flux. The day after Christmas I got in a little Cessna, flew up the Mississippi River and started to photograph the industrial sites. Of course, I had no idea what I was looking at, but it was clearly the right place to make toxic pictures. There were giant lakes of green liquid in mountains of white and tremendous impoundments of red 'mud' with wonderful flow patterns.

At that point, the environment was not the issue of the day. So back in New York, when I showed the pictures to editors, the main response was: 'Hmmm, interesting, but what is it?' So I went back to Cancer Alley and drove to the places I had photographed and thus began the grand research project: piecing together what was in the pictures, the story they told about our impacts on nature and the pollution of our air and water and how that story fitted into a larger story of industry, politics and finance.

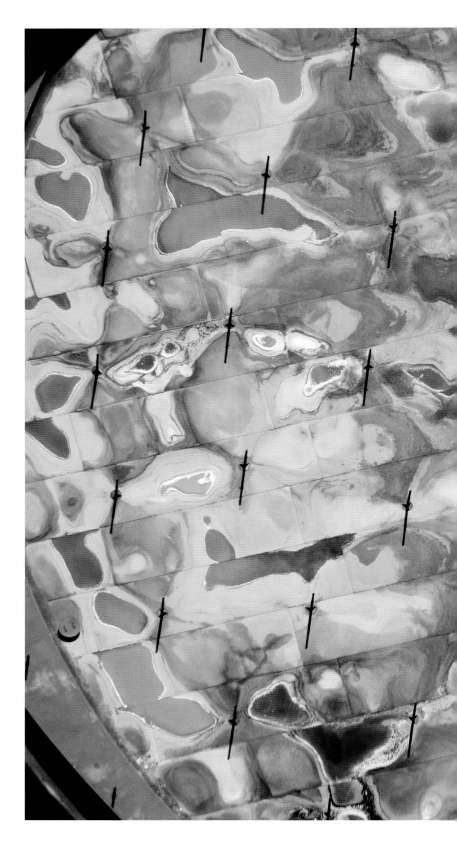

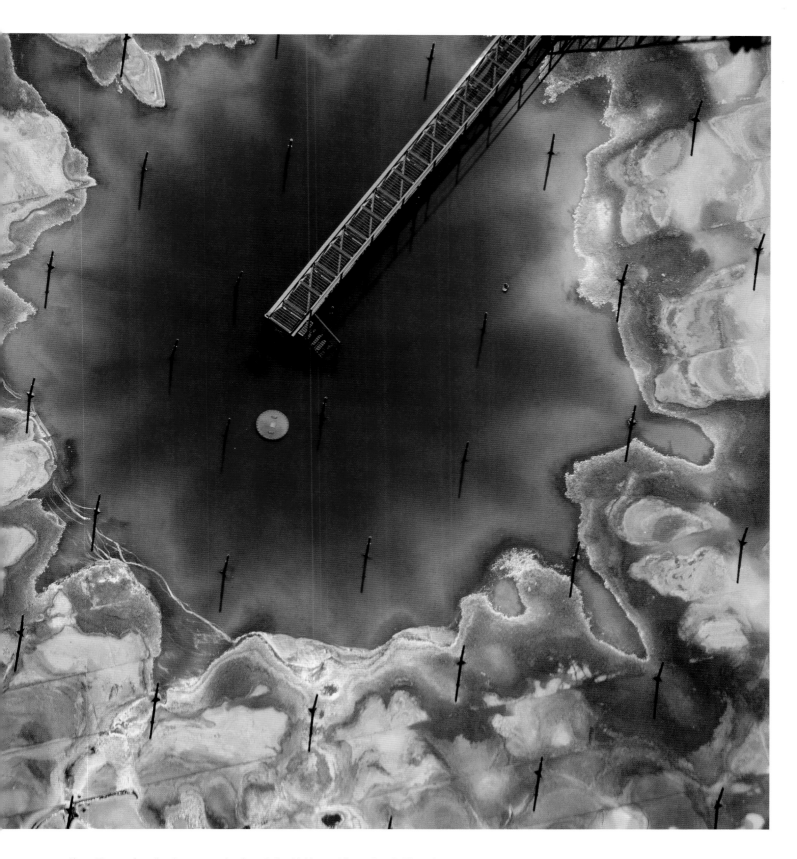

Above: The top of an oil tank at a tar sands refinery in Fort McMurray, Alberta, Canada. The tank stores between 400,000 and 500,000 barrels of the world's dirtiest oil. Tar sands, a layer of bitumen-saturated earth which can be refined into petroleum, are primarily extracted in Canada.

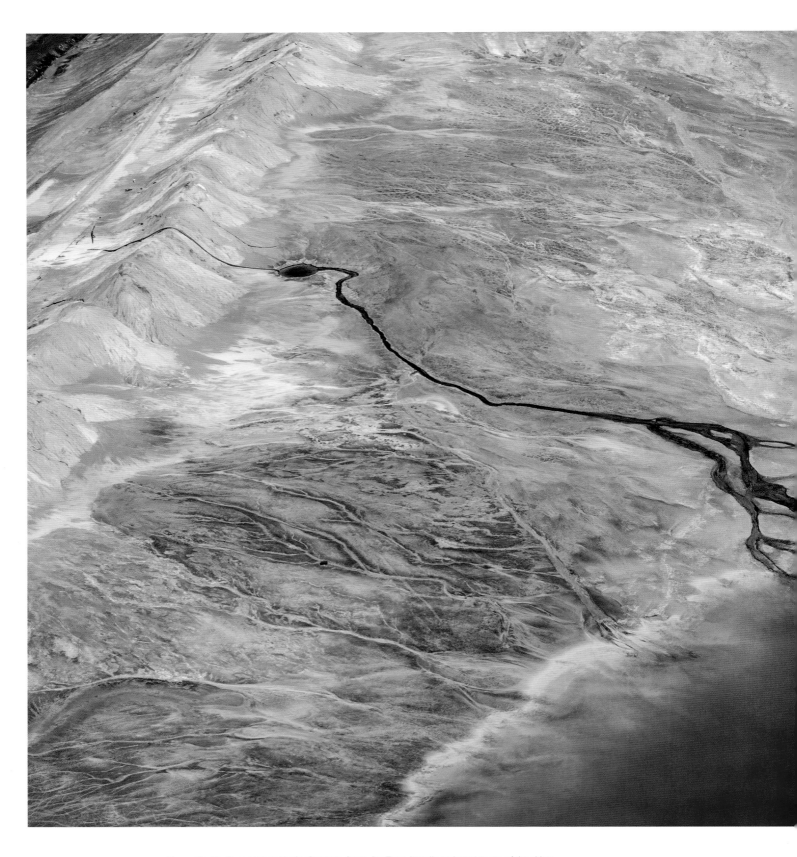

Above: The Rio Tinto Mine in Huelva Province, Spain. Rio Tinto, literally 'red river', is one of the oldest and most productive mines in the world, having produced a wealth of different metals over centuries. It is rumoured to have been King Solomon's mine and the reason that the Moors invaded Spain.

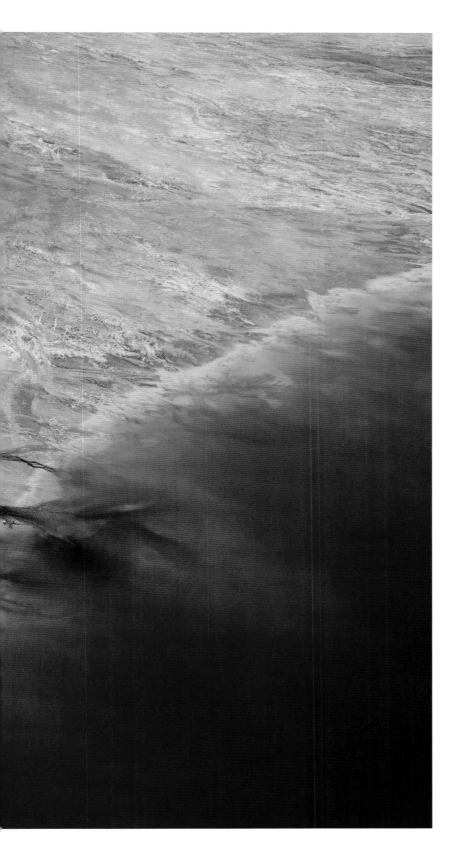

I'm a bit of an engineer at heart and I always want to understand how a process works. So while flying over an industrial facility, I want to take several kinds of pictures; first the 'art' pictures – those beautiful abstracts that make people feel something – but I also want the documentary pictures that explain how the process is working. A photo flight around a location entails looking, seeing, understanding and visualizing the shot and then actually making it. The time pressure is immense and the photographic conditions terrible: imagine trying to steady a camera with a big lens while sitting in a small car being shaken by a giant. And the plane is only in the right position for an instant. Having done it so often and developed a good understanding of the processes, I can usually identify a facility and find the essential photographs I want, though sometimes it has taken years to get a particular photo.

Following page, left: Teeth marks from an oscillating excavator in a brown coal mine in Garzweiller, Germany. The process of brown coal mining in Germany is a fascinating study of cruel efficiency; people are forced to move from their homes, which are demolished. The forests are then cut down and the farmland excavated. Coal combustion is the world's largest source of CO_2, as well as the largest source of uranium and mercury released into the environment.

Following page, right: A coal slurry in Kayford Mountain, West Virginia, USA. Mined coal must be washed with water and processed with chemicals to prepare it for market. This creates tremendous volumes of fine, wet slurry which is stored in impoundments held behind earthen dams built across valleys. On numerous occasions these containment structures have failed, releasing large quantities of toxic slurry which have inundated and devastated the valleys below the dams.

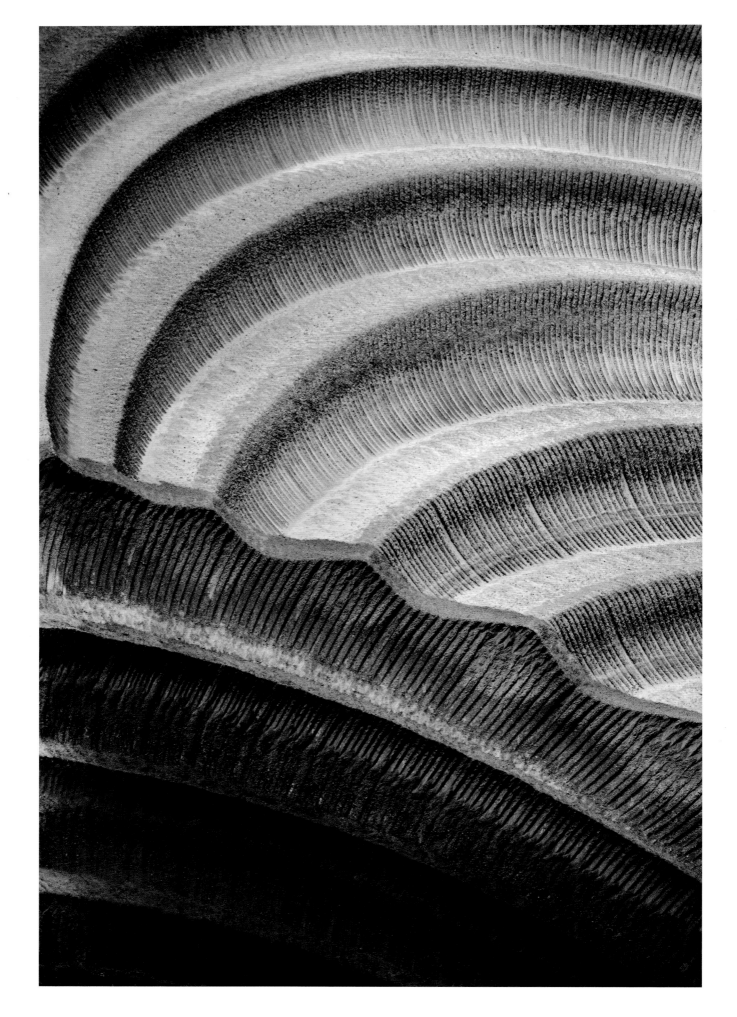

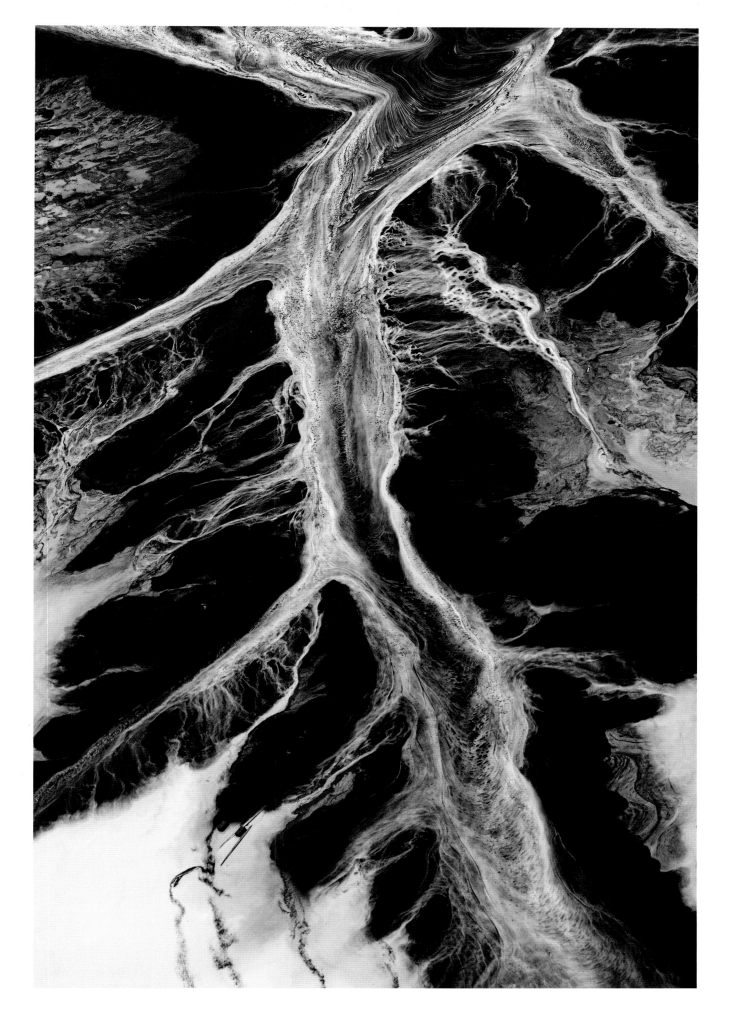

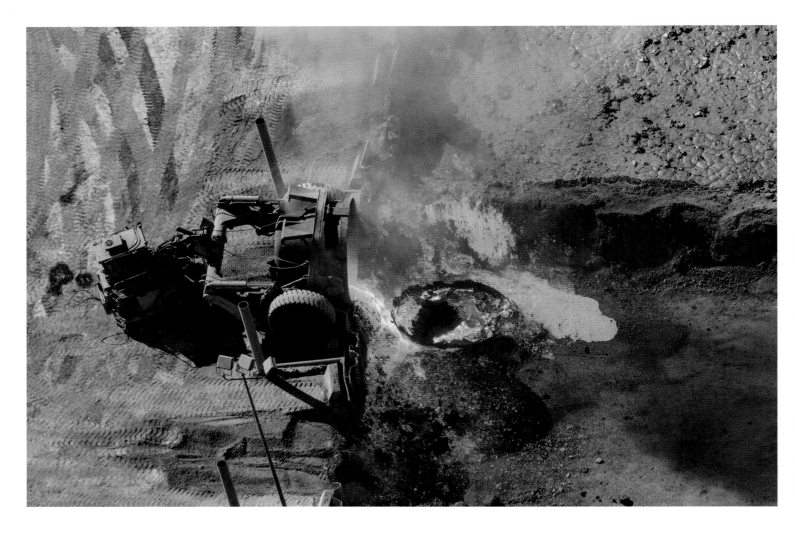

'Each of us, no matter how conscientious, must realize that we're stealing from our grandchildren by not living a sustainable life.'

The process of abstraction also took a while to understand; I had to get back on the ground and look at the pictures and think, 'Ah yes, this one works really well', precisely because we don't know what it is. So I started to look for that whilst I was on a mission. I often purposefully include details that can give a clue as to what we are looking at, or at least a sense of the scale.

One of the first places that these disparate elements came together was shooting the Rio Tinto Mine in Spain (p. 70). Legend says that the mine, which is one of the most productive copper and gold mines in the world, belonged to King Solomon. Copper is a low-concentration ore; it's piled in a giant heap and doused with sulphuric acid. Then from the bottom comes a leachate, liquid that is percolated through the heap that contains the dissolved copper, which must then be extracted. These are complex, often highly toxic, processes; some of them I understand, some not – I should have paid more attention to my high school chemistry teacher. In that particular Rio Tinto shot of the mine, it looks like slurries – meaning liquid with suspended solids – were dumped repeatedly, so we see these fingers dribbling down from a dyke. There are colours that recur, which can be clues for understanding what happened there.

What we see in these pictures are the hidden costs of mining: the detritus from the production processes that make the things that we buy every day, whether it's electricity, bread or the soda cans we throw away on the street.

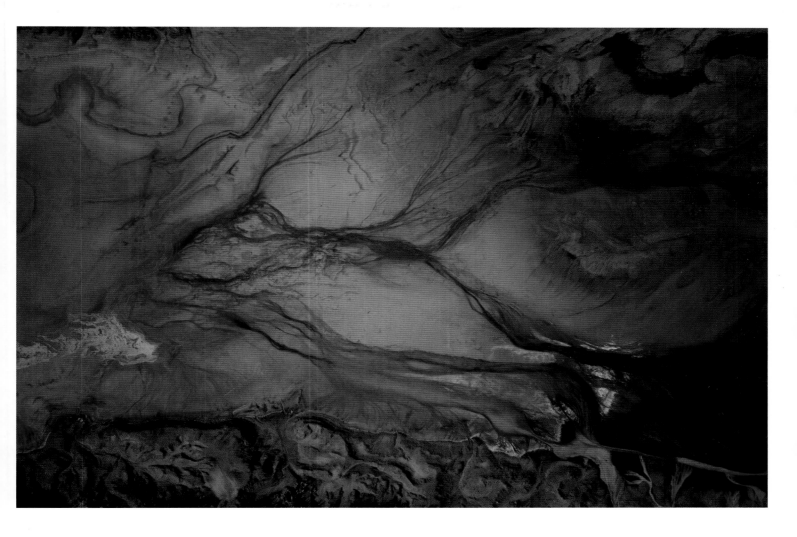

As an example, making just one single-use aluminium can requires enough electricity to power your computer for three hours. We are complicit, but it's a complicity of ignorance. We must educate ourselves if we want to make a difference and demand laws dictating that things are made sustainably. Let's be clear: the companies producing the terrible things that I photograph are usually acting within the law. And often, they have paid the politicians to write the laws for their benefit.

I believe we can create change in three ways: in the voting booth, through the things that we choose to buy and by speaking out.

There's a forest in Germany called the Hambacher Forst, one of the last ancient forests in the country. Since it's adjacent to an expanding brown coal mine it's been progressively cut down over the past twenty years, but still there are thirteen species from the European Red List of threatened species living there. The power stations fed by the coal from this mine (the largest hole in Europe), are the worst polluters and carbon emitters in the European Union. In the summer of 2018, this forest became the centre of a hot political debate in Germany and suddenly, all around Berlin, drawings appeared of chainsaws and the words 'Hambi bleibt' ['Hambach stays']. We made this a key part of the man and nature 'Artifacts' exhibit I did at the Berlin Museum of Natural History that year. I see the role of artists as reflecting and focussing the sentiments of their society.

Above left: A disposal truck pours waste slag from a steel mill into a pit in Huger, South Carolina, USA. This steel 'mini-mill' recycles scrap steel into steel beams for the construction industry. Slag consists of unwanted impurities that float to the top of molten metal during the smelting process.

Above right: Coal ash waste at an electricity generation plant in Canadys, South Carolina, USA. When coal-fired power plant ash is improperly disposed of, contaminants including arsenic, lead, mercury, selenium and others can migrate into groundwater, lakes and streams. This plant was cited by the US Environmental Protection Agency in 2011 as a 'proven case' of environmental damage.

Germany has very strict laws: tree-cutting has to be done in October. Momentum built and by September of that year, 50,000 Europeans marched into this last remaining bit of woods and said, 'You don't cut this forest.' And what do you know? A court in Cologne stopped the cutting of the forest, which prevented the expansion of the coal mine. Thus, eventually it will starve the power plant. When people stand up and declare their intentions and their wishes, governments quake. Look at the effect of Greta Thunberg and the Extinction Rebellion and FridaysForFuture movements; the derision that's directed at Thunberg tells us that the powers that be are worried about her and this momentum.

*

A perfect example of the hidden costs is playing out in the giant forest and river system we call the Amazon, one of the great stabilizing forces in the climate patterns of the world – but we are cutting it down to grow cattle and soy for export to supply the world's demand for cheap beef. The damage is systemic and total: deforestation, habitat destruction – which leads to the extinction of species we haven't even discovered – the alteration of the world's moisture patterns, increased methane emissions by the cows themselves, to list but a few. All for a fast food hamburger.

Similarly, if we buy the most common brand of facial tissue, we should know that it means the cutting down of an old-growth forest in Canada, the loss of habitat for all the wildlife there and the release of all that carbon into the atmosphere, both from the trees cut down and from the ground disturbed. And on top of all that, tremendous water depletion and water pollution. All for one facial tissue, which we discard after blowing our noses therein.

'We can do this, but we need
to realize the level of the crisis.'

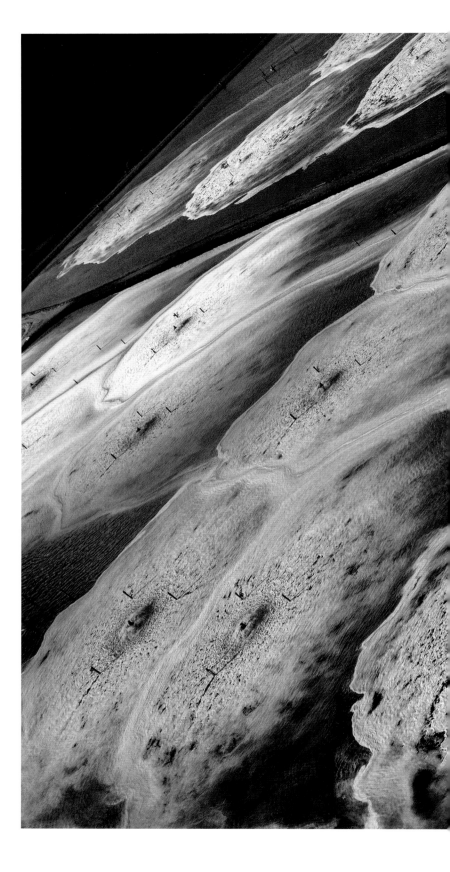

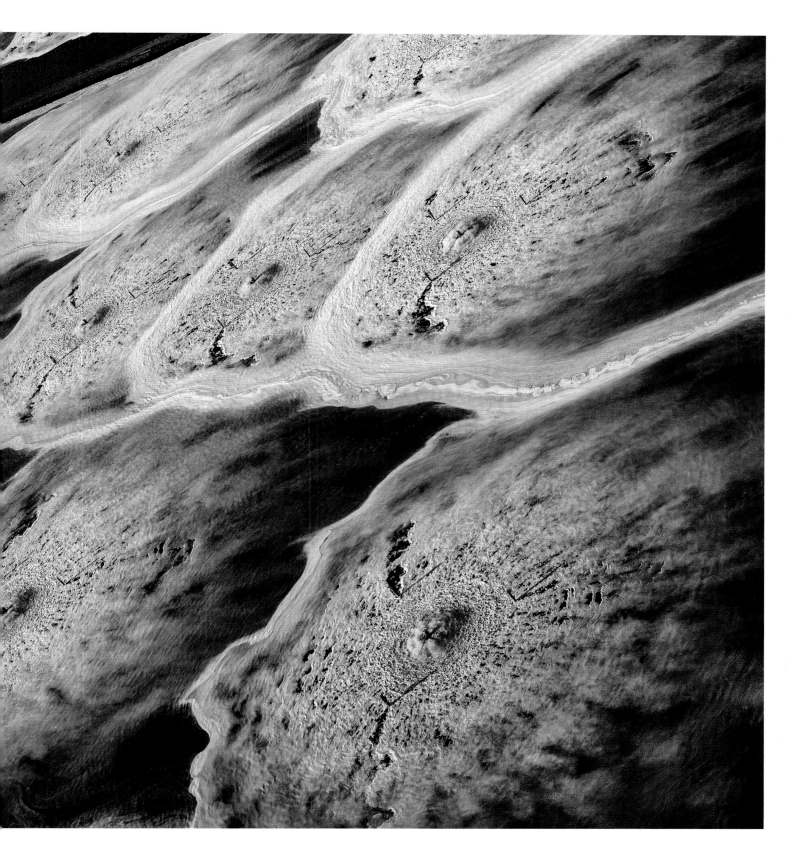

Above: Aerators agitate waste from the manufacture of facial tissues in Terrace Bay, Ontario, Canada. This aeration pond is part of the effluent treatment system. The primary task of the treatment is to remove organics (wood fibre) from the water before it is returned to its source. Water pollution from paper mills contains toxins such as lead, mercury, chlorine compounds and dioxin.

Previous page: Machine tracks can be seen in bauxite waste in Burnside, Louisiana, USA. At aluminium oxide refineries 'red mud' bauxite waste is pumped into vast storage impoundments and allowed to settle. The waste impoundments require grading with heavy equipment to maintain proper drainage for dewatering. Once dry, dust carrying contaminants is blown by the wind, covering everything nearby.

Above left: A drilling slurry at a hydro-fracking drill site in Springville, Pennsylvania, USA. 'Hydro-fracking' is the high-pressure injection of tremendous volumes of water and chemicals to fracture the subterranean shale rock and release the natural gas trapped there. These drilling muds (the waste pumped out during the boring of the hole) include rock debris, petroleum lubricants, heavy metals and possibly residual radioactive material.

What I'm trying to do is raise awareness, get people to feel and think about the hidden costs of each of these things. And the way to do that, I've decided, is by using art – by creating a compelling apparition that prompts a pause, to stop and think – and with a level of irony that causes the viewer to consider their part in all of this. I back up my work with a tremendous amount of research which is then correlated to the pictures, starting with the basic facts: who, what, when, where, why, how – to the more esoteric: what does it mean, how does it relate to the larger stories, both local and global.

*

The bottom line is this: we're in crisis; our society and economy could all come crashing down and no one wants to talk about it. We are altering the inputs to this incomprehensibly complex planet that has provided us with clean air, clean water, regular rainfall, fish in the ocean – all for free. What a gift! And we are disrupting that system. The most visible disruption at the moment is the climate crisis, caused by changing the balance of CO_2 in the system and thus disrupting the weather. In fact, it's not changing as fast as it could, because the ocean is sucking up all the carbon dioxide (we don't know why) and becoming more acidic, preventing shellfish from forming their shells and killing the corals. The oceans are going to crash and then they won't provide anybody with food. A huge number of the world's population lives off protein from the ocean. How will we feed those people?

Continuing to list the very plausible doomsday scenarios only bores, repels or disheartens – and thus demotivates. And in fact, there is plenty of cause for hope: the human spirit, earth system resilience and technology are my sources. I rejoice in stories of fisheries rejuvenating after extraction stops, of the efforts of groups of people to protect their local environment from extraction or pollution and the fact that solar energy is now cheaper than coal.

The message behind my work is: our consumer-disposable lifestyle is destroying this very complex natural system on which we depend. We must stop burning hydrocarbons today. We must change our societal model from consumption and disposal to sustainability. Ultimately that means that every system must be renewable – what you take out has to be replaced.

My belief is that only sustained popular expression of will can drive change. I believe that governments respond to corporations because corporations give governments money, but corporations will respond to their consumers. So, if we, as citizens, demand toilet paper made from post-consumer materials, we will get it. We've seen this again and again. When the hybrid car came out, the media laughed at it – but people bought it. I believe people are worried and want to do the right thing to save the environment, but don't know how. One powerful way is to be cognizant of the impact, the hidden costs, as we make our purchase decisions.

Above right: A phosphate waste impoundment in Lakeland, Florida, USA. This outlet pipe is at the bottom of a giant 'gypstac' phospho-gypsum waste impoundment and creates a stream that eventually reaches the local water table. The weight of these gypstacks is tremendous and there have been instances of the ground underneath the stacks collapsing, allowing tremendous volumes of radioactive, acidic waste to contaminate aquifers.

'I believe we can create change in three ways: in the voting booth, through the things that we choose to buy and by speaking out.'

We live in this bountiful world with all of our modern technology, so complex and interconnected. We have seen how quickly and unexpectedly drastic change can be forced upon us and the interconnectedness of the world means that disruptions spread quickly. None of us wants to go back to the Dark Ages; our world is comfortable and exciting. If we are to preserve this standard of living, we must move quickly to make industry sustainable and we must raise standards of living around the world so that people everywhere feel stable and secure.

Already Europe especially is changing. They are building windmills and solar plants – it's working. There are plenty of instances of societies making great sacrifices, getting behind a leader and doing what is necessary to save the world. We can do this, but we need to realize the level of the crisis.

Right: The top of an oil storage tank at a refinery in Pascagoula, Mississippi, USA. Burning hydrocarbons has numerous known and unknown effects. Climate change is the result most often in the news, but air pollution and the death and disease it causes are also getting attention. Interestingly, these two pollutants also interact in unpredictable ways: new research shows that the particles in clouds of air pollution are actually slowing the rate of climate change by shading certain areas and reducing heat gain. But the wrong areas are being shaded, specifically the oceans, which is disrupting monsoon rainfall patterns.

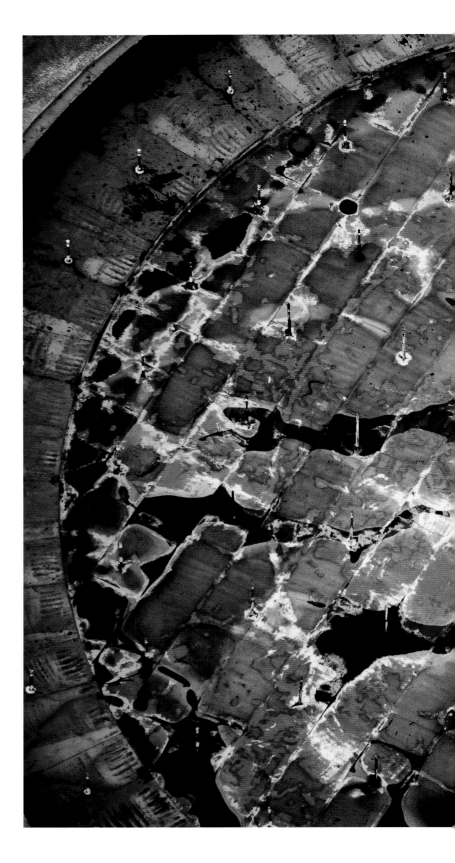

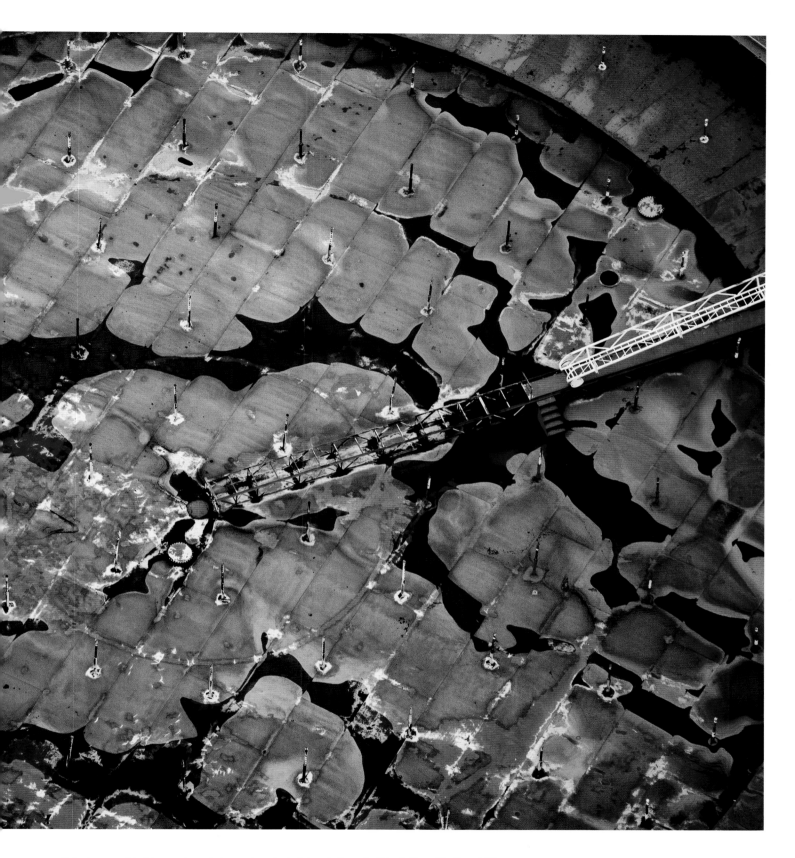

Following page: A bulldozer pushes petroleum coke, or 'petcoke', waste from oil refining in Texas City, Texas, USA. Petroleum coke, a solid more than ninety per cent carbon by-product of the oil refining process, is used as a source of energy and high-grade industrial carbon. Fuel-grade petroleum coke, which is high in carbon dioxide and sulfur, is burned to produce energy used in making cement, lime and other industrial applications.

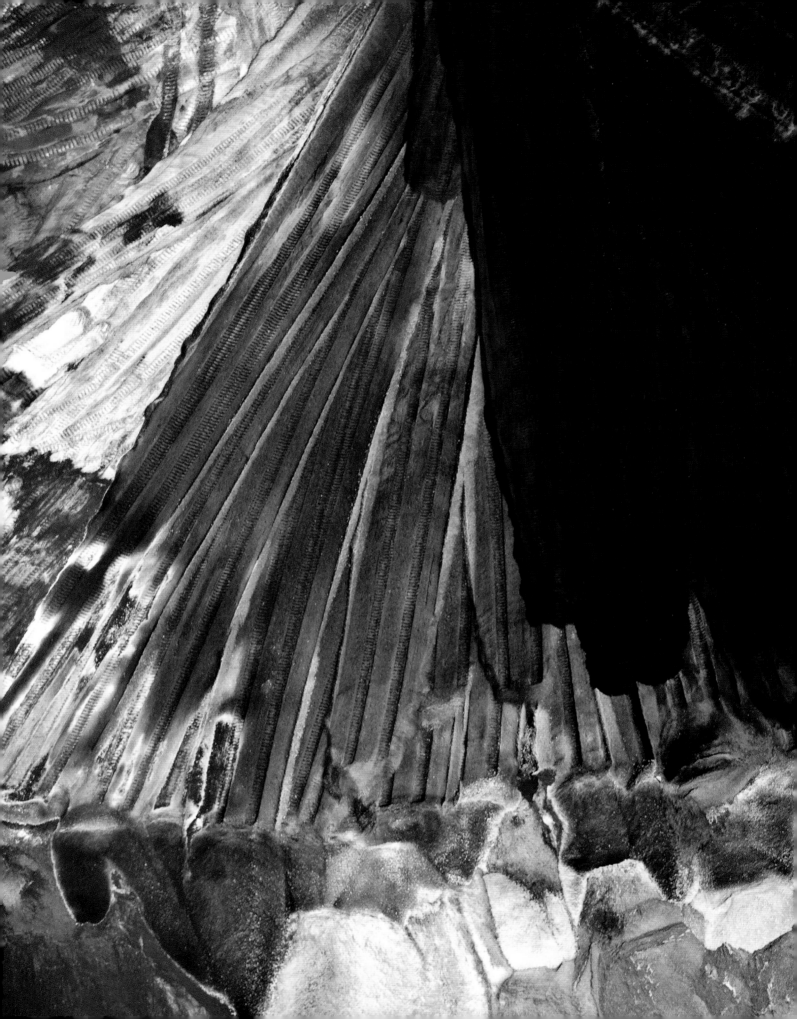

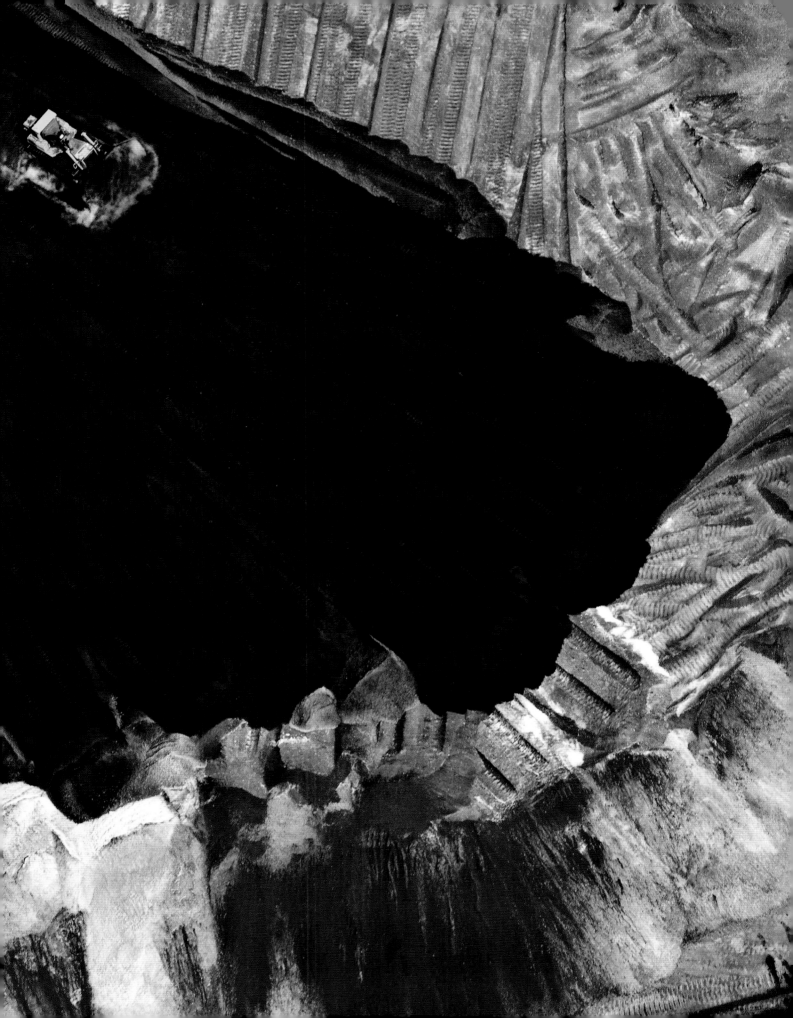

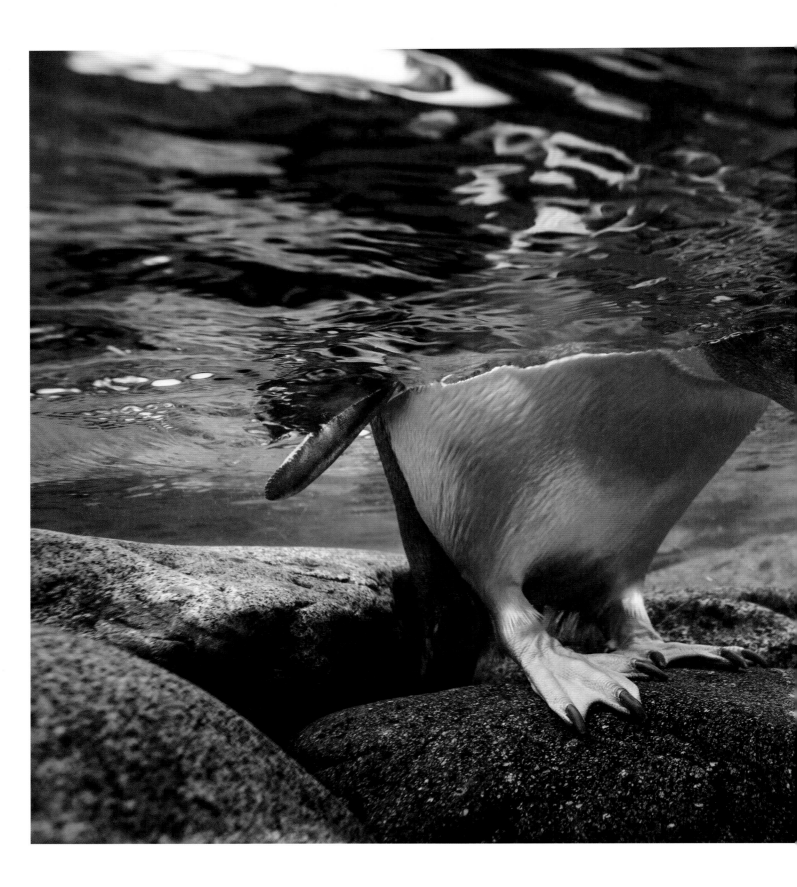

PAUL NICKLEN

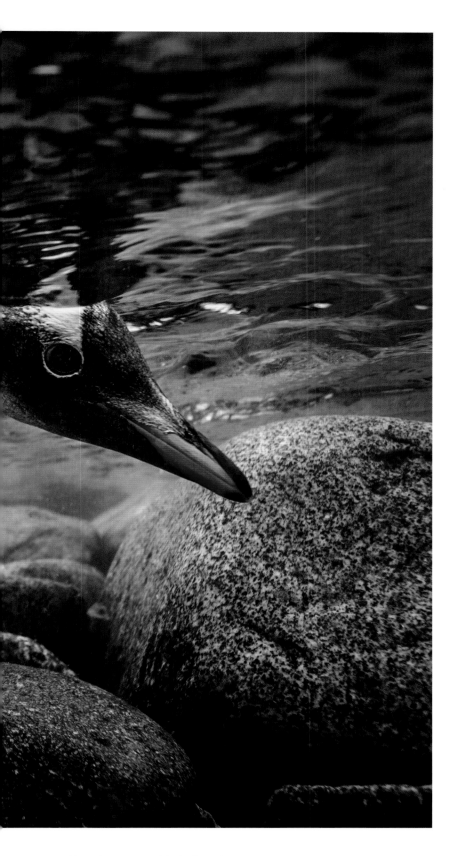

PAUL NICKLEN

Paul Nicklen is a marine biologist, contributing National Geographic photographer and co-founder of SeaLegacy, a collective of some of today's most renowned photographers, film-makers and storytellers working on behalf of the world's oceans. He specializes in the polar regions with the aim of generating global awareness about wildlife issues.

I'm a photojournalist and conservation photographer and I've been working with *National Geographic* magazine for twenty years. Together with my partner, photographer Cristina Mittermeier (p. 114), I co-founded a non-profit called SeaLegacy to use the power of visual storytelling to drive change for our planet.

My parents were both from farming families in Saskatchewan in western Canada. In their early twenties, they were offered jobs in the Canadian Arctic on Baffin Island (then called Frobisher Bay), now known as Iqaluit. You either fall in love with the Arctic, or you despise it; there's no middle ground. It's cold, miserable and isolated and my brother loathed it. I, on the other hand, at four years old, fell in love with the ice, the snow, the landscape, the seascape, the people and the animals. From there, we moved to an even smaller community of 190 Inuit people called Kimmirut, then known as Lake Harbour. We were one of three non-Inuit families, with no television, radio or telephone. Groceries came once a year by a ship, which dropped them off on the shore of Baffin Island.

We lived, travelled and hunted with the Inuit on the land and I witnessed the compelling, true sense of community. Every door in the village was open; it was considered unacceptable (even rude and inappropriate) to knock. Without asking for permission to enter, you could walk in at any time of day, sit down and eat raw caribou or seal meat, then go back outside and carry on with whatever you were doing.

Above: A gentoo penguin in the Antarctic Peninsula, Antarctica, checks that the coast is clear of leopard seals before heading offshore.

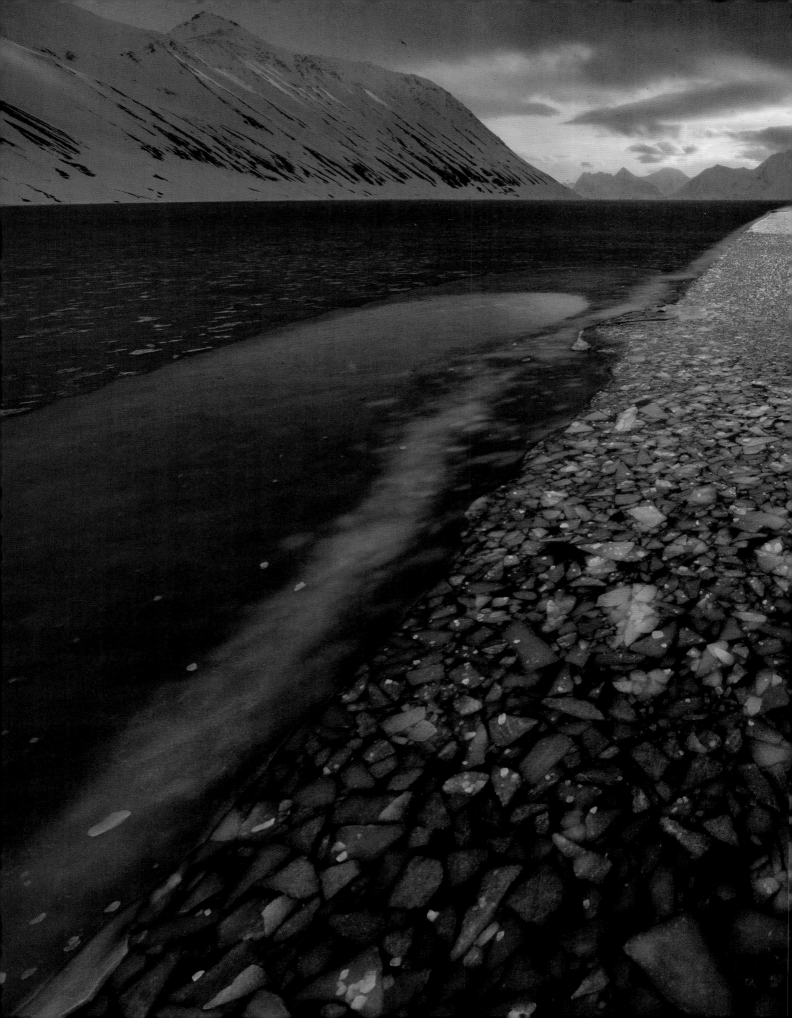

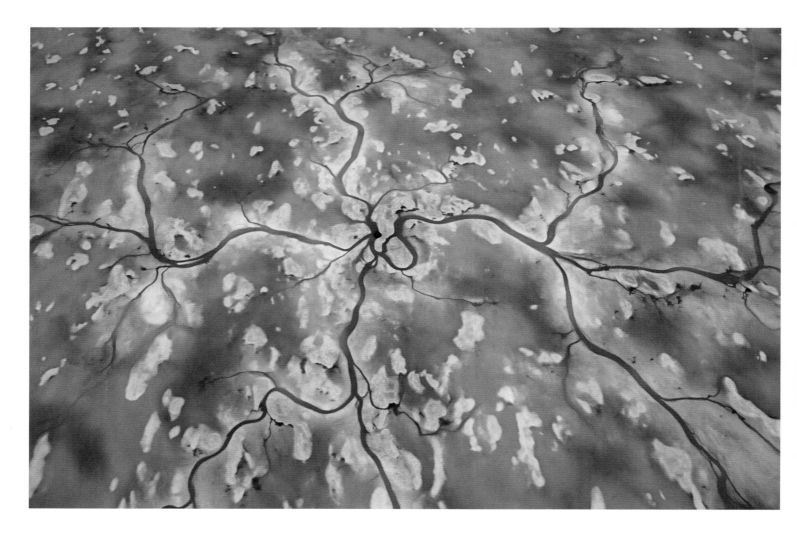

Previous page: Overnight, a thin layer of ice forms on the surface of the sea surrounding Spitsbergen in the Svalbard archipelago, Norway. By the end of the day, the ice will melt. At the time of photographing it seemed like a good ice year, but in reality the ice was thin and would soon disappear.

Above left: As sea ice melts the water turns a darker shade of blue, which holds more of the sun's energy thus accelerating the melting process. Here, the water drains down a seal hole in sea ice in the Coronation Gulf, Nunavut, Canada.

Above right: A ringed seal peeks through the glassy, calm surface of its seal hole, scanning for polar bears. Once it is sure that the coast is clear, it will move onto the ice to sun itself. These seals maintain up to five holes as they are constantly playing cat and mouse with polar bears.

Following page: A group of male narwhals perfectly framed by rotting sea ice is captured from an ultralight aeroplane fitted with amphibious floats, allowing it to take off and land on either water or sea ice.

The Inuit word *atakai* means 'following in the footprints of wildlife' and that's what we did – we'd follow the tracks of bears and caribou across the tundra and sea ice. Growing up in the Arctic made me tough. I always say that the skill I have that separates me from all of my peers, the thing I'm the best in the world at, is being freezing, hungry, in pain and miserable. If I can't feel my toes or fingers, I'll keep working.

*

I love being out on the sea ice. It's so quiet that you feel a roar in your ears, almost like holding a seashell to your ear, but it's dead silent. At minus forty [degrees Fahrenheit, which is the same in Celsius – minus forty degrees], hearing a crack or the crunching of a polar bear walking across the sea ice is a beautiful thing. From an artistic point of view, when it's minus forty or fifty degrees, that's when the polar regions become the most alive. For an artist, that's when your canvas is the richest; the light is the most beautiful and the mist is coming off the ice and the ocean. If that means being cold and living on the sea ice for two months at a time and waiting for two good hours with the wildlife, it's worth it. It's obsession, passion and love that allows me to suck it up when working in those conditions. Based on the Myers-Briggs Type Indicator (a personality assessment tool), I'm a massive extrovert, but even from the time I was young, all of my joy and pleasure in life comes from being alone in nature.

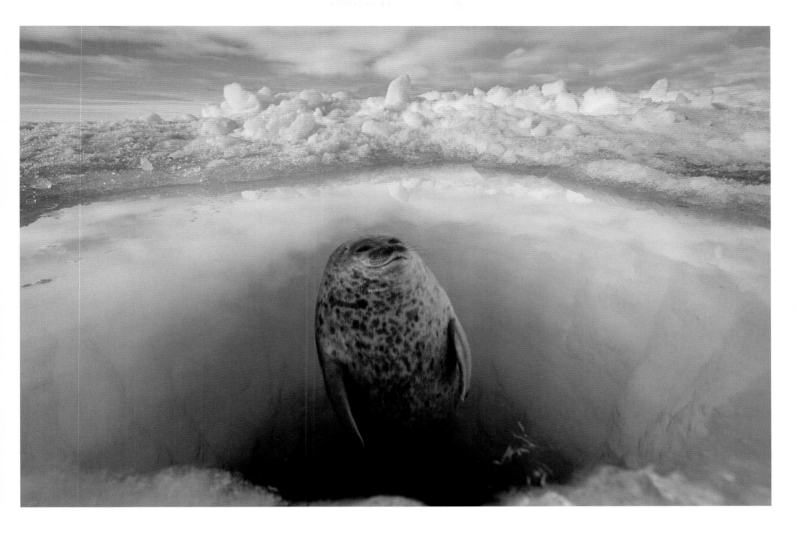

During my first year at the University of Victoria on Vancouver Island in British Columbia, I was walking back from class one night. I saw an advertisement for scuba diving and I remember being shocked that classes were open to the public. It was my lifelong dream! I had all of [ocean explorer, conservationist, film-maker and co-inventor of the Aqua-Lung] Jacques Cousteau's books, I had encyclopedias and as my love of wildlife took me more and more underwater, I now had a chance to learn how to scuba dive. That was my defining moment. Once I was underwater, I was like, 'Now what? I need to show the world what we're seeing here'. I was working toward my biology degree and all day long, my professors were using chalk to draw pictures of anemone, fish and the mating behavior of animals and I wanted to say, 'But all those things are right here!'

I bought a cheap Nikonos camera and made a deal with myself that if I maintained a D average, then I could maximize my diving time. Once I got into diving, I bought dry suits and tanks, but I was about to be kicked out of my dorm room because my bed and the scuba equipment smelled like rotten seaweed. I spent very little time studying; in exams, I'd rely on the deal I made with myself and work out what I needed to do to get a D. I didn't have a car, so I'd put on my drysuit, weight belt and tank, strap my fins to the back of my motorcycle and drive off to my dive sites with 3,000 pounds of compressed air on my back. I would dive at night, in rainstorms, snowstorms and winter: it was dive, dive, dive, all the time. I eventually thought, 'I'm going

'This entire ecosystem is connected and it all starts with ice.'

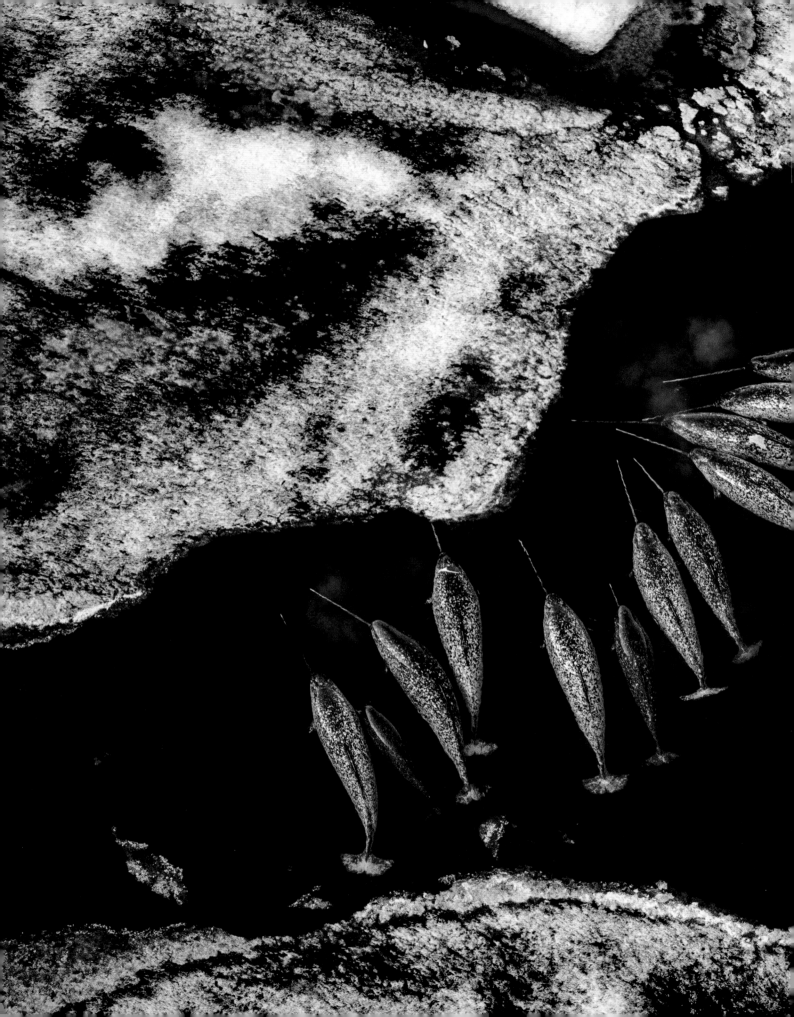

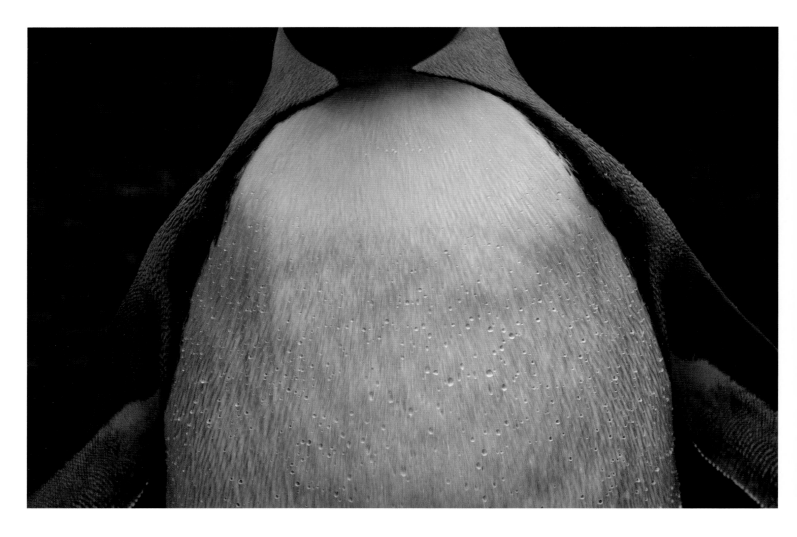

'Ice is like soil in the garden. A garden can't grow without soil and without ice, the polar ecosystems can't survive.'

to take a photography course' and once I did, I knew that was the direction I wanted to move toward.

I never thought it would be a career; I was diving because I wanted to see things. My whole world was sea life. One day, I was waiting for a friend in our dorm room when I clicked on the TV and saw the Cousteaus in the water with two killer whales. The whales surrounded them, then disappeared into the depths, both returning with sharks in their mouths, showing off. It was at that moment that I thought, 'I know what I'm doing for the rest of my life – this is it'. It became clear to me that this was the path I had to follow. My priority became finding a way to earn enough money to buy underwater camera equipment and start pursuing that dream.

The next logical step was to become a biologist, so I spent the next four years finishing my degree. After those years of studying, it was a frustrating time in my life. I was twenty-six, working in a government job and I accepted my fate that I was going to become a biologist restricted to turning the beauty of these animals, this nature and their ecosystems, into data points on sheets of paper. My bosses started to get upset with me because I was taking camera equipment everywhere I went on my scientific projects. They eventually gave me an ultimatum: 'Are you a photographer or a scientist?' That was when I said, 'I'm a photographer,' and I left my job. I'd saved $60,000 and I was ready to take on my photo career, confidently announcing to the world that

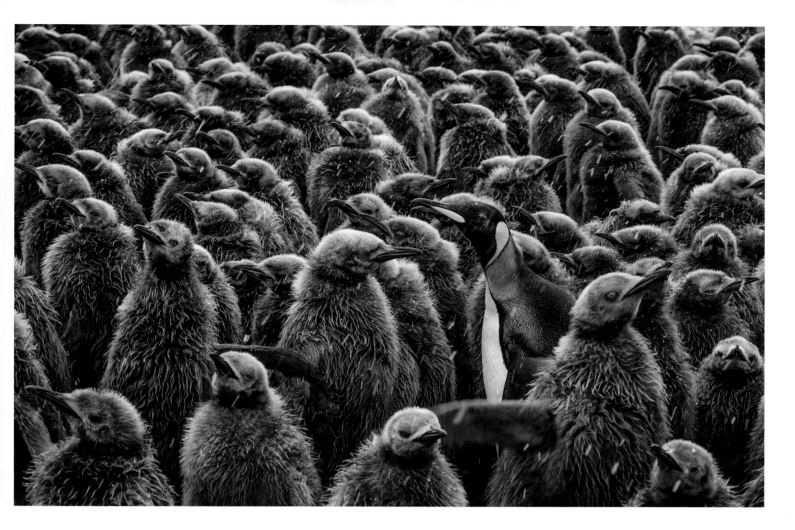

I was now a photographer. One year later, I was flat broke, having only sold a handful of pictures. I decided at that point to embark on a one-year journey to figure things out. I received a grant to work on a book, climbed into a small Cessna airplane and told the pilot to take me as far away from civilization as he could. I had six hundred pounds [two hundred and seventy-five kilograms] of equipment and he dropped me off in the middle of a barren landscape on the tundra of Canada's Northwest Territories on a cold spring day. He landed the plane with skis on a frozen lake and I said, 'If I'm alive, pick me up at the Arctic Ocean three months from now. I need to do this.' The happiest moments of my life have been when I'm alone in nature. And to be in the middle of nowhere with nobody within five hundred miles [eight hundred kilometres] of me, I felt fulfilled. One of the images from that expedition made it into *Canadian Geographic* magazine's 'photo of the month' feature and that made me hungrier for more.

*

What's mattered the most to me over the years is this desire to connect people to a world that I love – a world that I see changing before my eyes. As a biologist, I see the data that we collect and I know the science is essential. At the core of my work is art, science and conservation and my images have to be powerful, beautiful and evocative. If I'm using a telephoto lens to take a picture of a bear, wolf or fox, I'm shooting ID [identifying]

Above left: Oil on the outer layer of plumage of a king penguin in Gold Harbour, South Georgia in the southern Atlantic Ocean, protects its feathers from the water.

Above right: An adult king penguin searches for its chick in a crowd of 'Oakum boys', the name given to king penguin chicks by sailors because of their resemblance to the Oakum fibres used to seal the gaps between timbers on wooden ships. As they mature the chicks will shed their fluffy brown feathers to reveal beautiful adult plumage, which is adapted to survive the frigid temperatures of the Antarctic Ocean.

Following page: The Nordaustlandet ice cap in the Svalbard archipelago, Norway, lies just 6,000 miles [9,600 kilometres] from the North Pole. Yet, at the time of photographing, the temperature was in the high sixties [degrees Fahrenheit, 20 degrees Celsius]. In the next ten to twenty years, the Arctic could become completely devoid of sea ice during the summer months.

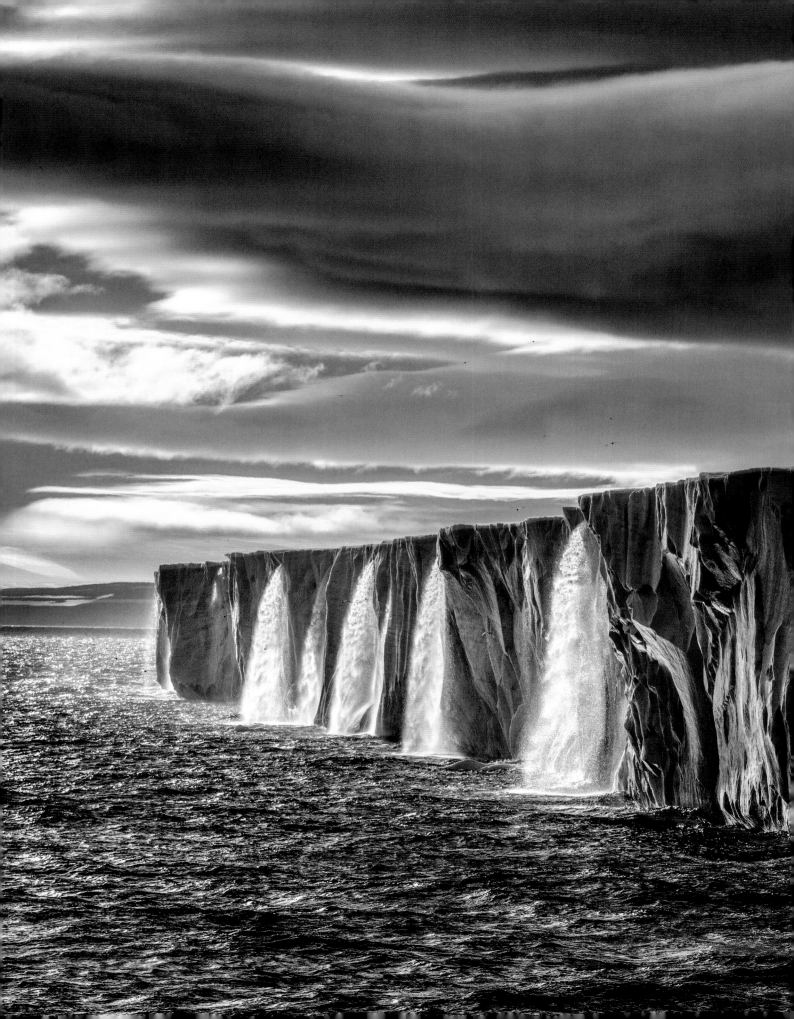

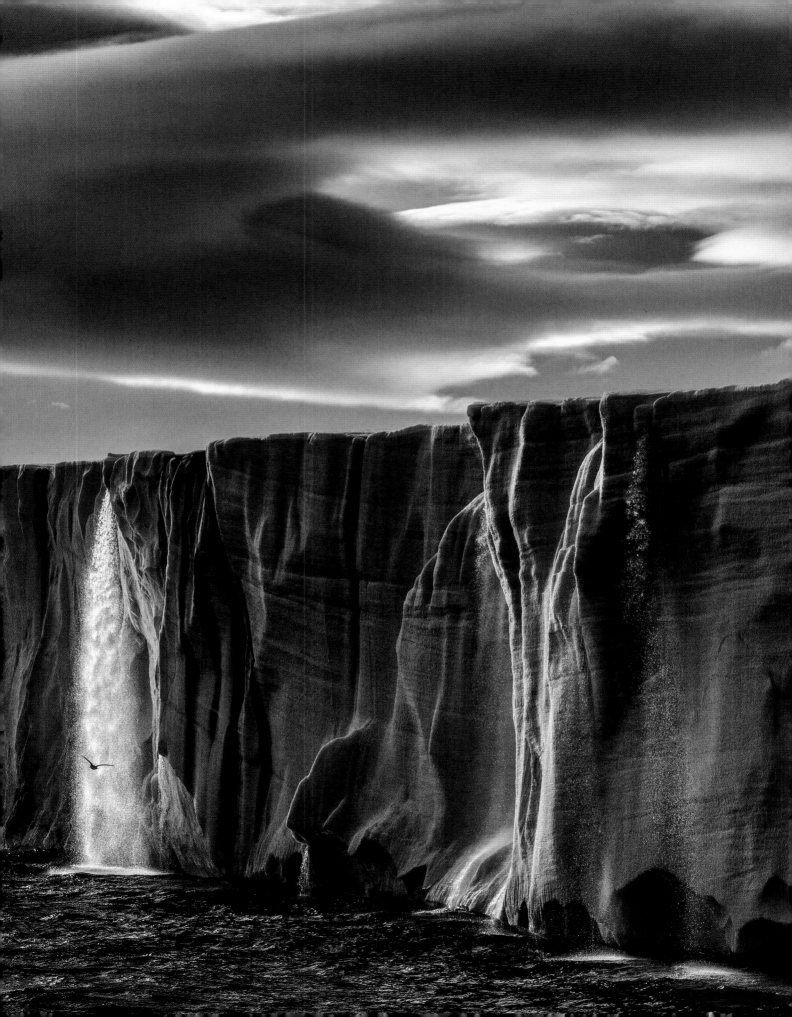

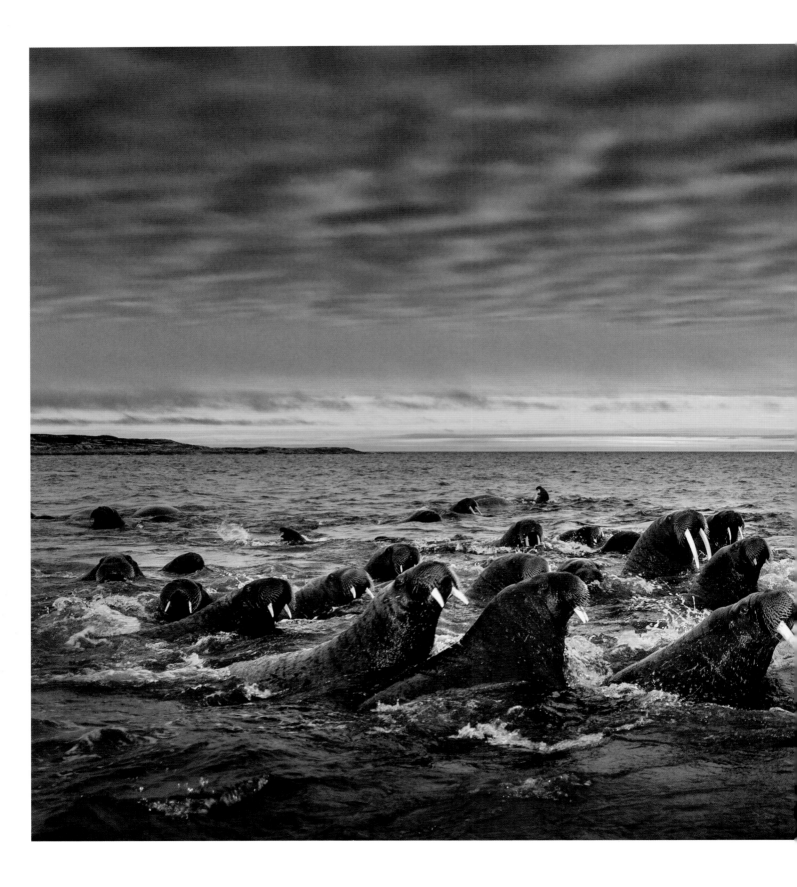

PAUL NICKLEN

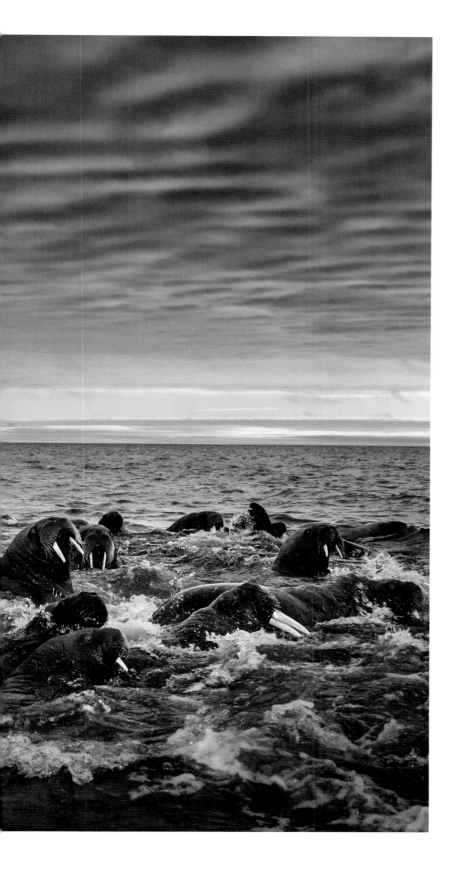

photos of those animals. But if I'm four feet [one-and-a-quarter metres] away from a huge male Atlantic walrus, on my belly on the sea ice and using a 16mm, ultra-wide lens, then I have elevated the stature of the walrus. I've taken an animal that is perceived to be fat, ugly and warty and celebrated him as a charismatic, intelligent, fragile, vulnerable animal affected by climate change. I need to draw people in and art is what starts that conversation. I'm proud of the photograph I made of that beautiful ice face in Svalbard [a Norwegian archipelago in the Arctic Sea] that has multiple waterfalls pouring off it – and there's an incredible story behind it (pp. 96-7). It's in the art where I want people to say, 'What is that? I need to know more.' It opens the doors to teaching people that, based on science, we are in the warmest time that's ever existed. We are losing our annual sea ice and we will see the loss of polar bears in the next one hundred years. And that's the conversation: that we're all in this together. Greta Thunberg is out there, starting a movement and she's basically done what I've been dying to do for years, slowly and gently, as a journalist. To see what she has started is a beautiful thing.

I've always been around wildlife and after a while, when you spend more time with wildlife than humans, they become your friends. People ask me if polar bears are scary and I tell them that the only time I've ever really been scared was when I was attacked in the subway in New York City. I've seen 3,000 polar bears and I've never had a scary encounter. And yet for animals like polar bears, narwhals and wolves that are so often misrepresented, I am working to give these charismatic megafaunas a voice – to represent them and talk about their vulnerability. People see polar bears as scary and vicious. I want people to see them as vulnerable, fragile animals that are ultimately going to disappear at the hand of man and the lifestyles we're leading.

To give some context to the habitat of polar bears, multi-year ice is ice that lives for many years; it survives throughout the entire summer and the fall, then freezes again the next winter and gets thicker and heavier. The thinner ice that doesn't survive the summer is called annual ice. When the sun returns to the polar regions in spring, whether it's the Arctic or the Antarctic,

Above: Atlantic walruses travel off the northern shores of the Svalbard archipelago, Norway.

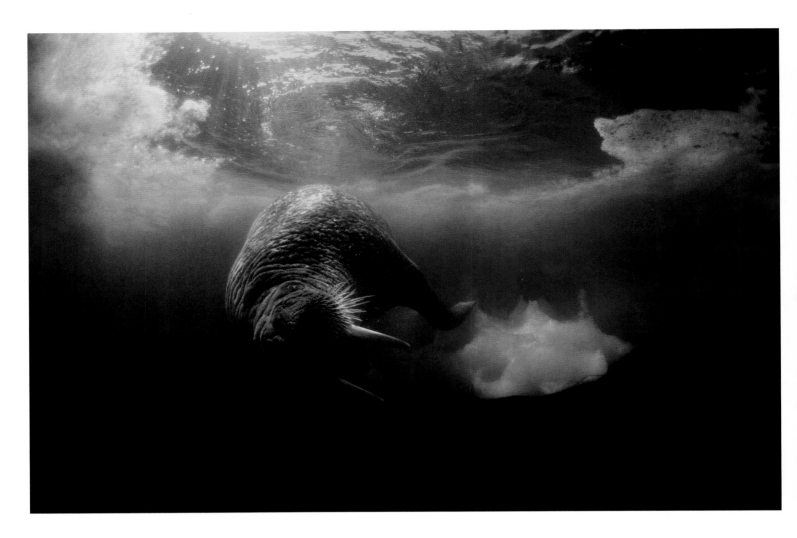

Above left: A walrus dives from multi-layer ice to feed on clams in Foxe Basin, Nunavut, Canada.

Above right: An emperor penguin rockets towards the surface as it prepares to launch itself out of the water and onto the sea ice with a bellyful of fish.

Following page: As graceful as she is curious and playful, a leopard seal swims in close to inspect the photographer's camera in the waters of the Antarctic Peninsula. Leopard seals are portrayed as the villain in almost every film that takes place in Antarctica, but are a charismatic, intelligent, vulnerable and misunderstood species.

photosynthesis occurs. If you put a mask below the ice in spring, you'll see the underside of the ice is entirely green: that's the phytoplankton growing beneath the ice from the sun's energy. And there are copepods, arthropods and zooplankton feeding on phytoplankton and millions of pounds of polar cod feeding on all this life – there are 300 species of microorganisms living inside the brine channels of this ice. The birds eat the polar cod. There are beluga whales; narwhals; bearded, ringed and harp seals; and at the top of the food chain, you have polar bears that specialize in eating seals and the odd whale. This entire ecosystem is connected and it all starts with ice. Ice is like soil in the garden. A garden can't grow without soil and without ice, the polar ecosystems can't survive. Many people think ice is thick, that it goes to the bottom of the sea – it doesn't. On top of the ocean, there is a very thin layer of ice, anywhere from six inches [fifteen centimetres] to ten feet [three metres] thick. And because that ice is like topsoil, everything grows from the underside. There are very few polar bears who can survive in open water; the vast majority need ice as a platform to survive and that ice is freezing later every fall and melting earlier every spring. Some polar bears are now staying on land for anywhere from four to seven months, just waiting for any type of ice so they can feed.

In 2017, Cristina and I were up in the Arctic and came across a huge, starving polar bear. He was lying on the tundra, like a blanket. He was so

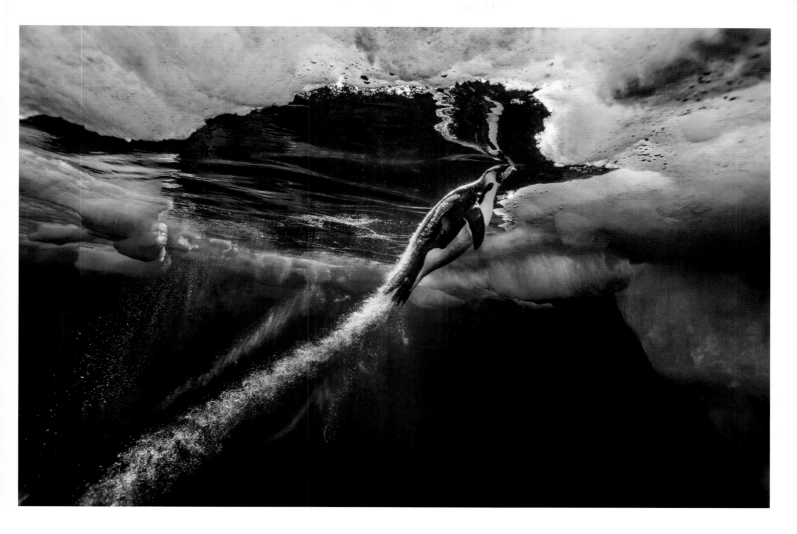

skinny and we thought he was dead. Then he stood up and I began to cry. He was like the walking dead. Scientists say we're going to lose thirty per cent of the polar bear population by 2050; in just thirty years, we're going to lose one-third of them. I want people to realize that although science is essential and we need the data, it's not just data points falling off a sheet of paper – you also need the visuals to say to people, 'This is what a starving bear looks like.' I filmed that bear walking towards us, like a ghost. I was crying and trying to get the focus right, to make sure I did that bear justice by getting the shots. When we released that video to the world, two billion people saw it. People were really drawn to that story and they thanked us for putting it out there. You shoot these visuals because you care about these species and the ecosystems. You care about animals, from the top megafauna to the krill, the copepods and the arthropods. You want people to wake up and realize that this is the foundation of all life on earth, not just for these animals. On the other hand, we had a lot of pushback. There were many deniers and a lot of hate. People don't want to deal with this; they want to attack the messenger and that's probably one of the hardest things. We've got to stop attacking each other and acknowledge that we're all on the same team. I don't care who you are or what government you voted for; this is your only home.

*

'Change is happening. A little too late and too slowly, but it is happening and that's what gives me hope. We know that there's no other option but to fight for this and I think we are going to win. There is hope everywhere around us.'

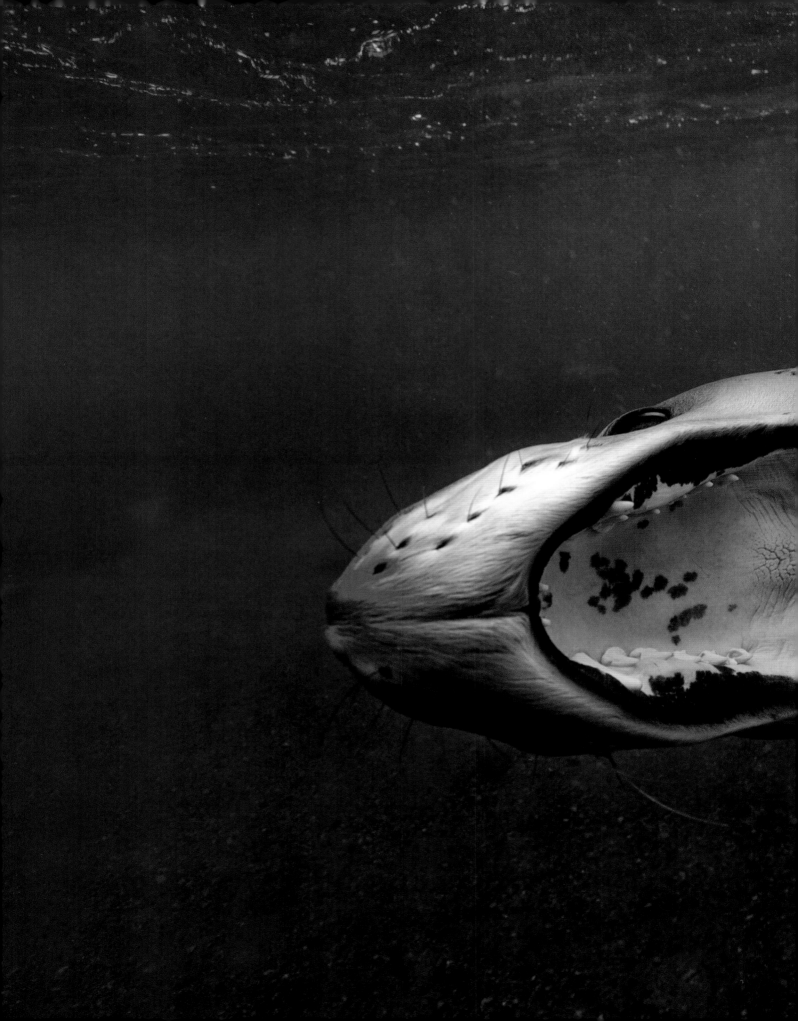

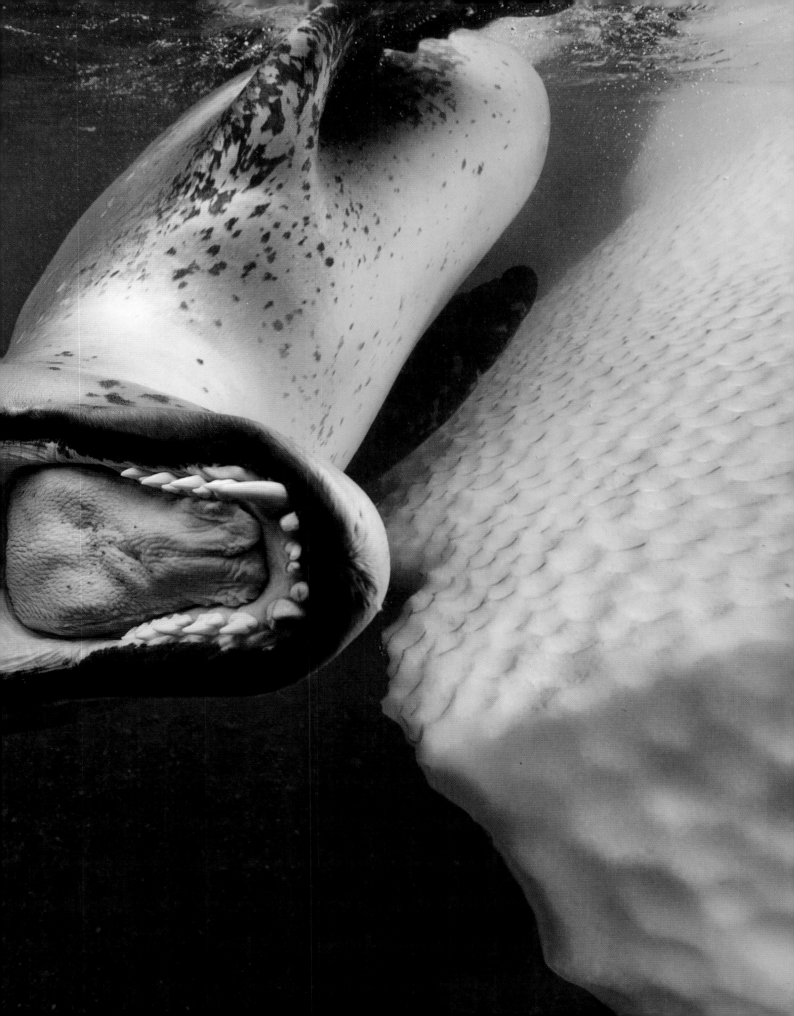

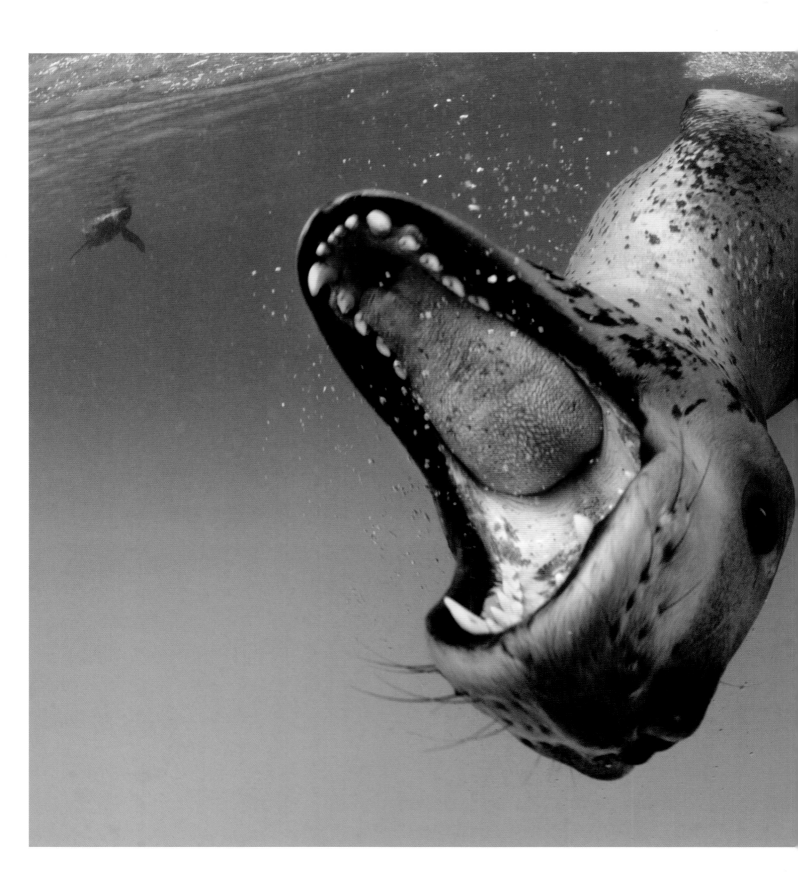

PAUL NICKLEN

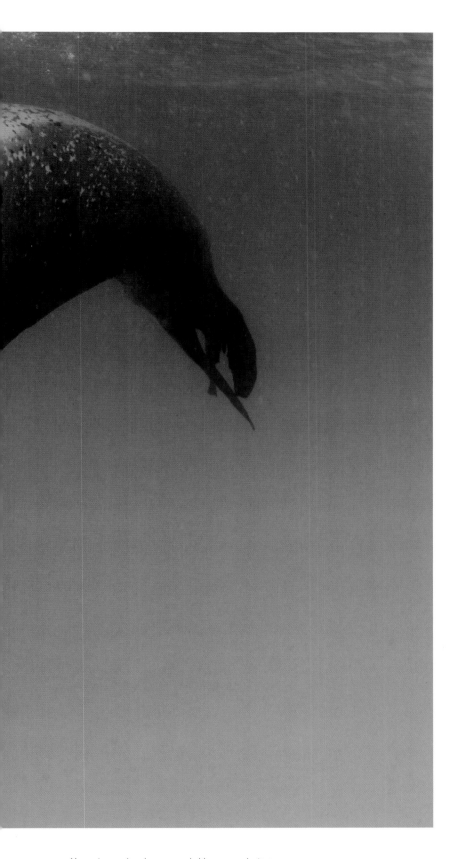

The most powerful encounter I've ever had with a wild animal was working with leopard seals in Antarctica. I've never believed that an animal is out to eat or attack humans. They're often misunderstood – I've seen that with every species I've worked with – and I thought, 'I'm going to go to Antarctica and get in the water with as many leopard seals as I can and find out if they are vicious. And if they are vicious, I'm going to report on that, but if they're misunderstood, then I'm going to report on that.' I was nervous, but I wanted to get to know this predator. The hardest part of the expedition was getting to Antarctica. We were in a fifty-foot [fifteen metre] boat in fifteen-foot [four-and-a-half-metre] seas and fifty knots of wind. It was miserable; I vomited for days, to the point that my diaphragm was in spasm.

When we finally arrived, I thought, 'I don't know if I can do this. I don't know if we're going to find leopard seals.' The previous year, the same boat didn't find a single leopard seal because of the ice conditions. But we put the dinghy in the water and right away, we saw a massive female leopard seal. She was bigger than I had imagined, over 1,000 pounds [450 kilograms] and twelve feet [three-and-a-half metres] long. We were in a twelve-foot long Zodiac and she was longer than the boat. She immediately grabbed a penguin and started smashing it against the hull of the ship, trying to kill it. She moved away from us and started to do a death shake, whipping the penguin back and forth so fast I couldn't see what was going on. The water was full of blood and guts because she had turned the penguin inside out to get rid of all the feathers. But I knew I had to get in the water. I put on my drysuit, hood, mask and snorkel and slipped over the edge of the boat. The leopard seal dropped the penguin and came over to me. Her head was twice as big as a grizzly bear and she was lunging at me. My head was basically inside her mouth. But I'd made promises to a magazine and you can't publish excuses. I was thinking that while I was shooting, even though I was inside the mouth of a leopard seal, 'Half-power on my strobes, F8, ISO 400; I've got to get these shots.'

And then she stopped, moved away a bit and then disappeared. I thought, 'Well, that was amazing – scary,

Above: Leopard seals are remarkable communicators, full of curiosity and display an excess of bravado for the first few minutes of a human encounter.

'By the second day, she started to bring me dead penguins; at one point, I had five dead penguins floating around my head and she just stared at me, wondering why I wasn't eating.'

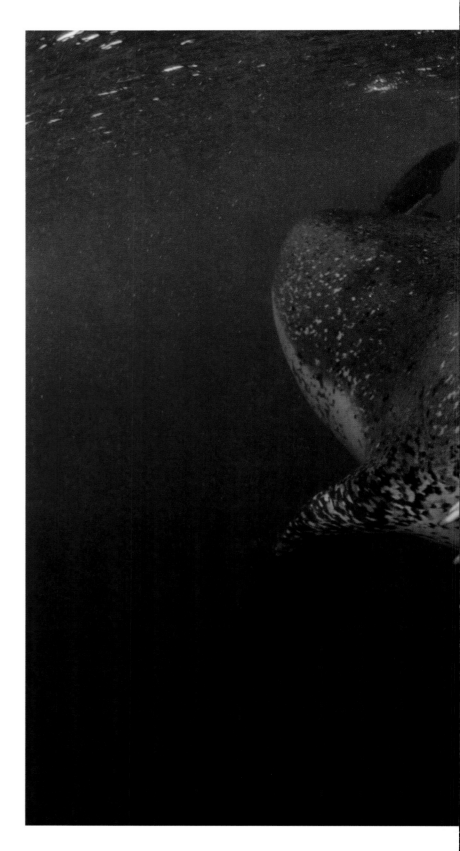

but amazing.' She returned with a penguin in her mouth and let it go three feet [one metre] away from me. When it swam away, she'd grab it and she did this over and over again. Although I don't like to anthropomorphize wildlife, I realized she was trying to feed me. When I didn't accept it, she seemed to realize I couldn't catch a live, swimming penguin, so she got another one and tired it out until it could barely swim away and ate it. By the second day, she started to bring me dead penguins; at one point, I had five dead penguins floating around my head and she just stared at me, wondering why I wasn't eating. And then she started to flip penguins on top of my head and poke me in the ribs. By the fourth day, I could tell she was getting sick of it. She was starting to blow bubbles in my face and getting angry. At one point, she rolled on her back and made this deep, guttural jackhammering sound – *guk-guk-guk* – and I could feel it vibrate through my whole body. I thought she was going to attack me out of frustration. While she was making those noises, I saw something else move and realized another big leopard seal had snuck up behind me. That threat display was for the other seal, who also had a penguin. She chased the seal, grabbed its penguin and brought it back and donated that to me as well. I'd go to bed at night emotionally exhausted. I couldn't sleep the first few nights, because I had gone from fearing I would fail the story to being force-fed penguins by a seal. It blew my mind.

In a seal's world, you're either breeding or you're feeding. Females are thirty per cent larger than males and on the feeding grounds, they are at the top of the hierarchy; they get the prime feeding spots when the baby penguin

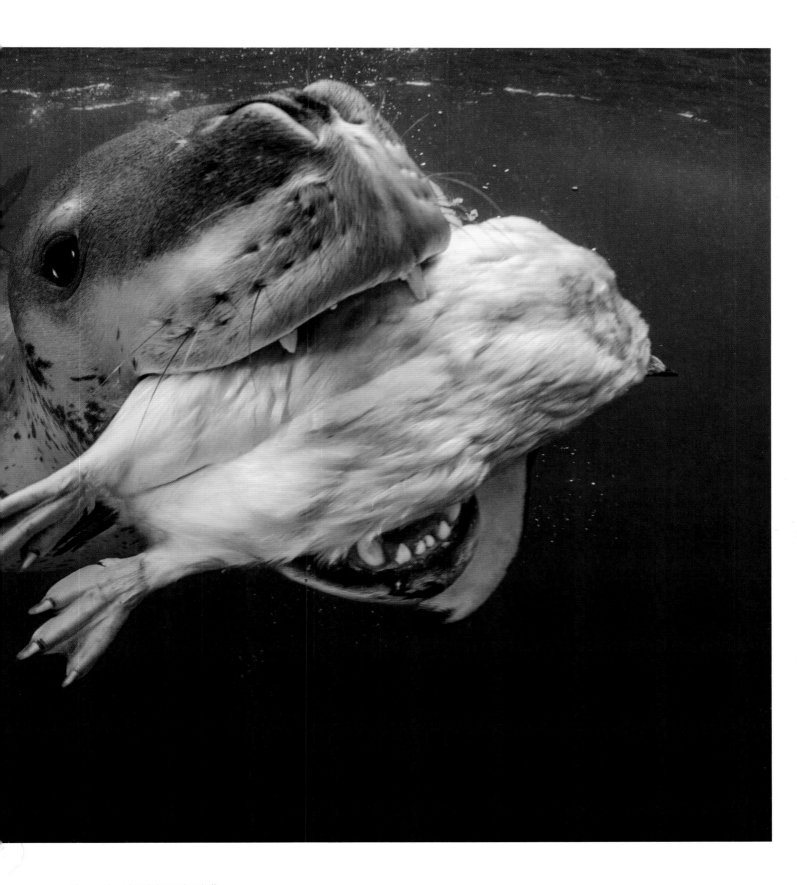

Above: A large female leopard seal offers
the photographer a penguin in Antarctica.

Above left: A grizzly bear marks its scent on a tree at Fishing Branch, Yukon, Canada. New research shows that it is mostly males that rub on trees as a territorial claim to an area and as a means of communication.

Above right: A female polar bear and her two seven-month-old cubs stand along the basalt shores of Spitsbergen in the Svalbard archipelago, Norway. Cubs this young are not yet expert swimmers and cannot remain in cold water for long periods of time. The Svalbard archipelago has many glaciers and adult bears can swim far enough out to try and snatch an unsuspecting seal off a piece of drifting glacier or sea ice. But the glaciers are rapidly receding and such ice islands are becoming fewer.

chicks are coming to sea for the first time and are easy pickings for them. This leopard seal had the best feeding spot and I had jumped right into it. In her mind, I had challenged her and when I didn't leave after her threat display, I think she got confused and thought, 'Well, you're here to feed, you're not a threat, but you're not eating penguins, so what do you want?' She tried to offer me a penguin to see what I wanted: 'I will feed you a penguin and once you accept it, I will know why you're here.' When I didn't accept a penguin, it drove her crazy. And it made the photography great! After the second day, I was laughing so hard: her whiskers in my face, pushing me in the cheek and my mask filling up with water. It was the best time.

*

It is often the big, tough, macho men who have the strongest opinions on these 'dangerous' animals, which they use to justify big-game hunting or the like. Cristina and I have been working with grizzly bears and filming big brown bears and people are killing them from three hundred feet [ninety metres] away. If I said to those people, 'You have to pull the trigger once that bear reaches three feet [one metre] from you,' they'd get to know it so well that they could never pull the trigger. We were in the Canadian Arctic and winter was coming; it was minus twenty [degrees Fahrenheit, minus twenty-nine degrees Celsius] and there were brown bears all around us. One day, a big male bear that we called Morris started to chase a chum salmon up the

river. Cristina and I were sitting on the edge of the river with our boots in the water and a salmon came right up underneath our feet. Cristina hasn't spent that much time with bears, but when Morris came running our direction and was suddenly three feet away [ninety centimetres] from us, we sat there looking at him while remaining incredibly calm. When Morris realized we were there, he stiffened up; he was scared and bracing himself for impact because his instinct is to prepare for an attack. He was nervous, but we sat there, relaxed, speaking calmly to him, saying, 'Hey buddy.' The fish obviously got away, but Morris seemed to grasp that three feet was a safe distance from us. After that, he kept coming back to be around us and it was a great experience.

By the time the project was over, all the bears had gone into hibernation. One evening, Cristina was in the cabin and I was down at the river, enjoying the massive scotch on ice that I'd poured for myself. And as I was sitting there, giving thanks for a great shoot, I heard a noise behind me. I looked back, figuring it had to be Cristina coming to join me, but it was Morris. He hadn't gone into hibernation yet and was standing right behind me. He looked my way before walking right past and down to the river, grabbed a big chum salmon and came back to the bank where I was and sat beside me. And as I sipped my scotch and Morris smacked his lips while eating his fish, I looked up and down the river, thinking, 'This is one of those life-defining moments.'

'Right now, we're sticking band-aids on problems. Every time we shop, every time we eat, every time we pull out our credit card and most of all, every time we vote, we are deciding for the type of planet that we want to occupy. That's where we have to make real, systemic change, starting with ourselves.'

If we fast-forward one hundred years, we're looking at the complete collapse of an entire ecosystem. Sea levels are rising and at some point, we're going to shift from denial to the realization that we're in trouble and that we need to act now. I think we'll see a global disorder and a global collapse. It sounds negative, but if we don't address this now, in one or two hundred years, we're going to be on the path towards the sixth mass extinction of not just other animals, but human life as well. And we're heading in that direction quickly. Some people get it; most people don't. We need to correct our wrongs. Four billion years of evolution could be completely undone in the next fifty to one hundred years. Over one million species will go extinct in the next fifty years, including polar bears and emperor penguins. The only option is for humans to make radical, quick shifts. A movement has begun, thanks to the likes of Greta Thunberg. But will change occur fast enough? We have to prevail and I believe we will. The other option is to disappear and I think we're too narcissistic to let that happen. But how much damage are we going to do in the process? Right now, we're sticking band-aids on problems. Every time we shop, every time we eat, every time we pull out our credit card and most of all, every time we vote, we are deciding for the type of planet that we want to occupy. That's where we have to make real, systemic change, starting with ourselves.

My second big assignment for *National Geographic* was in 2002 when I went through the Northwest Passage [a sea route that connects the Atlantic and Pacific oceans through the Canadian Arctic Archipelago] with some of the world's top scientists. They were looking at the effects of climate change on sea life and at the biota that lived on the ice and how connected they were. I could not get a single one of those scientists to go on camera and say that climate change was here and it was now. They were all good people, real scientists with integrity, but they were worried about their reputations, their names and their careers if they spoke out openly about climate change. Seventeen years later, we're all talking about it. Sometimes you have to crawl out from the forest and step out of the weeds to look at the big picture and realize that change is happening. A little too late and too slowly, but it is happening and that's what gives me hope. We know that there's no other option but to fight for this and I think we are going to win. There is hope everywhere around us.

Above: With sea ice disappearing at an alarming rate, a polar bear is stranded on land in the Svalbard archipelago, Norway. When bears get hungry, they become inquisitive. This bear triggered an infrared beam and took his own picture while inspecting the photographer's remote camera.

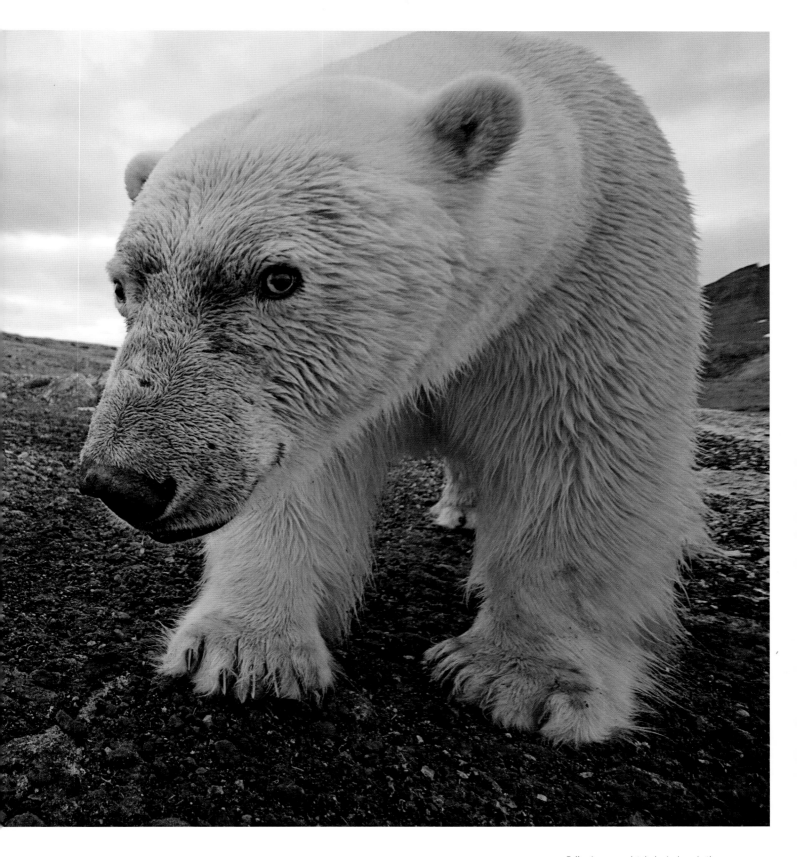

Following page: A tabular iceberg in the Antarctic Sound, Antarctica. These types of iceberg come in all shapes and sizes.

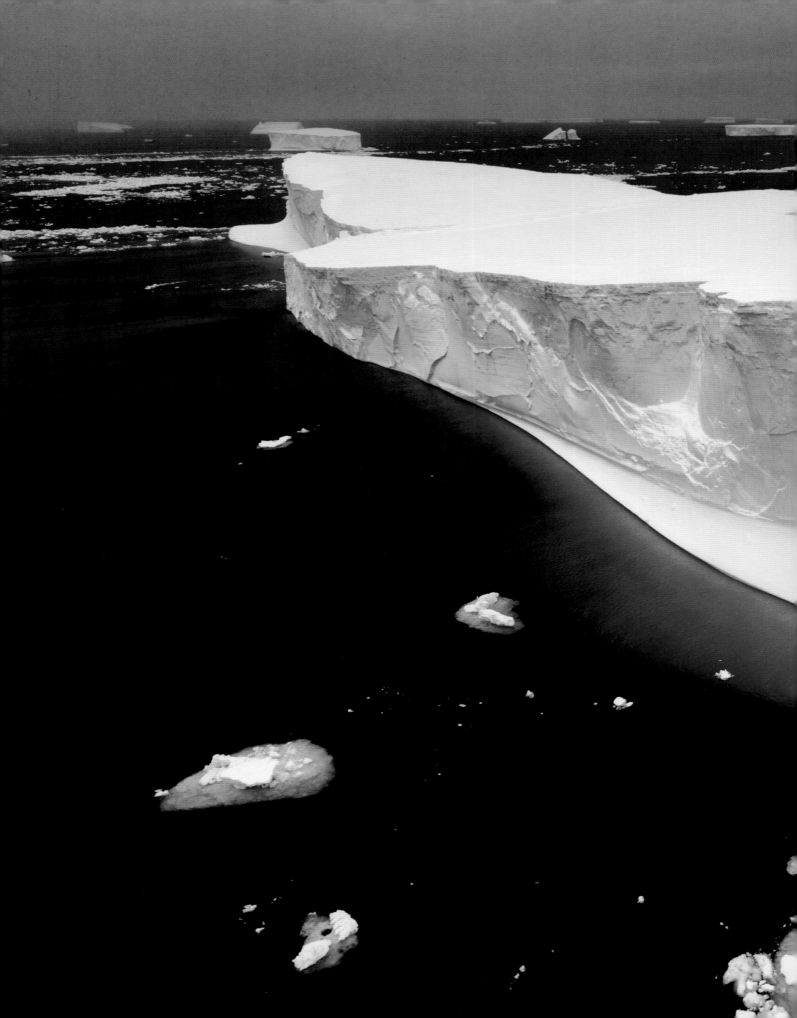

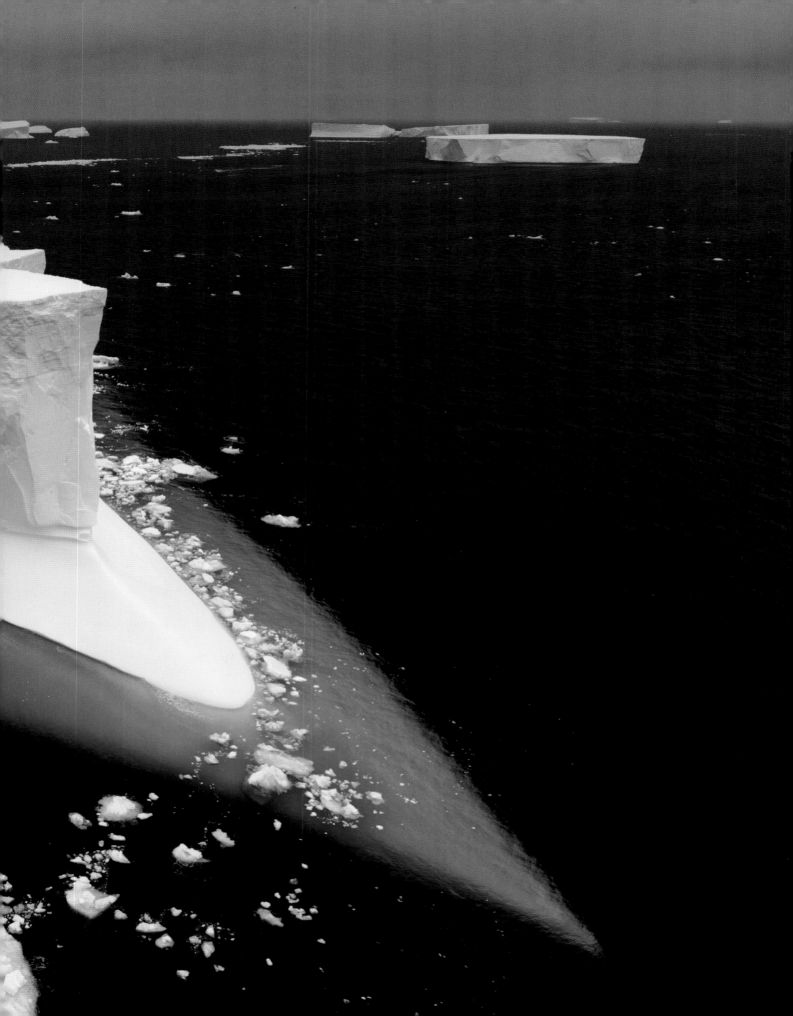

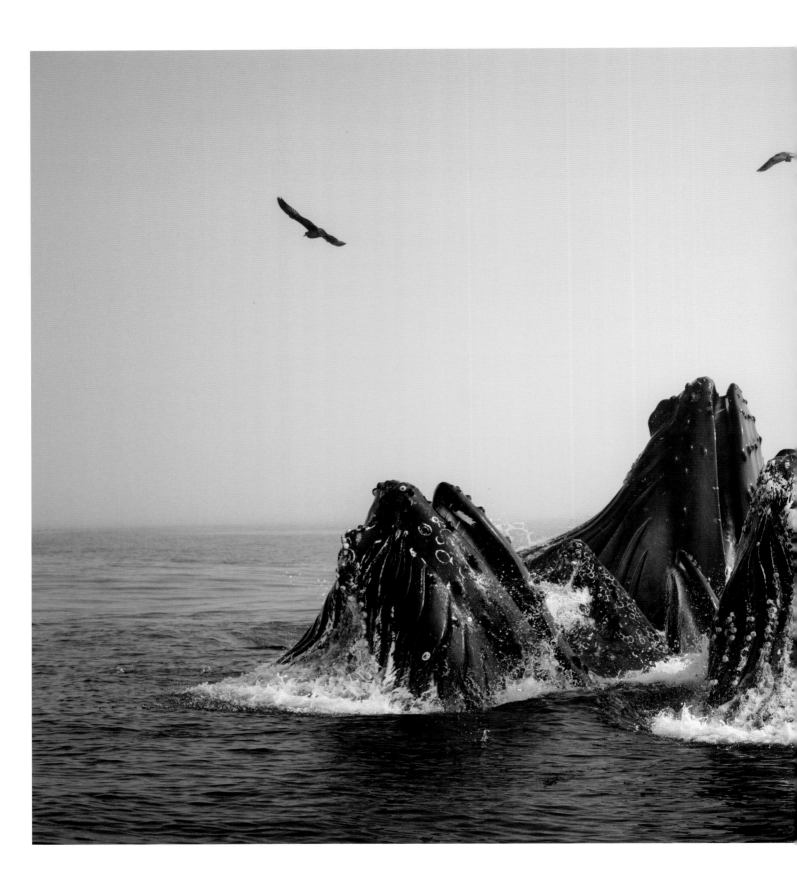

CRISTINA MITTERMEIER

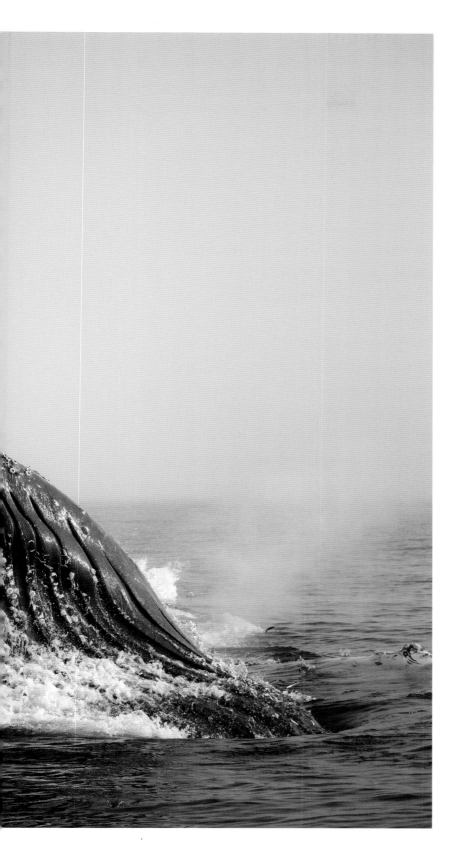

Above: Humpback whales in Monterey Bay, California, USA. Global populations are growing after the species was nearly hunted to the brink of extinction, but they are still in danger.

CRISTINA MITTERMEIER

Cristina Mittermeier is a marine biologist, contributing *National Geographic* photographer, founder of the International League of Conservation Photographers and co-founder of SeaLegacy, a collective of some of today's most renowned photographers, film-makers and storytellers working on behalf of the world's oceans. She specializes in conservation issues concerning the ocean and indigenous cultures.

I'm a conservation photographer and an advocate for the oceans: I am committed to fighting for the future of our planet for the rest of my life.

I grew up in a small city of 120,000 people in a mountain region of Mexico that was very conservative, very Catholic, rich with indigenous people, but wealth was scarce. Both of my parents were professionals so I was part of the middle class, living a sheltered life, attending private schools. And even though I lived next door to those with meager means, I always accepted that that was their fate and didn't question it. There was an unspoken embarrassment that having any indigenous blood in your veins was something to be ashamed of: the whiter you were, the better off you were and the better your chances to advance. But this wasn't talked about, especially in Mexico. There is a paralyzing, underlying racism there and I couldn't see it until many years later when I moved to the United States, which allowed me to look back at my own country with very different eyes.

As children, we tend to live in this little bubble where we're protected, not imagining that there is a bigger world outside of where we're born. That was me, growing up in a little city far away from the ocean. As a Mexican girl, even if it's not necessarily spoken out loud, I knew what was expected of me: to find a husband to take care of me. But I wanted to be an adventurer – to be out in nature, to go to the ocean – but that wasn't viewed as acceptable for a girl in middle-class Mexican

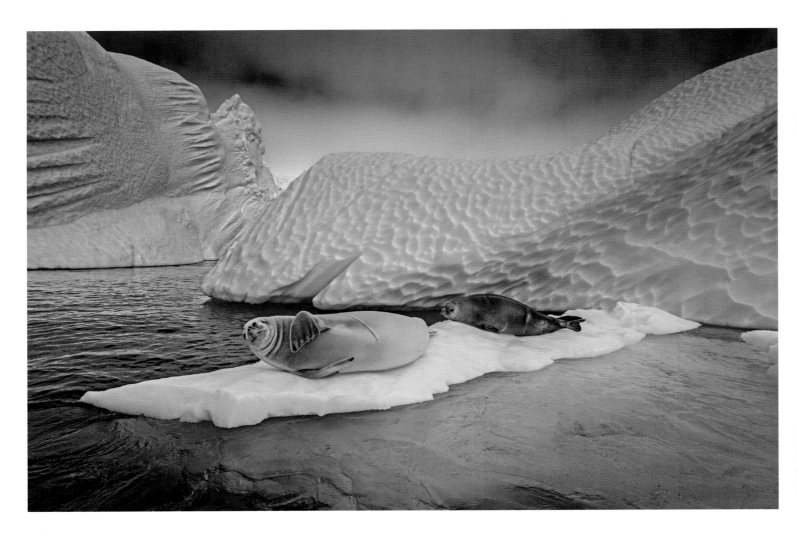

'Why?' 'Why is it that people don't get it?' 'Why are we still having conversations with people that don't realize that climate change is a real threat?'

society. I have an older brother and am the oldest of four girls. The unspoken reality in my home was that my brother would have a lot more privileges and opportunities; he was the one that was expected to go and do something amazing, while we girls were taught to knit, crochet, sew and cook. However, my mom championed us, never failing to say, 'Of course the girls should go to summer camp! They should learn to canoe, to hike and be outdoors.' I was lucky to have a mother who told me to go and do whatever I wanted to.

My hometown was tropical and lovely and we had a fantastic garden that towered with big trees. My mom is an incredible gardener and she liked to keep a menagerie of animals like chickens, peacocks, parrots, parakeets and lots of dogs and cats and other domesticated animals. I loved reading, so when my father came home with a series of adventure books for my brother that told wild stories of pirates in Malaysia having adventures in the jungle with tigers, sharks and crocodiles, I was jealous. My brother seemed somewhat interested, but I was fascinated! I would take those books (which I still have) and climb to the top of the highest tree to read, losing myself in that world. I devoured the stories told on those pages over and over again. I wanted to live that life of adventure like those pirates in my books were having out at sea, chasing whales and seeing other beautiful creatures, like dolphins. There was a romance about it that made me fall in love with the ocean.

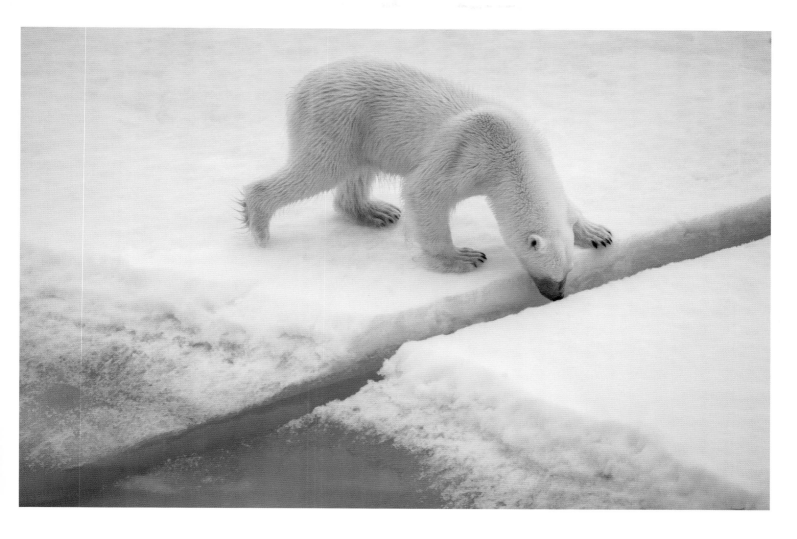

My dad was from a coastal town in an oil-producing region on the Gulf of Mexico and that's where my family went to the beach – a truly ugly beach. My mom had to carry gasoline so she could clean the globs of petroleum that stuck to our feet before we headed home at the end of the day. But to me, it was magical. I was five or six years old the first time I went into the ocean alone. A large wave picked me up and rolled me around and when I surfaced, I was hooked. I thought, 'This is it! This is what I want to do!' I knew I loved the ocean, but the connection to try to protect nature didn't come until many years later when I was in university.

As a teenager, I didn't want to leave home to go to university, so I decided to stay one more year, entering into a major in communications. At the end of that year – one of doing all the right things, dating the right boys, going to the right promotions for the girls (very high society) – I realized I was so bored! My parents had paid for that expensive first year of university and I found myself at a crossroads. I knew that that wasn't what I wanted to do; I wanted to be a marine biologist, but that wasn't an acceptable profession for girls in Mexico at the time. My father had the firm idea that I would go to his alma mater university to become an accountant like him. I wanted to go, so we made a compromise: I signed up for biochemical engineering in marine sciences at his university and I moved to the other side of the country.

Above left: Two crabeater seals rest on a bed of ice under the Antarctic sun, framed by overturned icebergs whose surface displays the scars and dimples of a long journey at sea, before arriving in this shallow bay to end their days.

Above right: Crossing over a crack in the ice, a polar bear searches for food in the North Pole. Classified as marine mammals, polar bears hunt seals and even whales, from both in and out of the water. Less than two per cent of their pursuits are successful. There are fewer than 25,000 polar bears left and as many as 1,000 are killed every year for both subsistence in indigenous communities and for trophy, which isolated communities rely on as one of their only sources of income.

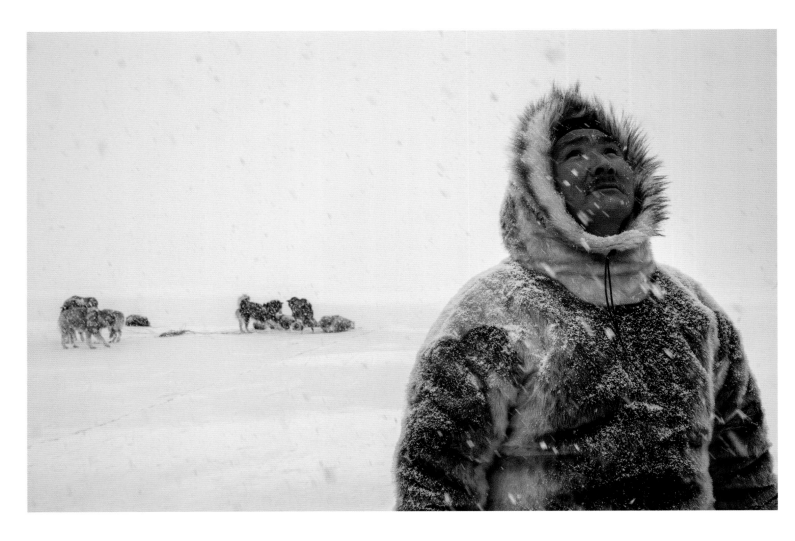

Above left: Naimanngitsoq Kristiansen, a traditional Inuit hunter from the remote village of Qaanaaq in northern Greenland, stares pensively at falling snow. He is one of the last ice hunters of the north, concerned with the consequences of a changing earth on his home and the lives of the people in his community.

Above right: Knowing that his dogs and his village depend on his aim, Naimanngitsoq Kristiansen waits for harp seals or walrus to appear. His village Qaanaaq is the northernmost human settlement on earth and its food options are very limited. It depends on seals and walrus for food and Naimanngitsoq's ability to hunt can mean the difference between a meal and hunger.

As part of my studies, we looked at commercial fisheries and aquaculture in the Gulf of California and part of our studies included going out on industrial fishing boats as observers. I think we all have this idea of how fishing happens – imagining the noble fishermen out at sea – but in reality, the way that fish are caught is rather brutal. The whole experience that an animal goes through when it's caught in a net is very traumatic. And it wasn't just the sardines or the tuna or whatever they were meaning to catch, it was all the other animals that were killed at the same time. Everything from sea turtles to dolphins to stingrays to seabirds were callously discarded, thrown back to sea like they had no value, no worth. As a young person, I found it unacceptable. The foundation of life in the ocean is based on the little fishes like sardines, anchovies and herring and the fishermen were scooping them up, almost as if they were mining them. You cannot call that fishing. I had a really hard time fathoming that this is how humans catch tuna; the mighty fish in the nets have no common semblance to the flakes of pink flesh in a tin can. The worst part was there were so many dolphins dying in the tuna nets, but as students, we weren't allowed to bring the entire carcass of a dolphin back to school to study – we were allowed only to bring the head. Decapitating a beautiful animal to bring its head back to school was just horrific. And while everybody likes a tasty meal of prawns, the way that these shrimp and prawns are fished is also horrific. Nets that are weighted down with big chains are dragged on the bottom of the ocean – it makes as much sense as hunting squirrels in the rainforests with bulldozers! The nets

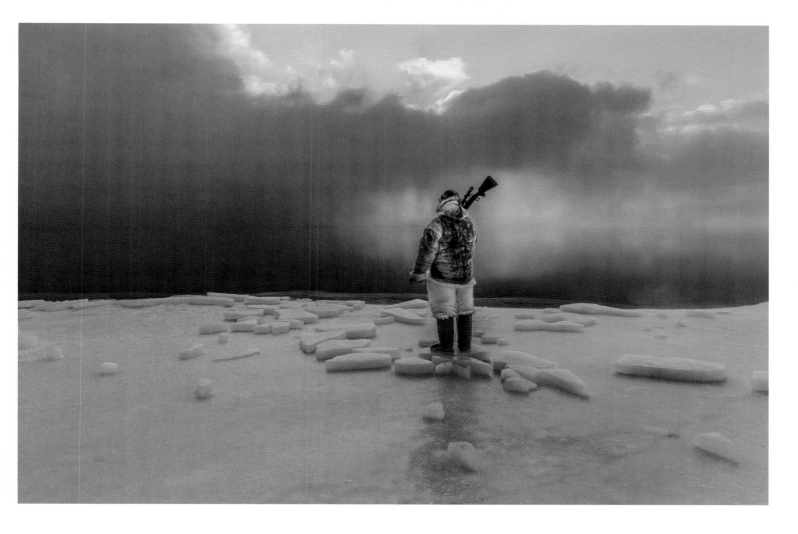

destroy everything as the bottom of the ocean is stripped to catch a handful of shrimp or prawns. Sea turtles, starfish – all the animals – have to die to harvest shrimp so we can eat them. Such a waste.

It was a bit shocking to me that we were not learning at all about how to preserve these resources; we were just learning about how to exploit them. By the time I graduated from university, I knew that I didn't want to be part of the fisheries community. So it was perfect timing when a hometown friend of mine reached out to let me know his uncle had a hotel in the Yucatan Peninsula that he wanted to turn into an eco-friendly resort. He didn't know how to do it, but he knew that I loved animals and he also knew that I was looking for a job. He couldn't pay me, but he would give me room and board in exchange for me making an inventory of the animals that lived on his property. What a job for a young biologist like me! I spent almost a year running around the Yucatan Peninsula, diving every day. I'd ride my bicycle through the jungle on trails, chasing monkeys and would sit for hours making drawings of flowers and butterflies. I made the most beautiful inventory of all the animals I saw and I loved it.

At the end of the year, a hurricane came through. Three months later, a group of scientists stayed at the hotel while they studied how an ecosystem recovers after a hurricane. I offered to take them around and show them all my special secret spots: the mangrove swamp, the coral reef, the seagrass bed and the

'This lack of commitment to community, this lack of care for the other, is absolutely at the heart of the environmental issues we are confronted with. Inequality and climate change are the two biggest issues that we're facing.'

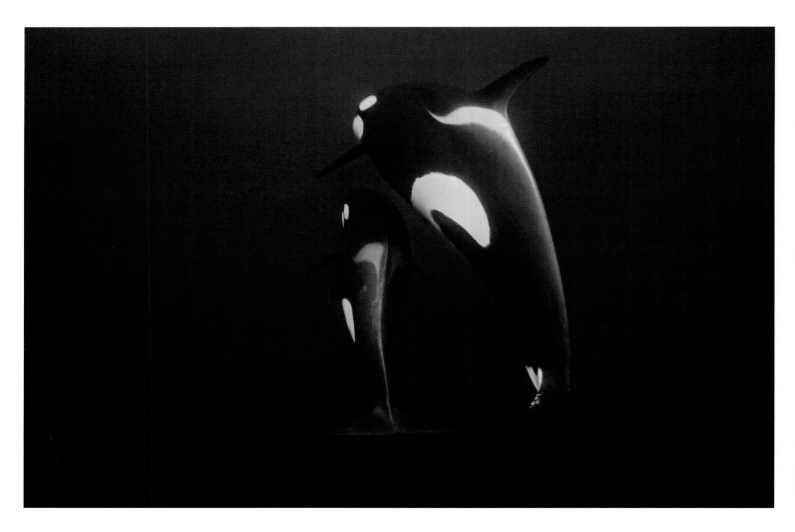

Previous page: Huskies have been tied
to Inuit culture for over 4,000 years. The
Inuit people depend on their dogs to do
the heavy work of pulling sleds across
the Arctic. Here, Peter Aviki, a traditional
Inuit hunter from the village of Qaanaaq,
organizes his team to embark on a thirty-
mile [forty-eight kilometre] hunt across
frozen sea ice towards the edge of the
ice floe.

Above left: A mother orca and her calf are
spotted in the northern fjords of Norway.
Orcas are not only resilient and intelligent,
but they help mould the ecosystem
they inhabit and are one of the greatest
matriarchal societies in the ocean.

Above right: One of the most deep-rooted
misunderstandings in society today is the
relationship between humans and apex
predators – be it wolves, killer whales,
grizzly bears or sharks. The image of this
oceanic whitetip shark was captured in
British Columbia, Canada.

crocodiles. They were impressed, asking me to take a job in Mexico City at
a new organization called Conservation International. That was my first real
job in conservation; I was a technical associate for the Marine and Rainforest
Project. It gave me my first opportunity to work as a field technician, which
also led me to my first interaction with photography when I was recruited to
assist Italian-Mexican photographer, Fulvio Eccardi, who was photographing
the understory butterflies of the Lacandon Rainforest in Chiapas, Mexico. As
I carried his equipment through the jungle and watched him work, I thought,
'This is what I'd like to do'.

Like so many scientists, I believed that just showing people the data would
be enough to make them magically understand – but sadly, that's not true.
People seldom read scientific literature and even though governments are
supposed to pay attention to science to guide policy, the truth is, it's so
much more convenient to ignore it and just carry on as usual. I had been part
of writing several scientific papers and it's a time-consuming process: you
spend so much time going back and forth with scientists, peer reviewing and
then when the article finally comes out, nobody reads it. But at the same
time, I was starting to take pictures and when one of my photographs was
published in a book, I watched a woman go through the pages, never pausing
long enough to read the science. Instead, she went right to the pictures,
stopping on a photograph as she wondered aloud, 'Wow, that's beautiful.
I wonder who this man is?' It made me realize that if you want to start a

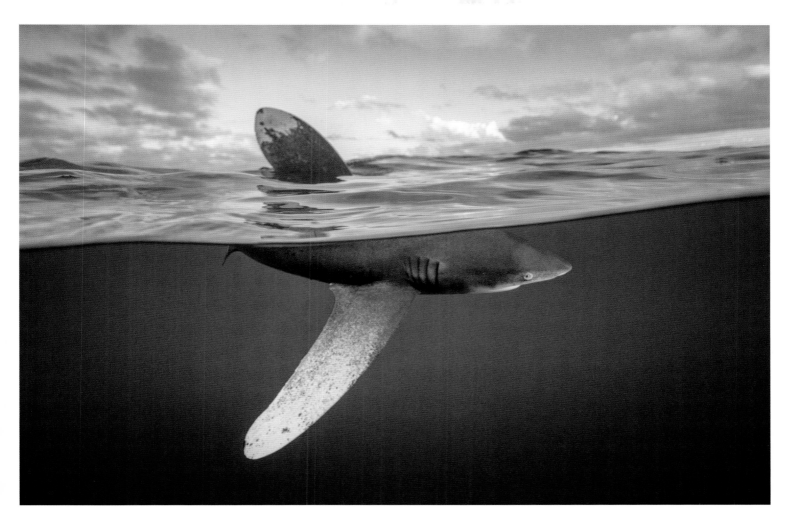

conversation with people who may not feel like they have the expertise to engage in a scientific dialogue, you don't lead with something that's entirely over their heads. Science is often inaccessible to most people, but photography? A photograph is much more welcoming as an engagement tool; it's something we all relate to. I remember seeing it so clearly and thinking, 'Ahh! So it's not science, it's photography'. And so I went back to school to learn photography.

How do you become one of the best photographers in the world? It's not how good you are, it's who you know. It's who's going to open a door for you to become part of a prominent publication or a book project. As a Mexican woman, I've often felt invisible, but I used that to my advantage! Over the years, I've participated in a lot of events and conferences where people just disregarded me, but I was learning so fast. And at the same time, I was looking at the pictures that everyone else was making and I realized that many photographers were just following each other, going to the same places to take the same image of polar bears, zebras or eagles. Because I had a deeper, scientific understanding of conservation, I knew that the more interesting story wasn't there. I knew that there were stories around the places where humans and wildlife and nature collide – the places where one can find great harmony and beauty, or great conflict. I knew that for me, that's where the story was and I could see that few others were telling it. So I thought, 'I'm going to make my career there'.

'The money that we have invested in protecting our own planet is really not commensurate with the size of the problem.'

'When people think about the world coming to an end, the extinction crisis, climate change, they think it's going to happen to somebody else in some distant future.'

During a family holiday in Tasmania, an island off the south coast of Australia, I started looking at postcards with images by nature photographer Peter Dombrovskis. His images were beautiful and poetic and as we drove across the island, I'd add to my collection of postcards every time we stopped at a gas station. As I learned about his work, I realized that Dombrovskis had changed the fate of Tasmania with his photographs. He worked with a 4x5 field camera that he had to carry out into the wilderness and he never took a photograph closer than two days' travel from the road. When he learned that the premier of Australia was planning on damming the Gordon and Franklin-Gordon Rivers for hydroelectric power, he realized that the beautiful places where he worked were about to be destroyed. He went into action, lending his photographs to a campaign to save the rivers. He was a timid man, so he was not an activist who would participate in marching and protesting, but his photographs told a very different story than the one the government wanted people to believe. They had said, 'There is nothing up there; those rivers are just leech-ridden swamps.' With his quiet, beautiful photographs, Dombrovskis showed his countrymen that these were precious places – and to the world's surprise, the battle to save the Franklin-Gordon Rivers was won. Not only were the rivers saved, but the area also became a protected wilderness area: the Franklin-Gordon Wild Rivers National Park. I remember thinking, 'This is exactly how we can use photographs to make a case for the protection of nature'.

That was a complete epiphany. When I began to take my photography more seriously, I was going to photography conferences, particularly in the US, including the North American Nature Photography Association (NANPA). The topics in the plenary sessions ranged from important things like filters to the latest game farm to the latest camera. And I remember saying, 'Hey, can we perhaps use our photographs to try to call attention to some of these places?' And they basically told me to shut up and sit down: 'You know we don't do environmental stuff here'. It was then that I decided I would start my own organization. It became an obsession to figure out who the photographers were who were actually doing something with their images and to create a different type of narrative for ourselves. I convened a meeting in Alaska, not expecting much from it, but 200 photographers traveled from all over the world to attend the meeting – and sitting in the front row were Joel Sartore (p. 264), Michael 'Nick' Nichols, Frans Lanting (p. 46), Art Wolfe, Tim Laman (p. 194) and Charles 'Flip' Nicklin and they were there to talk about how we could change the world with our images. Also in the front row were primatologist Jane Goodall, marine biologist Sylvia Earle, primatologist Russ Mittermeier and conservationist George Schaller, who stood up and said, 'You guys are better conservationists than most scientists and you haven't realized it yet.' And that's how conservation photography was born.

When I was trying to encapsulate and understand the type of photography that I do, it just didn't exist; you were either a nature photographer or a cultural photographer. So I invented a new term: 'conservation photography'. This was in the 1990s and at that time, environmentalism was seen as radical and polarizing, so I wanted to find a term that was more acceptable

to conservative audiences; 'conservation photography' seemed to have that credibility and respectability. It really became a platform for the photographers who were doing more than just taking pictures of nature – who were making images to actively advocate for the protection of nature – to find a bigger voice for their efforts to protect nature. That was the start of something really big and really scary. I committed to start a non-profit organization, the International League of Conservation Photographers, which became all-consuming to build, but it was necessary. Sitting in NANPA conferences, I remember thinking that all these people take pictures of flowers and they're called 'nature photographers,' and somebody like Nick Nichols, who hiked 1,200 miles [2,000 kilometres] across the rainforest from Cameroon to Gabon following the trails of elephants with the intention of protecting those forests, was also called a 'nature photographer'. I was frustrated by people thinking that those were the same. People like Nick needed a very different brand.

I try to be artistic, but I'm also very cerebral. So I think about 'Why?' 'Why is it that people don't get it?' 'Why are we still having conversations with people that don't realize that climate change is a real threat?' When you look at the amount of money that's invested in the science, in the policy, it's all so important, but when you try to raise money for the communications to share the message, the amount of money that we invest – what we spend on environmental work – is miniscule. I say to people, 'In the US alone, we raise $410 billion a year for charity, for all causes that we care about. Of that, forty per cent goes to religion and then more to education, art, health, humanity – all of which is very important – but only 1.8 per cent goes to this big bucket called "the environment".[4] That includes all of our oceans, all wildlife, climate change, dogs, cats and horses'. The money that we have invested in protecting our own planet is really not commensurate with the size of the problem and the money we have spent communicating the threat to the audiences that need to know is even less. I've now made it my life's mission to communicate the threat. It's not just about how beautiful it is; it is that we depend on it.

At the moment, there's a disconnect – that sense of loneliness you might feel in the middle of a big city is remarkable. But when you go and visit an indigenous community, you never feel lonely. Their society and economic systems are very different than ours and depend on collaboration, community and trust; they really depend on each other for survival. But the economic systems that we have built in cities are the opposite: this idea that it's me, for myself and I have to get ahead and it's all about making money and it's all about elbowing aside those who are competing with you. It isolates you. In any indigenous community, the goal is for everybody to be okay. It's not okay for somebody to become homeless or destitute; community always picks you up. But in the economy that we have built, that's not the case.

This lack of commitment to community, this lack of care for the other, is absolutely at the heart of the environmental issues we are confronted with. Inequality and climate change are the two biggest issues that we're facing. At the root of environmental problems is the economic model that we have

'We have succumbed to the fate that destiny is written and that we cannot change things. But I believe we can.'

'Change is such an opportunity. The future that I imagine is one in which humanity realizes the opportunity that we have right now.'

been led to believe works – the one that says banks and rich people and corporations will make money and then we're all going to benefit – but that hasn't been the case. You lose the care for each other when you become part of that economic machine of getting ahead, where you know that nobody's going to pick you up if you need it; you're on your own. I sense that young people are afraid of that and of what's happening to their planet, to their future. The powerlessness is paralyzing. So just like they pour onto the streets to follow Greta Thunberg, I believe if young people pour into the voting booths and we all vote for somebody who cares about the poor and about the environment and about the young, I think we could be okay; we could change things.

I often tell the story of my first assignment of going to remote villages in the Amazon because the indigenous people who lived there were about to be displaced by a giant hydroelectric dam, the Belo Monte Dam on the Xingu River in Pará, Brazil. And as indigenous people, without any education, they only vaguely understood what was about to happen. So I went there to create a portrait of the river and the people, to basically show the government that there were real families and real people living in these communities and they were about to be displaced, their lives changed forever. I spent a lot of time taking pictures of the beautiful body painting they did, of the children, the rainforest and the animals.

There was a moment when there was an opportunity to take a photograph of a woman who was mourning the loss of her child. She had dug up her child's body from the grave and she was carrying it around and hitting her head with a machete, so she was covered in blood. I could have taken a photograph of her, but I didn't have the courage. I felt like I was intruding in her life and I was thinking about my own children and how would I feel if somebody photographed me when I was in mourning. And it wasn't until months later, when the dam was approved, that I thought, 'Maybe dramatic photos like that would have created the change we needed?' We've seen it happen in the past, when Nick Ut's photograph of people in Vietnam running away from napalm stopped a war.

Since then, I force myself to make the photograph, even the ones that are uncomfortable, like the photograph of the starving polar bear. Paul Nicklen and I were attacked, threatened and violently criticized for that image. There are dark and scary corners of the Internet that emerged to weigh in on that photograph; it was painful, uncomfortable and very scary to realize the size of the community still denying that climate change is a threat. But I think the biggest lesson for me in all of this has been the guilt I feel when I have failed to act; when I haven't had the courage to make the photographs or to tell the stories or to be truthful. It is a horrible thing to see that you've failed somebody, that you didn't do enough, that you didn't stand up, that you didn't use your voice.

Above left: A Tamil woman sets out a handful of small fish to dry in the midday Indian sun. The majority of this small catch will go to make chicken feed.

Above right: A woman shelters in a small hut from the relentless sun in Madagascar's spiny forest. She wears a traditional mask made of powdered bark which acts as a natural sunblock and mosquito repellent.

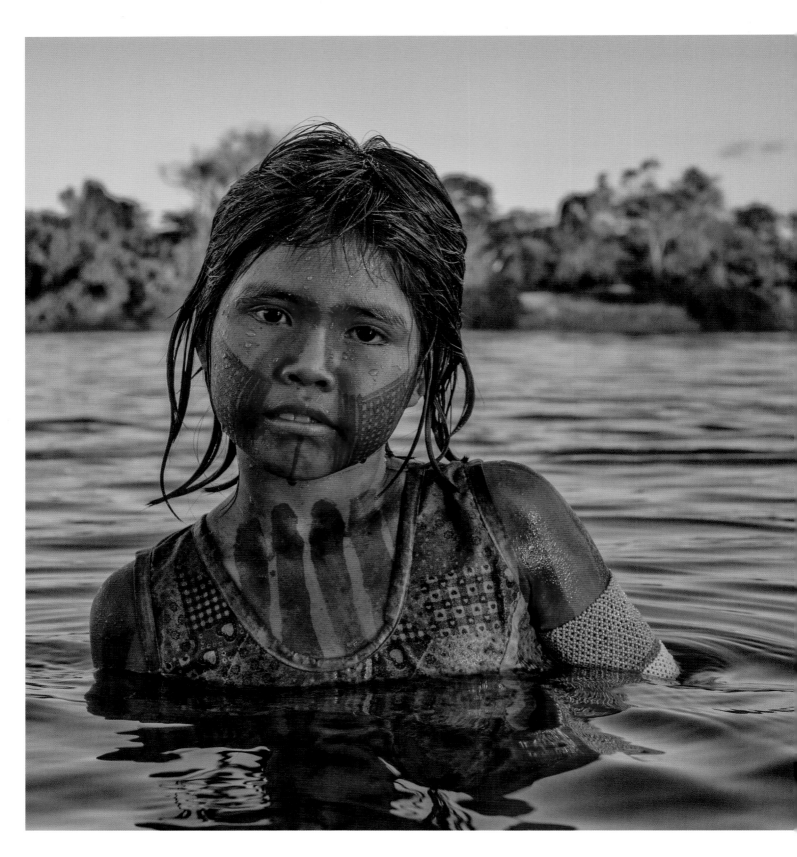

Above: A young Kayapó girl bathes in the warm waters of the Xingú River in the Brazilian Amazon River, Kubenkrajke, Brazil. The image was taken prior to the construction of the Belo Monte dam, a megaproject which, after completion, had significant impact on the forest, river and local communities.

Every time Paul and I post a photograph, we know that certain people are going to be offended or they're going to feel like we didn't do enough, or they're not going to like what we said or did. But all we're trying to do is build a majority of people who are prepared to say, 'This is the kind of planet I want to live on and this is what I'm willing to do for it'. It takes a lot of Greta Thunbergs. I may be wrong (and I hope I am), but I do think we're at a critical moment; we're at the crossroads and it's now or never, because the house is on fire. We are there.

I think that when people think about the world coming to an end, the extinction crisis, climate change, they think it's going to happen to somebody else in some distant future, which is a huge disconnect, but they also think of it as an event, like Armageddon. But it's not like that at all. What happens is a long time of poverty and suffering and humans becoming the worst version of themselves. It's already happening; people acting ugly toward each other and that's a scary, scary thought. To me, one hundred years of hunger, disease and famine is worse than a single cataclysmic event. But it doesn't scare me for myself; it scares me for young people and for children and it scares me because it's not fair to animals, wildlife, indigenous people, the poor and women.

Change is such an opportunity. The future that I imagine is one in which humanity realizes the opportunity that we have right now. We already have the technology to shift our entire energy scheme to renewable sources. If we do that, not only will we be saving our planet from this enormous carbon burden, we'll also create hundreds of thousands – even millions – of jobs for young people to retrofit our economy for a renewable-energy future. And that in itself is really hopeful. We have succumbed to the fate that destiny is written and that we cannot change things. But I believe we can.

Following page: An American crocodile greets the photographer in the Gardens of the Queen, a reef system off the coast of Cuba. Many believe that the species is aggressive and should be feared, but this animal didn't pose a threat as it was in a protected environment and had everything it needed.

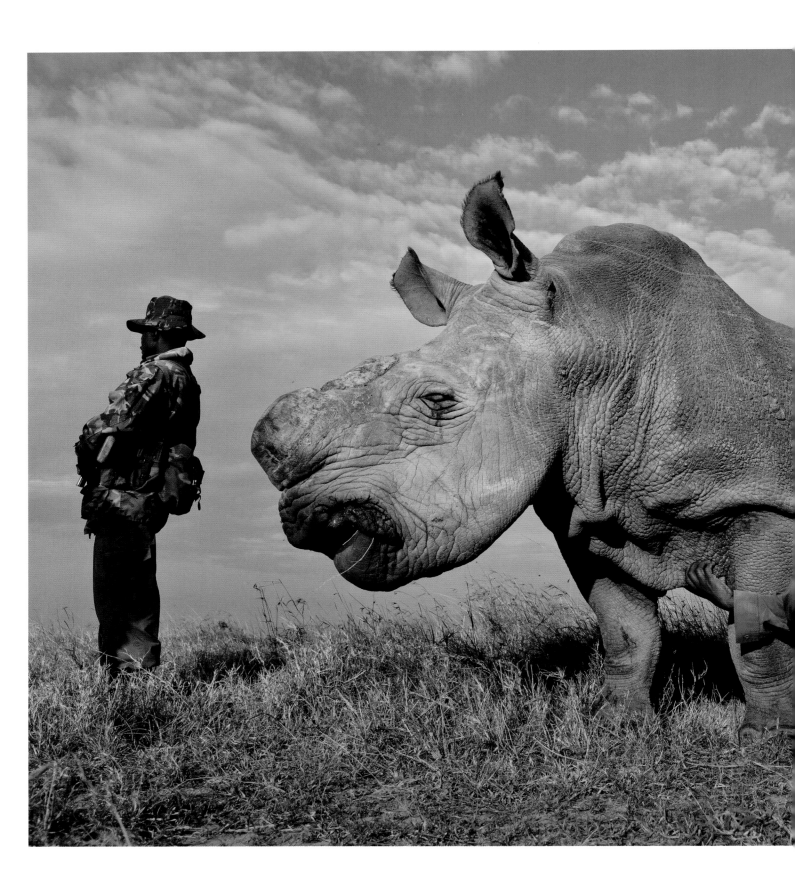

BRENT STIRTON

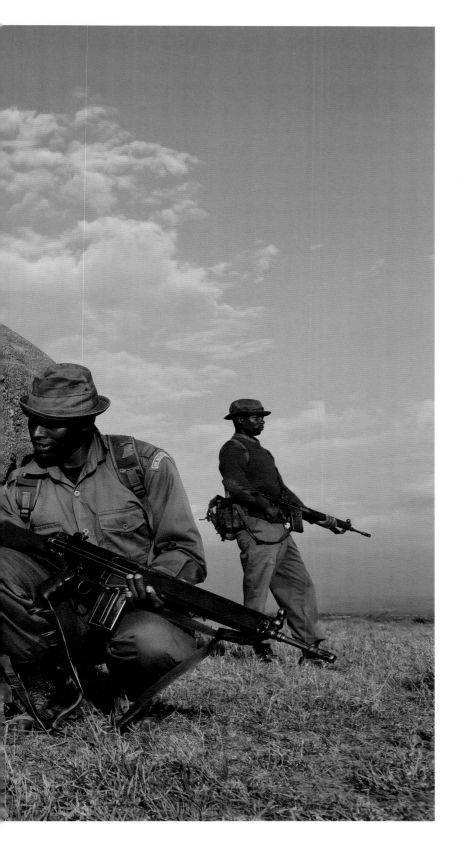

BRENT STIRTON

Brent Stirton is a senior staff photographer for Getty Images, a fellow of the National Geographic Society and a member of the World Economic Forum's Young Global Leaders programme. He specializes in documentary work focussed on humanitarian, environmental, health and conflict issues.

As a teenager I really wasn't very aware of what was going on in my own country. I grew up in South Africa in a fairly closeted environment so as I came of age and began to learn about how South Africa actually worked, it was quite a shock. And then I ended up doing my national service. At that time, there were conflicts in Angola and Mozambique, among other places, so that helped to open my eyes, along with working with a diverse range of people. I became so much more aware of what was actually going on and how important good journalism really was. I was in my early twenties when Nelson Mandela came out of prison in 1990, which was a really defining moment and at that point we had a lot of the foreign media coming over – that was my first exposure to the international photojournalism community. Then straight after that we had the genocide in Rwanda, the famines in Somalia, the fall of Zaire (now the Democratic Republic of Congo) and the ousting of Mobutu Sese Seko, so it was a whirlwind five years.

Above: A four-man anti-poaching team permanently guards a northern white rhino in Ol Pejeta Conservancy, Kenya. A not-for-profit wildlife sanctuary, Ol Pejeta Conservancy is home to the world's last remaining northern white rhino – the most endangered animal in existence.

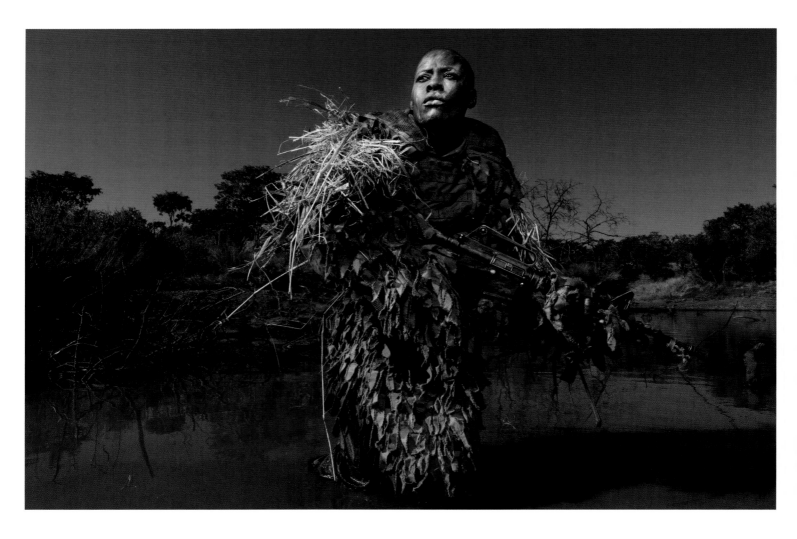

Above left: Women from an all-female conservation ranger force undergo sniper training in the bush to curb poaching in the Phundundu Wildlife Area, Zimbabwe. Called Akashinga, meaning the 'brave ones' in local dialect, it is a community-driven conservation model that empowers disadvantaged women to restore and manage a network of wilderness areas as an alternative to trophy hunting.

While I was doing my military service, I had a couple of friends who were photographers and their interest in photography made me interested. It was a sort of a meeting of two worlds; my eyes were opening to what was really happening in my country at that time and I was discovering this tool that was a truth-telling device. In South Africa at the time it was very difficult to work in the news because we only had Associated Press and Reuters and the roles there were very jealously protected, so I started working in other parts of Africa, just trying to be as mobile as possible. In 2003, off the back of a couple of World Press Photo wins, Getty Images called me and asked if I'd like to work for them as a staff photographer. And I think that was very fortunate, because they have, to a large extent, left me alone to do my thing, to work on my own themes. I'm an assignment photographer so if I am in Iraq, I'm there for a very specific story, I'm not embedding and following the news. I like doing jobs that involve a multiplicity of photographic disciplines; I spend six to seven months of the year working on conservation issues.

What ends up affecting me a lot is that this profession is quite predatory in a sense. You are coming into people's lives, parachuting in there, spending a couple of weeks with them in these dire circumstances and then leaving and coming back to this life where you sit down with a cappuccino. That's the reality of it and that definitely bothers me more and more. In terms of the conservation work, what's hard with that is, for a lot of people, doing this work it's a job – it's a job in places where there are no jobs. The brotherhood

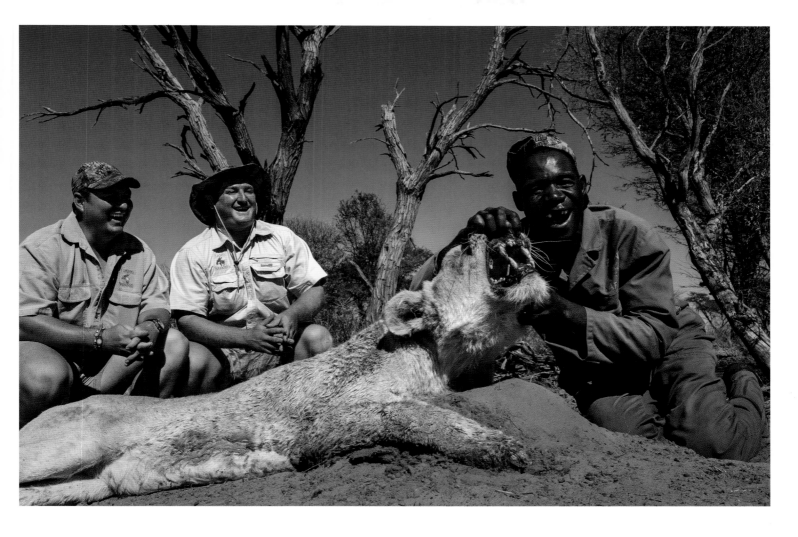

and the sisterhood and the caring for our animals, comes later and it comes because you go through stuff together. There's a famous expression that you don't go to war for your country, you go to war for the man standing next to you. And that's entirely true when it comes to conservation; I think a lot of stuff happens because of the person standing next to you.

*

I came to conservation photojournalism in 2007. We were working in the Democratic Republic of Congo (DRC) and there had been a great deal of imagery that had come out of there and I think that people were, in general, tired of looking at it and thinking about it. I think human beings respond to the suffering of other human beings, but there's a point where they are saturated with it, so then you have to find new ways to talk about things. So I went with Scott Johnson, the African bureau chief for *Newsweek* magazine at the time, to cover a group of conservation rangers inside Virunga National Park. The park is right in the heart of the conflict zone of the eastern Congo and it's an area bigger than Israel. There were six hundred conservation rangers in there and since President Mobutu had fallen in 1997 they hadn't been paid, but they were really just trying to keep this thing going. We went in there and our job was to cover the fifty rangers who were in a special group tasked with tackling what was, at the time, a rebel army, members of the Congolese army and around seventeen different paramilitary groups – all working inside this park.

Above right: American bow hunter Steve Sibrel hunts a lioness with professional South African hunter guides on a game farm in North West Province, South Africa. The hunting industry is a strong employer in Africa, with more than 18,000 hunters travelling to the continent every year.

Following page: Michael Oryem is a former Lord's Resistance Army (LRA) fighter who was involved in the poaching of ivory in Garamba National Park, Democratic Republic of Congo. Oryem was abducted by the LRA when he was nine and lived with them for over seventeen years in the wild. He defected and is now a member of the Uganda People's Defence Force (UPDF), the armed forces of Uganda, which attempts to locate and curb the activities of the LRA.

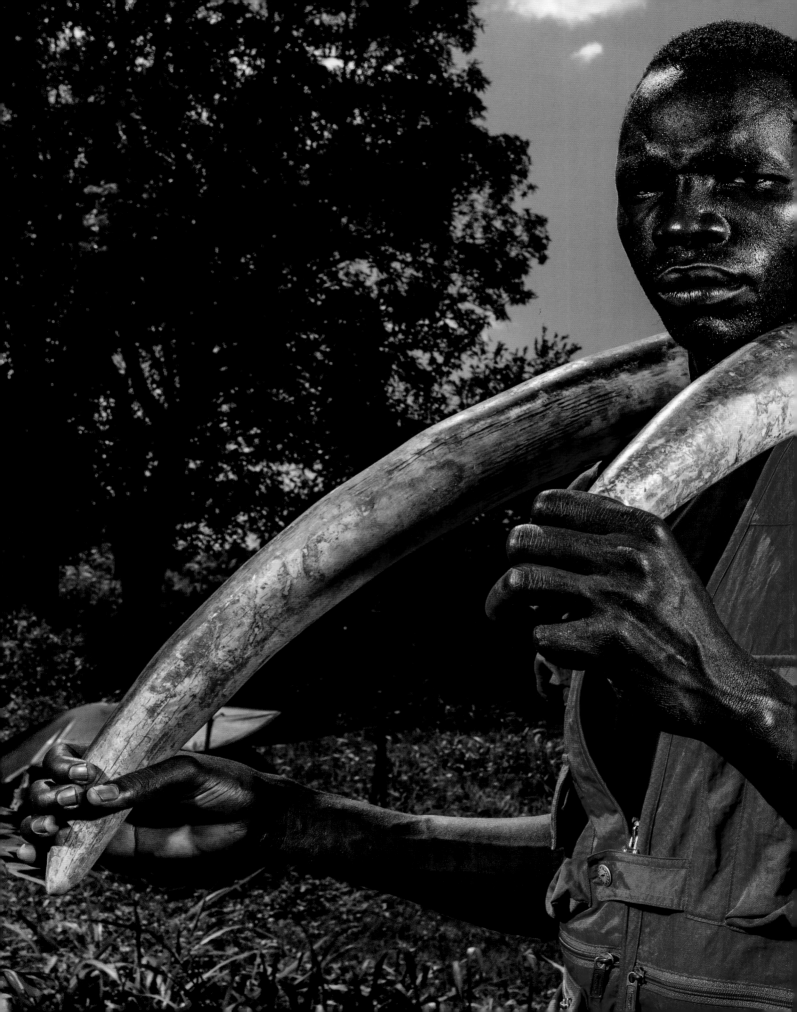

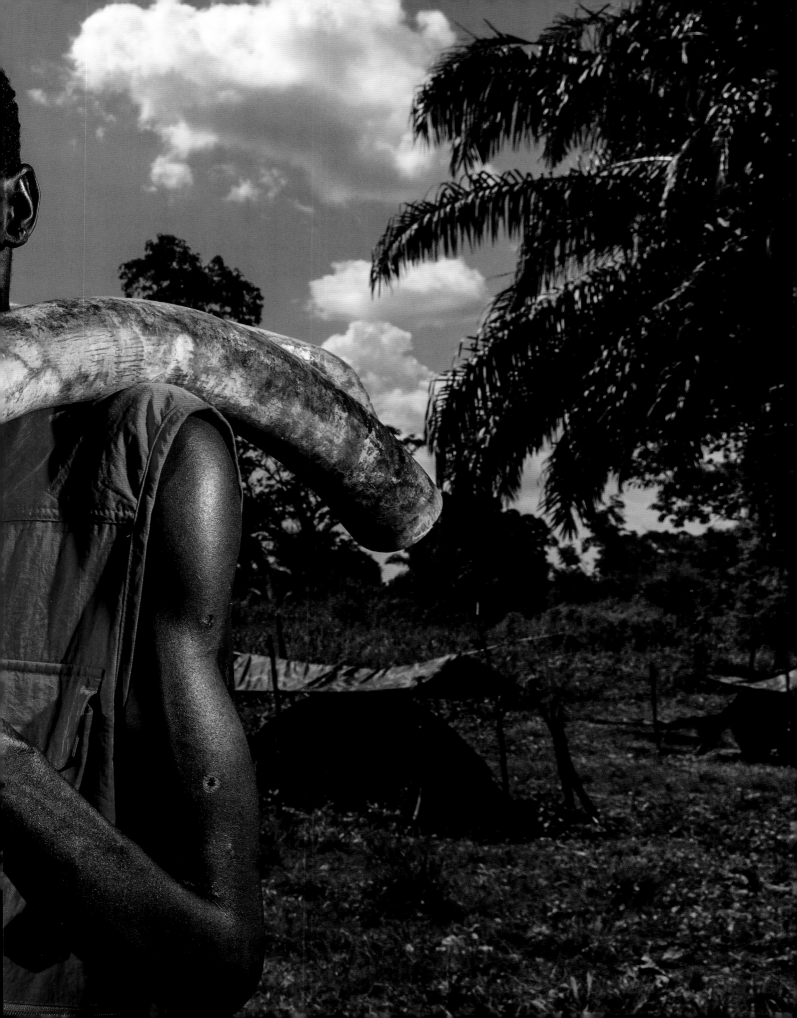

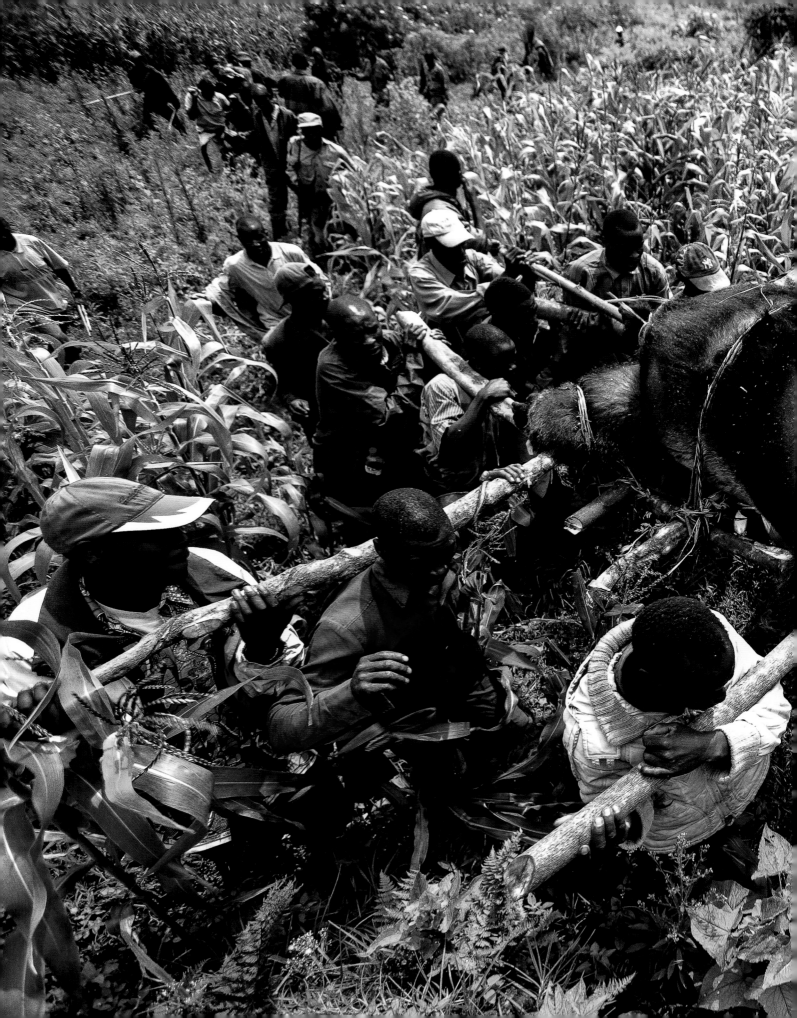

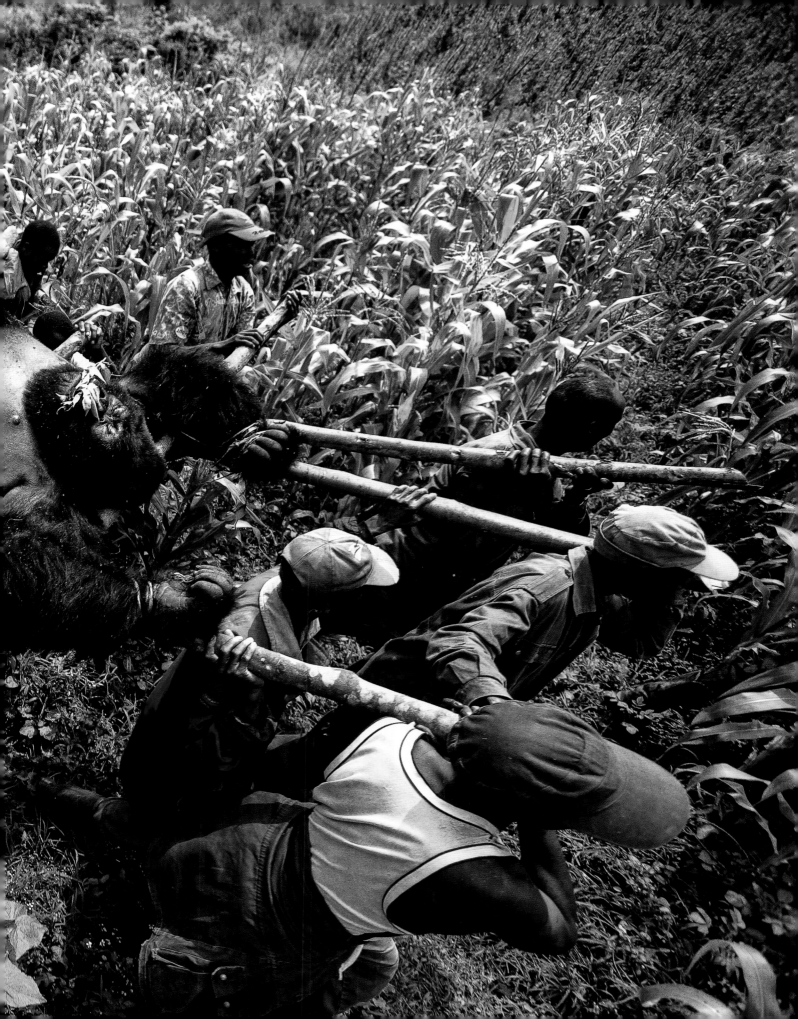

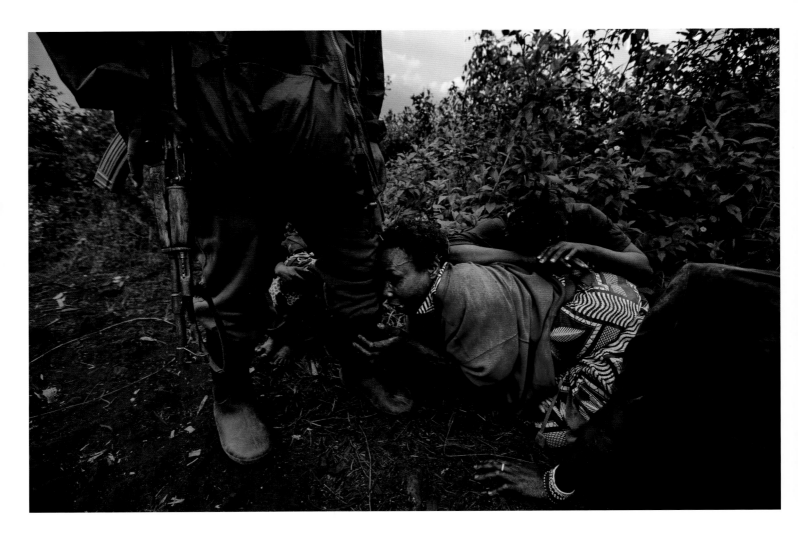

Previous page: Conservation rangers from an anti-poaching unit work with locals to evacuate the body of a male silverback mountain gorilla killed along with six adults and two babies in Virunga National Park in eastern Democratic Republic of Congo. It is suspected that political motivations linked to the local illegal charcoal industry were behind the killings. In 2020, sixteen people, including twelve rangers, were killed in an attack in the park carried out by rebels from the Democratic Forces for the Liberation of Rwanda.

Above left: Congolese Institute for the Conservation of Nature (ICCN) rangers conduct a raiding patrol near Goma in North Kivu province, Democratic Republic of Congo. They arrested a number of impoverished people from displaced communities, who are lured into the illegal charcoal industry by others who stand to benefit, including members of the Congolese military, armed rebel groups and business interests in Goma.

Above right: Caretakers interact with a newly orphaned mountain gorilla at Senkwekwe Centre, a mountain gorilla orphanage in Rumangabo, Democratic Republic of Congo.

This is also the park where two million refugees fled from Rwanda into [former] Congo and Zaire, living there until they were gradually repatriated, but the hard core elements remained and became a militia movement.

A few days into covering these rangers, we had word that some endangered gorillas had been killed. What I remember most from that incident was how seriously these rangers took it. They went and collected the bodies in the pouring rain and they found the bodies of four or five females, two of which were pregnant and one of which they knew had had a baby, but the baby was missing. The next morning we found the silverback and another couple of females and they transported the gorillas out, carrying the silverback in a really quite Christ-like way, like they were carrying a cross. I took some pictures and at one point I ran ahead of the procession and I built up some little rocks on a termite mound or something and I snapped three or four frames of these gorillas coming past. Then Scott and I heard that the Congolese army was looking for us because, as it turns out, they were involved in the killing of these gorillas – along with other people – so we crossed quickly into Rwanda, I filed the pictures and forgot about it. Then *Newsweek* turned it into a cover story and those photos got a lot of attention.

Those gorillas were killed because the rangers had been trying to stop a sort of 'charcoal mafia', which was made up of Tutsi businessmen and Congolese generals employing refugees who'd been displaced to go into the habitats

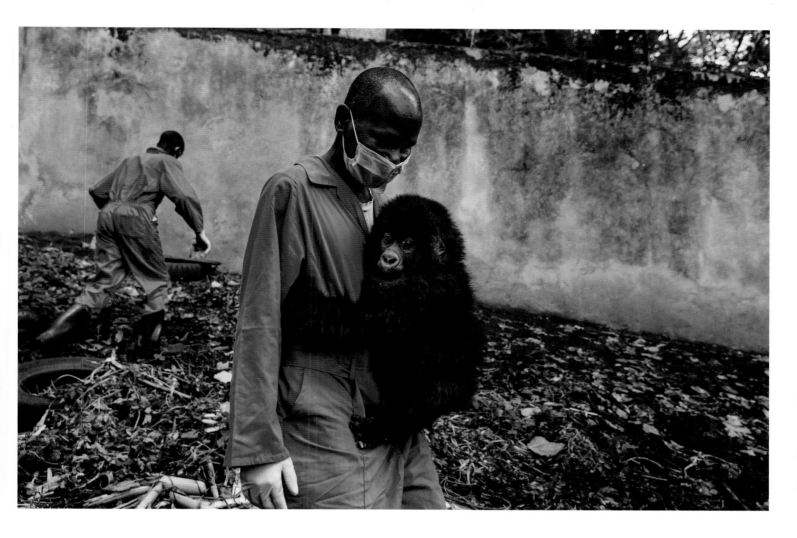

of these gorillas and chop down the hardwood trees, which make the best charcoal. It was worth $40 million dollars annually. There were a couple of rangers who were sharp and saw what was going on and tried to stop it. The gorillas were killed as a warning to those rangers, a way of saying, 'Look, if we can kill these animals so easily, don't mistake what can happen to you'. I was really moved by the fact that these men felt so close to these animals and I also recognized that here was an intersection between exploiting the environment and also conflict; these elements were no longer separate. If you're looking for members of a terrorist group or the like, you can find them in wild places. I don't think of the environment as a separate issue in photojournalism anymore. Capitalism, commerce, humanity – it's all related.

The bottom line is these issues are complicated so I want to understand them better and I feel as though I've been very lucky to have some of the best print space in the world to talk about these issues – so I feel like I have to do it properly. Recently I did a story on the pangolin, which is one of those animals that gets overlooked but is a complete metaphor for all the species. We're all very focused on the megafauna but there's all these other things that are completely disappearing in their thousands on a daily basis. So working on the pangolin I was asking, 'What is this about, what drives it? What are the potential solutions, who are the good guys, who are the bad guys?' Zoonotic disease has been a reality of humans consuming animals from the beginning.

'It's almost suicidal in terms of our civilization's thinking on these issues, but a lot of that's because people are simply in the process of surviving, feeding their families. Conservation is almost considered a luxury, when it should be a necessity.'

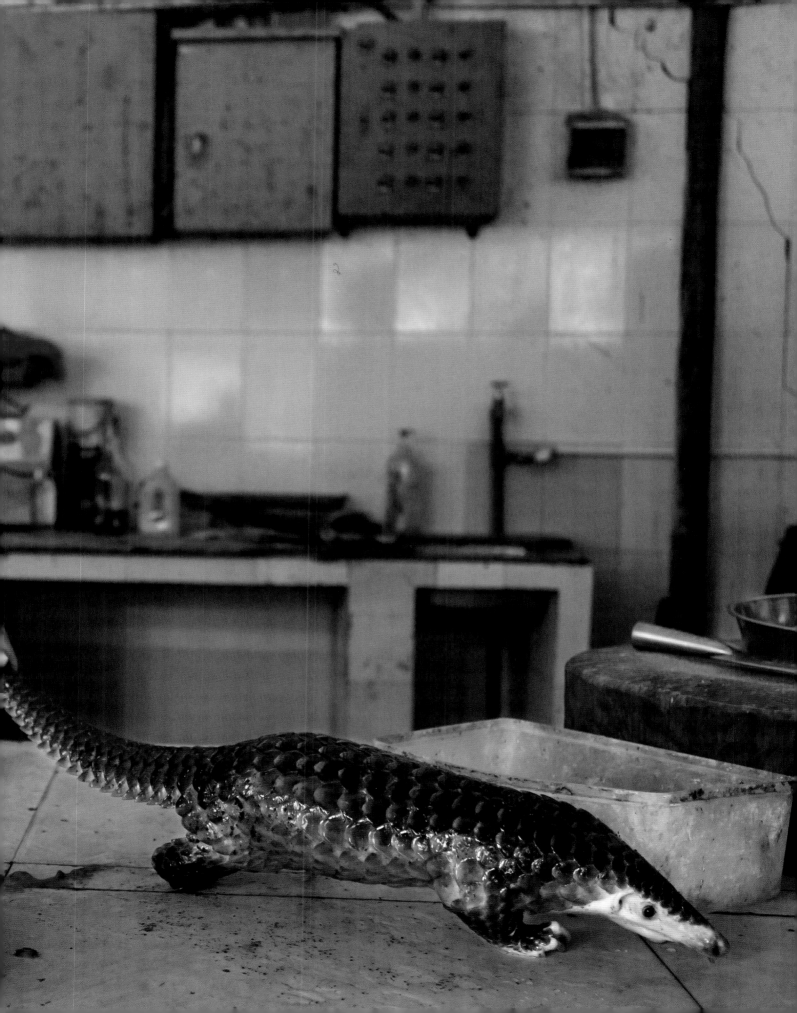

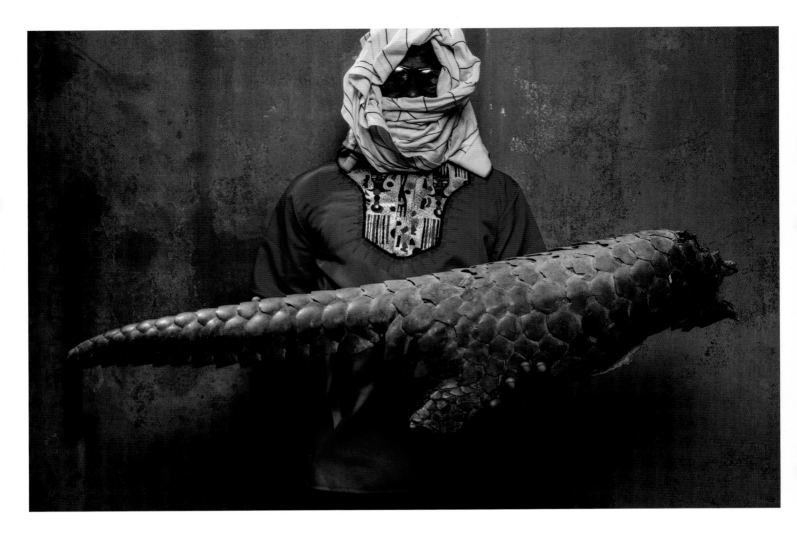

Previous page: A pangolin is slaughtered and prepared for a meal in a restaurant on the outskirts of Guangzhou, China. The price for the meal was RMB 1,200 [approximately US$170] per pound [450 grams] of the animal's weight. This pangolin was six pounds [two and three-quarter kilograms] and was force-fed liquids before being weighed to drive the price higher. The price of the meal was RMB 8,000 [approximately US$1,130] in total.

Above left: An undercover officer from a unit dedicated to trans-national crime holds a giant pangolin exoskeleton discovered in a raid on a house in Abidjan, Ivory Coast.

Pangolins have been identified as the most likely animal in the transmission of the Coronavirus; look how that has affected the world. China claimed to have shut down all their wildlife markets in the aftermath of the Coronavirus outbreak, but look at the cost, both in terms of human life and to the global economy, all because humans did not respect and treat animals correctly. This current disaster surely spells out that not everything is there for our consumption.

I think people do care about all of these issues if you take the time to explain it to them; you explain that these things don't occur in isolation and they are all totally interconnected. If we allow this to happen with one species, it's a really slippery slope for all species. I have a young son who is twenty months old and I like the idea that I can take him into the bush and show him this stuff. I challenge anyone to spend a few weeks in the bush and not understand that there is an underlying harmony to all things and if you simply spend time in that space, you will feel it. That's the kind of balance that most people are missing in their lives.

Conservation is often at the bottom rung of priorities for government, but a lot of that's because we haven't established a proper value system for it. I've been privileged to spend a lot of time in wild places and it's not always comfortable, but I definitely feel a more profound connection to things as a result of that – I wish I could give everyone in the world six weeks in a beautiful place so they could feel that. It's very worrying that certain leaders come to power now, at a

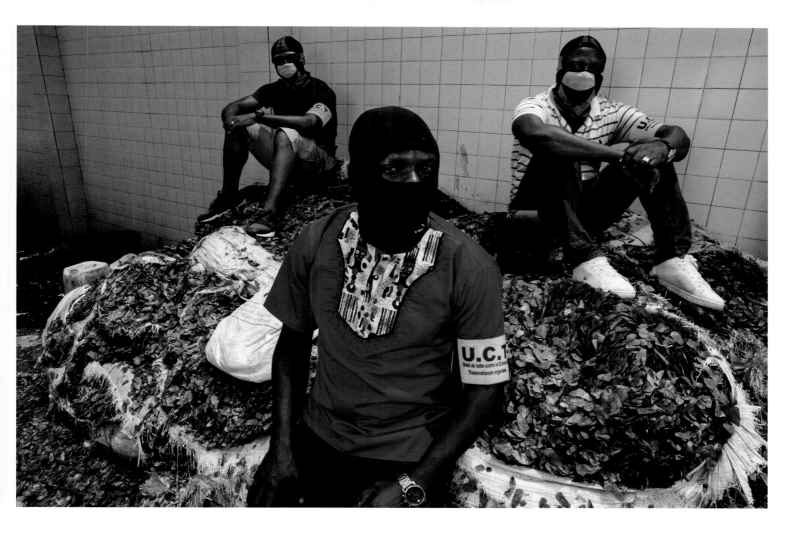

time when we have such a tiny window in which to conserve things. It's almost suicidal in terms of our civilization's thinking on these issues, but a lot of that's because people are simply in the process of surviving, feeding their families. Conservation is almost considered a luxury, when it should be a necessity.

There's an interesting expression that the only Amazon that people seem to care about these days is the one that delivers packages in neat little boxes to their front door. I think it is in an interesting idea that commerce is the so-called engine of our civilization. But what we are not doing, is understanding that there is a green commerce too and we have dramatically undervalued this space. There has to come a time when investment in green space, in conservation, is also an economic possibility – look at the way that the German banks are thinking about pulling out of fossil fuels. And I'm hoping that that happens in time. But in a world that's accelerating in terms of population, the idea that we could lose all these things without actually having arrived at a concrete value for them is astonishing. If we could put more energy into the here-and-now instead of trying to go to Mars, I feel we could do so much more.

I think we're experiencing a profound selfishness in the world at this time. Leaders who are advocating the continued destruction of the planet through fossil fuels, or through mining practices that are completely unnecessary and purely profit-orientated – how do you go home and look at your kids?

Above right: The raid netted two Vietnamese traffickers with 1,300 pounds [600 kilograms] of scales from the highly endangered pangolin.

Following page: Two rhino poachers wait to be processed in jail. They were apprehended by an anti-poaching team in Mozambique near the border of South Africa's Kruger National Park.

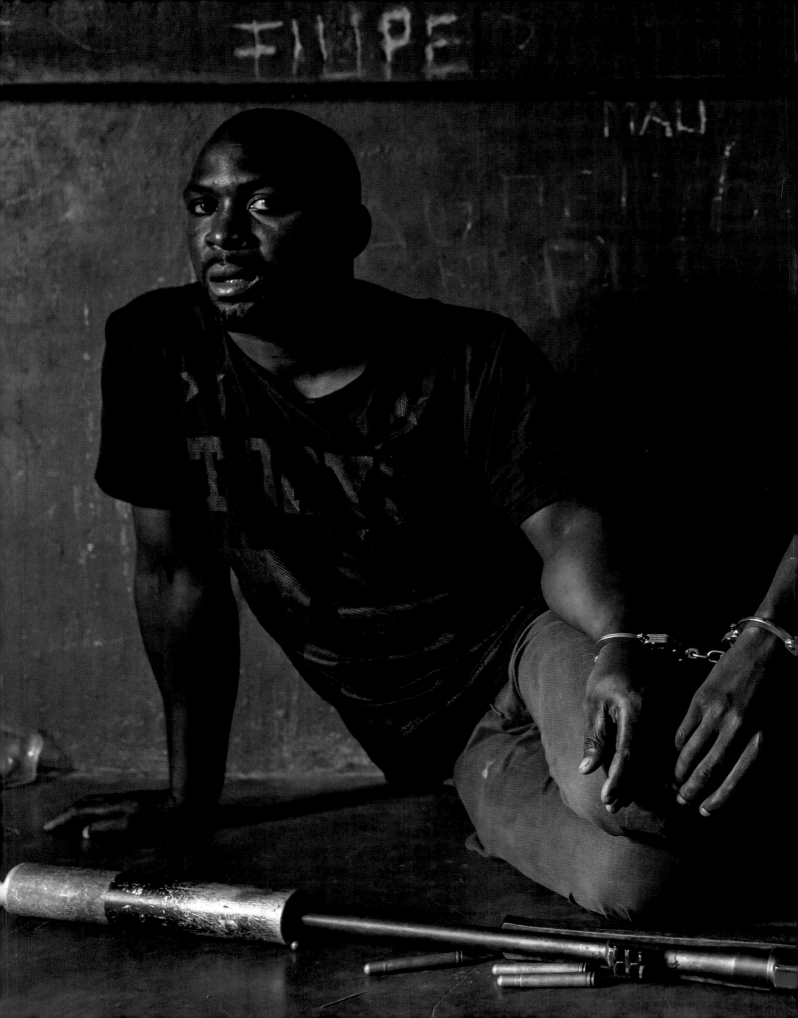

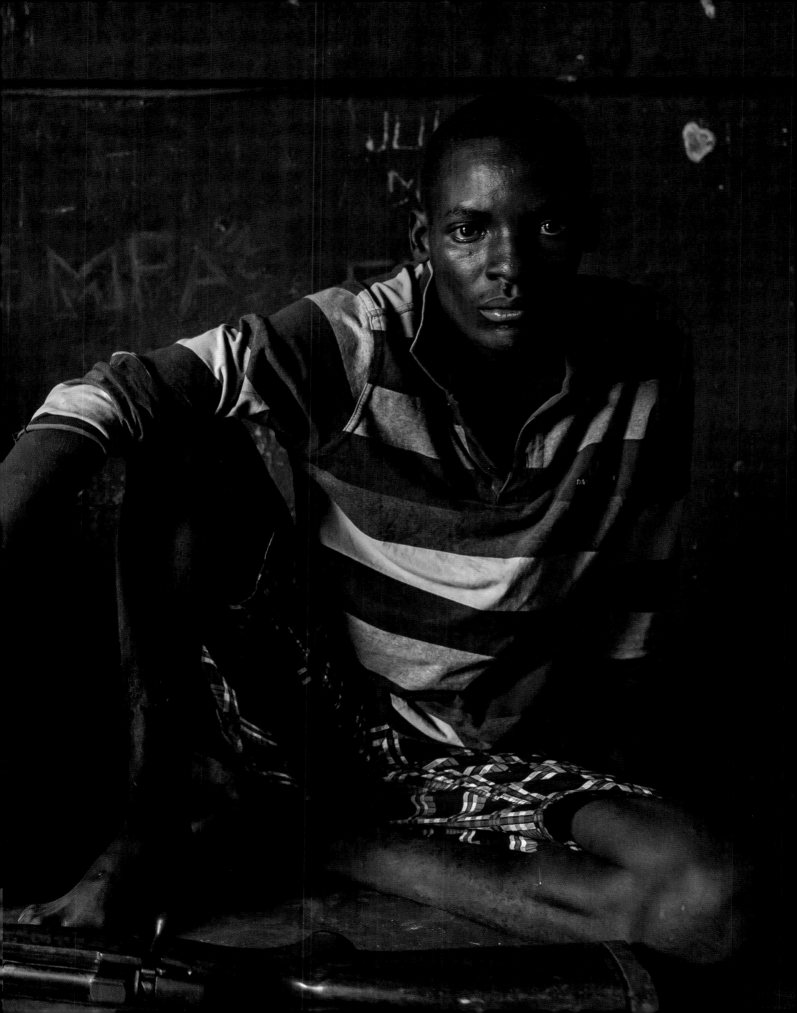

Above: Jin Mao Bone Carving Arts and Crafts in Beijing, China. This fifty-year-old ivory carving factory has thirty-four carvers and claims to do over fifty 'big pieces' every year. A 'big piece' is the equivalent of one tusk, as well as numerous smaller pieces. A large tusk weighs on average forty-five pounds [twenty kilograms] and sells in Beijing for approximately RMB 1 million [approximately US$140,000].

Above: Trafficked ivory recovered from a seizure in Singapore is prepared for burning in Manyani, Tsavo, Kenya. Five of the nearly six and a half tons [approximately six tonnes] collected will be burnt in Kenya under the auspices of the Lusaka Agreement Task Force, a group which was formed by affiliated countries as a common front in the battle against wildlife crime in Africa. The remaining ivory will allegedly be sent back to Malawi and Zambia where it originally came from.

Above: ICCN (Institut Congolais pour la Conservation de la Nature) conservation rangers deploy young bloodhounds to investigate the corpse of a recently killed sub-adult male elephant in Lulimbi, in eastern Democratic Republic of Congo. The lead dog Lily, just over a year old, followed the scent for several kilometres in the direction of a village long suspected in poaching cases in Virunga. Undercover intelligence could now seek out the ivory sellers.

Above: Master sculptor Marcial Bernales carves an ivory head-and-hand set for a Catholic religious icon in his workshop in Valenzuela, near Manila, the Philippines. Bernales has been carving ivory for forty-five years and has made hundreds of pieces, all of which are of a religious nature. His ivory pieces are in great demand amongst the wealthy collectors of the Philippines.

It's the triumph of the sociopath. The only way things are going to change is if we vote people out. One: we need people to go and vote like never before; and two: we need better leadership choices. We just don't have these people who are out there thinking about these issues. So, if you really feel strongly, make yourself available. What I do is try to provide verifiable proof of what's happening in the environmental space or in the field of human drama. But I want to give it to people I can believe in and it's become difficult to see those people.

Too often leaders have partisan interests and their own personal agendas. For me, leadership is really about putting aside all that stuff and answering immediate needs. If you're not doing that, you're fiddling while Rome burns; it's like rearranging the deckchairs on the *Titanic*.

Right: A dead black rhino bull, poached for its horns less than twenty-four hours earlier at Hluhluwe-Imfolozi Park, KwaZulu-Natal, South Africa. Rhino horn was widely used in traditional Asian medicine and today is still considered curative for everything from cancer to kidney stones. It is now worth more than gold.

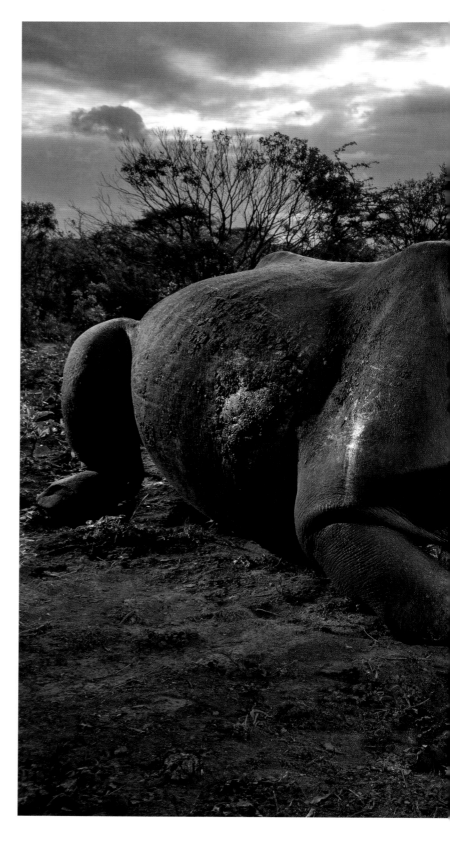

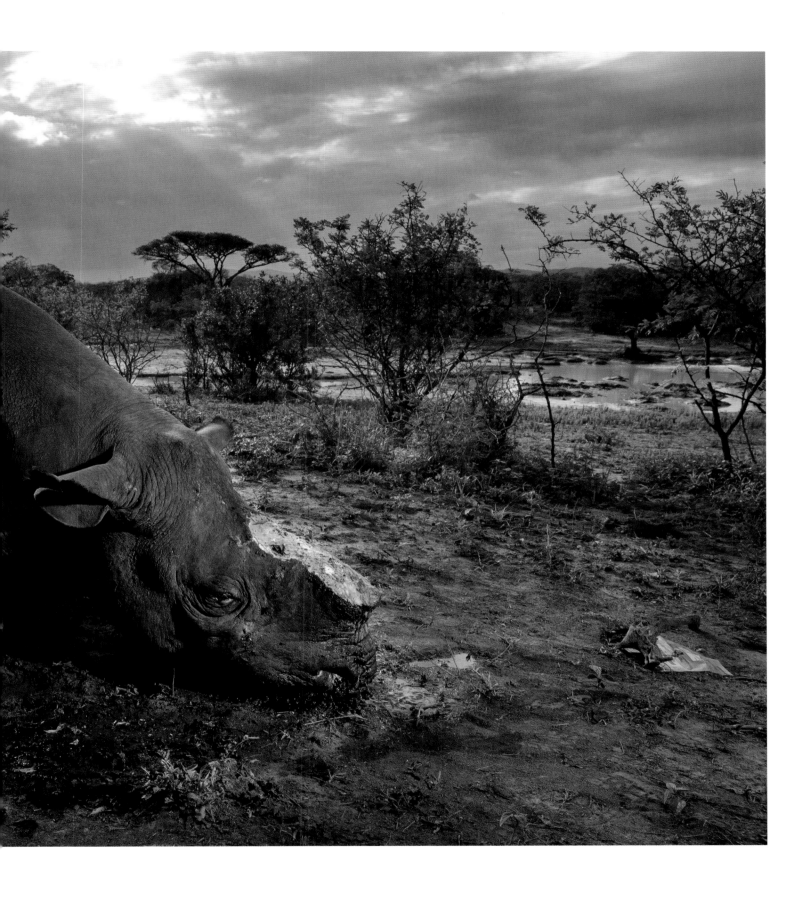

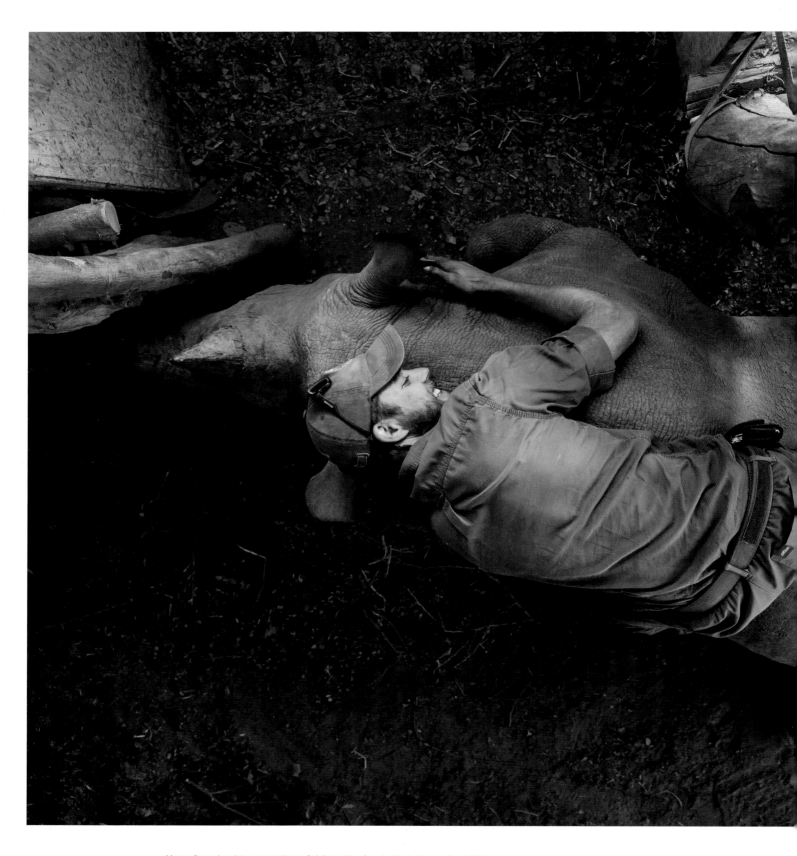

Above: Rwandan rhino expert Kenny Babilon with a female black rhino in Chad. Of the six black rhinos originally brought from South Africa for release into Zakouma National Park, she is one of only two remaining. The other four died from differing complications of pneumonia, hypothermia, twisted gut and West Nile disease.

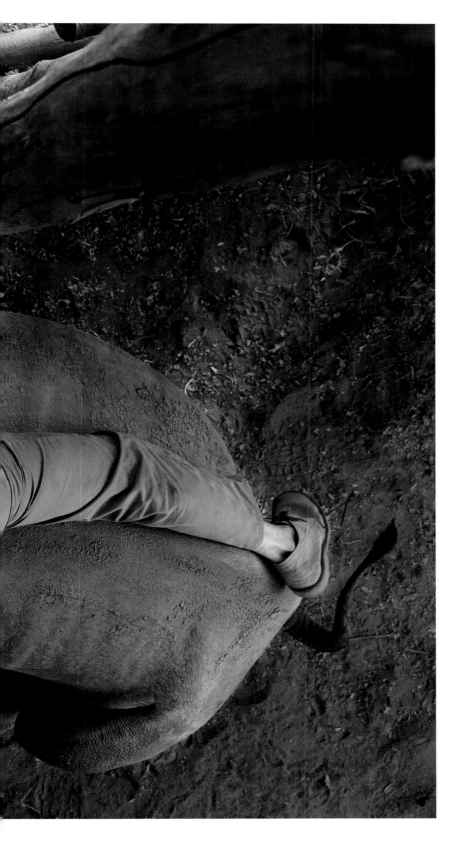

'Conservation is often at the bottom rung of priorities for government, but a lot of that's because we haven't established a proper value system for it.'

I think that a dramatic re-evaluation of wild spaces from an economic perspective has a much greater chance of genuine consideration by politicians than economists, because ultimately 'if it pays, it stays'. That's the reality of the world we're in: as we approach a population of eight billion people, that mentality is going to become the mainstay of our culture; democracy as we know it is going to change. But a reprioritizing of what natural spaces and animals mean and a genuine economic worth accorded to those things, is essential.

Following page: Magunda Hill is one of the tallest areas inside Garamba National Park, Democratic Republic of Congo. An observation post built at this strategic site allows rangers to be on the lookout for poachers and militia groups entering the park to hunt its animals.

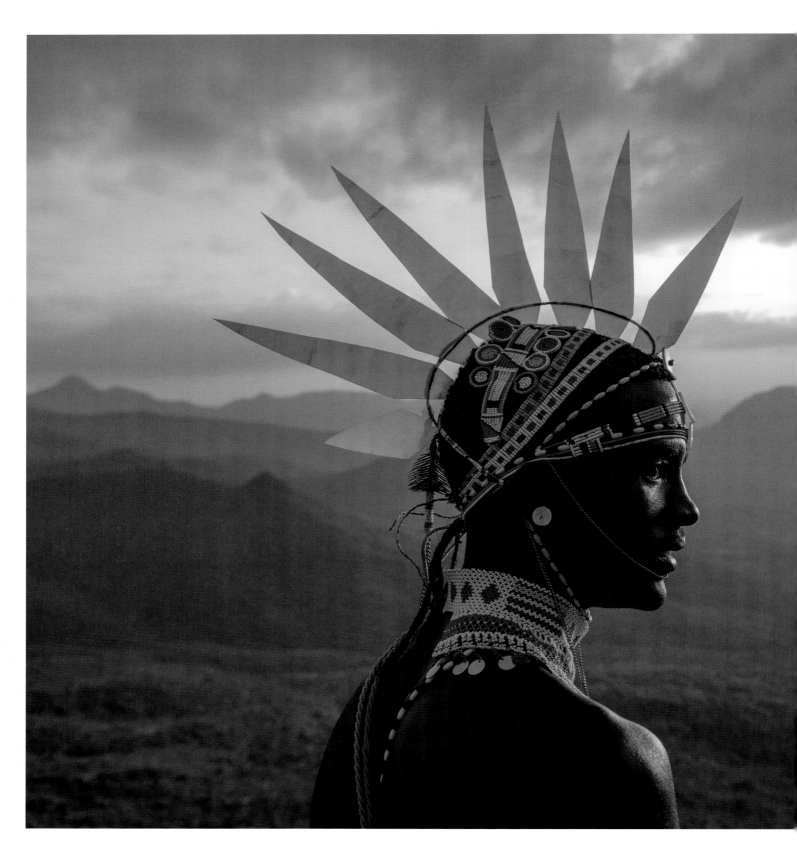

Above: John Nkuus Leripe, a Samburu, watches the sun rise over the Mathews Range in northern Kenya's Namunyak Wildlife Conservancy. Samburu are semi-nomadic pastoralists and Leripe and other men like him who live here are proud stewards of the land and the wildlife it holds.

AMI VITALE

Ami Vitale is a *National Geographic* photographer and film-maker. She has travelled to more than a hundred countries to document human and wildlife issues and through her work seeks to tell stories that create awareness and understanding between interhuman and human and animal communities.

As I child I was painfully shy, gawky and introverted. I was afraid of people and that made it difficult to engage with the world around me. My parents did everything they could to give me more courage. They would put me in front of a camera, take me to dance classes and once even dressed me up as a lion – perhaps thinking I would find my courage that way. In spite of my parents' good intentions none of these things instilled me with confidence, but the day I first picked up a camera, everything changed. Looking through the viewfinder, I found a world stripped of banality, a world full of wonder. Not only did photography enable me to see the world with fresh eyes, it allowed me to shift attention away from myself and focus on others. My camera gave me the ability to share and amplify other people's stories and this, I later came to realize, is my hidden superpower.

Photography, both as a medium and as a means of communicating stories, has a unique ability to transcend all languages and to help us understand each other. It reminds us of our deep connections and can be used as a tool for creating awareness and understanding across cultures; a tool for making sense of our commonalities in the world we share.

'We all have the capacity to get engaged and use our voices to make a difference. The messenger matters just as much as the message itself. Each of us can be a powerful voice when speaking to the people in our lives.'

I have worked in over one hundred countries documenting stories about war, security, poverty and health. What has slowly emerged from covering conflict after conflict and the worst of human tragedies, is a conviction that these stories about the human condition cannot be separated from stories about the natural world. We inhabit an intricate web and the outcome of almost every story is always dependent on nature. Today, I use nature as a foil to talk about our home – its past, its present and its future. In a field that tends to emphasize difference and focus on conflict, my mission has been to tell stories that remind us of our interconnectedness, of how much we share, rather than simply emphasize our differences.

*

One of the great turning points in my life came in 2000 when I was living in a remote village in the small West African country of Guinea-Bissau for half a year. My sister had spent some time there in the Peace Corps not long after the country was wracked by the Guinea-Bissau Civil War which took place there from June 1998 to May 1999. I wanted to go back and see what had happened to the people my sister had befriended while there; I wanted to understand how the war had impacted them. So I packed my bags and headed to a small village in the middle of the country for a two-week stay. Once there, I shared a mud hut with Fatima and Uma, two co-wives and their children. As I got to know Fatima and Uma and slowly became familiar with the rhythm of village, the two weeks I had allowed for my visit quickly turned into months and those months turned into half a year.

What I learned while there surprised me. In mainstream media, there are two prevailing narratives for Africa. On the one hand, there is a continent plagued by war, famine and disease; on the other, there is the Africa of safaris and exotic animals. What I encountered was neither of these. I encountered something far more complex. I encountered a story that I rarely saw portrayed in the mainstream media. I encountered a community with a deep connection to the natural world. There was a reverence and understanding that people's lives depended on nature. The village didn't have running water or electricity and there were no doctors, but I quickly realized that even if I was given an entire lifetime, I would not be able to learn everything that Fatima and Uma had to teach. To them, I was a mystery. I did not have a baby nor a husband, I could barely cook and I couldn't even get water out of the well. They could not understand how I had survived for so long without these basic skills for living. I spent the days learning how the majority of people on this planet live; I carried water and gathered firewood. In times of plenty, we shared a large bowl of rice; in times of scarcity, we subsisted just on the one cup of rice a day.

As the rainy season began, I became sick. I began hallucinating and could not get up because my body was so weak. Uma and Fatima immediately brought in a local healing practitioner, who produced amulets for me. These objects were small leather pouches containing carefully folded parchments with verses from the Koran, as well as symbols and geometrical patterns.

Previous page: A group of Samburu stand looking over the Namunyak Wildlife Conservancy from the Mathews Range Mountains in northern Kenya. Namunyak's 850,000 square acres [344,000 square hectares] contain higher populations of large mammals than any other landscape, protected or unprotected, in Kenya. Conservation efforts here are led by the local communities and focus on preventing habitat loss and stopping the spread of poaching.

Right: Anita and Sri Devi stand in a rice field in their village in Andhra Pradesh, India. Each day, women around the world spend a collective two hundred million hours collecting water for their communities and families and are not able to develop their own skills because of the time this takes. This pursuit becomes more difficult and time-consuming as climate change causes more frequent and severe droughts and as sea level rise contaminates other sources of fresh water.

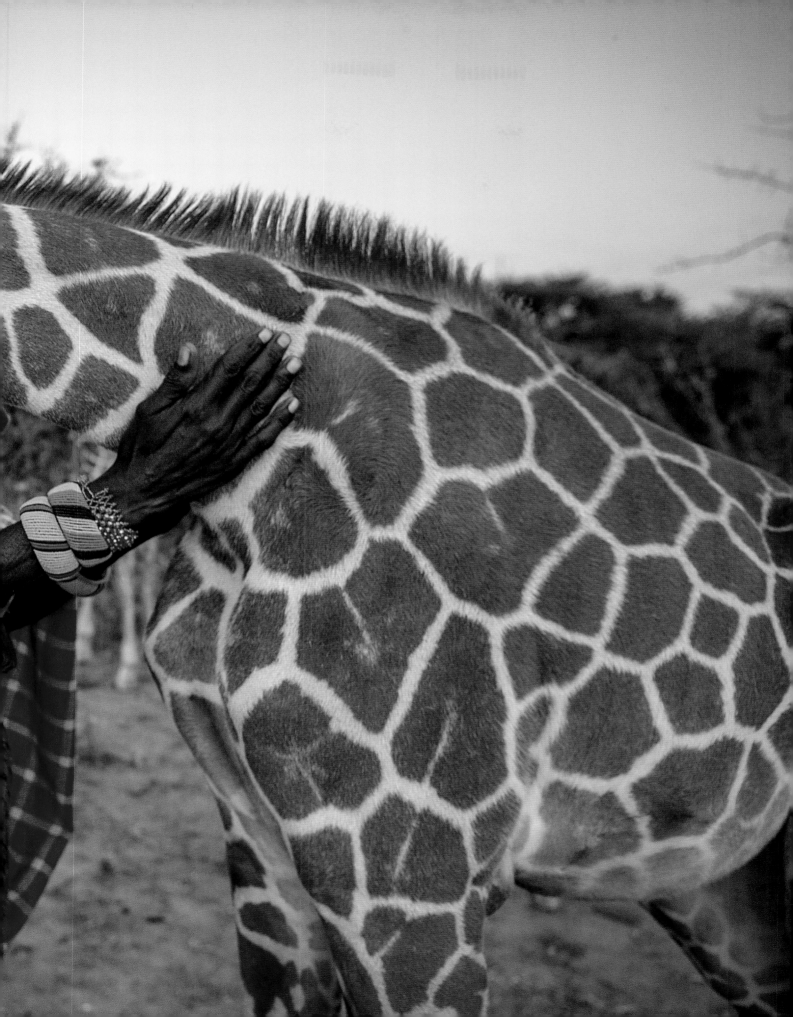

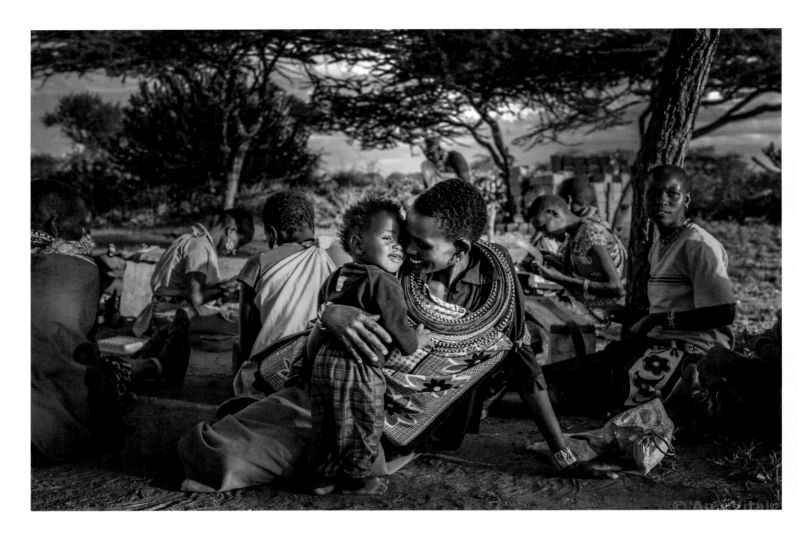

Previous page: An orphaned baby reticulated giraffe embraces wildlife keeper, Lekupania. This giraffe was rehabilitated and returned to the wild, as others have done before him. Right now, giraffe are undergoing what has been referred to as 'a silent extinction'. Current estimates are that giraffe populations across Africa have dropped forty per cent in three decades, plummeting from approximately 155,000 in the late 1980s, to under 100,000 today.

Above left: Ntipiyon Nonguta and her son, Bernard, aged one, relax with their neighbours as they make beaded belts for the Loisaba Community Trust in Ewaso Village, Laikipia, Kenya. Much needed attention has been focussed on the plight of wildlife and fighting the war on poachers, but little has been said about the indigenous communities that are on the frontlines of these poaching wars. The best protectors of these landscapes are the local communities themselves.

The healer told me to tie the leather straps around my arm and wear the amulets until I felt better – I never took them off while I was there. They also gave me medicine to treat malaria and within days I was better. I have carried these amulets with me across a hundred countries over twenty years of travelling. For me, they represent more than protection against disease and danger. They are an expression of empathy and a story of our shared humanity.

We often visit a place with the story already written in our heads even before we arrive. Guinea-Bissau taught me that it takes time to understand one another's stories but that once we do, we are transformed forever.

My life in Guinea-Bissau was vastly different from my life in America. That was not really surprising – in fact, it was expected. What was truly surprising were all the things that we shared. My last evening in the village, I sat with a group of children beneath a sea of stars, talking into the night about my return home. One of the children, Alio, asked me if we had a moon in America. I think of Alio every time I gaze at a full moon and I imagine him standing under that big sea of stars looking up at it. The moon is like a collective third eye. It shows us our common identity – an identity that knows no borders. It gives us a sense of oneness, a constant reminder that we are all tied together in an intricate web, whether we understand it or not.

*

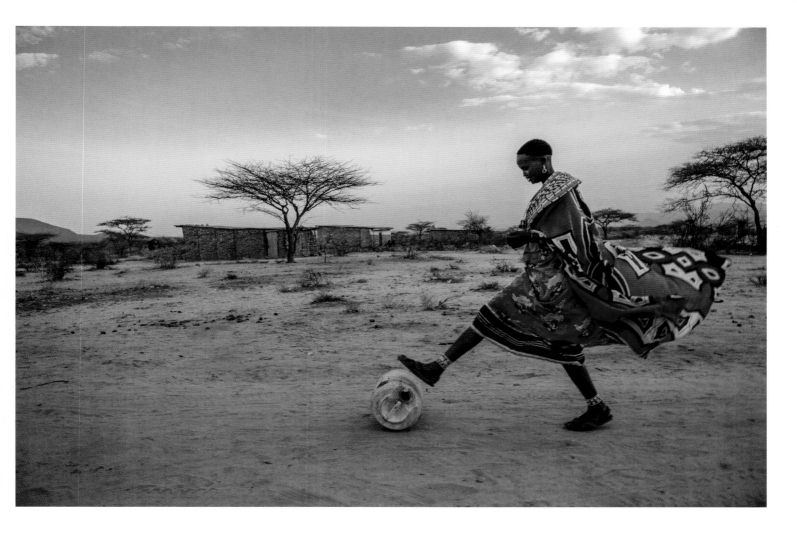

I can recall the exact moment when I truly began to understand how profound our choices are and the impact we have on one another and on all of life on this planet. It happened on a cold, snowy day in December 2009 in the village of Dvůr Králové nad Labem in the Czech Republic. It was on this day that I met a rhino named Sudan for the first time. Quite unexpectedly, this animal changed the way I see the world forever. What surprised me was how connected I felt to the gentle, hulking creature sitting in front of me. When I got close to him, I had the strange feeling that I had just met a unicorn. He was mythical and other-worldly, larger than life. I recognized I was in the presence of a sentient, ancient creature. His species has been roaming the planet for millions of years and up until the last hundred years, there were possibly hundreds of thousands of them inhabiting the planet.

But on that day in 2009, there were only eight of these rhinos alive and they were all in zoos. I was there because there was a plan to airlift four of these last eight northern white rhinos from the zoo in the Czech Republic to Kenya. At first, I thought it was a story straight out of Disney cartoon, but I quickly realized that this was a desperate, last ditch effort to save an entire species. When I saw these creatures, it seemed so incomprehensibly unfair that we had reduced them to this remnant of what they had been.

We imagine wildlife roaming the open plains of Africa freely. The reality is that they have to be guarded and protected around the clock, twenty-four-seven,

Above right: Naitemu Letur pushes a jug of water back to her home. 'Before, we would walk for hours every day just to get water,' she says. 'Sometimes it was not safe, but now we have plenty of water near our homes and this has made our lives more secure.' In earlier conservation efforts, threatened forests and endangered species were protected by uniformed guards. Here, they are protected by women and schoolchildren, who have a vested interest in a healthy environment because they benefit directly.

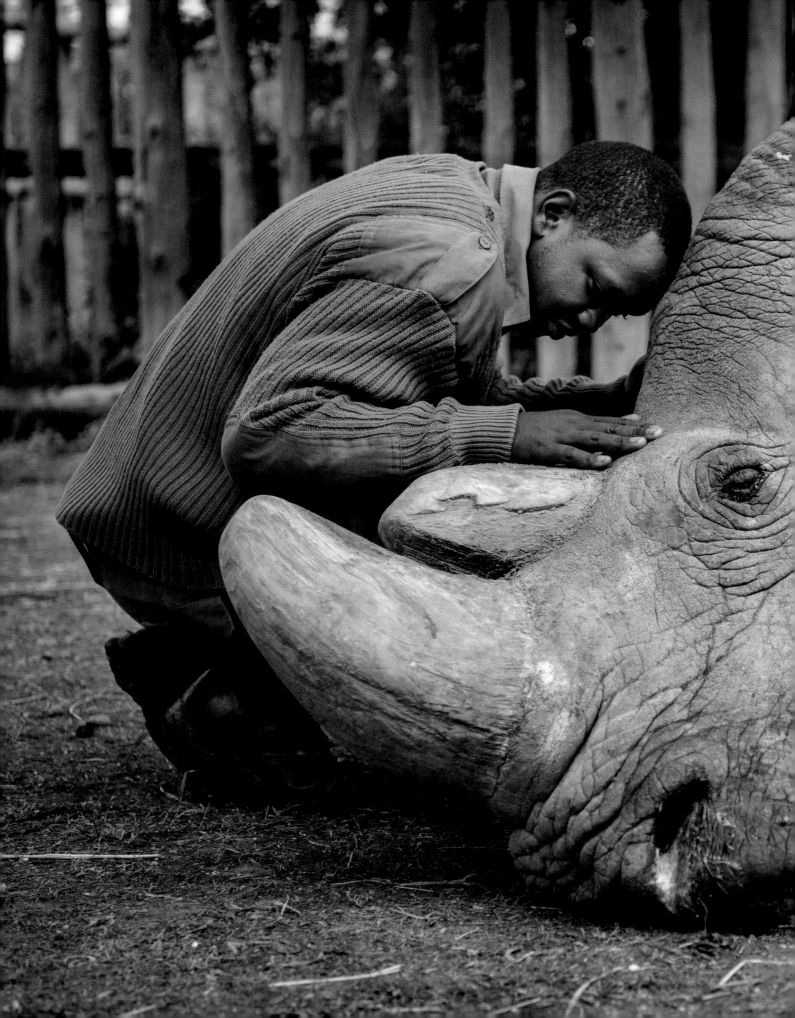

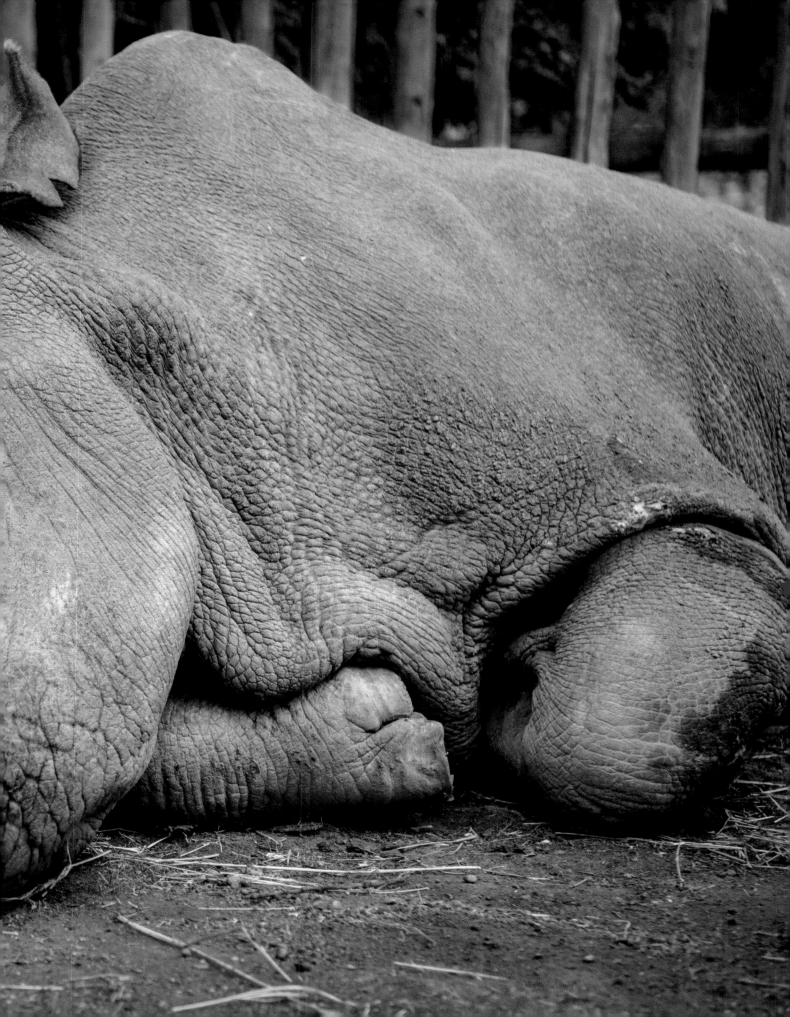

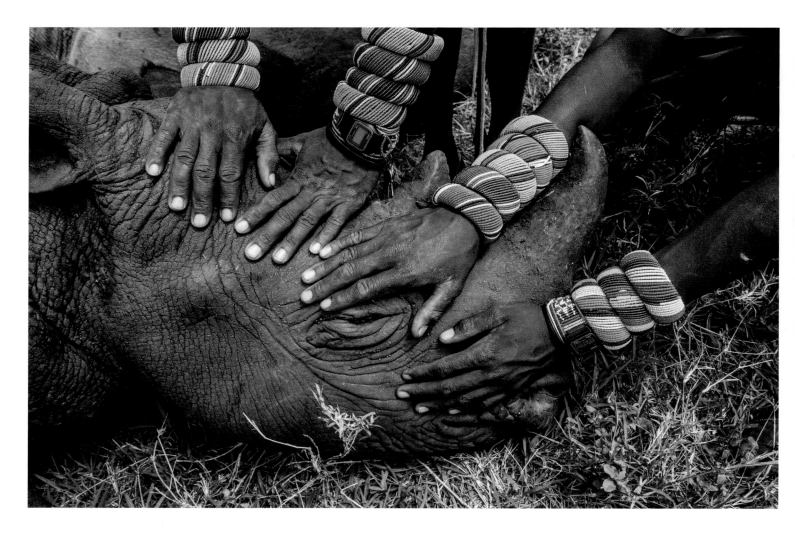

Previous page: Sudan, the last living male northern white rhino left on earth, is comforted by keeper Joseph Wachira, moments before he passed away on 19 March 2018, at Ol Pejeta Conservancy in northern Kenya. At the time, the photographer said, 'To watch the last of something die is something I hope never to experience again, but Sudan was surrounded by love, together with the people who committed their lives to protecting him. If there is any meaning in his death, it's that Sudan can be our final wake up call.'

Above left: In 2014, the photographer witnessed a group of Samburu warriors encounter a rhino for the first time in their lives, at Lewa Wildlife Conservancy in Kenya. Some of the warriors had never even seen a photo of a rhino. The young warriors from Northern Rangelands Trust community conservancies had been visiting to learn about conservation practices such as sustainable land use, grazing programmes and endangered species conservation.

by heavily militarized guards. For hundreds of years, rhino horn has been used by people around the world to treat illnesses, such as fever and stroke. Traditionally fervently believed to have miraculous healing powers, rhino horn is actually just composed of keratin – the same material our fingernails and hair are made of. Nevertheless, today rhinos continue to be killed for their horns. The horn is so valuable, it can be sold on the black market for three times the price of gold. Illegal poaching is one of the primary reasons that rhinos are so rare today. We are witnessing extinction right now, on our watch. Poaching is not slowing down and it's entirely possible, even likely, that if the current trajectory of killing continues, elephants and rhinos, along with a host of lesser-known plains animals, will be functionally extinct in our lifetime.

Much-needed attention has been focused on the plight of wildlife, but very little has been said about the indigenous communities on the frontlines of the poaching wars. They hold the key to saving Africa's great animals. The best protectors of these animals are the people who live alongside of them.

Human activity has placed one million plant and animal species in immediate danger of extinction, causing what scientists have identified as the sixth mass extinction event on this planet.[5] This extinction event is different – not only is it driven by humans, but it is happening at an incredibly fast and accelerating rate. Removal of a keystone species has a huge effect on the ecosystem and impacts all of us. These wildlife giants are part of a complex world created

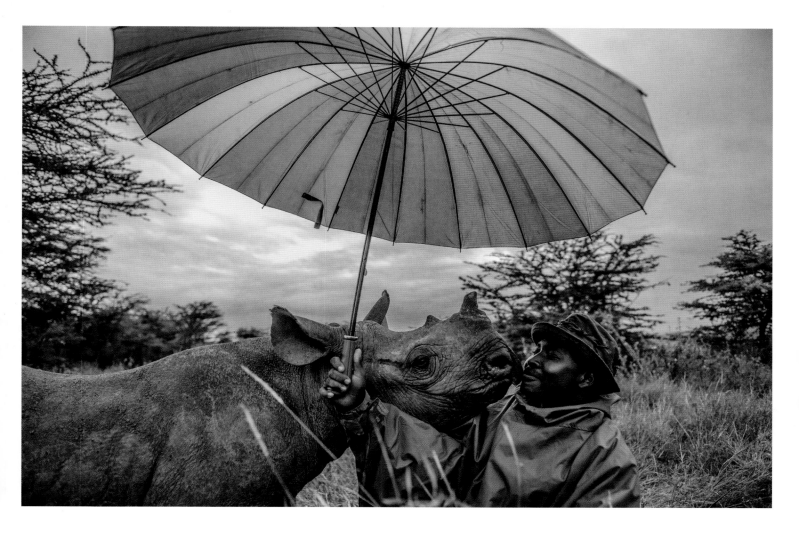

over millions of years and their survival is intertwined with our own survival. Without rhinos, elephants and other wildlife, we all will suffer in ways we do not yet fully comprehend.

Fast forward to 18 March 2018, where I was giving a talk in London when I received a call to hurry back to Kenya. I had made a number of trips to visit Sudan in his new home in Kenya, but this time it would be different. This time I was travelling there to say goodbye to Sudan – goodbye to the last northern white male alive on the planet. To watch the last of something die is something I hope never to experience again. On the flight to Kenya, I worked through the many emotions I felt at the thought of saying goodbye to the Sudan that I had come to know over the last several years. I could employ my powers of rationalization and tell myself that he had had a good and long life. I have lost those close to me before and as difficult and heart-wrenching as it would be, I knew that I would slowly be able to come to terms with saying goodbye. What I could not begin to wrap my mind around, what I could not come to terms with, was the enormity of what it meant to say goodbye to a species. Learning how to grieve for a species may be a uniquely brutal and heartbreaking lesson that is specific to our generation.

I arrived and Sudan was surrounded by the people who loved him and had protected him. All I could hear was one bird wildly chirping against the

Above right: Kamara is nuzzled by orphaned black rhino Kilifi who he hand-raised, along with two other baby rhinos, at Lewa Wildlife Conservancy in Kenya. Kamara spends twelve hours every day watching over the vulnerable orphaned animals. This area was once home to one of the densest black rhino populations. Today, most locals have never seen a rhino in their life. In just two generations this animal has been poached almost to extinction.

Following page: Mpala, an orphaned elephant cared for at Reteti Elephant Sanctuary for the previous two-and-a-half years, is finally returned to the wild. Three-year-old Mpala arrived when she was seven months old, a victim of the drought. She integrated into the herd quickly. Her place was in the middle of it all – if there was a ruckus to be had, she was throwing back her trunk and rumbling in the muck, enjoying a refreshing mud bath.

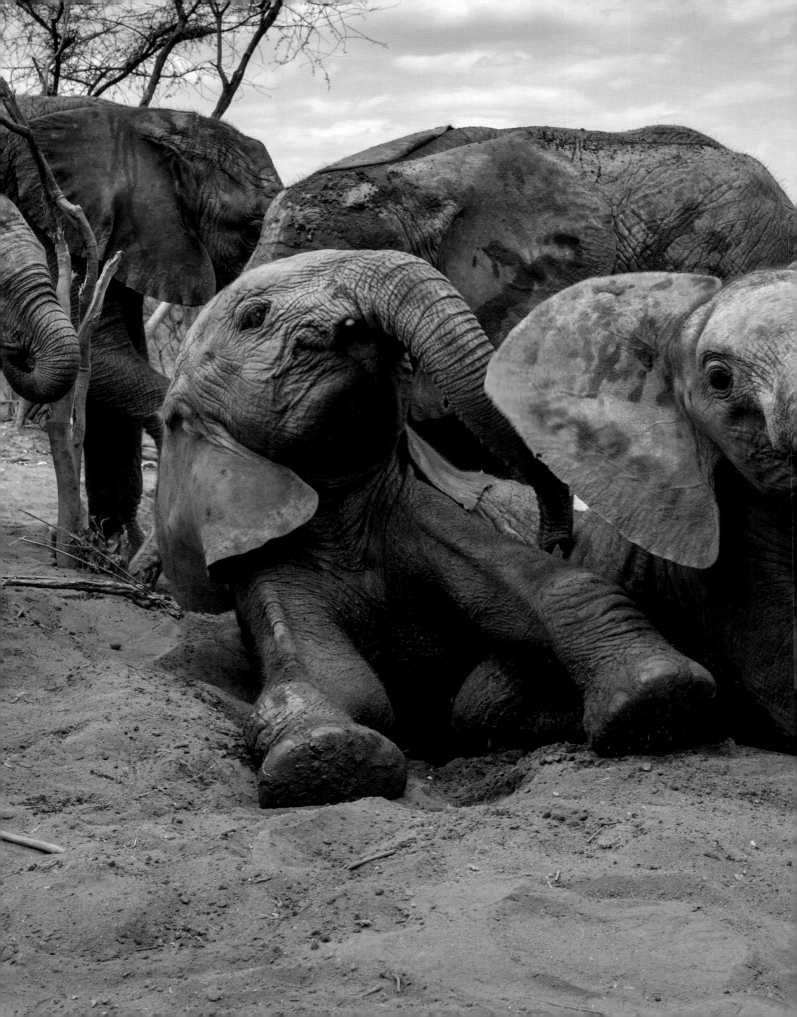

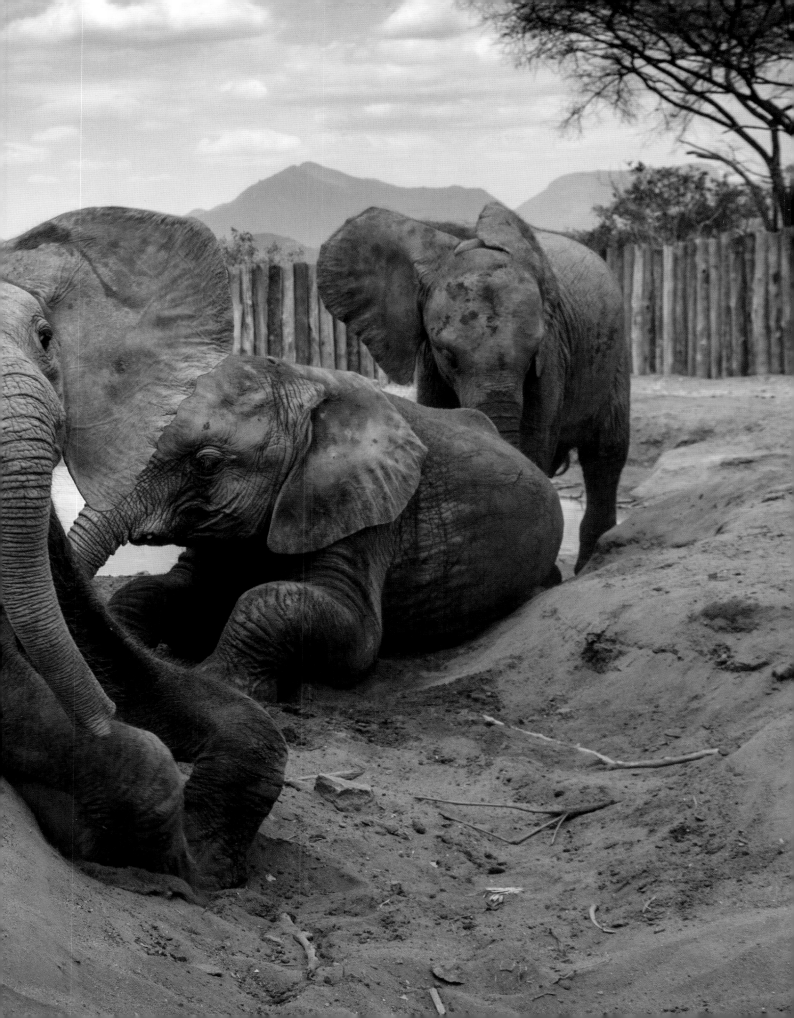

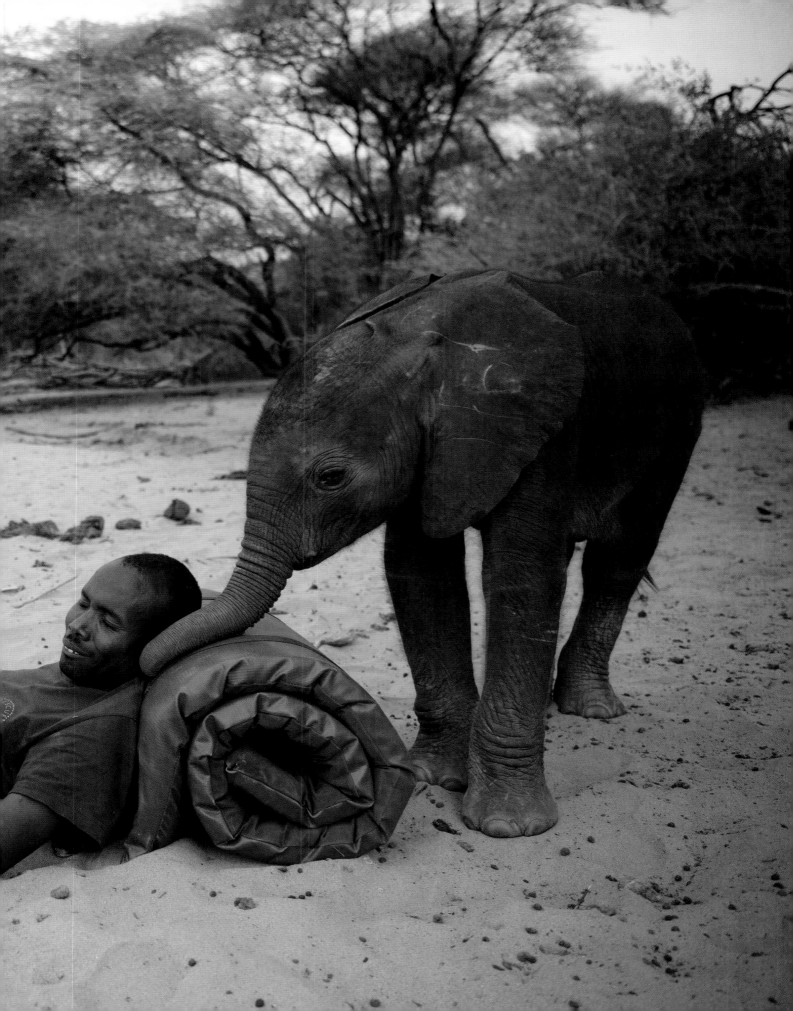

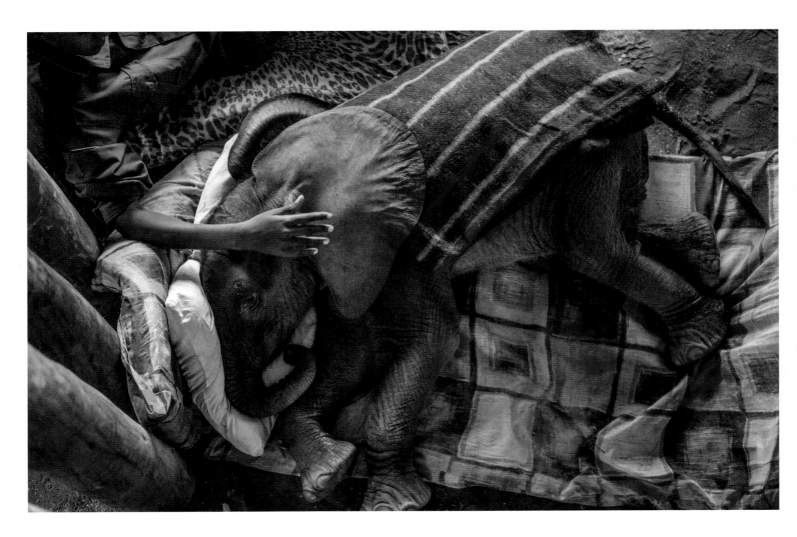

Previous page: Samburu warriors found this baby elephant, dubbed Kinya, trapped in a hand-dug well. When her herd didn't return for her, they took her to Reteti Elephant Sanctuary where she was cared for by keepers such as Rimland Lemojong, pictured with her here. Despite being rescued, Kinya died weeks later.

Above left: The highly trained wildlife keepers at Reteti Elephant Sanctuary work to comfort rescued elephants who have been orphaned or abandoned by the wild herds that live near the Namunyak Wildlife Conservancy in northern Kenya. Elephant calves are often orphaned or abandoned due to poaching, human-made wells, drought, human-wildlife conflict and natural mortality. Reteti's goal is to rehabilitate these calves and return them to the wild herds.

backdrop of the quiet, muffled sobs of his keepers. They spend more time protecting these animals than they do with their own children. This gentle, hulking creature was the last of a species who had survived for millions of years, but he couldn't survive us; he couldn't survive humankind.

*

Let this be our wake-up call. In a world of almost eight billion people, we must begin to see our world as part of the natural world; the natural world as part of our world. Our fates are linked. Losing one part of nature is a loss for all of nature. Without rhinos and elephants and other wildlife we suffer more than just the loss of ecosystem health. We suffer a loss of imagination, a loss of wonder, a loss of beautiful possibilities.

Planet earth is the only home we have and together we have poked some holes in our shared little life raft. I want everyone to experience and benefit from the diversity of habitat and life we have today in all of its forms – from glaciers to deserts, from elephants to the tiniest of ants that inhabit the earth. We must not condemn future generations to a world bereft of these experiences.

What happens next is in all of our hands. Nature is resilient if we give it a chance – if we give it our time. We all have the capacity to get engaged and

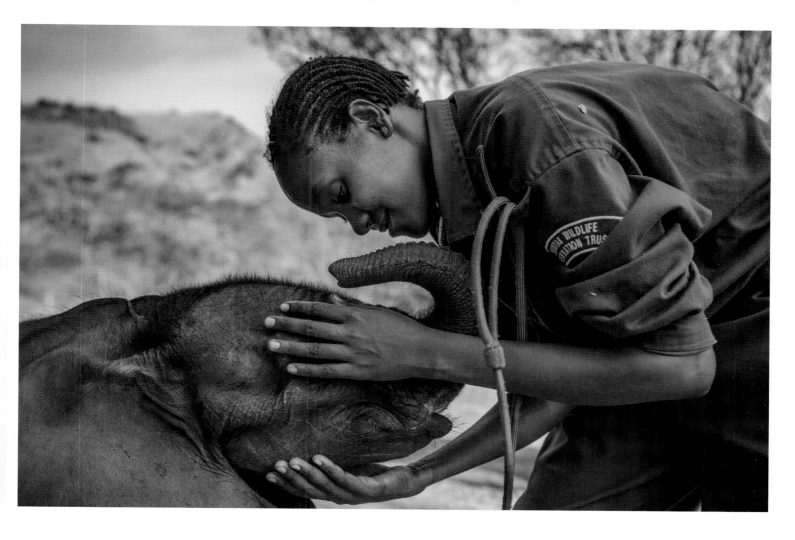

use our voices to make a difference. The messenger matters just as much as the message itself. Each of us can be a powerful voice when speaking to the people in our lives.

I believe we must first fall in love with the world around us. Love gives us the courage to make a difference. But I know it's not just about loving this planet; in fact, that's not going to save us. What's going to save us is believing in the wonder of this world. Wonder allows us to go beyond routine ways of thinking and to reimagine our future together, to reimagine a world graced by rhinos. Wonder shows us how deeply connected we are to one another and that our choices are profound in their impact. Once you take that brave first step and allow yourself to fall in love, you open yourself to the experience of wonder. It is inexplicable and it changes everything. This is what happened to a few of us when we met a rhino named Sudan.

When Alio asked me if we had a moon in America, he taught me this universal truth: we, all of us together, form an intricate web. We are bound to each other simply by virtue of who and what we are. We all want to be on the right side of history and that can only happen when we realize that history is our story and our story is the story of every living thing on this planet. We must not fall into the trap of thinking that this issue is too big to deal with, or that someone else will take care of it. It is up to you. It is up to me. It is up to us.

Above right: Mary Lengees, one of the first female elephant keepers at Reteti Elephant Sanctuary in northern Kenya, caresses Suyian, the sanctuary's first resident. Suyian was rescued in September 2016 when she was just four weeks old. To date, Reteti has rescued more than thirty-five elephants and reintroduced six back into the wild. Those who have returned to the wild have quickly reintegrated into wild herds in the area, the most hoped for outcome.

Following page: Ye Ye, a sixteen-year-old giant panda, lounges in a wild enclosure at a conservation centre at the Wolong National Nature Reserve, managed by the China Conservation and Research Center for the Giant Panda. Her name, whose characters represent Japan and China, celebrates the friendship between the two nations.

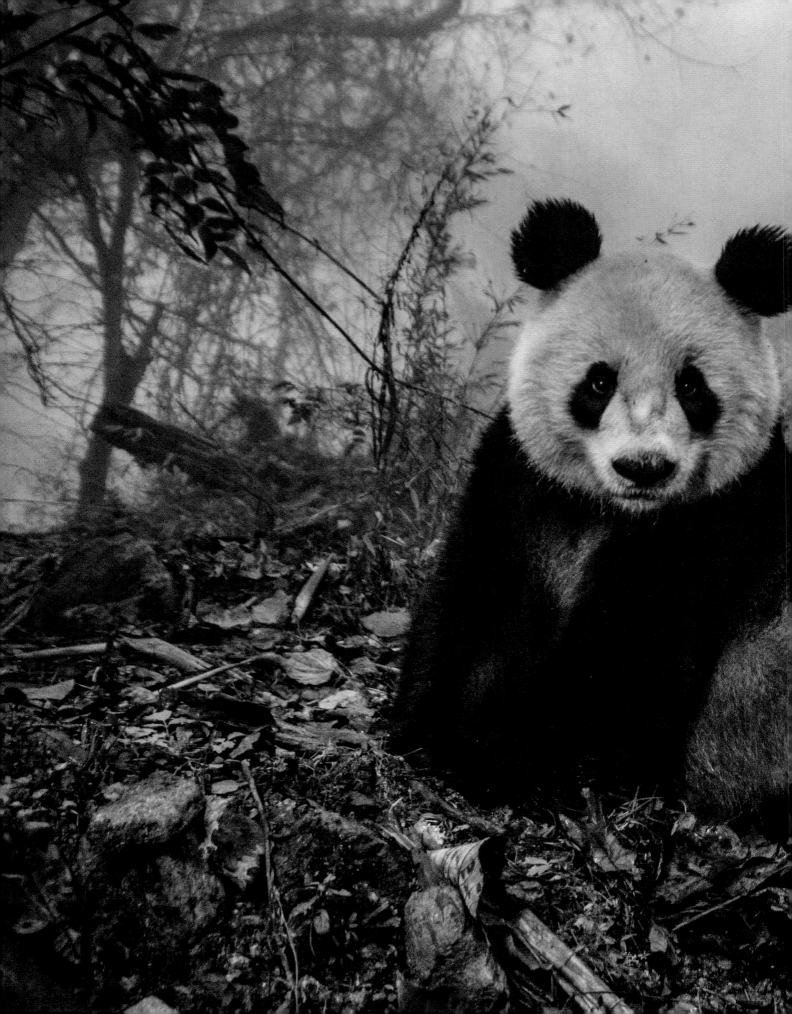

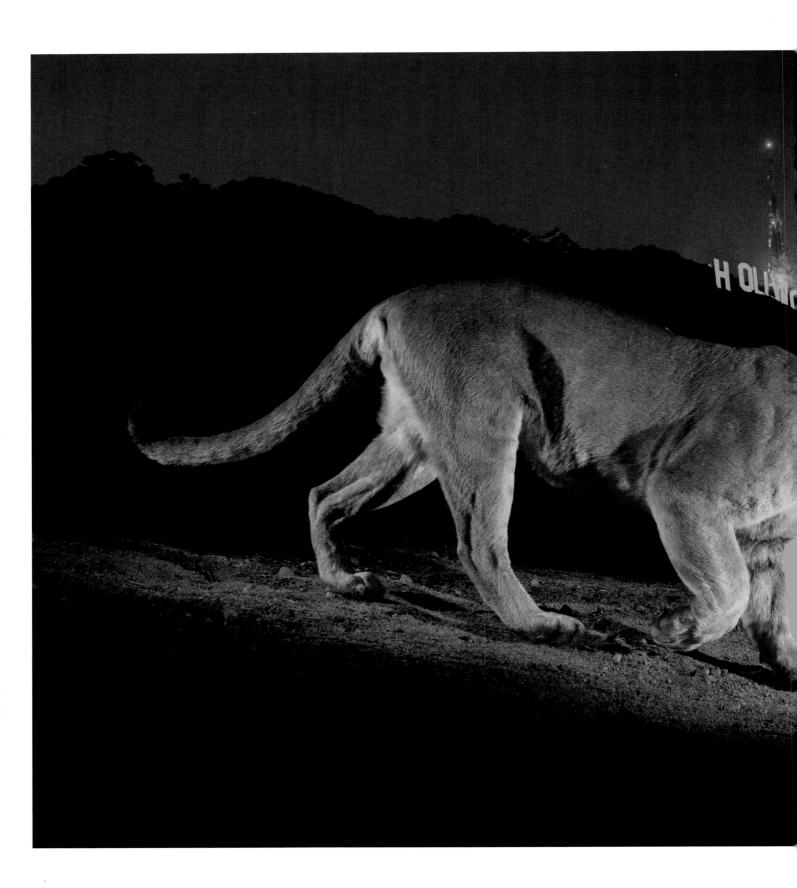

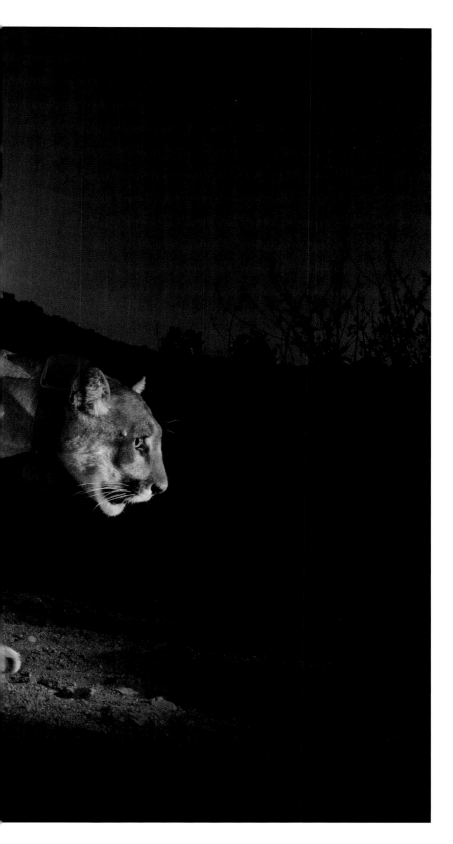

STEVE WINTER

Steve Winter is a contributing wildlife photographer for *National Geographic* and has photographed wildlife in some of the world's most remote locations. His primary focus is on the preservation of the world's big cats and their habitats by documenting the importance of the natural world and its intersection with people and cultures.

When I was a kid, my dad was an amateur photographer and he was part of a camera club, so I was always around photography. Then, when I was about seven years old, my father gave me my first camera; a point-and-shoot Instamatic. I remember looking at *National Geographic* magazines – you'd think when you're seven and eight that all this can't sink in – but I'd always been fascinated by people and cultures. I used to daydream about walking down those dusty village roads, I'd read historical fiction books, King Montezuma and the *Last Stand of the Aztecs* and *Ferdinand Magellan: An Explorer's Tale* and I'd look at *Nat Geo* and just go into the picture. Then I started looking at Life magazine: it was during the Civil Rights era here in the United States and I would see these images which, to me, were extremely powerful and it made me want to know what was going on. We were going through a lot at that time of the decade – JFK [US President John F. Kennedy] had been killed so there was a lot of turmoil – and I realized how powerful photography was.

By the time I was eight, I knew I wanted to be a *National Geographic* photographer. The funny thing is, is that not in a million years did I think I would photograph animals; it never entered my mind. That came later, when I fell into focusing on big cats. When I was eleven, my dad and I built a darkroom in the basement and throughout school I was the photographer for the school newspaper and the yearbook. I had my first show when I was fourteen at the Allen County Public Library in Fort Wayne in Indiana, USA.

Above: A remote camera captures a radio-collared cougar known as P-22 in Griffith Park, Los Angeles, California, USA.

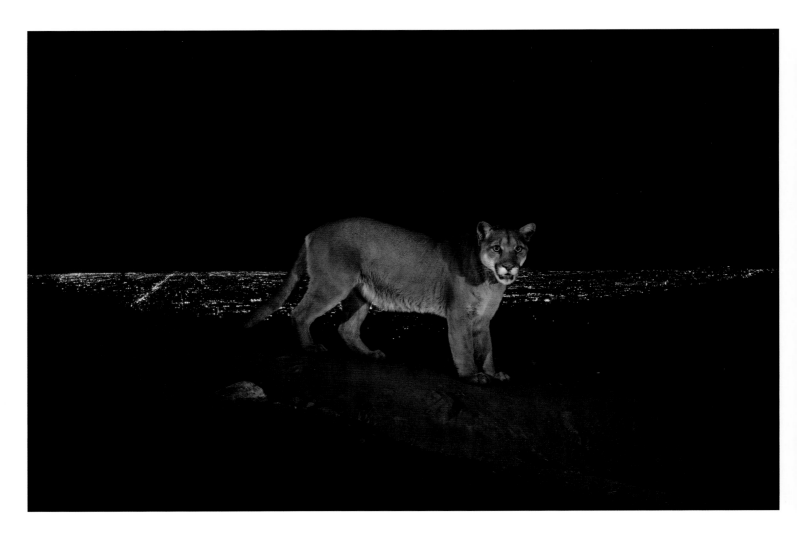

Above left: Cougar P-22 stops on the trail in Griffith Park, with the lights of Los Angeles in the background.

Above right: A graduate student darts a male cougar in the Black Hills mountain range in South Dakota, USA. The South Dakota Game, Fish and Parks (GFP) puts radio collars on many of the cougars they capture. During hunting season many of the cats are shot – a total of nineteen at around the time this photo was taken – and the hunters give the collars back to GFP who can then trace where they've been.

It was summertime and while my dad was at work, I would walk the streets of areas poorer than where I lived and I would take pictures. A lot of kids were playing in the streets and the alleys and I would get to know them because I'd be there every day. There was a photo of a kid with a tin can tied around his wrist and these dirty kids in an alley with an inner tube with an old car behind them. And it was a real epiphany about photography to me, because I was taking images that, when I looked at them, it was like, 'Wow!' Art is about emotion and it's like you're looking in those kids' eyes and you're connecting with the person in that image. And now with animals, it's the same thing; you need that connection. People always talk about not anthropomorphizing animals. But when you have a connection with the animal's eyes or the people's eyes, it's deeply affecting to us as humans. That is the connection and the emotion that we all hope to bring out through our photographs.

*

After college, I was stumbling around this whole idea of when you are creative, you have to rely on yourself, your creativity; you're not going into work and punching a clock nine to five. And it was scary, because I was told throughout my life that I was going to college to learn how to be someone. Well, I was already someone. I was a photographer! So I went around the world, bringing my camera with me. I didn't take so many pictures, but I saw cultures. I went to India, Sri Lanka, Istanbul. Then I found a place that would

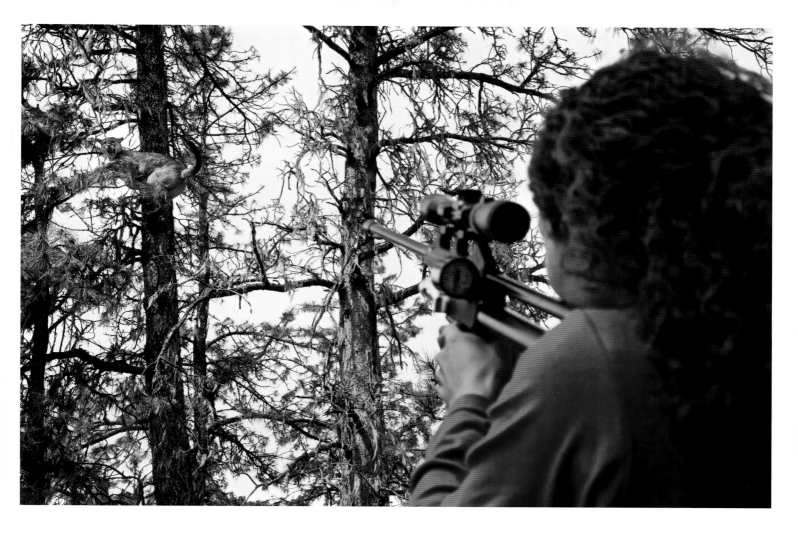

take my credits from college and I moved to San Francisco, went to art school and got back into photography, which was the best thing that I ever did. I was working at a photo store in San Francisco. At the time, *GEO* magazine was probably ten bucks on the news stand because it flew all the way from Hamburg, Germany, to San Francisco. So I'd go to the news seller and I'd look at them and I'd see [Michael] 'Nick' Nichols' images. Lo and behold, one day he walks through the door to get his film processed. Nick would come back from a trip and he'd have all these yellow boxes from Kodak. I ended up being the person that would open the store and I'd unlock the doors for business for the day and I'd look on the big light table at his images and then put them back perfectly so he wouldn't know.

Years later I got a call from Nick after visiting him and he asked if I wanted to be his assistant. And that was it! I worked for Nick for five years. We did some incredible stories together and it was a once-in-a-lifetime experience, a real cross-current of things, but it wasn't my dream. Nick's dream was also my dream: to be a *National Geographic* photographer. And he said, 'Well, you have to go to New York.' I was going to move to Santa Barbara or San Diego or something and Nick said, 'No man, you wanna work for *Nat Geo*, you got to go to New York.'

Two years later Nick calls me up and he says, 'You're going to get a call within a few minutes from the deputy director of photography who wants you to do a story for *National Geographic World*', which was a kids' magazine, as back

'If we can save the ecosystems and these animals' habitats, we can help save ourselves. That's my mantra: if we can save big cats, we can help save ourselves. We don't have a choice; we either save the planet or we perish.'

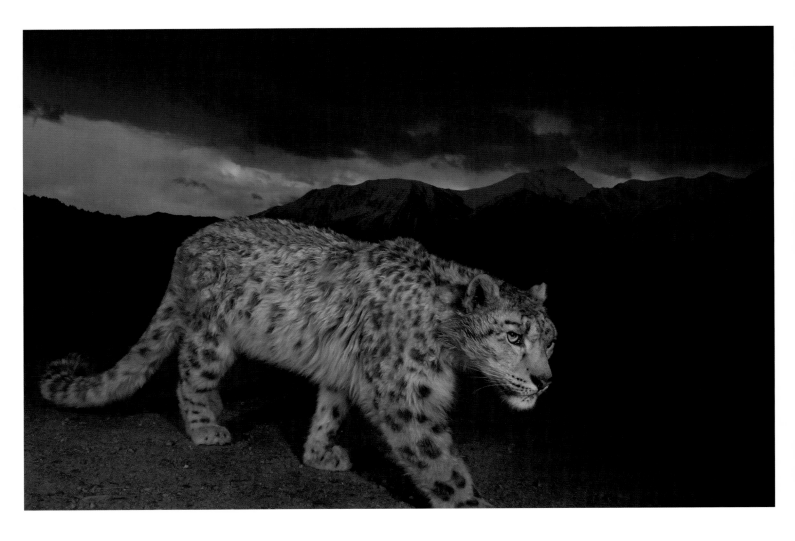

Above left: A snow leopard is photographed by a camera trap in Kharlung Ridge, Hemis National Park, India.

then all the photographers worked for any magazine that was *Nat Geo*. It was a life-changing experience for me to get the call and the story I did on a kids' adventure camp up in Vermont became the cover of the *National Geographic World*. Right after that, [photo agency] Black Star said, 'We have a corporate job and they want someone to go to the rainforests of Costa Rica and work with these scientists. You work for *National Geographic*, you wanna do it?' So we went down, my family and me. My wife got seven stories for *Science* magazine and I did a PR shoot for Merck & Co. [pharmaceuticals] who were trying to find new drugs in the rainforests working with the National Biodiversity Institute of Costa Rica.

After arriving at the world's largest jungle research station in La Selva Biological Station in north-eastern Costa Rica, the next morning we woke up at dawn and we put our rubber boots on that we'd got in the market in San Jose – made out of real rubber so fangs can't get through them – and went to look at the jungle. We walked in and all of a sudden darkness enveloped us. The sun was just coming up and the rainforest is really foggy in the morning; it's a hot and steamy jungle. That was the beginning of a six-week trip that changed our lives. We were working with passionate, dedicated scientists and learning about something that neither of us had any background on. None at all. Now I work with big cats, I know so much about working and living in the jungle in all these remote places around the world; back then, we knew nothing. I'd barely passed biology in high school.

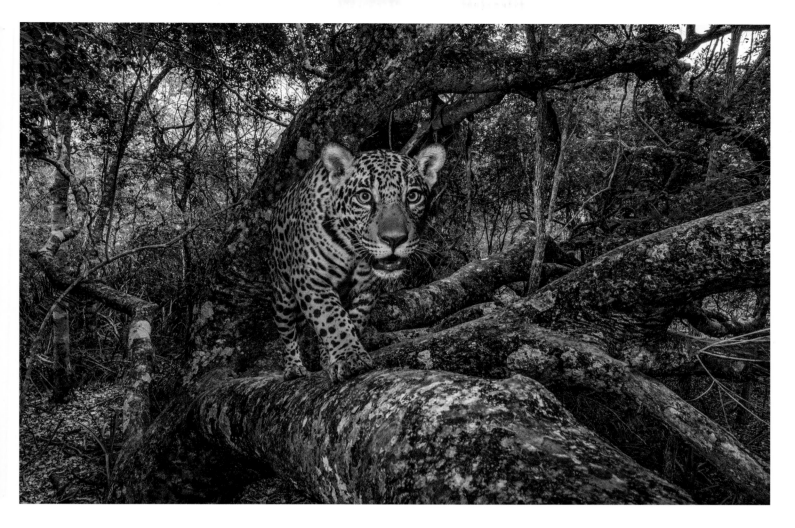

Above right: A ten-month-old jaguar cub
is captured by a camera trap as it returns
to the safety of a tree in Brazil's Pantanal
region, the world's largest tropical wetland
and one of the last bastions for jaguars.
Mothers coax cubs into climbing trees
early from a young age so they learn to
avoid predators.

Those six weeks changed my life and then I came back to *National Geographic World* and said, 'You know all your animal stories are about some old dude with white hair and a white beard; all these people, some of them are young scientists just coming out of college and many of them have brothers and sisters, or sons and daughters, that are the same age as the readers of this magazine. Why don't I start doing stories on animals and science stories and conservation, environmental stories and use kids of the same age?' And it was a real big hit and so I worked for *World* for a couple of years and then made it into doing single stories – single pictures again for the front of *National Geographic* magazine – and then I proposed my first story and they said yes. So I became a photojournalist that concentrated on the natural world.

*

How I got involved with big cats was on the first story that Tom Kennedy [then *National Geographic* Director of Photography] approved which was an idea that came from that first trip to Costa Rica. The first scientist we worked with gave me a story idea on the resplendent quetzal, the sacred bird of the Mayan and the Aztecs and it had a cultural angle too because local indigenous people have a relationship to many of the species with which they live. I thought we could reach more people that way too.

Some nights, when I would come back to the one-room shack in which I was staying, the hair on the back of my head and the hair on my arms would stand up. You get this tingling feeling. At first, I didn't know what it was, but it's a primordial thing and then one night I'm all alone in that one-room shack reading my book, when all of a sudden, the stairs are creaking, then the floorboards are creaking. I figure I am a dead man. The place [I was in] had just been bought by the nature conservancy and was accessed by a gate on a local farm down the mountain. The father and brother of Juan Carlos, the naturalist that was finding all these quetzal nests for me, lived on the farm and had both been shot at by loggers who hated the fact the area was now protected. And so, I thought that that stairs creaking was the guys that I would see walking through this forest smoking, with shotguns over their shoulders, while I'm sitting in my blind every day. Then I hear scratching and sniffing under the door. I grabbed my machete and whacked it on the side of the bed, figuring the noise would do something. Silence. And then for some unknown reason I whistled and I heard paws going down the stairs. The next morning, I looked at the bottom of the stairs: jaguar tracks. But right after I whacked the machete, I called on the walkie-talkie down to Juan Carlos, told him what happened and in Spanish, he said, 'Steve don't worry, it's just a black panther.' And I always say that is the night that the big cats chose me, because I didn't know anything about them before then.

My first cat story was on jaguars, which had never been done before for Nat Geo and I stumbled around for months, failing. Then a scientist from Brazil emailed me and said, 'I heard you're doing jaguars for National Geographic; I just found a spot you can see them. I just put a radio collar on a cat to see where it moves. Come down to Brazil, to the Pantanal', which is the world's largest wetland. And by the time I got down there, he had been given Brazil's biggest scholarship for biology and was off to Imperial College London. But he introduced me to where he was seeing these cats. The Pantanal is ninety-five per cent privately owned and it's a cattle ranch, so I was working with cowboys and ranchers. Every one of them carried two guns and their goal was to kill a jaguar. Culturally it was machismo;

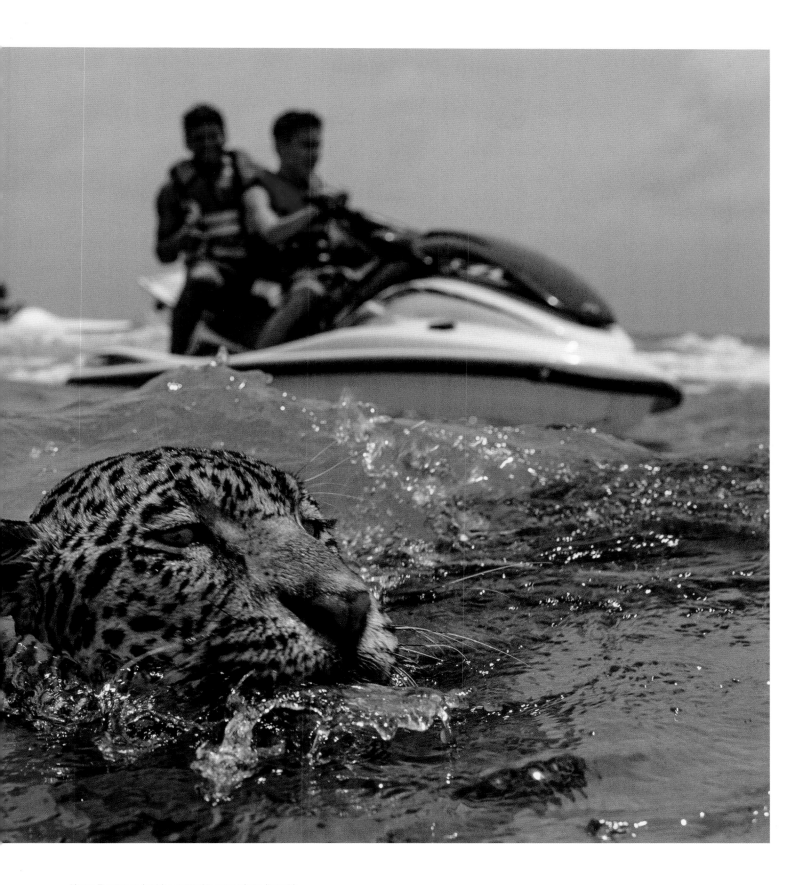

Above: Tourists and guides on jet skis get ready to dive with two tame jaguars in the blue waters of Cancun, Mexico.

it's what they did on a Sunday. They all said, 'Every one of our dead cows is the fault of a jaguar.' I thought that statement was wrong. I got scientists involved and their study found that only one per cent of cattle deaths could be attributed to jaguars. People said, 'Why did you even waste your time doing this? But why would I spend two years working on a cat just to watch it die?'

*

All this is about trying to get people to understand the importance of these landscapes in which these animals live. People love big cats – tigers are the most popular animal in the world when they do surveys. So how do we understand that we live on this breathing, living planet and we are destroying it because we think it's just a dumping ground? This disposable society, disposable products, using chemicals in our agriculture. Where does the oxygen come from? Where does the water come from? How come all these things are alive on our planet, including us? We don't think about it, there's no relationship, there's an invisible wall there. We don't think about the fact that our breath comes from the rainforests and the oceans. So it's been very important for me to try to do talks and do my work and try to find a way to get people knowledgeable about this blue-green ball we live on. Now we have a great spokesperson in Greta [Thunberg] because she just won't take anybody's ridiculous notions. But I think the bottom line is we need to face up to the fact that we're standing on something that's alive and we need to respect it; we wouldn't treat our own bodies this way because we would find ourselves becoming sick, diseased and dead. I always tell people right at the beginning of my talks: 'Think of an ecosystem like our bodies – if one of our organs doesn't function properly, neither do we and it's the same with an ecosystem.' You take out that top predator and you have an ecosystem like the east coast where we have Lyme disease [which is transmitted by ticks] and all these zoonotic diseases [that can be transmitted from animals to humans] that we didn't have when we had a predator here, such as the mountain lion, which is now coming back. I did the first mountain lion story for *Nat Geo* and you start to understand all these intricate connections in the world in which we live and that has become my goal.

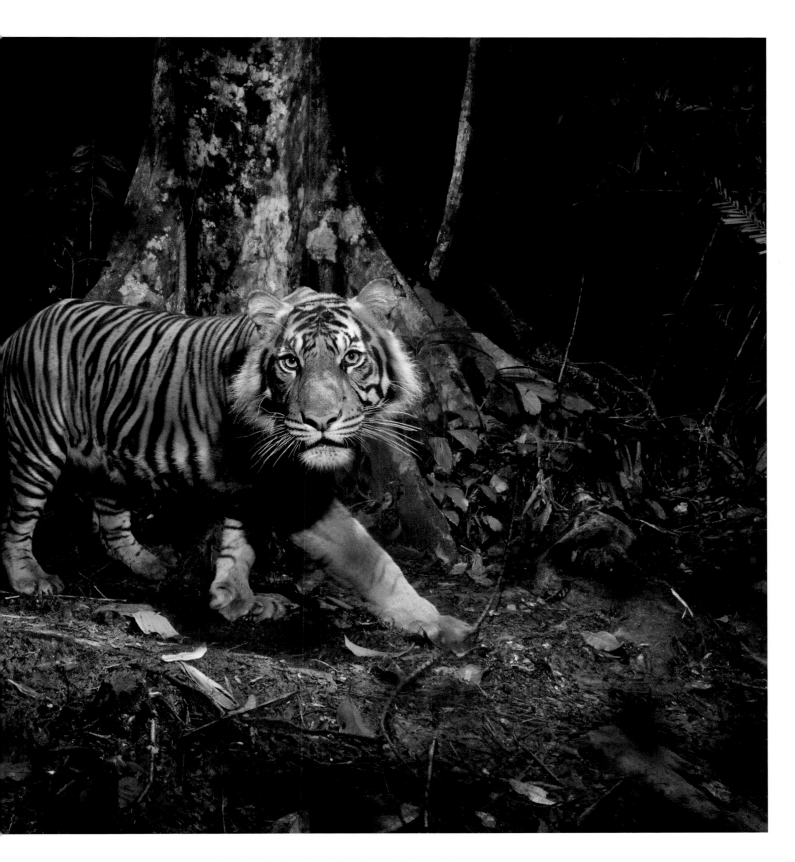

Above: A tiger peers at a camera trap it has triggered while hunting in the early morning in the forests of northern Sumatra, Indonesia. Photographing the critically endangered Sumatran tiger is difficult: only few remain and those that do mostly live in rugged mountain areas. The photographer was given information on where to set the camera trap by a former tiger hunter now employed as a park ranger.

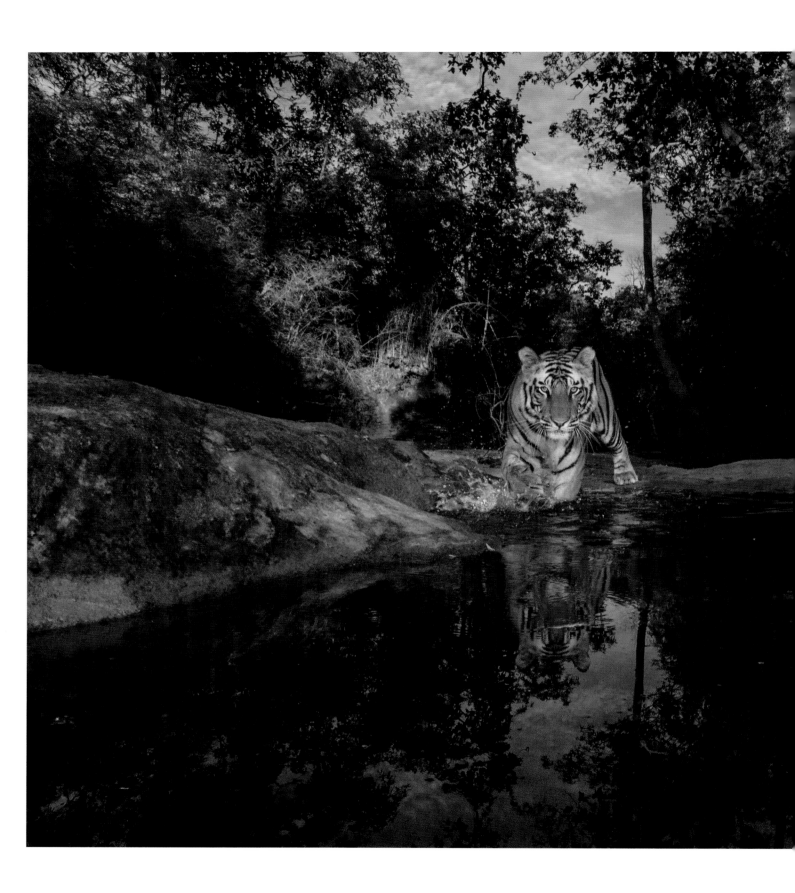

STEVE WINTER

'All this is about trying to get people to understand the importance of these landscapes in which these animals live. It's very important for me to try to find a way to get people knowledgeable about this blue-green ball we live on.'

As journalists, we're not allowed to do activist journalism, but we are allowed to do investigations that give governments, or the people in power, the knowledge that they need to act. So during my last tiger story, I'd been to this place called the Thai Tiger Temple. Everyone told me not to go, that it was a really bad place. So I went there for four days, I got an incredible picture and it runs in a *Nat Geo* tiger story. I talked to my wife about it when I came home and maybe eighteen months later she gets contacted by a woman in Australia because she'd seen my wife had been writing about similar things and she said, 'I have some undercover footage from the place, do you want to do some investigation on it?' *Nat Geo* said they wanted to do it, but they wanted video too, so I said I'd do that. And we went and filmed what was going on. So we did the video, *Nat Geo* put it up and every Bangkok media outlet took the videos and my photos straight off the Internet and Instagram and my wife wrote four more stories about it. And four and half months later, the government came in and confiscated all the tigers; they found tigers on meat hooks in the freezer and cubs in jars. And all of a sudden, you've made a difference.

Above: A fourteen-month-old subadult tigress walks into a waterhole in Bandhavgarh National Park in Madhya Pradesh, India.

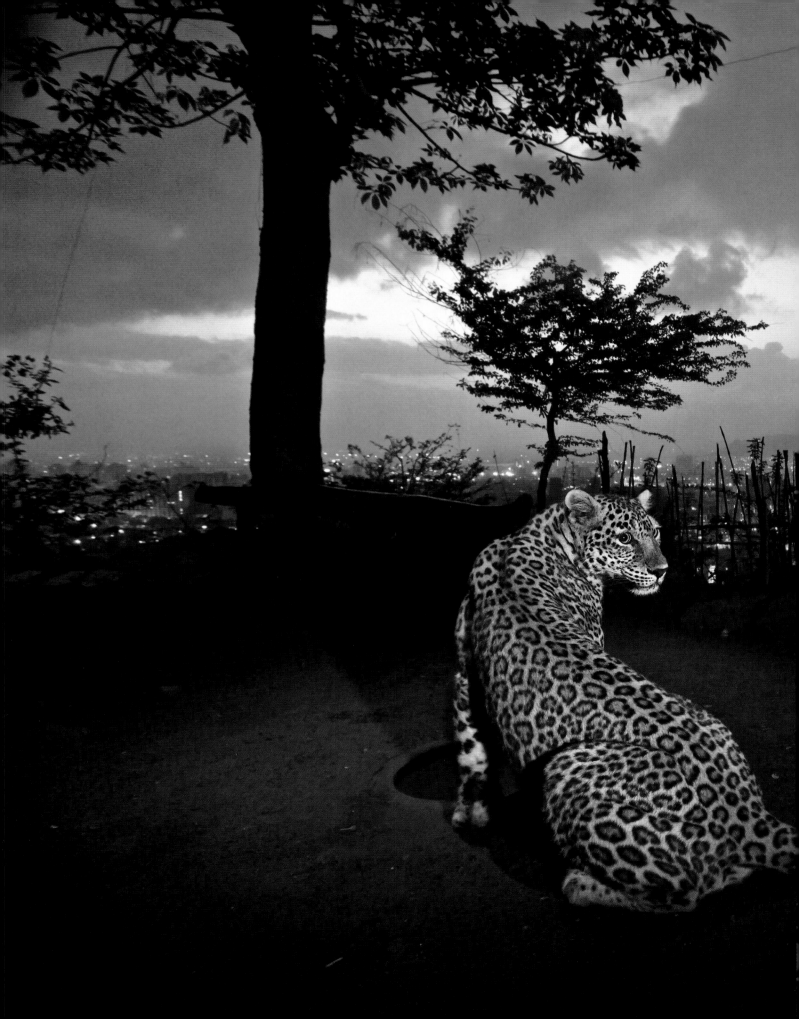

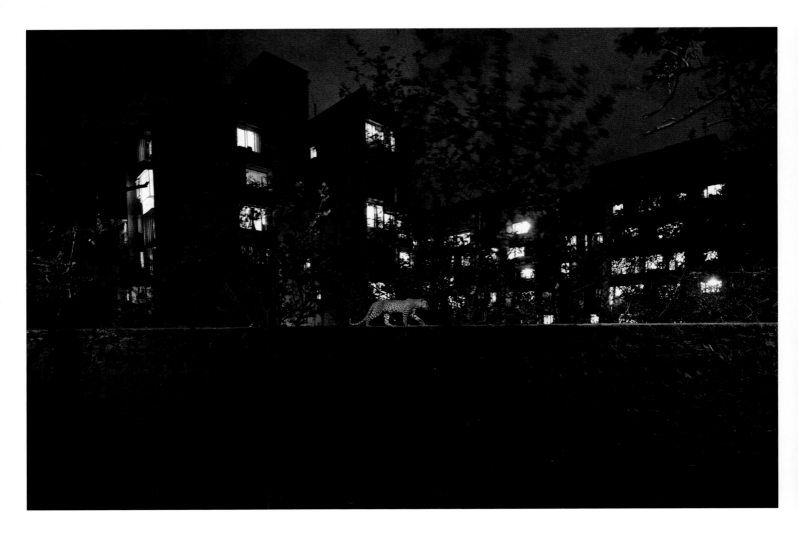

Previous page: A leopard in Sanjay Gandhi National Park in Mumbai, Maharashtra State, India. The park is one of a small number of national parks that exist entirely with a metropolitan limit. Here, a leopard is interrupted as it surveys Mumbai by night.

Above left and right: Leopards walk on the border trail of Sanjay Gandhi National Park in Mumbai, India, seemingly unperturbed by the apartment blocks in the background.

It's great to do stories where I can tell someone or show someone something they haven't seen before, whether it's the leopards of Mumbai city in India and a TV show that shows them walking right past people's apartment buildings, or Hollywood cougars [mountain lions]. Boom! That brought people into the cougar story. It took me fifteen months to get the photo of a cougar in Griffith Park in Los Angeles, right under the Hollywood sign (pp. 178–9) and I wanted to do it because just north of there, is a whole group of mountain lions that are being studied by the National Park Service.

*

These images bring people into your story, because the bottom line for me is to get people knowledgeable and emotionally connected to nature. I end all of my talks at *Nat Geo* with an animation of going around the world and telling people all of the places that big cats live. All those forested areas are vitally important – they create the oxygen we breathe – so the aim is to make people realize that if you love big cats, well, their homes are vitally important to us as humans. If we can save the ecosystems and these animals habitats, we can help save ourselves. So that's my mantra: if we can save big cats, we can help save ourselves. We don't have a choice; we either save the planet or we perish.

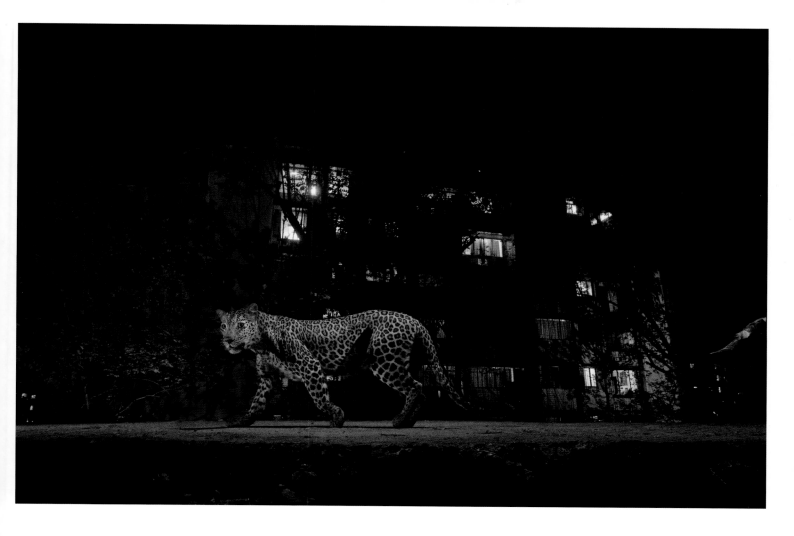

I think the younger generation is looking back on my generation as the great destroyers, in a way. We did things, not from specific design – it was just the way we were brought up. Then all of a sudden, we were concerned about litter and then clean water and then recycling and now global warming. We're on this train that's going really fast, and we have to stop and understand that the technology that we now have at our fingertips is important for us to use. China and India are home to some of the largest solar farms in the world, China is a leader in wind energy, and in the USA more renewable energy is actually produced than coal electricity – tens of thousands of people find work in the construction and operation of these power plants. That's free energy, and it should have been done decades ago. This is our future.

I'm going to start a campaign and tell everybody in the audience to hold their nose and put their hand over their mouth and stop breathing. Does this make you realize how important oxygen is and where it comes from? It comes from Mother Nature; we were given this and we've got to save it – the oceans and forests and grasslands. My goal is to do stories that have tangible results so that the next generation can step up and do their part to save this planet that gives us all life.

'The aim is to make people realize that if you love big cats, their homes are vitally important to us as humans.'

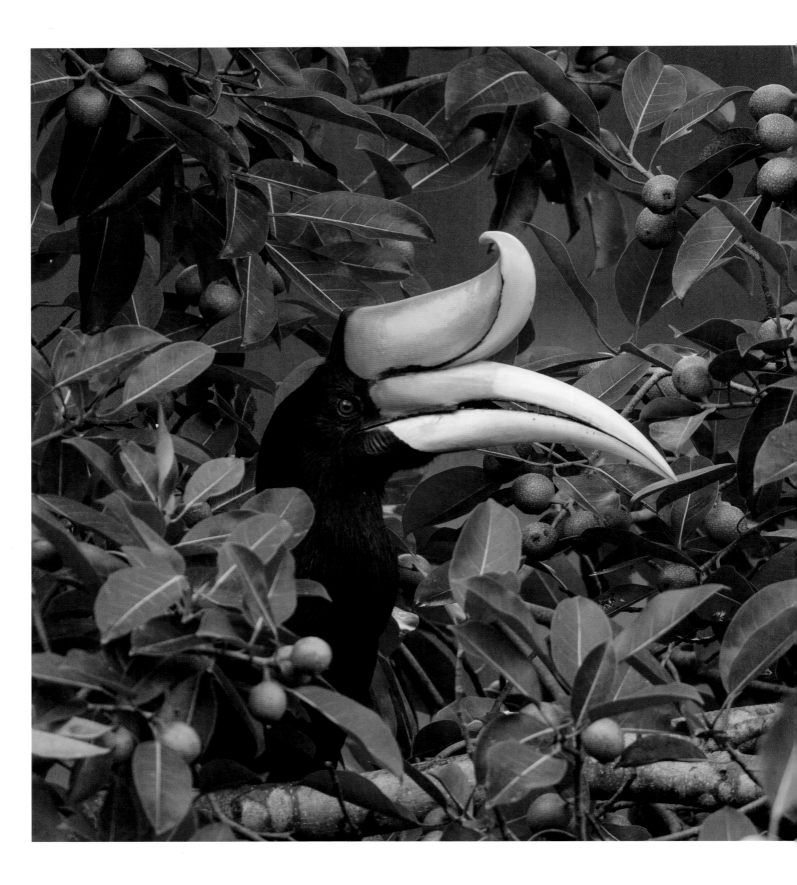

TIM LAMAN

TIM
LAMAN

Tim Laman is a contributing *National Geographic* photographer, field biologist, film-maker and a research associate in the ornithology department at Harvard University. He is best known for his work in the rainforest canopies, his work on orangutans and his long-term project to document all birds of paradise species.

I was born in Japan of American parents and spent most of my childhood there, until I went to college. My parents were Protestant missionaries and worked with various churches in southern Japan and then my dad became a professor at a seminary in Tokyo. I think the most formative thing about my experience in Japan for my interest in nature and wildlife and photography, was that even though Japan is a very populated country and we lived on the outskirts of a big city, the mountains were never far away. From my house I could walk up the hill and into the woods and then up to the top of a mountain overlooking the city, which I explored with my friends; we felt like explorers, bush-whacking up gullies that had no trails. My family also had a little vacation home up in the mountains near Nagano alongside a lake. We had rowboats and sailboats and there were mountains and woods all around and our rustic little cabin was full of crickets and bugs. I spent quite a bit of time out in nature.

Above: A male rhinoceros hornbill feeds on the fruit of a strangler fig at the Hala-Bala Wildlife Sanctuary, Narathiwat Province, Thailand.

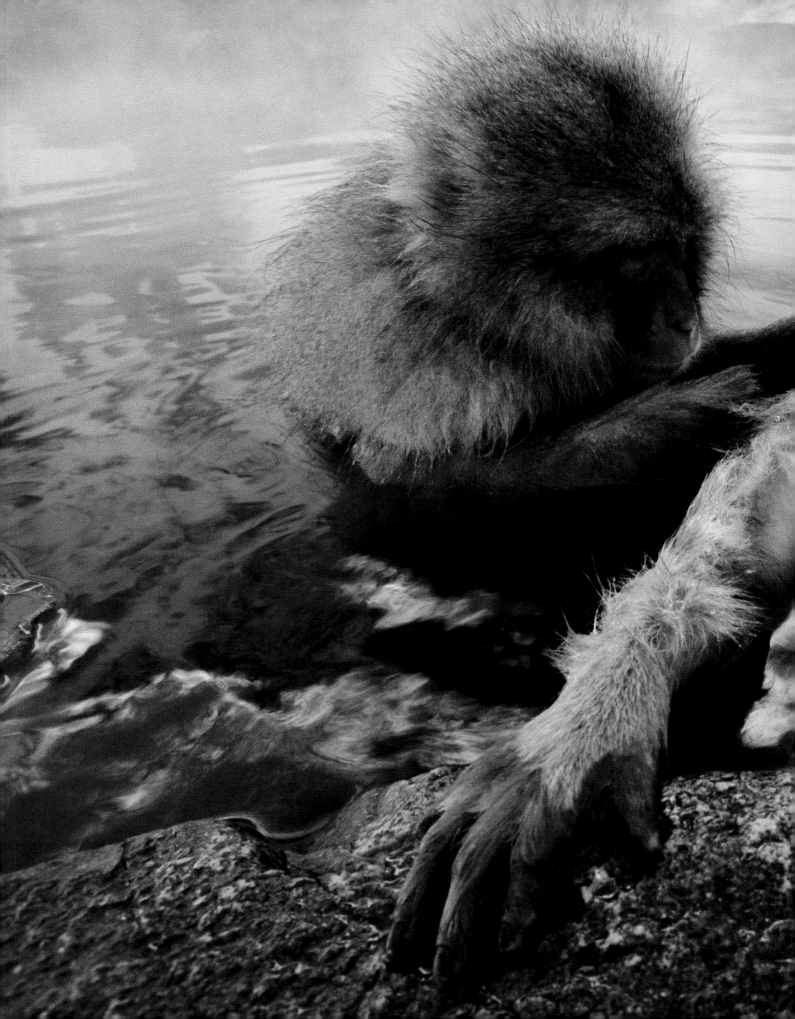

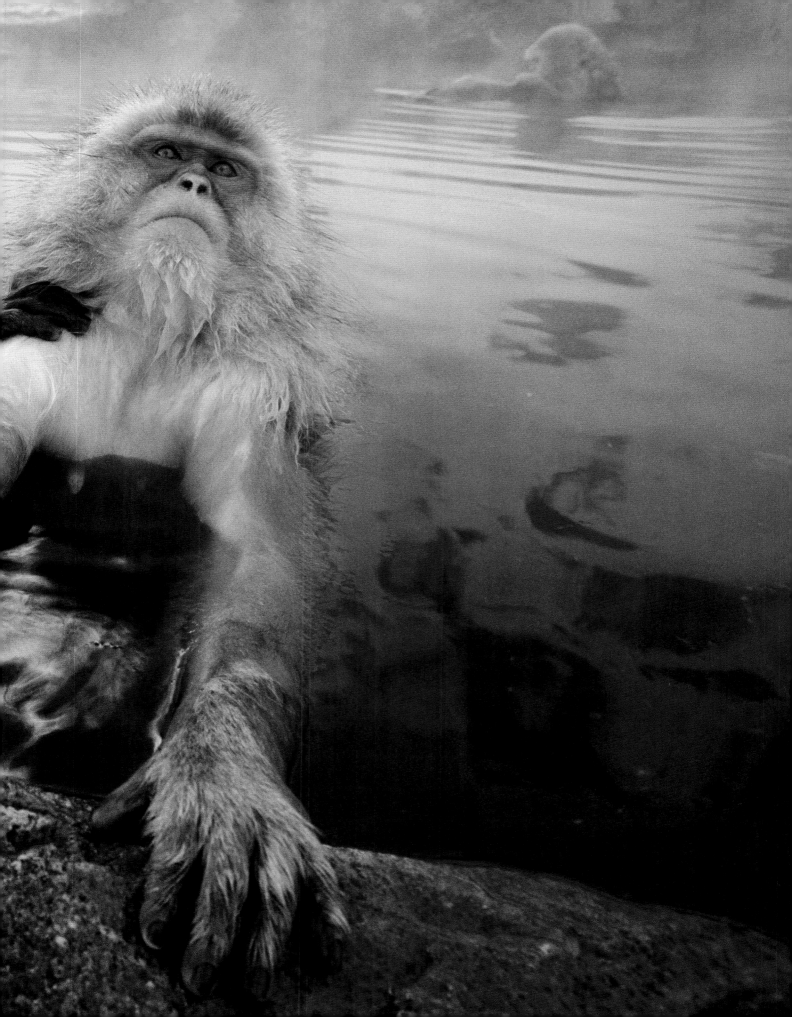

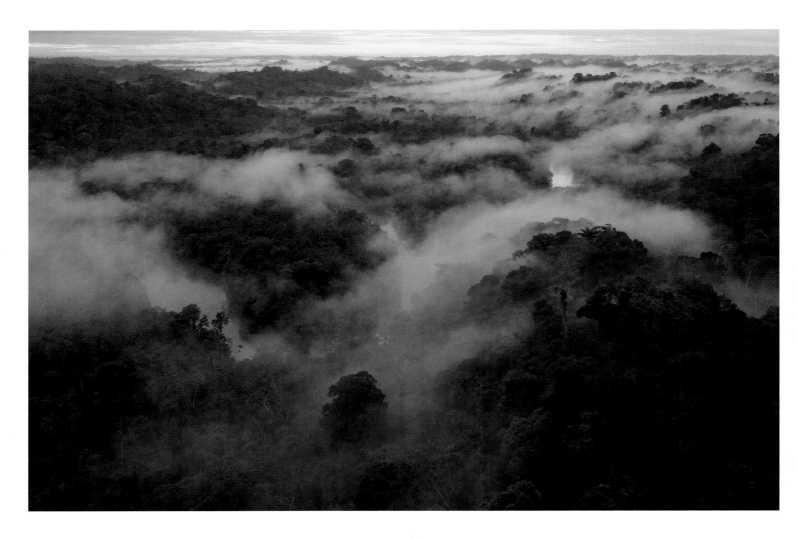

Previous page: A Japanese macaque (or snow monkey) soaks in a hot spring pool while a companion grooms her in Jigokudani Monkey Park, Nagano Prefecture, Japan.

Above left: An aerial view of morning mist above the Tiputini River in Yasuni National Park, Orellana Province, Ecuador.

In my teenage years I was really into hiking and backpacking and I was active in Boy Scouts. My friends and I did a lot of hiking and mountain-climbing trips around Japan and by the time I went to college, I definitely had the idea that I wanted to do something related to fieldwork and being outdoors in nature. I liked science and I was curious about the natural world, so I was drawn to biology, but I was also interested in photography. My dad was an amateur photographer and when I was in the eighth grade, he gave me one of his completely mechanical Kodak cameras. You had to guess the exposure and set the aperture and shutter speed, so it was a great learning tool. Then when I was in high school I saved up and bought an SLR [single-lens reflex] camera.

I became more and more serious about my photography and during college I had some summer jobs working as a field assistant on research projects; I did a little bird photography. By the time I was in grad school and studying rainforest ecology, working in the rainforest in Borneo and pursuing my PhD at Harvard University, Massachusetts, I was definitely getting really serious about photography. I got into a stock agency in Boston and started to sell a few pictures and by the time I was finishing up my PhD research I was pretty intent on trying to do something for *National Geographic*. The magazine had a huge influence on my ideas about photography; my parents were subscribers, I loved looking at the magazines and I think deep down I'd always had this idea that it would be pretty cool to be a *National Geographic* photographer. So when I was in grad school I applied for grants from the National Geographic Society

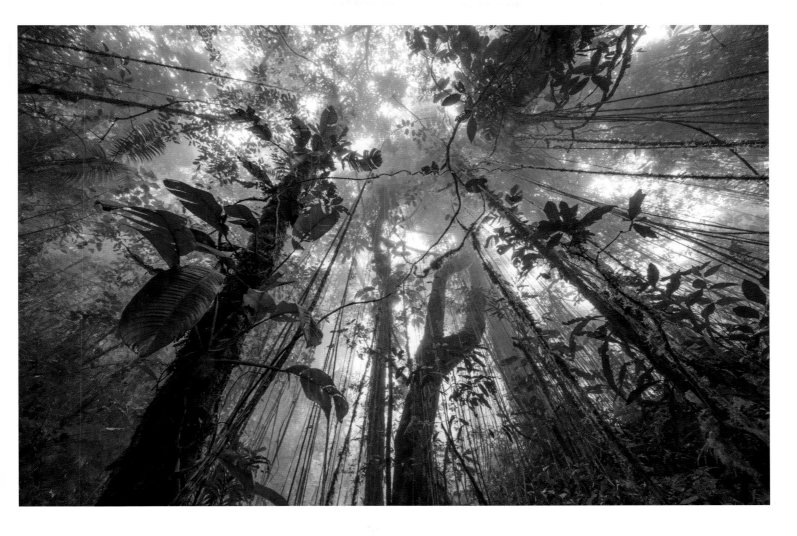

and succeeded in getting funding and that helped me go do my fieldwork in Borneo and gave me a connection with the Society. I approached them and got an introduction to one of the photo editors at the magazine. I went down to Washington and had an interview with Mary Smith [former senior editor] at *National Geographic* – she was the liaison between the research side – people like primatologist Jane Goodall – and the magazine. Before I met her, on the phone, she said, 'Well, you know, we have a few scientists who think they can take pictures and most of them can't, but I'll be happy to have a look at your work.' After I showed my portfolio to her, she said, 'You have some decent frames here, but there's no way you're going to get a story in the magazine because of your lack of experience. You should do a lot more work, but if you are going back to Borneo, I'll give you all the film you want.'

So the next time I went to Borneo, I spent a whole year there living in a remote research camp doing my research project and I had about two hundred rolls of film. At that time my wife, Cheryl [Knott] had started to do research there on orangutans and so we began working together. During that second full year in the rainforest, I spent a lot of time working on my photography. Any time there was a really good opportunity, such as a fruiting tree where animals were coming to feed, I'd climb trees or make blinds; really making an effort to take my photography to another level and focusing on getting a few 'killer' frames. And at the end of that year, I went back I went to see the editor of the *Geographic* again and I got my first story accepted.

Above right: A forest interior view on a misty day. This montane rainforest is located in the mountains of the Pegunungan Arfak Nature Reserve, West Papua province, Indonesia.

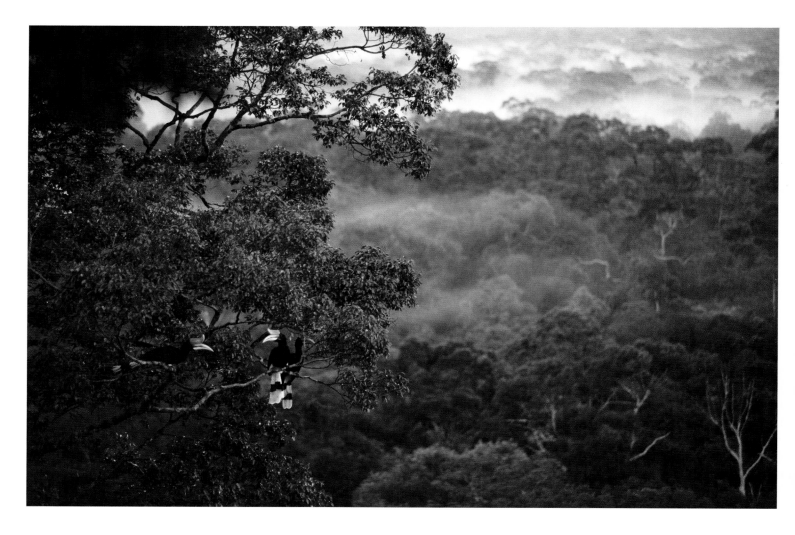

'Every population is unique
and deserves to be protected.'

I realized that year, how much effort you have to put in to get a really unique shot. I think that's what most people don't realize: you really don't need that many good pictures; you just need a few *really great* pictures. And so it's worth spending a week, two weeks, three weeks, climbing a tree every day before it gets light and waiting for the hornbills to fly in, to try to capture a unique moment. Many times, I've stayed up a tree up all day, but usually the peak activity is in the morning, four or five hours from when it gets light. Sometimes I actually put my blind right in the same tree that the birds and other animals are coming to because there were no good trees close enough to have a view into it. You also get a different view from inside the tree, looking out and an unusual perspective can really add to a photograph.

*

My first story for *National Geographic* was about my PhD research exploring the rainforest canopy in Borneo and the strangler fig trees and the surrounding wildlife. Coming from a background in rainforest biology, I continued to pitch stories that were all in that genre and they were all related to underlying interests in conservation. I'd had a bit of a post-doctoral career doing pure research and I was publishing scientific papers in academic journals about rainforest ecology, but I knew that only tens – or, if I was lucky, hundreds – of people, were ever going to read those articles. And meanwhile, as I spent more and more years going to Borneo, seeing more and more rainforests

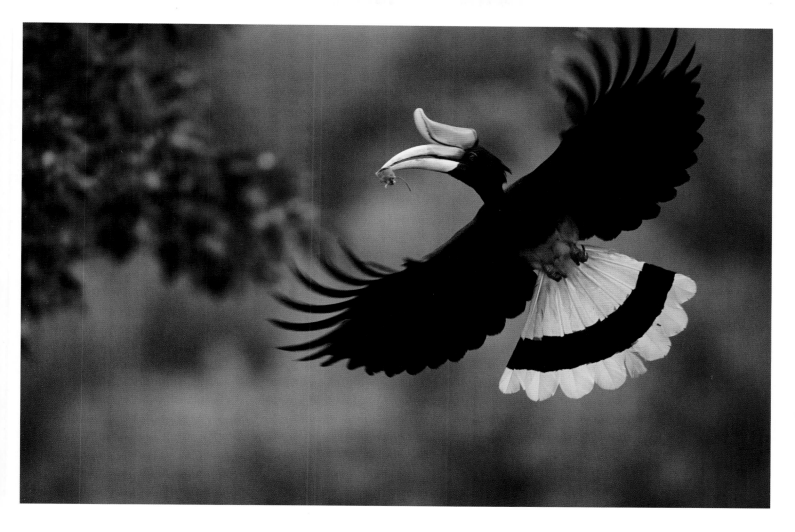

getting cut down, I realized I had this opportunity with photography to reach a bigger audience. Then I succeeded in turning my PhD project into a *National Geographic* article and I knew that millions of people saw that. So I continued pitching stories to the *Geographic* and started to get assignments, too. First, I told stories about the orangutans, the hornbills, the proboscis monkeys and the other rare endangered species from Southeast Asia and then I broadened out into other parts of the world and other subjects. But I've always had an underlying goal to tell the stories of these conservation issues and species and places, that need more attention and protection.

That mission has only grown stronger. A recent story on orangutans focused on the cultural uniqueness of different orangutan populations, in an attempt to tell the story that all orangutans aren't the same; every population is unique and deserves to be protected. I also photographed palm oil plantations that were destroying orangutan habitat and orangutan rehab centres where all these orphans are ending up because their mothers have been shot and they are being forced out of the wild. In recent years, I've worked on helmeted hornbills, not only photographing them in the wild, but also trying to find the shops in China where they are selling carvings made out of the ivory-like substance that their horn is made of. The demand for silly human trinkets and decorations is driving this bird extinct. It's incredibly maddening. It just boggles my mind how narrow-minded and short-sighted humans can be in terms of what they're purchasing and not thinking about

Above left: Rhinoceros hornbills perch high in the canopy in Gunung Palung National Park Reserve, Borneo, Indonesia, with lowland rainforest behind. Lowland rainforest is a critically endangered habitat in Borneo.

Above right: A rhinoceros hornbill male carries a mouse to its nest, Budo-Su-ngai Padi National Park, Narathiwat Province, Thailand.

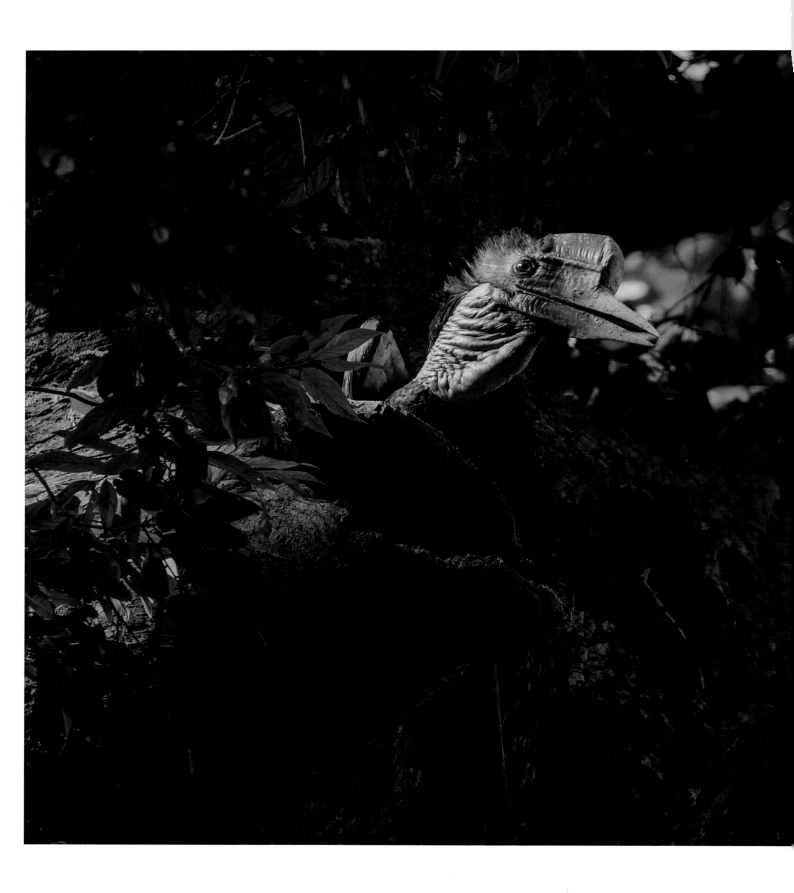

TIM LAMAN

the greater picture. I'm a little bit encouraged by the fact that conservationists I was talking to in China said that the younger generation gets it: they don't want to have shark-fin soup at their wedding anymore; they don't want to buy rhino horn.

*

I have a few personal passion projects that I've been working on for many years. One of them is on orangutans. I really didn't focus on them until I met my wife, who is a primatologist and started working on orangutans back in 1992. So I started documenting her work and realized how amazing spending time with a great ape in the field was and how similar they are to us in so many ways. I worked with Cheryl to do an article in *National Geographic* back in 1998 and we've done three now, as well as several films. It's become a lifelong project – I've been photographing orangutans seriously for more than twenty-five years now, to really tell the story of how they live in the wild and that you can't just take an animal like that and put it in a zoo, or a rehab centre, then release it back into the forest if it grew up without its mother. In the wild, they spend at least eight or ten years with their mother, learning about everything there is to eat in the forest, how to make a nest to sleep in and so on. All the knowledge that they acquire is passed on culturally from their mothers and other orangutans and they have unique behaviours, just like humans who grow up in different cultures. We all have our own knowledge and experiences and if you imagine raising a human completely in isolation from any other humans, it's not going to be a real functioning person. Orangutans learn by imitating their mothers and other orangutans, so if they're raised by people, they

'The demand for silly human trinkets and decorations is driving the hornbill extinct. It just boggles my mind how narrow-minded and short-sighted humans can be in terms of what they're purchasing and not thinking about the greater picture.'

Above: A male helmeted hornbill perches above a nest cavity getting ready to regurgitate fruit to pass to the female and chick inside, Budo–Su-ngai Padi National Park, Narathiwat Province, Thailand.

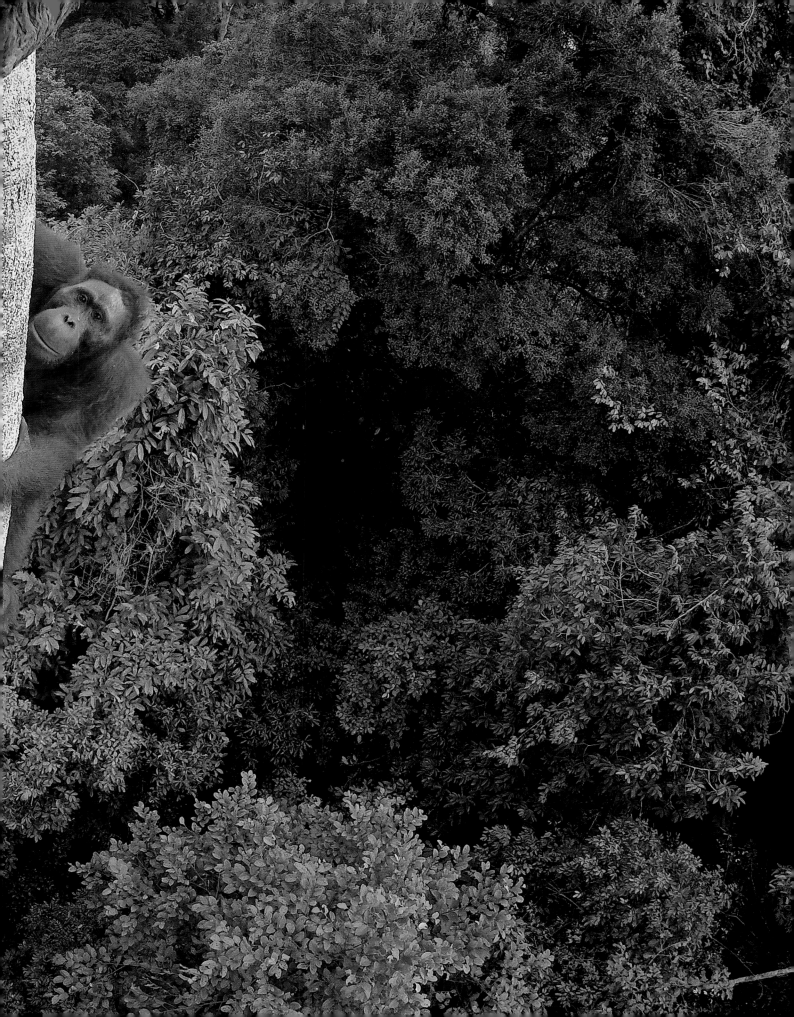

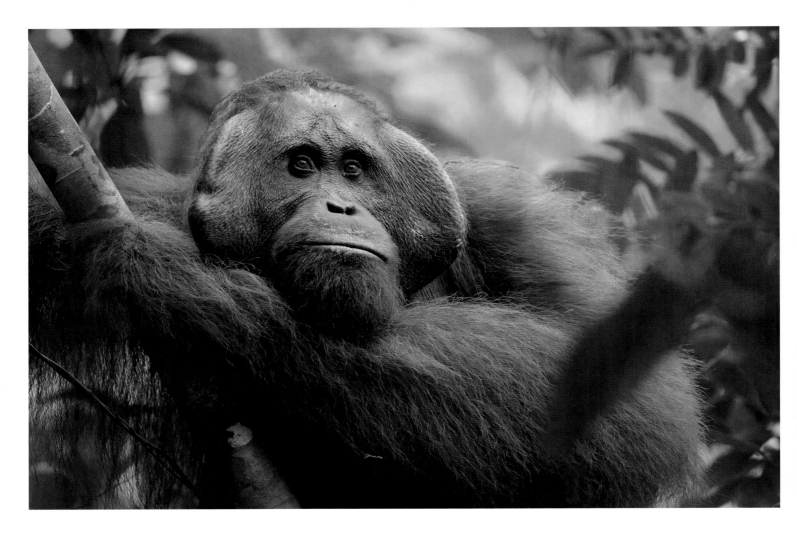

Previous page: An endangered young male Bornean orangutan climbs over one hundred feet [thirty metres] up a tree deep in the rainforest of Gunung Palung National Park Reserve, West Kalimantan, Borneo, Indonesia.

Above left: An adult male Bornean orangutan belonging to the *P. p. wurmbii* subspecies, Cabang Panti Research Station, Gunung Palung National Park Reserve, West Kalimantan, Borneo, Indonesia.

Above right: A young adult female Bornean orangutan takes a break from her foraging rounds through the forest. Orangutans are the most solitary of the great apes.

learn to imitate people and they learn all kinds of non-orangutan behaviours. So what I think is most important is protecting wild orangutan populations with their cultural knowledge intact.

Photographing orangutans is a challenge and I found the techniques like blinds used to photograph other animals won't work. Orangutans are incredibly smart and aware of everything around them and so even hiding in a very well-concealed blind with camouflaged netting, I never had an orangutan come near who didn't notice me. From one or two trees away, they would always start smacking and making sounds that indicate that they are suspicious about something. Orangutans have never climbed into the same tree as me. There was one particularly memorable moment from my time in Borneo. Orangutans there are mostly up in the trees; you really don't see them on the ground. I was crossing a big boulder-strewn river that you could hop rock-to-rock to get across and I paused in the middle to check out the view, looking up and down the stream. Only sixty-five to one hundred feet [twenty to thirty metres] away from me was a big male orangutan going the other way and he was so concentrated on his footing that he didn't even see me. It was just two apes passing each other at dawn.

I keep coming up with new stories to tell and new ways to tell them. I've been photographing a particular baby in Borneo who is the daughter of a female I photographed when she was born herself, in 1999. I've been photographing

her as she's growing up and now she has her own baby I wanted to tell her life story, so it's an ongoing project. And we know these individuals – they are completely wild orangutans, we never interact with them – but they are used to being followed by researchers on the ground periodically. When I show up with a camera, they just completely ignore me. All of the three different species of orangutans are critically endangered, so there's obviously an urgency to keep getting the message out about orangutans and the importance of protecting their remaining habitat.

*

Another one of my long-term personal projects is the birds of paradise. I started going to New Guinea and photographing birds of paradise around 2004 and initially I was trying to photograph a representative sampling for a *National Geographic* article. There are about forty species and thirty-nine that were recognized at the time I started. I made five month-long expeditions to different parts of New Guinea between 2004 and 2005 and produced enough good pictures for the article. I'd photographed about fifteen species, but then I realized that I had enough contacts, I knew where to go, that I could photograph them all. I partnered up with Ed Scholes from the Cornell Lab of Ornithology in New York who was doing his PhD on birds of paradise when I first met up with him. We came up with a plan to photograph all the birds of paradise, do a book, do a film and use them to inspire people to conserve the

'There's an urgency to keep getting the message out about orangutans and the importance of protecting their remaining habitat.'

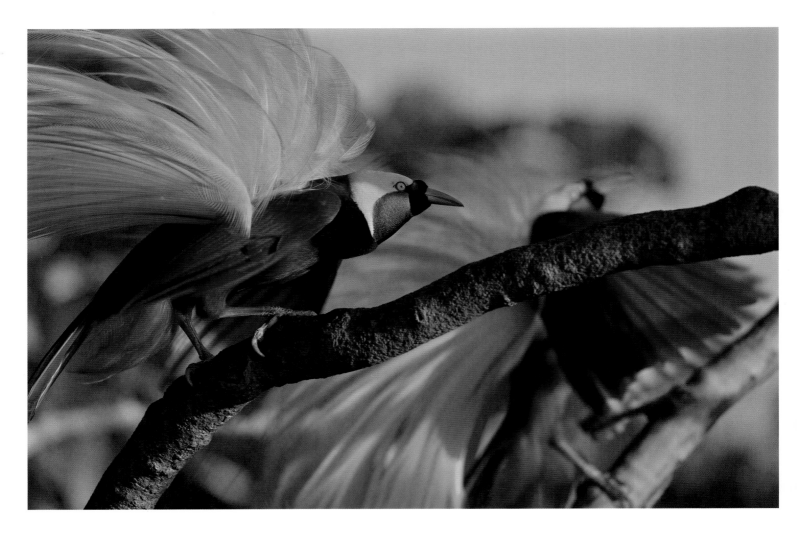

'It's hugely important for climate change that forest stays as forest – all that carbon that's in there – and the birds of paradise are flagship species that can focus people's attention on conserving New Guinea's forests.'

forests in New Guinea. We succeeded in photographing all thirty-nine species, after doing eighteen expeditions to New Guinea. Most of the time we were camping in the forest there; we'd organize old-fashioned expeditions with porters, two weeks' worth of food, cooks and assistants and we'd trek up into the mountains and set up a camp with big tarps and tents underneath them and a small generator to charge our batteries and go to work.

In terms of their conservation status, birds of paradise are in pretty good shape compared to orangutans. There are a handful of species that are on small islands, where they have very limited habitat and are considered endangered, but for the most part, the big island of New Guinea – which is the second largest island in the world after Greenland – still has over eighty per cent pristine forest. It's the third biggest rainforest in the world and it's not really on people's radar. It's hugely important for climate change that that forest stays as forest – all that carbon that's in there – and the birds of paradise are the kind of flagship species that can focus people's attention on conserving that area. Ed Scholes and I have a collaboration with the local government in the Indonesian half of New Guinea [Western New Guinea; the eastern half of the island is Papua New Guinea] to provide the visuals for their campaigns to promote tourism and a green economy – so that's an opportunity to use the strikingly beautiful birds of paradise to help protect the rainforest there.

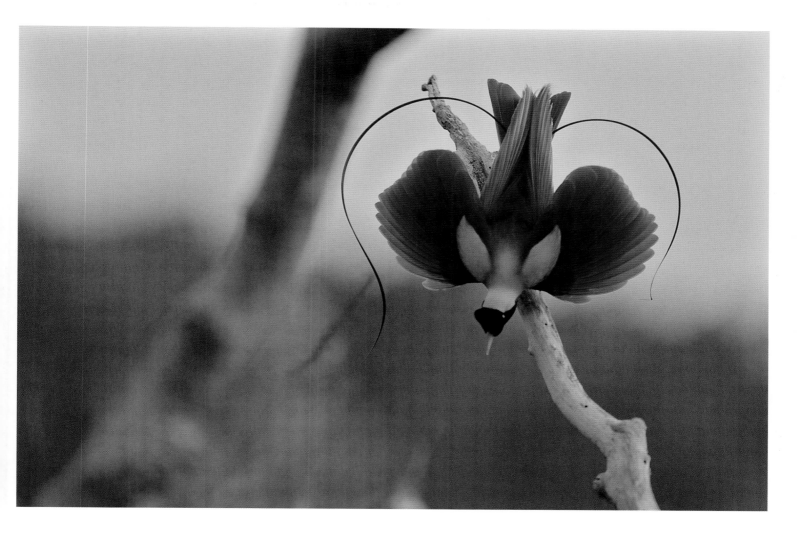

There's one time when I really remember that mode of incredible excitement [which is] when I got the image of the sunrise with the greater bird of paradise perched out on the canopy (pp. 210–1). I created that photograph in kind of a unique way – I wasn't looking through the camera, but using a remote camera. I had been climbing the tree next to where the bird displayed for about a week and photographing from a blind there. I had the idea to shoot a wide shot from the tree where the birds were displaying, but there was no space to make a blind up there so I'd climb up in the dark in the morning, mounted a camera, hid it with leaves and then ran a cable (this is back in 2010 and there weren't really good wireless trigger systems yet) to my blind in a neighbouring tree where I could see from. I'd haul up my laptop, connect everything up and hope it worked. And after doing this for many days, finally this one morning the birds were there and then all of sudden the sun popped up from behind a cloud and lit up the mist and lit up the birds and as I was shooting, the pictures were loading into the laptop screen and I just knew that it was an amazing image.

*

I appreciate what I do all the time. I think about all the people in their offices and sitting behind their computers – when I'm home I do that too. People often ask me, 'How can you sit in a blind for twelve hours up in a tree?

Above left: An adult male greater bird of paradise in the static pose-part of its display, Badigaki Forest, Wokam Island in the Aru Islands, Indonesia.

Above right: A red bird of paradise male practices his inverted courtship performance at a treetop display site on Batanta Island, West Papua.

Following page: A greater bird of paradise displays at sunrise in the Badigaki Forest, Wokam Island in the Aru Islands, Indonesia.

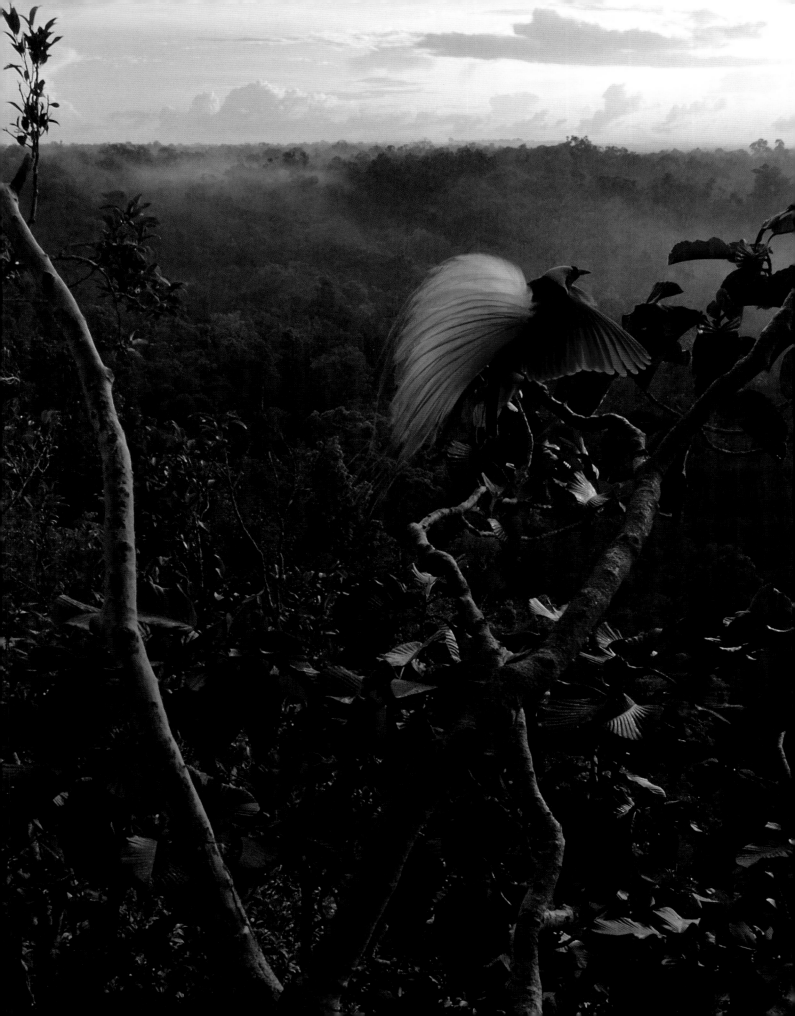

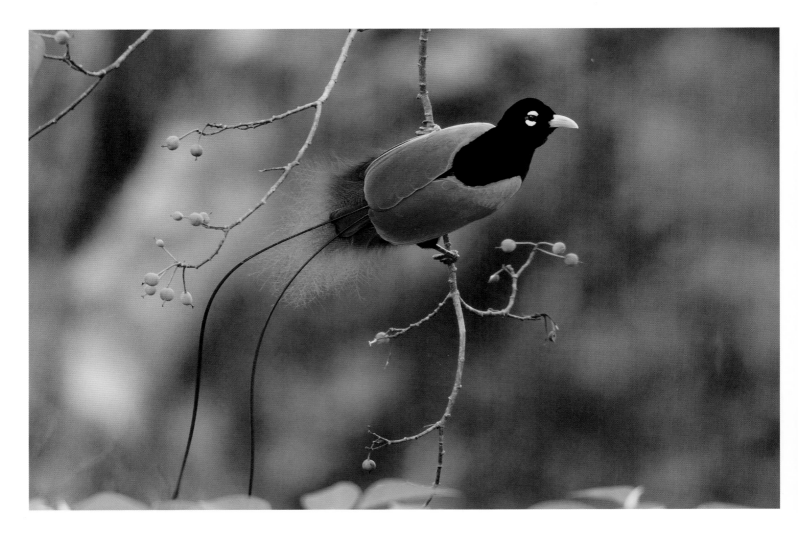

'It is pretty amazing, to be here doing this, being the eyes for people around the world who don't get to see these things first-hand. I'm very aware of this honour and this privilege, that I have.'

It sounds incredibly boring.' And I ask them if they've ever sat at a computer for twelve hours. Maybe I'm waiting for a particular bird to show up, but I'm also observing what's going on around me. So, sometimes other animals are showing up, or it's just a beautiful view. It's not always pleasant – sometimes you're hot and uncomfortable – but it has its good moments. It's a great time to think and I also can read books sometimes, depending on the species I'm waiting for – some of them are quite noisy when they're arriving so I don't need to be staring out the whole time. I used to have paperbacks with strings going through them, so if the animal came, I could just let go of it so I wouldn't miss the shot.

I've always been drawn to these experiences in these wild places. I think from my earliest memories of youth, I had this urge to explore and go to wild places that few people go to; to see animals that few people get to have close encounters with and then hopefully make a good photograph of them. Those are the moments that I really live for, that I really find the most fulfilling – the moments when you know you've captured a great image are very exciting and rewarding, the peak moments – but I've had plenty of times when I'm in an amazing place and maybe the pictures aren't coming together, the animals aren't showing up, but I'm up a tree overlooking this beautiful sunrise thinking, 'It's pretty amazing, to be here doing this, being the eyes for people around the world who don't get to see these things first-hand.' I'm very aware of this honour and this privilege, that I have.

Even if I couldn't make a living doing it, if I wasn't ever getting paid to do a story for *National Geographic* or produce a film, I'd just love to be doing it anyway. One of the really inspiring things about the New Guinea rainforests is that there are just so many discoveries still to be made, so many species that are still undescribed. The fact that you can still make these discoveries is really exciting to me. Biologically the world is so rich and so undiscovered still. There aren't enough lifetimes to do it all.

*

The trends in habitat and species loss around the world are not good. In the thirty years or so that I've been going to the tropical forests of Indonesia and other parts of Southeast Asia especially, I've seen a huge amount of forest turn into agriculture. I'm very concerned about that and about whether we can protect enough of what's left. The good news is that what we do have left is still rich and the situation is not hopeless. For example, one of the countries that I've been to that has the worst kind of environmental degradation, is the Philippines, where there's less than five per cent of the original forest cover. But in that five per cent, there's an incredible richness of species and there are still blocks of forest that are big enough to sustain wildlife, so we shouldn't write off the Philippines because it's a conservation disaster; we should focus on that five per cent that's left and protect it and try to create good buffer zones. I want people to realize that it's not too late, even in the places that seem the worst off,

Above left: A male blue bird of paradise in a fruiting tree, Tari Valley in the Southern Highlands province, Papua New Guinea.

Above right: A male king bird of paradise sports green central tail feathers, a red body and blue feet in the Oransbari forest, West Papua, Indonesia.

'It seems pretty greedy for just one species to take up half the earth, so it doesn't seem too unrealistic that we should protect half of the earth for everything else.'

there are still pockets of nature that are worth protecting and we need to try to protect those. And then there're the areas like New Guinea where there's still eighty per cent of forest, where we have an opportunity to really be ahead of the curve and not let the huge multinationals come in and turn it all into agriculture. So I think it's twofold: protecting those big blocks of wilderness, but also not giving up on the smaller places; both are really important.

One of my PhD advisors was E.O. Wilson, a famous biologist at Harvard. He is an incredible visionary and he wrote a book recently [2016] called *Half-Earth: Our Planet's Fight for Life*, where he's saying that we need to set aside fifty per cent of the planet for all the other species. It seems pretty greedy for just one species to take up half the earth, so it doesn't seem too unrealistic that we should protect half of the earth for everything else. But right now, we're protecting less that twenty per cent with all the national parks and protected land around the world, so I think that's an ambitious but noble goal – to increase the amount of protected areas in the oceans and on land, so that half of the earth is there for other species. And it will, of course, benefit us as well, because there are so many benefits from whole, intact ecosystems.

You see [today's] youth activists concerned about climate change. It's happening. If you look at the past fifty years, many new conservation areas have been added all around the world, [but] it's just not happening quite fast enough. We need to ramp it up to really protect enough of the earth. That's going to be a real challenge, but the signs are there and I think the youth in the United States are getting much more involved in environmental issues. Even in Indonesia, where I worked for many years, when I post pictures of nature in Indonesia or pictures of disasters like fires there, I get so many comments from young Indonesians. They are proud of their natural history. I post a picture of a bird of paradise and the comments are, 'Hey, that's from our country, that's one of our symbols of Indonesia.' So I see that interest and that potential there.

I'd like to see a government in the US that was very pro-conservation and pro-environment and not just in the US, but all around the world. We need bold leaders who are concerned about the environment and thinking about future generations and not just about maximizing growth. It's mind-boggling to me that the US is no longer part of the Paris Agreement [an agreement within the United Nations Framework Convention on Climate Change, dealing with greenhouse-gas-emissions mitigation, adaptation and finance, signed in Paris in 2016]. It's extraordinary. In the US it's partly cultural; there's a certain culture of 'belonging to a certain group', that has certain viewpoints, that is hard to change; for some, it's like changing somebody's religion to get them to 'believe in' climate change, when in reality we should all be accepting the overwhelming scientific evidence that's out there.

*

One of my philosophical attitudes is that I want to be doing this photography work, this kind of storytelling work, for conservation, but also there's a part of me that just wants to do it for my own personal satisfaction and enjoyment of being in the natural world. There's a famous quote from Edward Abbey, an American environmental writer, about being 'a half-hearted fanatic'. 'It is not enough to fight for the land; it is even more important to enjoy it. While you can. While it's still here.' He says something along the lines of that you can be a fanatic about saving the world and saving the environment, but don't forget to enjoy yourself in the outdoors. Go on some adventures and enjoy nature and live your life. You can't just be a depressed fanatic worrying about the environment all the time. So I take that to heart and I spend time just enjoying nature: going on hikes; going skiing; going on wildlife-viewing trips with my kids when I'm not on assignments.

There are plenty of places in the world I still want to see and one place that I've been to and would love to see more of is the Raja Ampat Islands in the north-western part of Western New Guinea. I've been there a lot to photograph birds of paradise, but it also has the world's most diverse coral reefs and I love diving; I do underwater photography as well and I've done a little bit of work there. Amazingly, when there's so much devastation happening in coral reefs around the world, the reefs in the Raja Ampat area are still in really good shape; they seem to be particularly resilient to coral bleaching events and there's really rich fish abundance. I'd like to be able to do some storytelling to help ensure the area survives the stresses on coral reefs around the world. Hopefully it can be a refuge to help to reseed other reefs.

My hope is that my photographic work, my visual storytelling, can make at least some small contribution to conservation. I was really encouraged recently when an article was published about an incident in the Aru Islands in Indonesia, which is where I made that picture of the bird of paradise at sunrise. After I made that image, around 2013, there was a very corrupt politician who managed to give out a license, sort of illegally, to a huge sugar cane company to clear two-thirds of that island and turn it into a giant sugar cane plantation. And the local people decided to protest. They had a big social media and visual campaign and they used my images – including that one – as the centrepiece of their campaign. Just recently, I read an article about how that all came out and that they had succeeded in blocking the company from logging, from turning this forest into a sugar cane plantation and there was a comment in the article about how my image had been an important rallying point of the campaign. It's really satisfying to know that all this work I put into getting these unique images, can have an impact and I just hope, that through the rest of my career, I can create more images that will contribute to conserving the world's biodiversity.

'I'm very concerned about whether we can protect enough of what's left. The good news is that what we do have left is still rich and the situation is not hopeless.'

Following page: A split-level view of rainforest overhanging corals in the passage between Waigeo and Gam Islands in Raja Ampat Islands, West Papua, Indonesia. Archerfish swim over colourful soft corals.

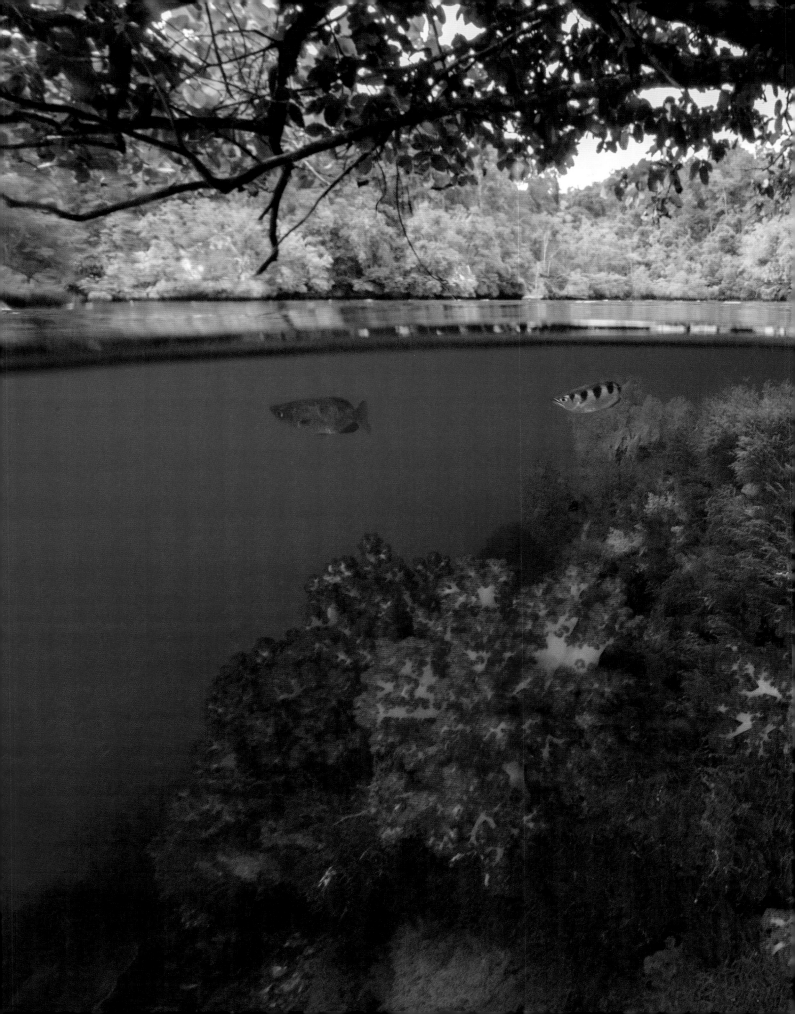

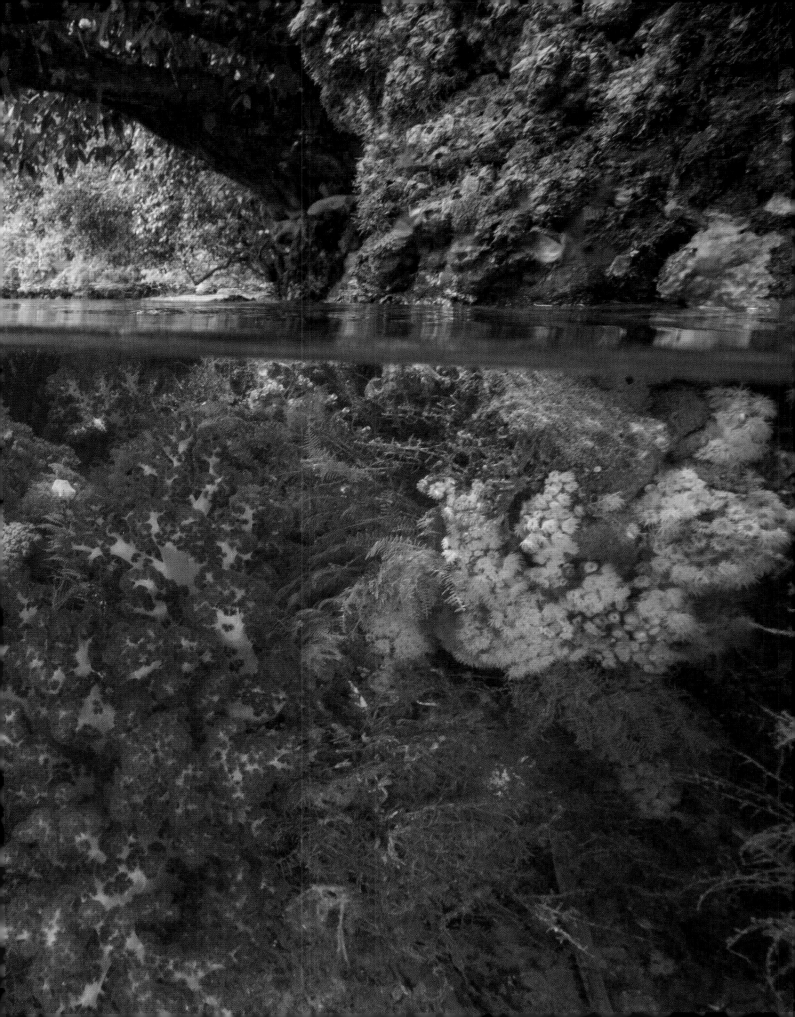

Above: Ounianga Sérir, a group of lakes in the Sahara Desert in northern Chad, is in the process of being cut into pieces by fingers of sand that blow through breaks in the surrounding cliffs. The heat and strong winds cause a high rate of evaporation that has caused the potable groundwater to become saltier than seawater and devoid of fish.

GEORGE STEINMETZ

GEORGE STEINMETZ

George Steinmetz is an exploration and science photographer who specializes in aerial photography. He is a frequent contributor to *National Geographic* and the *New York Times*. His latest work focuses on new developments in food science and technology and the issues associated with large-scale industrial food production.

While I was on assignment for *National Geographic* magazine a few years ago, I got arrested for flying my paraglider over a cattle feedlot in Kansas, USA.

The arrest came as a bit of a shock to me. After taking photos around the world for the past forty years, I had run into my fair share of roadblocks: I was detained in Iran three times for spying while flying over the desert and in Yemen I was put under house arrest after taking photos of an archaeological site. But I found it really strange to be booked and put in jail in my own country for photographing agriculture. I was just flying over a rural area looking at patterns of cows and fences. What were they trying to hide? Then it dawned on me that there are parts of our food supply that the people who make it don't want us to see. As a reporter you learn that when there is something that people really don't want to talk about, you are getting close to a good story.

As a photojournalist, I have always been drawn to stories that are under-reported and difficult to tell. If someone tells me that I can't do something, it only makes it more attractive. With pictures I try to show people things that they have never seen before. My goal has never been to tell others what to think or do, but to help people understand our world a little better through the photos I take.

Above left: Terraced crops climb the slopes of every mountain in northern Rwanda which is mainland Africa's most densely populated nation. Nearly every speck of arable land is taken, so people are encroaching into protected forests. Land scarcity was a contributing factor to the 1994 Rwandan genocide.

Above right: Wheat crops on the Loess Plateau in central China. The fine, silty soil was deposited here by desert winds over thousands of years and the silt has been carved into terraces for agriculture. The wheat is mostly harvested by hand using a gasoline-powered disk saw mounted on a stick and the wheat stalks are then tied in bundles to dry before being threshed at home for family consumption. Farming on terraces like this is labour intensive and farmers are finding crops harder to maintain as their children migrate to the cities for higher paying jobs.

I became interested in taking pictures somewhat by accident. I was finishing my third year at Stanford University, California, USA with a Geophysics major, but had no idea what I wanted to do for a living. So I decided to take a year off and go on a long hitch-hiking trip across Africa. I thought I would find wildlife and exotic tribes like I had seen in the pages of *National Geographic*, so I bought a camera from my brother and a lot of film. I soon found that taking pictures pushed me to meet strangers and put myself into unusual situations, whether it was the top of a water tower, or the inside of a hut with a medicine man. I liked the process. I also liked the pictures that I got; they told stories rather than being just pleasing to the eye.

Most of my rides in Africa were on the tops of trucks rolling down dirt roads. I sat on sacks of cargo, sharing kola nuts and learning French and Swahili from local traders and market women. Sitting up on top, I had this fantasy about what it would be like if I could fly over the African plains like a bird. I thought that if I could see it from above, I could decode the landscape. I could start to understand the geographic relationships and tell the story of a place. A lot of people don't really think of landscapes as telling a story, but after studying geology and becoming interested in ecological relationships, I wanted to understand the forces that shape the land and make it the way it is. I wanted to take pictures that explained that.

After returning to California, USA and refining my craft, I started getting work for magazines, eventually even top publications like *National Geographic* and the *New York Times* magazine. But that experience as a hitch-hiker stayed with me, especially the fantasy of flying over the vast tapestry of Africa, so I talked *National Geographic* into doing a big story on the Central Sahara. There were no planes or helicopters to hire in Niger or Chad, so I had to find another way and I learned how to fly a motorized paraglider, the lightest and slowest aircraft in the world. The motors are not so reliable, but in the desert I could make a running take-off or landing almost anywhere. In flight with a motor on my back, it was like a flying lawn chair, with unrestricted views one hundred and eighty degrees in horizontal and vertical dimensions. It was most interesting flying low and slow, from one hundred to five hundred feet [thirty to one hundred and fifty metres] above ground. That's a height where you can see the world in three dimensions, but with a view of the dunes going all the way to the horizon. Nobody had been able to photograph such remote places that way before and I fell in love with these strangely surreal landscapes. After two trips in the Sahara, I decided to try the Atacama in Chile and Peru and then the Gobi in China and another and another. It took me fifteen years, but I eventually flew over every extreme desert in the world, in twenty-seven countries, plus Antarctica.

'Over the years, my work has turned me into an accidental environmentalist. I never set out to be an advocate for our planet, but I think that if people know more about an issue, they can make choices that will lead to solutions. Our individual choices add up.'

GEORGE STEINMETZ

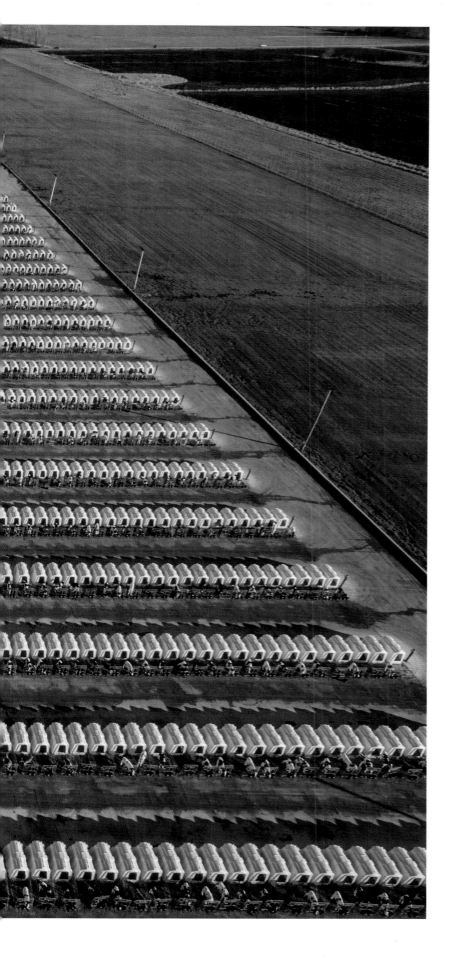

'I realized there are big parts of the food chain that consumers don't really understand. I think if people understood more about what they were eating and how it's made, they would make different choices.'

As I was finishing up my desert project, an editor at *National Geographic* asked me if I would be interested in using my paraglider to photograph farming for a series on meeting the future food demands of humanity. I realized that it could be most interesting to look at mega-farming, not the red barn with a cow under a tree. I knew from my time in Africa that from the air you need big herds to get interesting pictures of wildlife and for farming I would need to focus on mega-farms, with row upon row of repeating patterns. My editor liked the idea and sent me to Kansas.

The experience of getting arrested for flying over the feedlot made me want to look closely at other parts of our food supply and like the deserts, one kind of food has led to another. Most people want to see beautiful photos of the food they eat. If you look at food magazines, they like to show the latest restaurants with beautiful food and the cool chef with the tattoos. They don't want to deal with the reality of where that food comes from.

But as I started documenting food production, I realized there are big parts of the food chain that consumers don't really understand. I think if people understood more about what they were eating and how it's made, they would make different choices. I don't want to tell people what to do, but I hope my work can help them make more informed and responsible decisions.

Previous page: An aerial view of Brookover Ranch Feedyard which is situated just across the Arkansas River from Garden City, Kansas, USA. The adjacent centre-pivot crop circles provide feed to fatten the cattle.

Left: Approximately 3,300 hutches provide shelter for newborn calves at a large dairy operation in Wisconsin, USA.

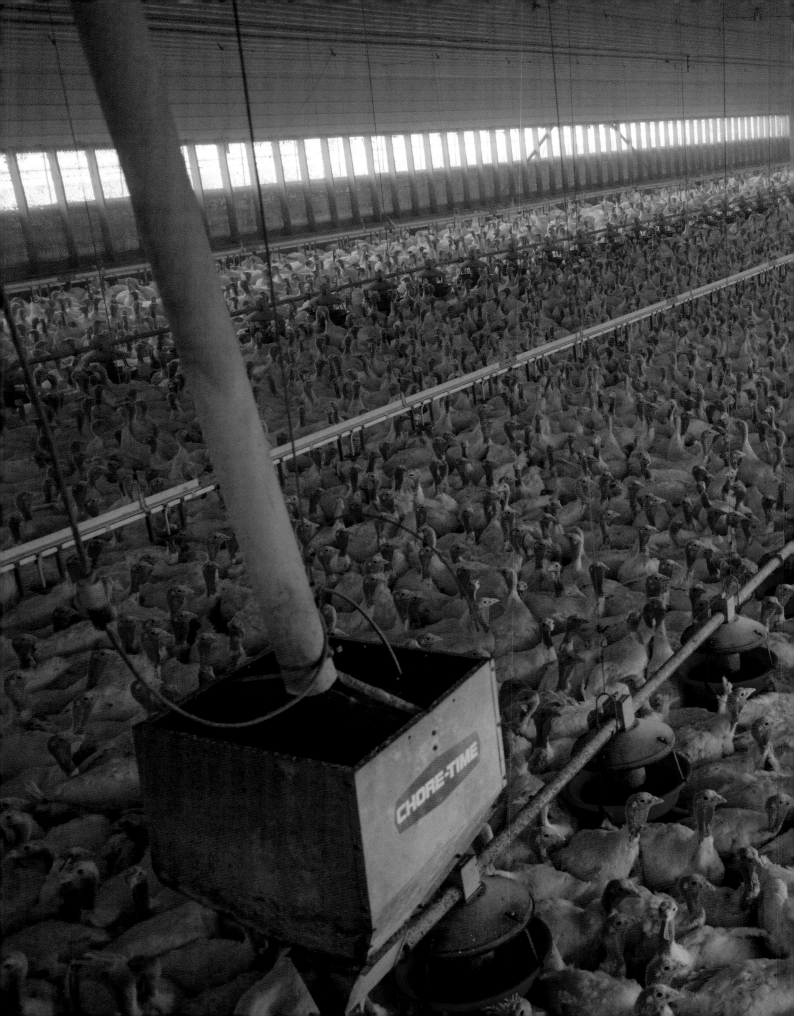

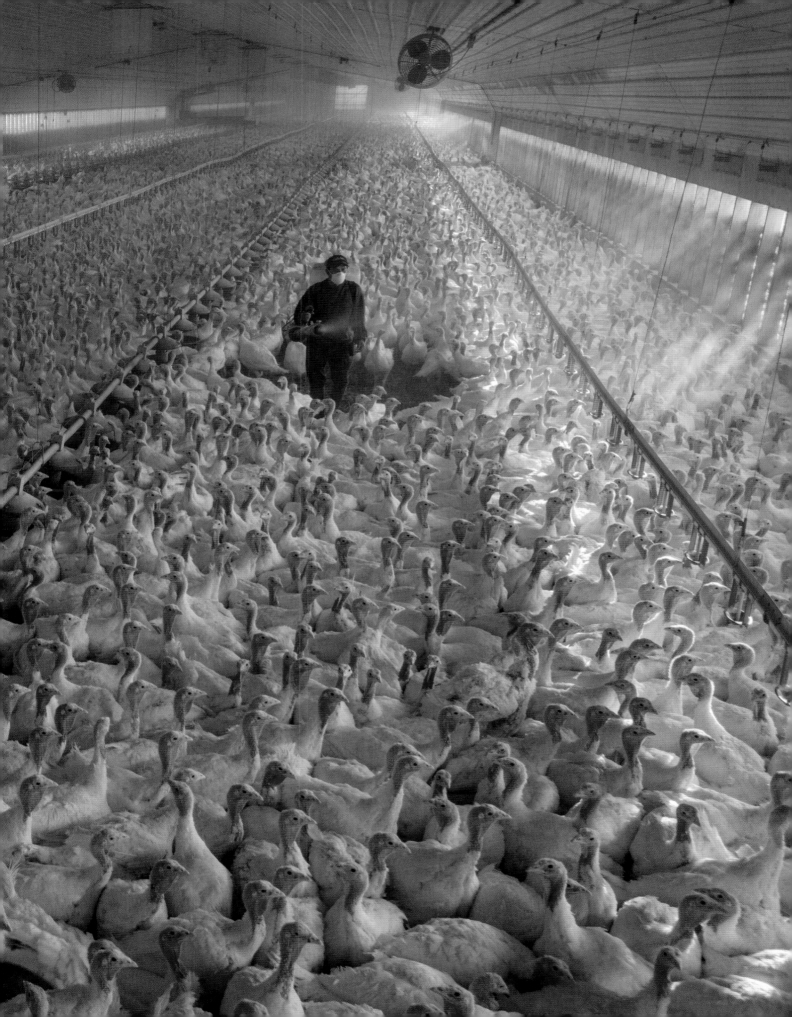

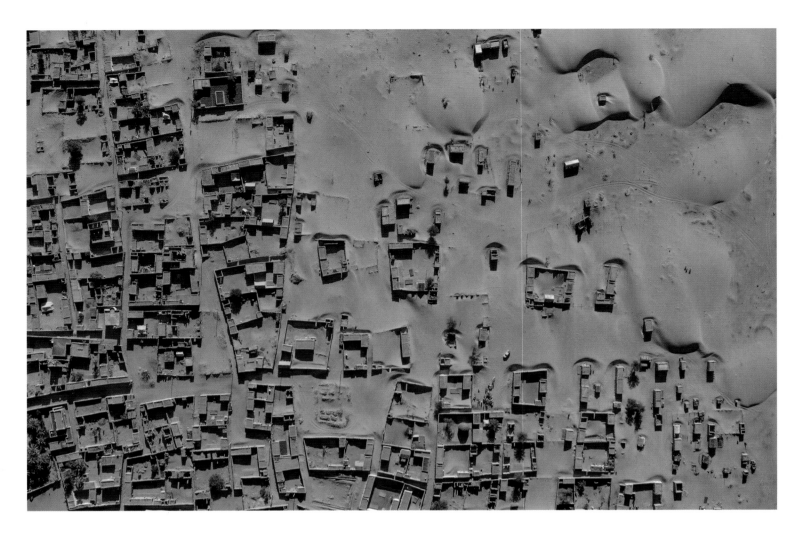

'We are entering an era of limited resources. We're getting to the point where we're running out of fish in the sea and virgin terrain – we're consuming resources faster than they are replenished – and we have to start thinking about how we can reduce our impact on the world.'

For example, most consumers have no idea about the link between what they eat and the destruction of the Amazon rainforest. A few years ago, I chartered a small plane in the Amazon basin during the peak of the dry season, which is also the peak fire season that leads to deforestation. If you look at a time-lapse of satellite data of the Amazon from the past few decades, you can see that it's dissolving: It looks like it's been nibbled to death by termites. I saw the same thing in other tropical forests in Indonesia and Malaysia. These areas are the greatest repositories of biodiversity on the planet, with an uncountable number of distinct life forms. We are chewing up these forests for hardwoods, paper pulp, palm oil, soybeans and cattle ranches. People in the developed world aren't aware of their complicity in the process.

Likewise, people have no idea how their meat and dairy products are made. A few years ago I went to one of the largest dairy operations in the United States – a company called Milk Source in Wisconsin. They have six large dairies, with 30,000 cows in the region. They have one facility where they bring all of the calves that have been separated from their mothers but are not yet ready to start breeding. They call it Calf Source, and it's a grid of a few thousand calf hutches, which looks almost like a Legos when seen from the air. If you talk to a dairyman, they would tell you that it's a very healthy, sanitary and efficient way to raise cows. But when you look at it from above, it's clear that we're treating these animals like they are pieces of living plastic or something. To me it's metaphorical for how we've come to make food on a large-scale, commodity basis.

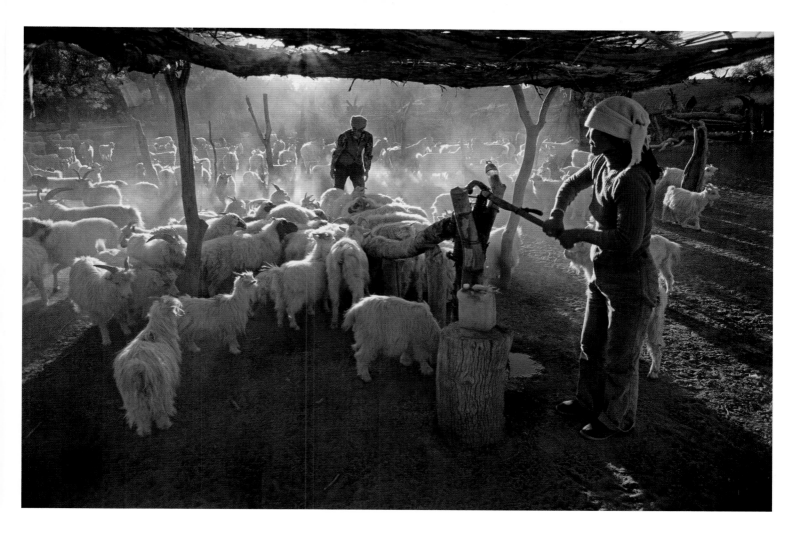

These operations are called CAFOs – Concentrated Animal Feeding Operations – and can be quite disturbing to see. They are industrial scale operations where animals are genetically engineered or selected to be freaks of nature. These cows have udders down below their knees, they can hardly walk, let alone run from a predator. All their male offspring are being killed, mostly for veal. But it's an incredibly efficient way to make food. We have bred chickens with super-sized bodies, so big that they can hardly walk. If you compare an American or European chicken to an African chicken, which are scrawny little things, the developed world chickens look like sumo wrestlers with feathers.

It seems really heartless, but if you're trying to feed 9.7 billion people – which is the projected world population in 2050 – on a limited amount of land, that's a logical solution. If you are going to preserve wild spaces, you want to limit the amount of food and land resources you use and CAFOs are an incredibly efficient way to do that. Most consumers are unaware of the fact that organic and free-range methods use a lot more resources and have higher rates of mortality.

Over the years, my work has turned me into an accidental environmentalist. I never set out to be an advocate for our planet, but I think that if people know more about an issue, they can make choices that will lead to solutions. Our individual choices add up. For example: Oreo cookies have a lot of palm oil

Previous page: A turkey farm in Clayton County, Iowa, USA, which houses 18,000 turkeys at different stages of growth. The birds are fed a mixture of corn and soybean meal, supplemented with minerals. They require just over two pounds [one kilogram] of feed per every pound of weight gained and grow from a chick to a twenty-four pound [ten kilogram] sell-weight bird in eighteen weeks.

Above left: The ancient oasis town of Chinguetti in northern Mauritania was founded in 1262 at a crossroads for caravans carrying salt. It has long had a struggle with being buried by mobile sand dunes.

Above right: Goats jostle for position at the water pump worked by De Quigigi, a woman in Ejinaqi, Mongolia. Decreasing rains combined with agricultural diversions placed on the river upstream, have turned what was once a desert oasis into a dust bowl.

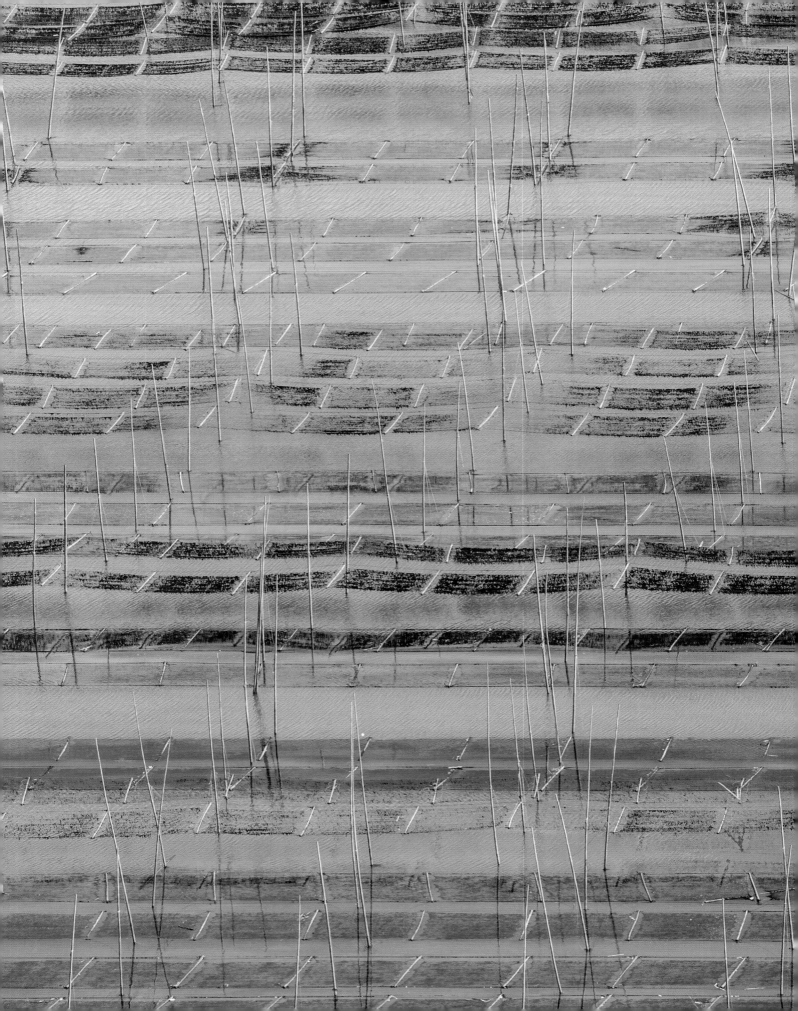

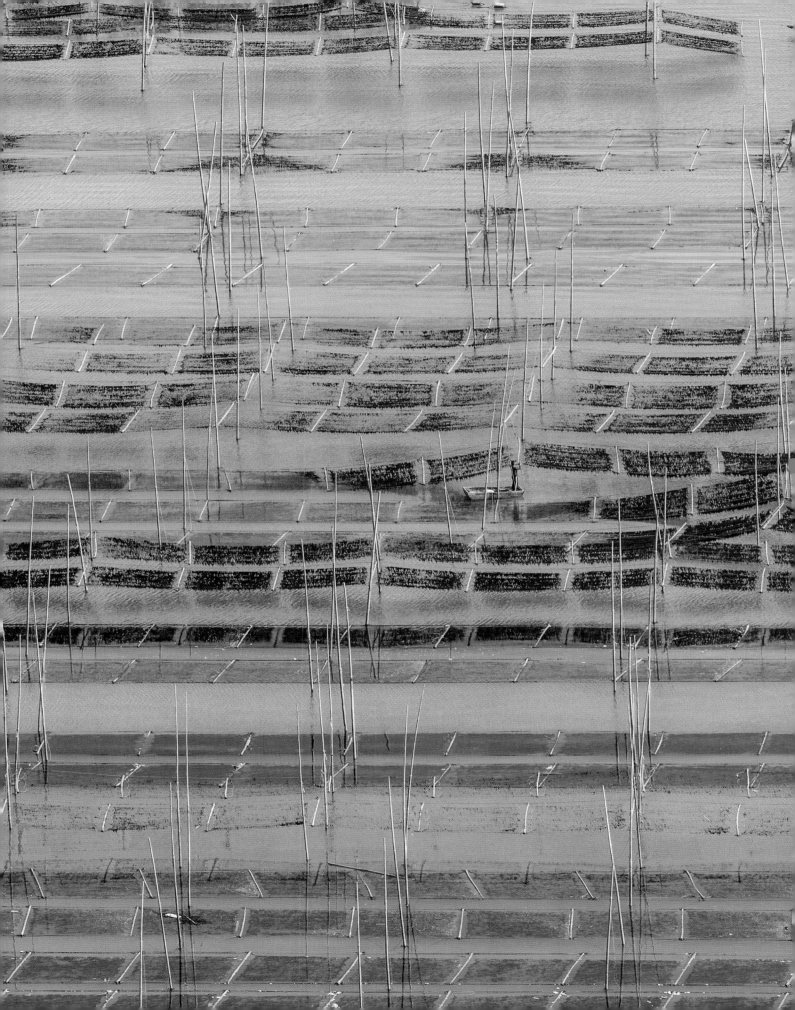

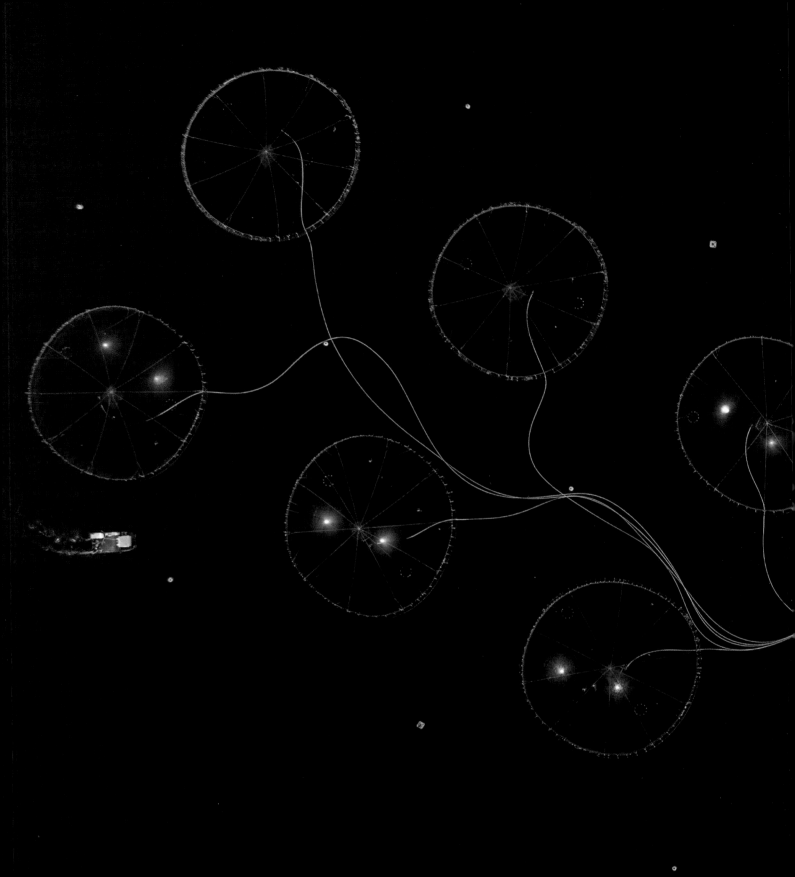

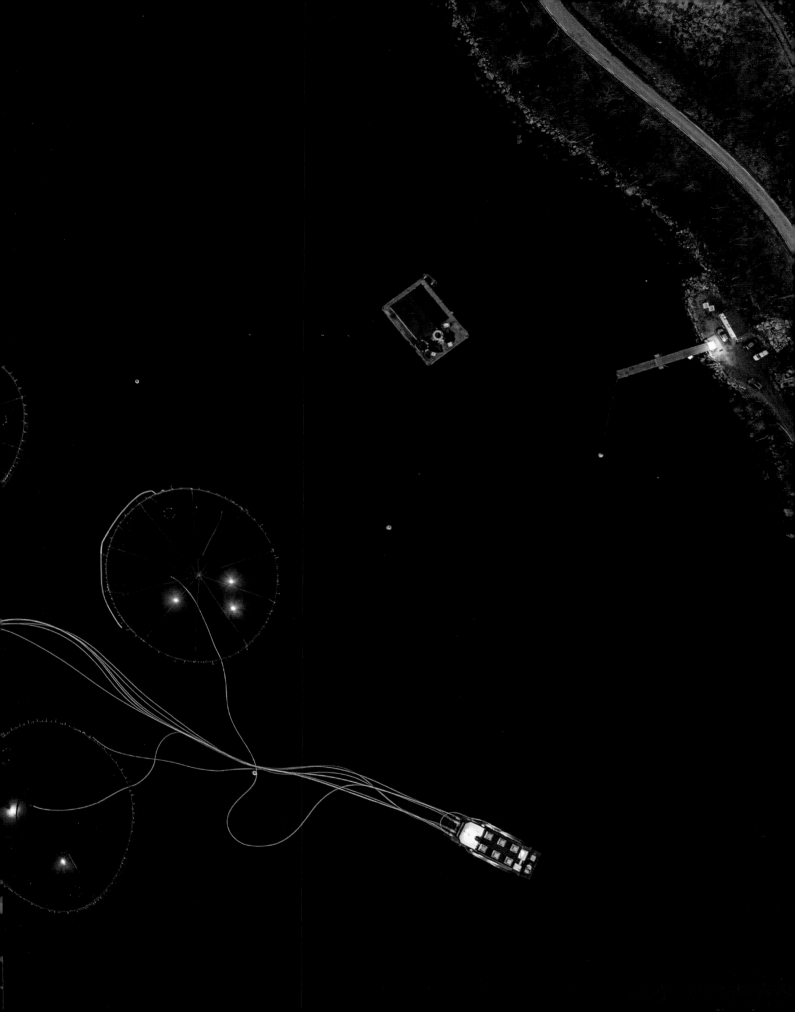

Pp. 230–1: With only a small percentage of land suitable for agriculture, China makes intensive use of the sea. In the Fújiàn province most of the region's wild fishery has been depleted so the shallow, muddy coastline has been divided into vast tracts of aquaculture for fish, seaweed and shellfish.

Previous page: MOWI salmon farm in Sagelva, Hjørund Fjord, Norway, is the biggest grower of farmed salmon in the world. Each of the eight pens holds 200,000 Atlantic salmon.

Above left: A new generation of oil palms at the Sapi Plantation in Sabah, Malaysia. The green area on the left was planted a few months earlier – with ninety-eight inches [2,500 millimetres] of rainfall annually and abundant tropical sunlight, ground cover emerges rapidly

Above right: Pools of evaporating saltwater that look like a mosaic floor, in the desert area of Teguidda In Tessoum, Agadez Region, Niger.

in them and palm oil plantations have caused the loss of much of the natural forested areas in the world. The packages are labeled and if people stopped buying things with palm oil in them, there would be no palm oil plantations.

Same goes for shrimp. Every pound of shrimp you eat means taking two or more pounds of live fish out of the ocean. Is that really the best thing for our biosphere? We all vote with a fork, three times a day.

I realize that we don't always have control of what we consume. At home my wife cooks most dinners and we have two teenage boys with us, so I live in a space that I don't entirely control. We are all in that predicament to some extent, like when you travel on an airplane you are offered very limited choices with very little information. But even with small changes, the cumulative impacts can make a significant difference.

My work on food has led me to the conclusion that we are entering an era of limited resources. We're getting to the point where we're running out of fish in the sea and virgin terrain – we're consuming resources faster than they are replenished – and we have to start thinking about how we can reduce our impact on the world.

The era that scientists are starting to call the Anthropocene started in my lifetime. It's an apt description for how we've reached a point where humans

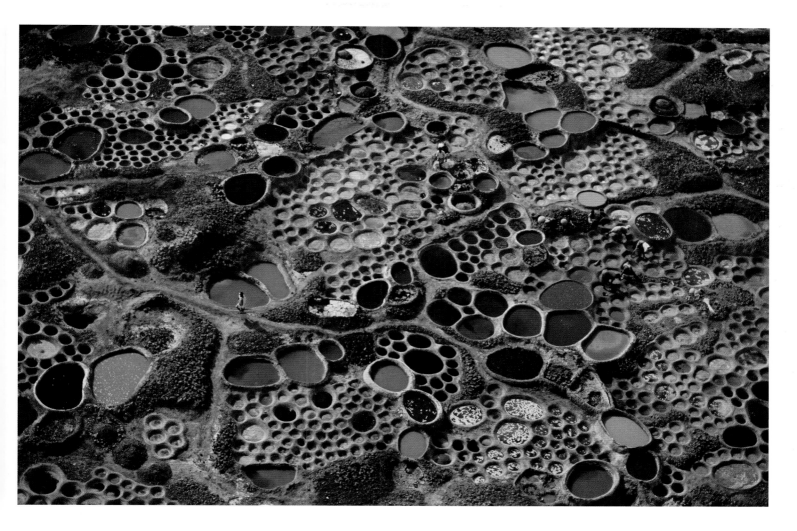

have come to dominate the planet in a profound way. I think we have to rethink the 'man versus nature' narrative that dominated when I grew up and revise it to be more like 'man with nature'. As I get older, I feel it's my responsibility to try and make people aware of that. I'm sixty-two years old and that's what I want to do with the time I have left – to be active and running around the world documenting things.

A lot of nature photography today is about capturing the last really beautiful, pristine, intact ecosystems. And I love seeing that stuff! But that's not really the majority of the earth's surface anymore. Even the most remote parts of the world's deserts are being exploited and wild ocean life is being sucked out of the oceans by big factory trawlers that are removing key parts of the marine ecosystem. We have to tell these difficult untold stories so that people understand.

My friend Paul Nicklen (p. 86) was down in Antarctica and found krill boats that were basically stealing the food from the whales and the penguins, which is part of what is causing massive penguin mortality there. That's the untold story. As a journalist, when something's under-reported, that's what we need to examine.

People love to see beautiful photos of coral reefs and colourful anemones, but to me that's kind of like nature porn and except for some very remote areas

'The Anthropocene started in my lifetime. It's an apt description for how we've reached a point where humans have come to dominate the planet in a profound way. I think we have to rethink the "man versus nature" narrative that dominated when I grew up and revise it to be more like "man with nature".'

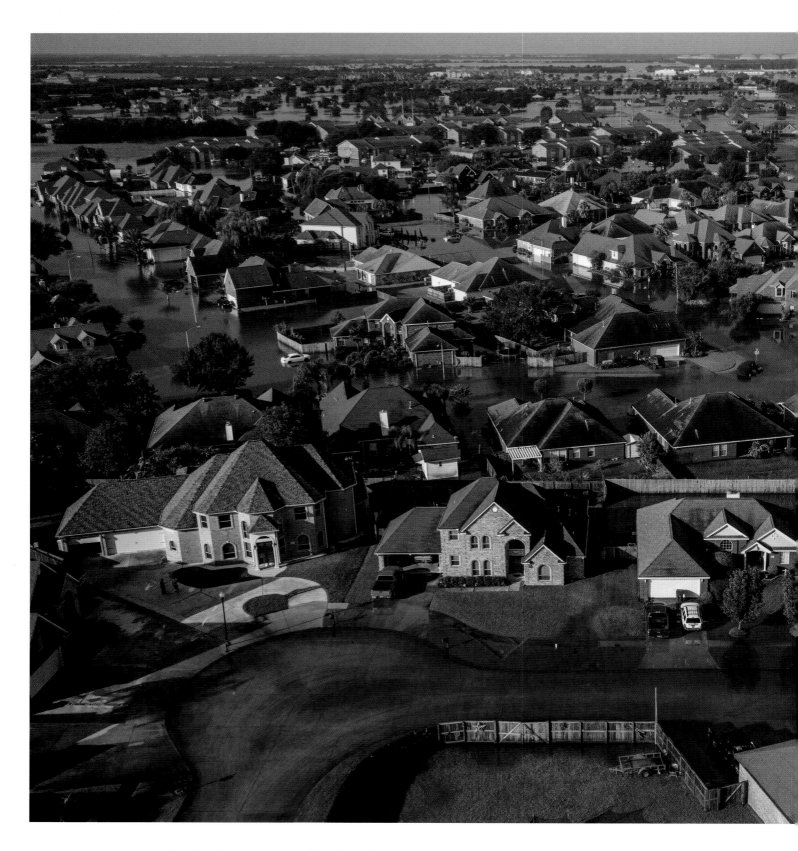

Above: Flooding in Beaumont, Texas, USA, the day after Hurricane Harvey dumped thirty inches [760 millimetres] of rain on the region in eighteen hours in 2017, causing catastrophic flooding.

Following page: Thirteen-year-old Rodello Coronel Jr. picks through trash looking for recyclable plastic in the river on the Parola Binondo side of Manila harbor, home to over 20,000 squatters.

'You find fewer climate change deniers among younger generations. They're very aware of how our planet is changing and they want to do something about it. That's really encouraging.'

it's not the norm. I've been looking at big industrial tuna boats that hunt schools of fish with helicopters. These things are like James Bond boats going out looking for tuna. That hasn't really been photographed before and it's hard trying to get people to engage in these more difficult stories. Maybe I'm a negativist trying to photograph all these problems. It's definitely easier to sell pictures of a polar bear jumping from one ice floe to another, than it is to sell one of a dying polar bear.

What I've seen has made me reconsider what I eat. When I'm invited to dinner in an Arab village, where they kill the goat behind the kitchen, I still go out and watch them kill the goat because I'm respectfully interested in the process. I think we all need to understand that process better.

Young people get it. You find fewer climate change deniers among younger generations. I think they're very aware of how our planet is changing and they want to do something about it. That's really encouraging. Older people get set in their ways and don't really want to change. That's one of the great things about humanity. Everybody dies and you have renewal, so our culture just keeps growing and innovating. I think the current challenge is to find ways that we can innovate to lessen the human footprint. Part of that solution is developing new techniques and improving food genetics. I don't want people to feel guilt-tripped, but I think we should all be more mindful of the consequences of the choices we make.

Pp. 240–1: The Coffey Park neighbourhood of Santa Rosa, California, USA, after the 2017 Tubbs Fire. Fanned by strong winds, the fire was the second most destructive wildfire in California history, destroying more than 5,600 structures.

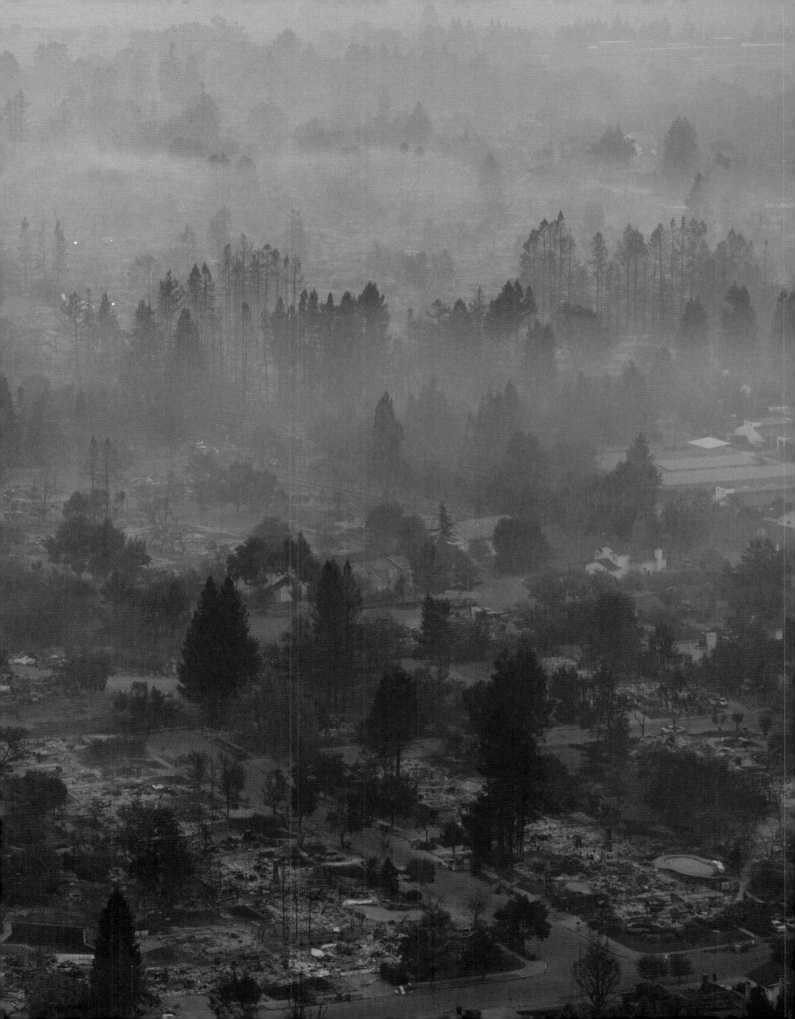

Above: On 30 January 2000 a tailings dam in north-western Romania broke, spilling cyanide into the Danube River and killing large numbers of fish and other species in Romania and neighbouring countries. Here, on an older lake near Bozanta Mare, Romania, where tailings were also dumped, a decommissioned pipeline acts as a monument to the heavy-metal mining techniques that feed global consumption.

RICHARD JOHN SEYMOUR

Richard John Seymour is a photographer and BAFTA-nominated film-maker. His work explores the often hidden effects of globalization and the way they are changing the planet and how, in turn, these human-made changes to the environment are affecting us.

I'm a photographer and film-maker. I grew up in the countryside in Shropshire in England, which is a very rural part of the country and one of the least densely populated. My background is in design and architecture – I was interested in the countryside as a design project and when I was studying to be an architect, I started to use photography and filmmaking as a way to document the kinds of spaces that I found inspiring. I wanted to have a discussion that explored the forms of design that aren't usually talked about in the architectural profession but actually have consequences on our world that are perhaps larger than city or building design; this idea of how landscape and city are all part of the same process and how the countryside – where I'm from – is essentially designed to serve the needs of the city.

Above left: A cleaner works underneath the Shenzhen Stock Exchange building, Shenzhen, China.

Above right: A lone figure surveys the site of a new construction project in front of the new Shenzhen skyline in China, with the Shenzhen Stock Exchange building in the background.

At first, I started out by visiting the buildings that I found quite interesting. Then I started travelling to Europe – to places where I found the architecture the most interesting – but what ended up becoming my first most notable work was the work I did in China. That was really when I started to use photography in a way that affected me and it motivated me to pursue it more. My first trips were with a group of artists, researchers and architects in 2014 and were designed to investigate, in as many ways as possible, the implications that our lives were having on places that we don't often get to see, whether they be cities in China that are built to perform one specific task, or whether they be landscapes that are being ravaged and destroyed for the coal that fuels the steel industry that is required for architecture, for instance.

Each one of us on the trips were in essence part of a collective, but we all branched into our different areas of interest. For me, these visits to China were when I first started to realize that while these places in China were

fascinating on one level and on a scale of which I'd never seen before, they were in effect designed and made to facilitate the lifestyles of someone like me. When I saw what kind of space and what kind of scale is required to fulfill the lifestyle we have in the developed world, I was inspired to create work that would communicate this hidden world to people.

For instance, landscapes that might appear to be quite beautiful, melancholic spaces are actually being completely destroyed. For me, beauty is a tool; it's a way of attracting someone's attention and for me it's important to use all of the tools in the arsenal that you have as a visual artist. Beauty is one of the most powerful tools we have, because it immediately attracts people's attention and perhaps gives them a bit more time with a subject than they would otherwise spend if they saw something that wasn't so beautiful, that was easier to dismiss, gives them a perspective that they might not otherwise get. The power of imagery is such that it can transcend time, it can transcend language – it's a very powerful form of communication.

'These visits to China were when I first started to realize that while these places in China were fascinating on one level and on a scale of which I'd never seen before, they were in effect designed and made to facilitate the lifestyles of someone like me.'

'If you think of the plastic that is on show in Yiwu – each one of those stalls can produce each object they have in thousands, or tens of thousands – so even if each one of those stalls sells, say, ten thousand plastic "things" a year, that suddenly becomes extremely scary numbers.'

Because I grew up in the countryside, I have a connection to it; studying and being interested in the environment from a young age, I think gave me a feeling that there's a design problem happening. We're using finite resources at a rate that is not sustainable. And it's happening at a scale that no one can see – the idea that we can't sustain life on this planet at the rate at which we're using the natural resources of the world; the idea of what are we doing and how can we improve the situation?

About three hours outside of Shanghai, China, is a city called Yiwu where they have a market called Yiwu International Trade City [also known as Yiwu Market] and it's the world's largest small commodities market. I discovered it on one of my trips to China and it became something for me – the more I delved into it, the more interesting it became. For instance, sixty per cent of all Christmas decorations are made in Yiwu. The market itself has over 70,000 stores, exactly like the ones shown on pp. 250–5. And not only that, but each item in those stores is a one-off. You don't go there, fill up your shopping trolley and leave. You find an object that you like the design of – of which there are hundreds of thousands, if not millions – and then you order it to be made in a nearby factory by the thousands. It's for budget retailers or wholesalers, the products for sale are the kinds of things that you see in the Poundland or Dollar Store type of stores.

They're basically showrooms for nearby factories. It literally takes days and days of walking just to cover a small percentage of what's there. And there are many stories inside the building, it is almost a city in itself; people eat in that building, they sleep in that building, they have their kids in that building. The whole scenario is a really interesting pressure point in this global system we're part of. Here you get to see a small, small percentage of what is happening in our world. If you think of the plastic that is on show in Yiwu – each one of those stalls can produce each object they have in thousands, or tens of thousands – so even if each one of those stalls sells, say, ten thousand plastic 'things' a year, that suddenly becomes extremely scary numbers. It's almost impossible to comprehend.

I wasn't able to really investigate beyond the 'shop window', but I managed to get the contact for someone who worked in one of the Christmas decoration factories and I managed to get in there. It was the middle of summer in Yiwu, eighty-five degrees [Fahrenheit, thirty degrees Celsius] and there were just dozens and dozens, hundreds, of people making Christmas decorations and wearing Santa hats. It was just the most surreal thing ever. Seeing that puts a sour taste in your mouth when you go home and in just a few months the Christmas decorations start to go up and you know that there's somebody who's been working in a spray room and is probably developing all sorts of health problems to spray the red glitter onto the holly decorations. That really changes the way you see those sorts of objects.

*

One of the biggest takeaways from everything that I've done so far, is that I think about these things as design problems and the thought-process behind the way we design the things that we use has to extend beyond not only their manufacture, not only their use, but also what we do with them afterwards. Changing the way we look at the world, or at least changing our economies from a linear into more of a circular idea, is a really important change that needs to happen. And that probably is happening, but what I hope to do with some of my work is contribute to it speeding up – I hope that maybe by people being so overwhelmed by, for instance Yiwu, by confronting people with the scale of the problem, is a way of helping them think about it. Looking at the bigger picture, looking at the way in which things are connected, looking at things beyond the scale of the nation state and the scale of the planet. That's the only way we can solve most of the biggest problems that we have. CO_2 doesn't understand a national border. Cooperation at a planet-scale is required.

One of my projects, *Landscape Healing*, was a documentary about a large-scale rewilding project in Norway conducted by the Norwegian military. In Norway there is a law that determines that polluter is responsible for the pollution,[6] so the Norwegian military is taking seventy-seven square miles [20,000 square hectares] of former shooting ranges – which are full of heavy metal pollution and unexploded ordinance – and attempting to turn them back into wilderness.

There are two parts to that story. The first part is that Norway produces a lot of oil which is its primary source of wealth and that wealth has been put into a sovereign wealth fund which is now approaching around a trillion dollars, so it means there is a lot of public money to invest in projects like this. But the real reason the military is doing it is because they're legally obliged to clean up after themselves and because they're responsible for it, they're the ones who have to pay for it, but in turn funded by taxpayer's money. That's almost the only way to get corporations and institutions as big as that to spend that much money – it's a twelve-year project and I think it will cost them about half a billion Norwegian Krone [approximately US$50 million]. In the grand scheme of things, it's not that much money – it just scratches the surface relative to the amount of oil Norway is shipping to be used by the rest of the world – but if we were to follow through with that law globally, I'm not sure how we would manage it, but now's the time to start trying.

The *Landscape Healing* project was really interesting for me as a design idea because it asks the question, 'Can humans create wilderness?' And, the idea of the Norwegian military rewilding a large part of their landscape is a really interesting way of using national resources that begins to address the scale of the action required. It requires architects, it requires biologists, it requires all manner of scientists, it requires the labour of the military – all instigated by a piece of legislation. For me, that's extremely inspiring, because it shows what's possible. Nature can heal itself, but it shows that it also requires a big action on our part. Maybe it's not possible through individual action for us to do what's needed anymore?

*

'In the last fifteen years we've produced half of the plastic ever made and in the last twenty-five years we've emitted *half* of the CO_2 ever emitted in the history of humanity. Since we've had the information that we've needed to change our habits, we've massively done the opposite.'

Previous page: A store selling artificial flowers in Yiwu International Trade City in Zhejiang province, China.

Pp. 250–5: Stores in Yiwu International Trade City, China. Also known as Yiwu Market, it is the world's largest small commodities market and holds over 70,000 showrooms representing neighbouring factories that produce a variety of products for the world market, including toys, household cleaning equipment, knitted hats and scarves, balloons, car accessories and artificial plants.

'All of a sudden, governments are forced to admit that they can afford to do things that they've been saying they can't afford to do for decades. My biggest hope is that this will embed itself into our subconscious and that we will start to think more radically about what's possible.'

Right now [when this interview took place] we're in a moment in which the Coronavirus – Covid-19 – has forced many countries to be in lockdown. There are huge amounts of death and illness, which is a tragic scenario, but there are glimmers of hope on a larger scale if you ignore the pandemic itself and look at the action that's been taken to stop the spread. I think if you had told anyone two, or even six, months ago that planes would be grounded, car manufacturers would make medical supplies instead of cars – not in a matter of years or months but literally in a matter days – and that as a result humans are stopping pollution on a level that has never been seen before, I don't think anyone would have believed that to be possible; which is also a really big barrier to stopping large-scale concerted action. But we've been forced into it by this pandemic and it proves that big-scale change is possible. And that it's not the end of the world! Most people are managing to adjust and all of a sudden, governments are forced to admit that they can afford to do things that they've been saying they can't afford to do for decades. My biggest hope is that this will embed itself into our subconscious and that we will start to think more radically about what's possible.

Above: A frozen river of tailings from a nearby mine cuts across the lake in Geamăna, in Translyvania in Romania. Geamăna is an abandoned village which was sacrificed to make way for a tailings lake for the nearby Rosia Poieni copper mine. All that remains is the top of the church spire.

Above left: Văcărești, a neighbourhood in south-eastern Bucharest, Romania. Construction of a huge artificial lake was started here under communist leader Nicolae Ceaușescu's regime, but never completed and the land is now used as an unofficial city wilderness with unauthorized livestock grazing and settlers occupying the vacant land.

Above right: A toxic tailings lake in the city of Baotou, the largest city in Inner Mongolia, an autonomous region of China and location of one of the largest steel processing factories in the world.

I hope what will come out of the Coronavirus-crisis and what I've seen through the *Landscape Healing* project, is that ultimately what's required to make the scale of change needed is legal action – we need to change the rules of the game. We like to think of corporations as 'people', but they're not. They don't think like humans, they don't have empathy and I think that we're in a position where, even if a large percentage of us make huge changes to our own lives voluntarily, the only way to make sure everybody acts in the same way and in a fair way, is to make sure the rules we all abide by are fair and adequate to protect us all.

And that's going to require political movement and it's going to require political participation. Hopefully when young people are old enough to vote, that will be a great change in the tide. We see them getting more engaged with the Greta Thunberg movement and she is proving that voting is not necessarily the only option we have – we can also protest, we can also become politically motivated – and for me that's the first step to becoming more politically engaged. Voting, but with the ultimate goal of changing the legal system, changing the rules of the game.

*

I'm constantly inspired by the ability of humans to adapt to their environment and to adapt their environment to themselves and while that can play out

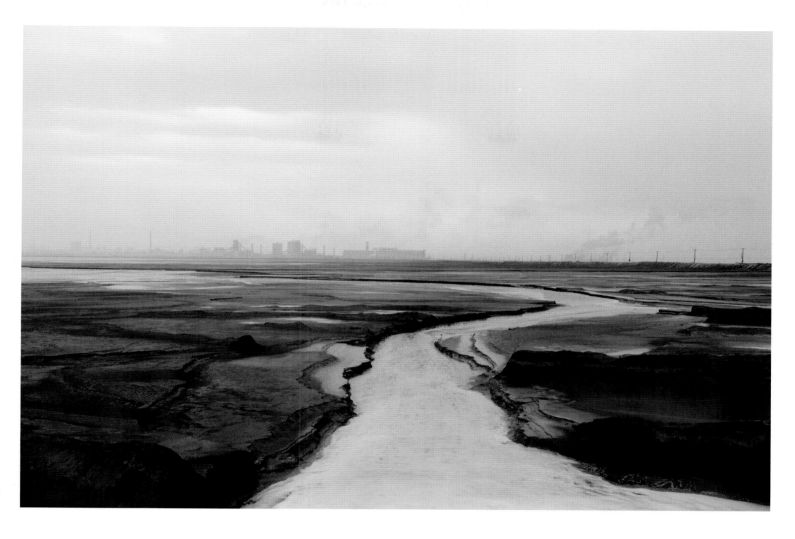

negatively as well as positively, it gives me a sense of optimism that huge scale change is possible. If you look at a city like Shenzhen in China, in much less than one lifetime it's gone from a fishing village to a global metropolis. It can be easy to be stuck in the moment and not understand the level of change that's actually possible, but it's not something that's specific to China; we're starting to see that that change on a huge scale is possible wherever humans are involved. Humans are very good at adapting themselves to their own advantage and right now, the question now is about making the system and the circumstances right for that to happen in a positive way for our planet.

But in a certain way what I find the most inspirational, can also be the most disturbing because it's not only for the good that humans adapt themselves and adapt their environments. In Romania there is a place called Geamăna, in Lupșa in Translyvania in Romania (pp. 256–7). Geamăna was a small village situated slightly below a copper mine further up into the mountain. The copper mine needed the area that the village was in as a waste dump, so they built a dam wall and forced the residents to move out. Slowly but surely the tailings lake grew and grew and eventually covered the village and now all that's left is the village church; the spire is all that's visible. For me that image is a powerful symbol of capitalism superseding religion – a church spire drowning in the waste from a copper mine. I think photography is very good at that, at communicating facts in an emotional way.

*

'The thought-process behind the way we design the things that we use has to extend beyond not only their manufacture, not only their use, but also what we do with them afterwards.'

'Nature can heal itself, but it also requires a big action on our part. Maybe it's not possible through individual action for us to do what's needed anymore?'

We've had a lot of the data that we've needed to save us for a very long time, but we've been relying on individual action and that's very problematic because not only have we not been able to solve all of our problems with individual action since we've known about the data, it hasn't resulted in much. For instance, in the last fifteen years, we've produced half of the plastic ever made. And in the last twenty-five years, we've emitted half of the CO_2 ever emitted in the history of humanity,[7] which is actually after we've known about the damaging effects. Since we've had the information that we've needed to change our habits, we've massively done the opposite.

What needs to change now is that we need to see a level of political activism at a scale that we haven't seen before and however we do that is different for every country and every situation, but at an individual level voting is an incredibly important factor. It can literally change the world. You can be creative with the ways in which you do that. Even something as simple as writing to your elected representative and telling them, 'I won't vote for you if you don't make improvements to the way you look at the environment'. They're people, they'll read it, they'll think, 'Somebody is sending me this. If one person is sending me this, maybe hundreds of people are thinking it'. So it might feel small, but I think individual action has to be more in the area of politics and less in the area of personal consumption habits, in order to make a big difference.

Above: Blåisen, part of the Hardangerjøkulen glacier in the Hardangervidda mountain plateau in Norway. Hardangervidda is one of Europe's largest remaining wilderness areas but despite this, the glacier is reducing in size and some scientists project it will have fully melted by 2100.

Following page: A satellite image of the earth's surface taken from NASA's Landsat 8 satellite. Satellite data is used to analyze weather patterns, crop yields, environmental catastrophes and even evidence in cases of international crimes, but increasingly is being used for mineral prospecting. By interpreting non-visible bands of the electromagnetic spectrum captured by satellite, prospectors can analyze satellite images for signatures of potential mineral deposits.

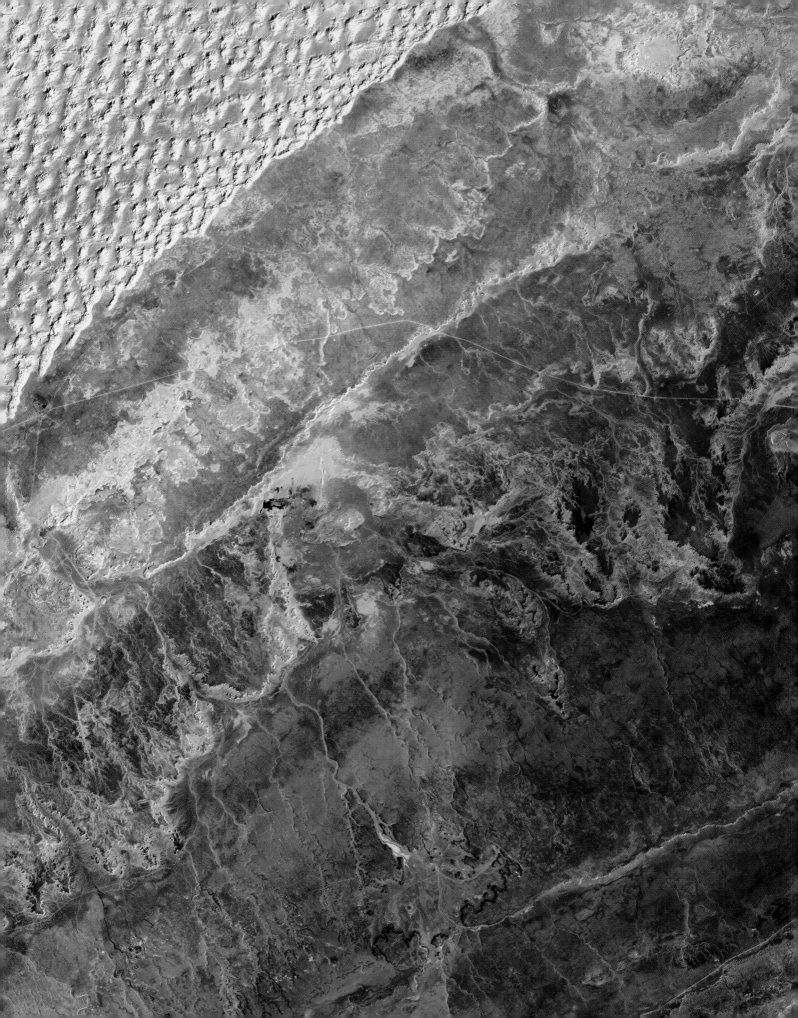

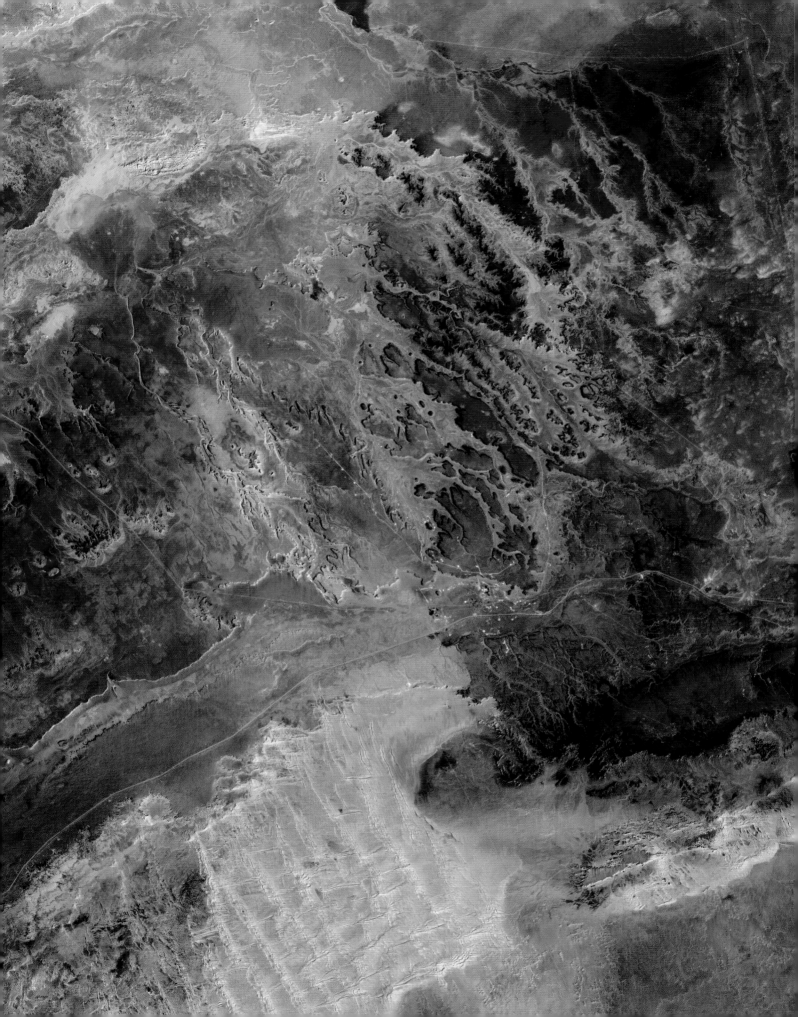

JOEL SARTORE

JOEL
SARTORE

Joel Sartore is a photographer, a fellow of the National Geographic Society and the founder of *Photo Ark*, an international multi-year project in association with *National Geographic* to document the approximately 15,000 species living in captivity.

I was born in Ponca City, Oklahoma, where my Dad was an oil refinery chemist. We moved to Nebraska when I was two years old so that my father could work for a company that made growth implants for cattle and hogs. I grew up in a middle-class town called Ralston, on the edge of Omaha. After high school, I went to the University of Nebraska [Lincoln], where I had three instructors who were crucial: two taught writing and one taught photojournalism. The photography instructor, George Tuck, was the first professor I'd ever met who remembered my name. On the second day of class he passed me in the hallway and said, 'We're expecting great things from you, Joel'. It turns out he was good with names and said that to everybody, but it worked on me – I believed him.

My love for all species is thanks to my parents. They really cared about nature and inadvertently passed this on to me. As a child I didn't realize how special that was. My mother loved her backyard birds and flowers; even the squirrels and the rabbits interested her. It was a big deal each spring when the snow geese migrated high overhead – we would drop everything to watch them. My father took me hunting and fishing every weekend that we could get away. He used to say, 'It doesn't matter if we get anything or not, it's about being out here and being together'. Some people take their kids to sporting events or shopping, but my parents took me outside.

Above: A young white-bellied pangolin clings to her mother's back at a facility in Florida, USA. This captive-born baby was a first in captivity, an important step in protecting pangolins from extinction due to poaching. The demand for pangolin is driven by the false belief that their protective keratin scales have curative properties.

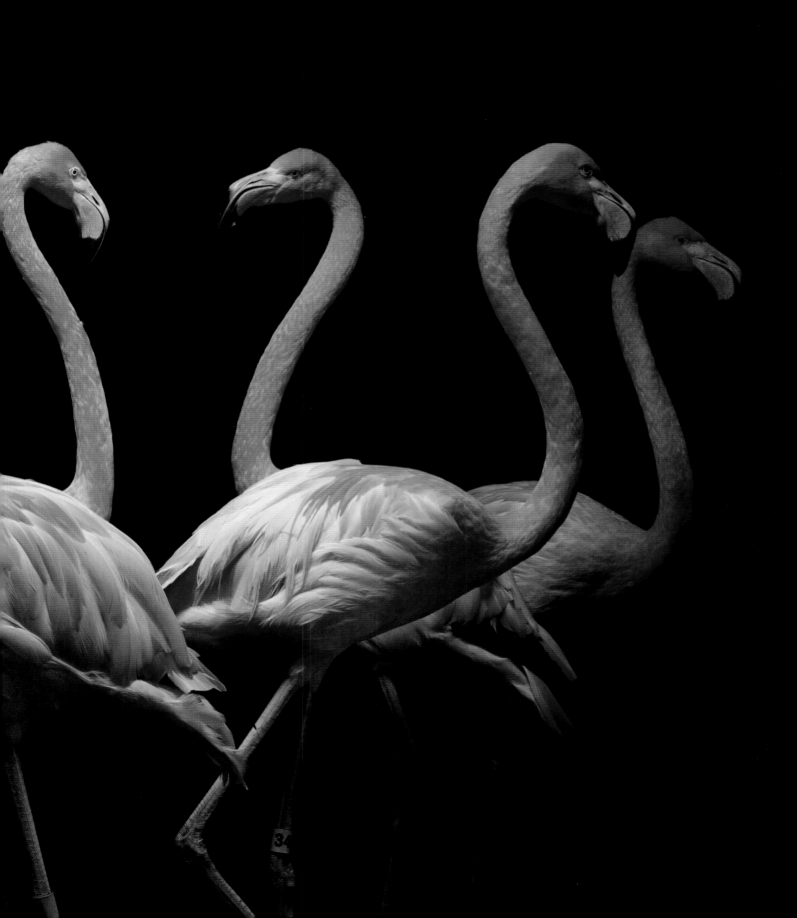

Previous page: American flamingos at the Lincoln Children's Zoo in Nebraska, USA. These graceful and striking birds have a love-hate relationship to one another; they must flock together to feel safe, but bicker and squabble constantly. The *Photo Ark* was started in 2006 at this zoo, which is just a mile from Sartore's home.

Above left: A federally endangered Florida panther at Lowry Park Zoo in Tampa, Florida, USA. Named Lucy, she was among the last purebred members of her subspecies. In order to save the species from extinction, several western cougars were released into the Florida wild to improve the genetics of the wild population.

Above right: Rajah, a male white Bengal tiger at Alabama Gulf Coast Zoo, Alabama, USA. This colour pigmentation rarely happens in the wild but has been around for decades in some captive populations, much to the delight of zoo visitors.

After I got my degree in journalism, I went to work at the *Wichita Eagle* newspaper in Kansas as a general assignment photographer. Steve Harper was director of photography and after a while he would let me do my thing. He said, 'Look, I'll give you one day a week to just shoot the kind of things you want to shoot, as long as you are producing photos we can run in the newspaper.' I started really using that day, plus my weekends and eventually I got noticed through some news photography contests and caught the eye of *National Geographic* photographer Jim Stanfield.

Jim gave me a recommendation to send my portfolio in to *National Geographic*, but the interview at their DC headquarters didn't go so well. I was nervous, hadn't slept, it was raining, I had a splitting headache and I'd started to get a cold. My guard was down. I sat in the office of the assistant director of photography, Kent Kobersteen. It was late in the day and the hallways had these fabulous pictures – Jim Brandenburg's white wolf jumping on the iceberg and Steve McCurry's Afghan girl with the green eyes – and I had a portfolio with pictures of chickens, hogs and rodeo queens. I didn't belong there.

I was sitting like a lump on his office couch and hadn't said anything for a long time. He eventually went through his mail, then he turned off his desk light and got his coat. He had forgotten about me. I cleared my throat and he said, 'Oh yeah, it's time to go. By the way, why should I hire you?' I said, 'I don't

know, I don't like people that much and I hate to travel.' I was just being honest, but what I meant was, I don't like crowds and I don't like leaving home. He shrugged and I left, figuring that was the last time I'd ever step foot in the place. Then I got a letter in the mail two weeks later. It was on a *Geographic* letterhead and from Kent Kobersteen. The last sentence was, 'We'll be calling you, count on it'. And they have been ever since, for some thirty years now.

My first assignment for them was a few chapters in a *National Geographic* book while I was working for the *Wichita Eagle* and then I got a magazine shoot and one led to the next and I kept doing those magazine shoots for about seventeen years – until my wife, Kathy, got sick. That's when everything stopped.

*

For a long time I was a globe-trotting photographer. I worked around the world on just about every continent and shot thirty stories in seventeen years: lions taking naps in the trees in Uganda, crocodiles at waterholes in Mozambique, the Endangered Species Act in the US, a big story on America's Gulf Coast and human interest stories; on State Fairs [agricultural shows], a feature on the Tex-Mex border, even one documenting my home state of Nebraska. And then came an important phone call.

'When I look extinction in the eye like that, I think, "This is epic in ways I don't understand and it's going to eventually have very drastic consequences for humanity".'

I'd been up on Alaska's North Slope for several weeks and my wife said, 'You need to come home. You've been gone seven weeks and I don't want to do this anymore.' I went home to work on my marriage and very soon after she discovered a tumour in her right breast. She was on chemo and radiation for nearly a year for breast cancer. We had three little kids at home; I'd never even changed a diaper on the youngest one. He barely knew who I was. I'd been doing all these stories for *Geographic* and they were successful, but I wasn't that successful being at home.

Being a *Geographic* photographer is a little like being an astronaut. What are you going to do when that's over? I had zero clue. I was worried my wife was going to die, I was worried I wouldn't know how to raise our kids – I didn't know how to cook, or how to really use the washing machine – and I was worried we'd lose our house, because we were paid by the day when I was in the field – and I wasn't doing that anymore.

I had a year at home and we made it – my wife got better [and is still doing fine today, thankfully]. But during that year I had a real opportunity to stop and think about the direction of my life. I'd noticed that in thirty stories, only two had moved the needle of conservation. A story on Madidi National Park in Bolivia had helped prevent a dam from being built, which would have drowned a thousand square miles of rainforest. A second story on koalas in trouble in northern Australia helped get them listed by the government as imperilled, we think. But that's not very good odds and I really wanted to try to change the world.

During that year of Kathy's illness, when she was sick and sleeping, I would sometimes wander around our house and look at the walls. We have work up by John James Audubon – prints of birds that are now extinct. I looked at a book showing the work of Edward Curtis, a photographer who had worked his entire adult life, as Audubon had, documenting something he thought would vanish. For Curtis this was Native American culture because he could see how much European settlement was displacing Native Americans. Then there was the painter George Catlin, who did the same

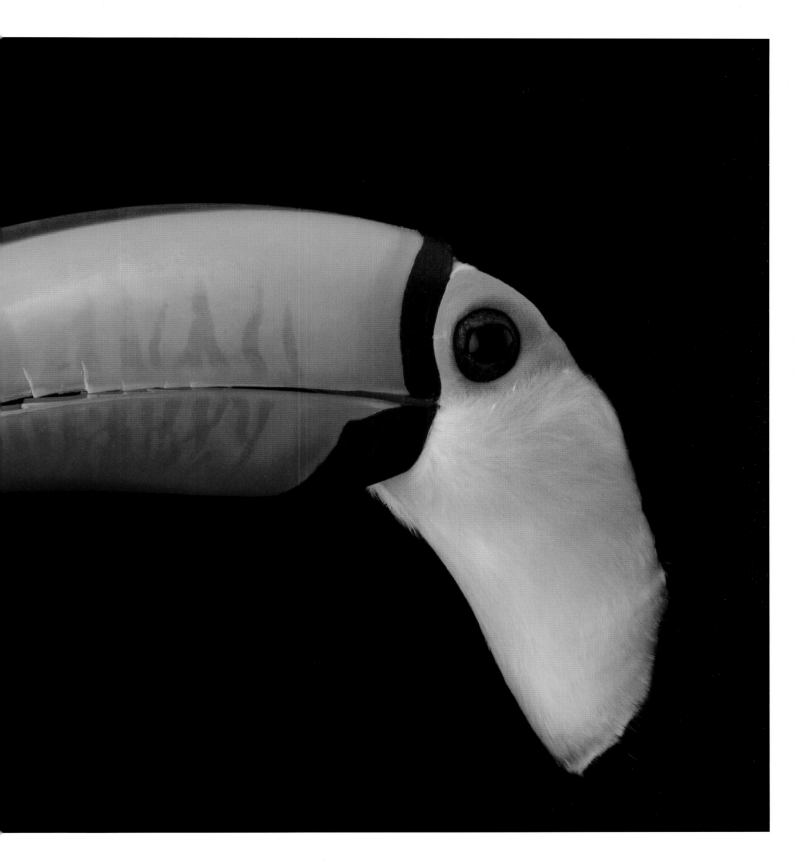

Above: A toco toucan at Henry Doorly Zoo and Aquarium in Omaha, Nebraska, USA. In the wild, the toco toucan's huge beak is half the length of its body and is used in a variety of ways, from harvesting fruit to plundering the nests of other birds inside tree cavities. The beak is also used to intimidate other birds and would-be predators.

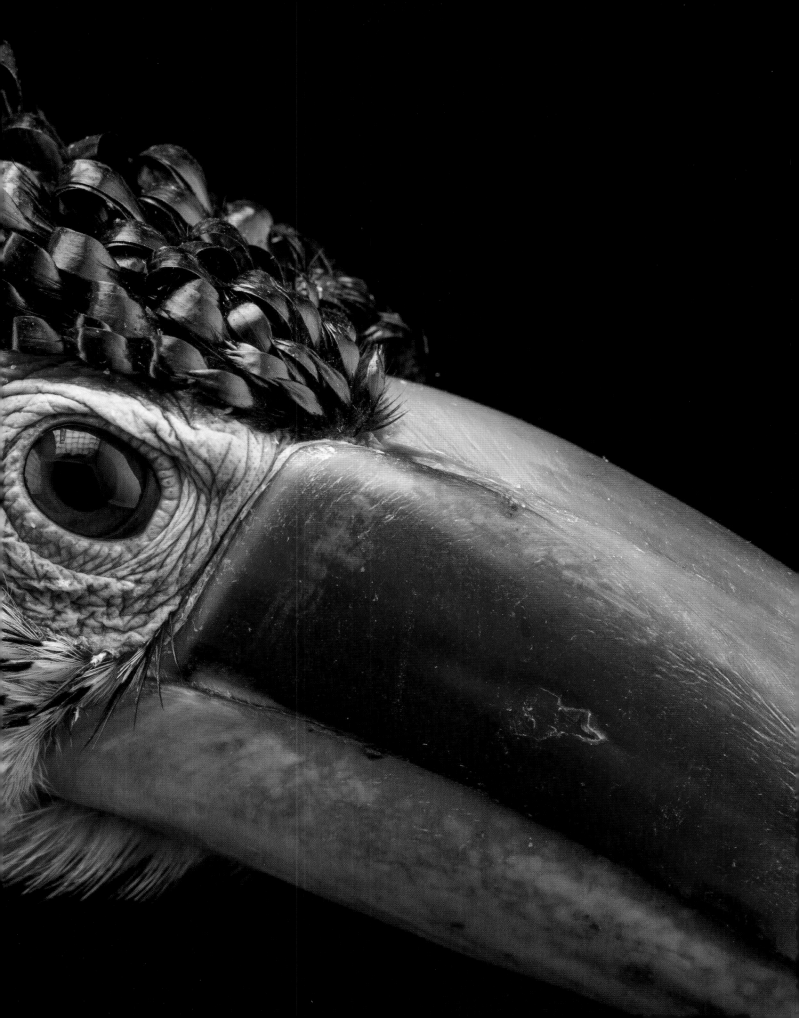

'Human beings are the ones that hold earth's fate in our hands. We really do need to pay attention and look these animals in the eye. Hopefully then people will decide whether or not the future of life on earth is worth it.'

Previous page: A curl-crested aracari at the Dallas World Aquarium in Texas, USA. The curled feathers on top of the head are stiff, like a plastic whisk broom. Known for its extensive collection of large-billed birds from Central and South America, this zoo breeds many species of toucans, toucanets and aracaris.

Right: An endangered Peruvian woolly monkey at Cetas-IBAMA, a wildlife rehabilitation centre in Manaus, Brazil. The centre is administered by IBAMA, the government wildlife agency of Brazil. This juvenile female had severe growth deformities due to poor nutrition from being reared as a pet by a citizen. Her mother was likely killed so that she could be sold into the pet trade. In her rehabilitation centre home she gets along just fine, though her deformed legs make it impossible for her to be released back into the wild.

thing with native peoples many decades earlier. All three men gave their full measure of devotion to one thing; they concentrated, focussed and gave us bodies of work that still hold up today. I told myself that, if Kathy got better, I would do the same – focus on just one thing. I was forty-two years old and figured I had twenty-five years left in me if I stayed healthy. A lot could be done in twenty-five years. So when Kathy's health improved, I began to document captive animals instead of photographing them in the wild.

Working with animals in human care was very different to what I had done previously. It was almost all indoors, in controlled situations. I learned how to use studio lighting and black and white backgrounds. We used the lighting so that we could really see each animal's true colour: in nature, a lot of them live high in the trees and they appear green because the sunlight passes through the leaves; or they live in soil, or in muddy water and you can't get a good look at them. I've learned over my career with *Geographic* that many of them were really in trouble, especially little fish and aquatic invertebrates in desert areas where people were diverting the water to grow food. Those were the animals that were going to go extinct first, without anybody ever photographing them alive. For many of them, there were no photographs at all, only drawings.

And that's how the *Photo Ark* started. Eventually my goal became to photograph every captive species in the world. When I started in 2006, all the accredited zoos and aquariums in the world contributed their inventories to a central database which added up to about 12,000. A lot more aquariums and zoos have been added since then, so we figure the inventory is approximately 15,000 globally.

It's hard to say when a species goes extinct for sure, but of the 10,000 that I've photographed so far, we think about ten have either become extinct, or are very close to it, with just one or two left. By the time this book comes out, they may be gone.

The reason we use black or white backgrounds is to enable direct eye contact, with no distractions, so that all species are given an equal voice. Because they're all the same size, the mouse is every bit as big as an elephant. And a little hot springs snail is as large as a jaguar. There are plenty of people who know what gorillas, zebras and tigers look like, but very few have ever heard of most of the little creatures that we photograph. So this is their only chance to sing.

*

I'm very driven by the thought of extinction and that goes back to when I was growing up. My mother got me a book when I was child called *The Birds* and in the back was a chapter on extinction. There were five or six bird species that had gone extinct in the United States and one of them was the passenger pigeon. Martha was the last of billions and she died in 1914 at the Cincinnati Zoo, alone in her cage. We [humans] had learned where to find the last great flocks through the telegraph back in the late 1800s and were

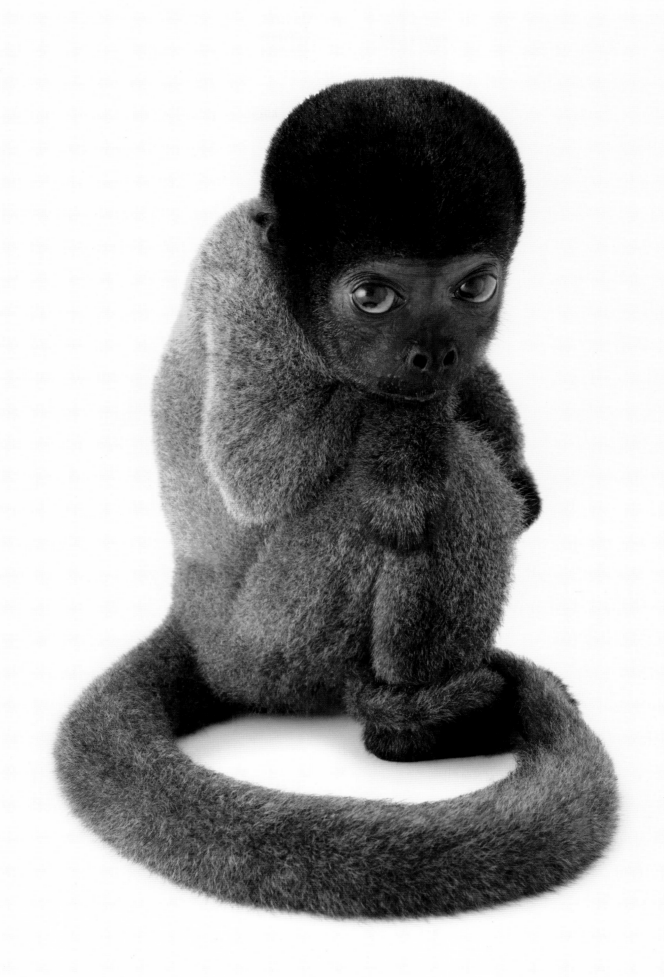

Above left: An endangered Gee's golden langur at the Assam State Zoo-cum-Botanical Garden in India. Known as one of the most beautiful primates in the world, their numbers are dramatically down due to habitat loss. **Above right:** A clouded leopard at the Houston Zoo, Texas, USA. This species is a great climber and spends a good deal of its time in trees hunting and resting. Whether up high in the canopy or on the forest floor, the striking pattern of its coat yields great camouflage in the Asian forests it calls home.

able to hunt them to extinction. This species went from about four billion to just Martha. When I finally got a chance to interview at *National Geographic* in Washington D.C., I first went to see Martha's stuffed body in a display case at the Smithsonian National Museum of Natural History. It was a big deal to me, a pilgrimage, to see that bird.

I've cared about the extinction of species since I was a little boy because of Martha and that book chapter with other extinct birds – some of them just drawings because they were never photographed alive. It's astonishing to me that we're still killing off species and at an increasing pace. I never thought I would live long enough to see another 'passenger pigeon' – any animal that would go extinct, especially a bird. But each year now, I meet one or two birds, as well as fish and amphibians that are going to become extinct. There's no stopping it now, but we can lessen the impact through education. That really is my motivator. If it's between staying at home and watching TV, or getting out and trying to stop extinction, I don't have much of a choice.

I often think that it was looking into the eyes of Martha as a boy that motivated me to do this work. In that image of her was a sign with big letters that said EXTINCT. It was so brutal and final. She's just sitting there, stuffed and strapped to a perch. That's likely the reason I strive for eye contact in my photographs; in the eyes we can see that animals are all very intelligent – they wouldn't have made it this far if they weren't. The same is true for the

animals I photograph that don't have eyes – like sponges, jellyfish or corals – they are all survivors and know how to make it through time, eons longer than humans have been around. I believe these other living beings have a basic right to exist.

Today, we human beings are the ones that hold earth's fate in our hands. We really do need to pay attention and look these animals in the eye. Hopefully then people will decide whether or not the future of life on earth is worth it. If we don't start paying attention to something other than politics, who won the ball game and the price of fuel, we will just stare into our phones all the way down and that will be it.

It's imperative that people get smart enough, quick enough, to realize that when we save these other species, we're actually saving ourselves. People are so distracted now that conservation work must be really engaging in order to pull them into the tent and teach all the great things they can do.

Everybody wants to view themselves as a good person; so let's teach what folks can do to help save the planet. Really easy, simple, smart things that will put money in your pocket. Being green is profitable. If we can teach that, we've got it.

*

'Figure out something you're very passionate about that will make your own backyard or town a better place, then become an expert and spend years doing that one thing. After all, at the end of your days, in your declining hours, don't you want to look in a mirror and smile, knowing that you did everything that you could while you were here?'

Not very long ago we humans were up in the trees on the plains of Africa. It was all about survival for most of the world's people then and it's still about survival today. We're driven by greed and fear: 'If I don't get it, somebody else will' and we're afraid if we don't grab all we can, we'll fail and starve and die.

We are hardwired to be very aggressive and 'go for it', all the time, at all costs. That is not a generational thing, that is a human thing. We care about ourselves first – to survive, breed, procreate, pass on our genetics and we are a very successful species in that way. We're thriving and not going down in number – but it's at a great cost to the planet. How do we change that in time? I don't know if it's possible. I hope so. I wish that people would get smarter and show some kindness to each other and to the animals and plants around us.

Years ago, I asked a philanthropist why he didn't contribute more to conservation. He was doing a lot of work around the world, giving money to villagers to help them learn better farming techniques, develop their wells and build schools. He said, 'I actually *am* funding conservation. I know people will take every last animal and plant if they don't have a stable way of life. If they don't feel secure in their living, they will go and extract all the natural resources.'

So as I go through life and meet people, I listen to them and I learn. Until the human population settles down and feels comfortable with their standard of living, we are going to continue to lose wild places and wildlife at alarming rates. That's the number one thing: trying to stabilize economies while slowing explosive exponential population growth. Perhaps then we can feed the people we already have. If we cannot do this, the only other animals to survive will be those that are super-adaptive to humans and thrive no matter what. As [scientist and author] David Quammen once put it, we will end up with a 'Planet of Weeds'.

The main issue that I see is that we need vast blocks of habitat saved now, in order to stabilize our world. If you cut down all the trees along the equator, all the rainforests, you're going to disrupt the rainfall cycle

Above: A critically endangered grey-shanked douc langur at the Endangered Primate Rescue Center in Cuc Phuong National Park, Vietnam. To make our *Photo Ark* portrait we used a cage that the animals were accustomed to entering for transfers and converted it to a small 'set' using black and white backgrounds.

that provides us with the rain we need to grow crops. That's our bread and butter. We have to stabilize the earth's entire environment and that means big chunks of every natural system must be saved; the ocean, prairies, tundra, alpine zones, mangrove swamps, all of it, along with eliminating fossil fuel use, recycling everything – the works. It's all tied in together – slow down on consumption, on overpopulation, all these things. One immediate concern is that we don't allow the Amazon to be cut and burned down. If we allow that to happen, we won't make it. And not just there – Gabon, Congo, all these places that still have great belts of rainforest that stabilize rainfall – those forests have to be protected too.

But we humans are so warlike, if we don't have something to fight about, we'll make it up. That's why sports and politics are so popular, it's controlled warfare. We're just primates, fighting it out. But we must learn to rise above our nature and quickly. We must get smart enough and fast enough to realize that it is at our peril if we ignore what these species are saying.

A lot of people don't think very far ahead. They have a, 'We'll be dead by then' mentality. That's not a plan. It's not even trying. I often use this analogy when people ask me, 'What good is that little frog that's gone extinct. Who cares?' I say, 'Well think of it this way: If you were flying on an airplane over the ocean and you looked out your window and you saw a rivet coming loose on the wing, you'd probably go back to reading your magazine. But if you saw a bunch of rivets popping off the wing, you'd get a little sweaty. You'd tell the flight attendant and you'd start looking for a parachute if it got bad enough'. Well there isn't a parachute for this.

Since we can't get off this planet, we'd better start making sure that we don't lose more species, because we don't know where the point is at which we have catastrophic failure for a main grain or other food source. You don't want the wings coming off, ever. It's just basic. But even when I use that analogy, it doesn't really register with people, even though I'm seeing the rivets working loose out of the wing every week – hundreds and hundreds of species on the cusp of extinction. It can really get unsettling. Sometimes it's a little tough to sleep at night. But I don't ever get depressed; I just think, 'We're going to use this species as an example, we're going to teach with it, tell its story and let people know that this doesn't have to happen.' And I also know that most of the species you see in the *Photo Ark* can be saved at this point in time. That's what the *Photo Ark* is about: mobilizing people to action, now. We need to save the ship while we still can.

*

I work with animals in human care and that means zoos, aquariums, private breeders, wildlife rehabbers and, occasionally, nature centres. These places are literally the arks now, especially zoos and aquariums. They have species that are gone from the wild, so if they quit breeding them and sharing genetics with other zoos, these species would be completely gone. Zoos also do a tremendous amount with education. For an urban society that's more and

'If you cut down all the trees along the equator, all the rainforests, you're going to disrupt the rainfall cycle that provides us with the rain we need to grow crops. That's our bread and butter.'

Previous page: An endangered white-fronted capuchin at the Summit Municipal Park in Gamboa, Panama. Though he appears to be shy and avoiding the limelight, he's actually munching on a banana. Keepers often use food as incentives to shift animals into perfect positions during *Photo Ark* sessions.

Left: A painted frogfish at Henry Doorly Zoo and Aquarium in Omaha, Nebraska, USA. Though this animal stands out when in the open, he blends in perfectly when resting in coral of the same colour, allowing him to both ambush prey and hide from predators.

'If it's between staying at home and watching TV, or getting out and trying to stop extinction, I don't have much of a choice.'

more confined to cities, zoos are the last place where you can go and see how a real wild animal moves, how it sounds. This is a big deal. When nature is restricted to some quaint notion on a smartphone, are we really going to step up and fight to save it?

I was with a fellow *Geographic* photographer Tim Laman (p. 194) years ago in Equatorial Guinea. We were being driven somewhere and I was griping about how bad things were. I'd just been to the bushmeat market where people were eating monkeys and he said, 'Hey man, this is the best time to be in conservation. We can reach the world now with the Web. This is actually the golden era, there's so much we can do.' He was very excited about that. That conversation in the back of the car changed my mind. I thought, 'You know what, it doesn't do any good to just sit and complain. There are amazing opportunities. We can speak directly to the public.' And we do, all the time. *Geographic*'s got one hundred and thirty million people following its Instagram feed. That's the power to save species, right now, like never before. I'm really hopeful. Besides, it doesn't pay to be otherwise, does it?

I want to share my excitement with others and also get feedback as well, which we now can thanks to the internet. We can see what people react to; what they like; what moves them. They're not motivated by insects or snakes, but they do like animals that appear to smile, like dolphins and primates. I even have a photograph of a turtle that looks like he's smiling. People are drawn to animals that are anthropomorphic; that look like us. We actually had a PhD student study *Photo Ark* pictures and rate people's responses. If an animal is down on the ground it doesn't register at all, but if they're sitting up that's better. And if they're standing, that's something we human primates view with more respect, or at least pay more attention to. So if they stand up, they've got big eyes and they're a furry mammal – now we're talking! This is the way to get the world's attention.

*

People ask me what my favourite animal is and I say, 'The next one', because I have to care about them all, whether they're insects or polar bears. But a few that have really resonated with me are animals that are very close to extinction, like the northern white rhino named Nabire that I photographed at the Dvůr Králové Zoo in the Czech Republic. At the time, she was one of five left and now there are only two: a mother and her daughter in a pen in Kenya. That's it. At the time, Nabire was very old and tired; she had fluid-filled cysts and they couldn't anesthetize her to remove them because she wouldn't have been able to withstand the procedure. The zoo's PR contact said, 'I'm glad you're here now, because if you had waited another little while, she's probably not going to make it.' We did our shoot and she was very sweet. The keeper, who had raised her from a baby, broomed forage for her in the centre of our black set and she ate, then she lay down, took a nap and I think a week or ten days later one of those cysts in her burst and she passed away.

Right: Two koala joeys cling to each other, waiting to be placed with human caregivers at the Australia Zoo Wildlife Hospital in Queensland, Australia. As juveniles, baby koalas need a lot of attention and emotional support, which is given to them by a network of people who run authorized foster homes. Once they're old enough, the koalas will be released into the wild.

JOEL SARTORE

Then there was Toughie, the Rabbs' fringe-limbed tree frog. He was the last one, from Panama. They were wiped out by chytrid fungus, which is an amphibian-killing disease that's spreading around the world. Toughie was living in a little trailer in the parking lot at the Atlanta Botanical Garden in a 'frog pod', which is an isolation chamber so they couldn't get sick. But he eventually died of old age. I went and photographed him two or three times and I show that frog everywhere I go; he's even been projected on the side of the Vatican. I'm just trying to convince people that all species matter, no matter how small. When I look extinction in the eye like that, I think, 'This is epic in ways I don't understand and it's going to eventually have very drastic consequences for humanity'. It's like I'm a guy standing at the edge of a bridge that's out, waving my hands. I'm seeing car after car go over. Eventually they'll stop and listen, won't they? So I'm fired up every day to get up, get out and get it done.

⋆

When I was a field photographer for *National Geographic*, one of my first stories was on America's Gulf Coast, which is 1,800 miles [2,900 kilometres] long from south Florida to south Texas and rings the Gulf of Mexico. I spent twenty-seven weeks on that coast. In Florida I saw a mosquito control team fly big airplanes spraying insecticide mixed with diesel fuel all over the marshes and housing developments. But it didn't just kill the mosquitos as it was intended to; it killed the butterflies, the beetles, the bees – everything. I thought, 'That's not right'. Next I went over to Galveston Bay. My wife had come down to see me and we walked on the beach. The bottoms of our feet turned black with spilled oil – tar – and we saw medical waste like hypodermic needles, blood bags, I.V. lines, used diapers and nylon rope. We came across a dead dolphin tangled up in fishing net. It was so depressing. Then we took a boat tour up the Houston Ship Channel and I thought I saw something moving in the water. The captain said, 'Son, I've been running this boat up and down this channel for seven years and I've never seen anything alive in this water.' It's the region where the US turns oil into gasoline. I saw things like that over and over again on that story.

Above: An Edward's fig parrot at Loro Parque Fundación, Tenerife, Spain. Known as one of the most striking of all parrots due to their colourful facial feathers, this species is one of many being bred by the Loro Parque Fundación, one of the largest parrot breeding programmes in the world.

Above left: A Himalayan griffon vulture at the Assam State Zoo-cum-Botanical Garden in Guwahati, Assam, India. In the wild, this bird lives at higher altitudes and is among the largest of the old-world vultures.

Above right: A single-wattled cassowary at Avilon Zoo in Rodriguez, the Philippines. Though this bird was completely calm, cassowaries are known to ward off threats by jumping up and using their large claws to fend off and even kill predators.

In my travels, I've seen too much to let it go; people eating everything, even bats and spiders. People cutting down woods on really steep slopes that will only be productive as farm ground for about a year. I've seen plastic garbage everywhere, especially in the oceans and along waterways. And air pollution so thick people are wearing masks and still getting sick.

People think they've got to wait for an election year to vote and change things, but actually we're voting every day. Every time you break out your purse, your wallet, your credit card, you're voting. That's the power to change the world, right there. Your money is either tearing the world down or building it up. What are you buying? Are you buying things made out of palm oil that's produced unsustainably? Are you buying a bedroom set made out of carved hardwood from the Amazon? And how much fuel are you burning? Are you driving around a big SUV by yourself in an area that never gets snow or ice? Think about the stuff that you consume. Eat less meat – it takes a lot of water, chemicals and fossil fuel to produce. Yes, eat organic, but don't pour insecticide and fungicide all over your lawn and then wonder why you don't have vegetables that are any good. Support initiatives that get us off of fossil fuels and stop thinking about getting 'more, more, more' all the time. These are the things that people have to overcome if we want to survive.

At the end of the day, when people are gone and the pressure is taken off the landscape, nature will come roaring back. But it will be in a very different

complement of species, climate patterns, the works. We can't afford to be the 'earth-eaters' anymore. We have to be thoughtful for a change. I think that's finally dawning on us, but it's a race to see if we can turn things around in time. Will we get smart enough, fast enough?

Right now, half of our country [USA] is facing off against the other half of the country and we're not moving, we're just howling against each other. We are not going to make any progress if we spend all our time fighting and hating. The solutions we need to save the planet [and ourselves] will have to be on a scale unlike anything we've done before. We all need to move in the same direction. And I hope that direction is, 'Let's consume less and only buy sustainable products. Let's have renewable energy that doesn't throw tons of carbon into the air daily.' Unless we apply ourselves, we're going to heat the planet and disrupt everything: rainfall, temperature, disease. And don't forget the mass movement of people that will occur, because most live near coasts that are going to become flooded as sea levels rise. Even if you don't fully believe in human-made climate change, wouldn't you want to hedge your bets a little bit? Wouldn't you want to be safe?

When it reaches crisis point then everybody will be beating down the doors of Parliament and Congress yelling, 'Why didn't you do something to save us?' Well, because nobody was interested. Our presidential debates haven't included questions asked about the environment for years. Nobody cares.

'Every time you break out your purse or your wallet, your credit card, you're voting. That's the power to change the world, right there. Your money's either tearing the world down or building it up.'

'What's the money for? You can only drive one car at a time, fly on one jet at a time, eat one meal at a time. What are you going to do with the rest of it?'

Right: A mossy leaf-tailed gecko at the Henry Doorly Zoo and Aquarium in Omaha, Nebraska, USA. Though easy to see against a plain black background, this animal would be virtually impossible to spot when at rest on a lichen-covered rock or tree with similar colour patterns. Note that nearly every edge of its body is serrated, which camouflages even its shadow.

But they better start paying attention. It will take the right leadership at the right time and I don't know if we are there yet in terms of being nervous enough to want to change. I can see why some politicians are popular; they say, 'Let the good times roll. There are no problems, buy as big a car as you want, burn as much fuel as you want, do whatever you want.' On the other extreme, a few politicians are saying, 'No, austerity is the way forward'. I don't think either of those approaches is going to work, to be honest. We have to convince people that it's fun to be green. It's also profitable to save the planet. And it's very satisfying.

I always tell people to specialize, figure out something you're very passionate about that will make your own backyard or town a better place, then become an expert and spend years doing that one thing. After all, at the end of your days, in your declining hours, don't you want to look in a mirror and smile, knowing that you did everything that you could while you were here?

*

Every time I go out on photo shoots, I meet conservation heroes who are doing all they can. I'll give you a couple of examples: one is a guy named Tilo Nadler, founder of the Endangered Primate Rescue Center (EPRC), which was the first wildlife rehabilitation centre in Vietnam. He was an electronics engineer who went to Vietnam in the early 1990s on vacation. He quickly saw there was a problem with baby primates being confiscated from poachers by the government; there was no place to put them, so they were being euthanized. He told me, 'It wasn't what I did, it wasn't what I knew how to do – but I couldn't let them do this.' So he started EPRC in the north of Vietnam and he and his team saved two species of primate from extinction: the Delacour's langur and the Cat Ba or white-headed langur. He now has populations of these langurs, plus gibbons, in big outdoor enclosures eating native vegetation, thriving and breeding. Tilo started all this at an age where he knew he'd never live to see the day when these animals could actually all be set free without still facing poachers. He founded that centre because it was the right thing to do, regardless of what it would take in terms of funding or personal sacrifice – he actually moved to Vietnam from Germany. That, to me, is the true measure of him, to know you're likely not going to see the pay-off, but you are going to do it anyway. It's like planting a fruit tree when you are a hundred years old. I've never met anybody that went into conservation that regretted it. That heartens me.

I rode an elevator recently after I'd spoken to a group of financial advisors – big money guys that did nothing but think about ways to get more money added to the top of the big piles of money they'd already amassed – and in the elevator they said, 'Well, we all feel worthless now, Joel, thanks.' I said, 'Well you shouldn't, because you actually can change the world. The conservationists I speak to don't have two nickels to their name. You guys have the power to start investing in green funding and to say no to things that are terrible environmentally. You don't have to invest in those types of destructive industries anymore.' And maybe in that little elevator ride from

'We must have nature;
it does not need us.'

sixth floor down to first floor, the light came on above a
couple of their heads. I hope so. What's the money for?
You can only drive one car at a time, fly on one jet at a
time, eat one meal at a time. What are you going to do
with the rest of it? Try to grow your company and make
profit? To make more profit?

There's got to be a higher ideal. I'm greatly encouraged
by the nearly two hundred Fortune 500 company leaders
who recently took an ethics pledge that said, 'We're not
just going to think about the bottom line, we're going to
think about the societal and environmental costs of our
actions.'[8] That is HUGE. When I started in photography,
companies didn't even have to pretend to be green, so
we've come a long way. But true change is generational
– twenty, twenty-five years. How many of those twenty
to twenty-five-year blocks do we have left before the
wheels really come off of the environment? And that's
the whole ballgame; nature keeps our planet stable.
We must have nature; it does not need us.

Above: An endangered baby Bornean orangutan named Aurora, with her adoptive mother, Cheyenne, a Bornean-Sumatran cross at the Houston Zoo, Texas, USA. When the baby's biological mother wouldn't feed Aurora anymore, Cheyenne indicated to keepers that she would like to care for her. Cheyenne turned out to be a very good mother and Aurora grew up happy and healthy.

THE PHOTOGRAPHERS

J Henry Fair p. 64

Based in New York City and Berlin, J Henry Fair creates imagery and media to explain the science of complex environmental issues. His "Industrial Scars: The Hidden Costs of Consumption" project, a collection of largescale aerial photos accompanied by documentary research, examines the drastic impact humans have had on the natural world to prompt viewers to consider the hidden environmental costs of the things they buy. He is co-founder of the Wolf Conservation Center in South Salem, New York, USA, a non-profit organization that utilizes the experience of meeting wolves face-to-face to educate people about the importance of protecting wild places and breeds wolves for reintroduction. He also collaborates with environmental organizations in his capacity as a photographer to help efforts to enact legislation or influence public opinion. His work has been featured in major broadcast media and publications around the world. Further information about each of the images featured in *Human Nature* can be found at jhenryfair.com.

Tim Laman p. 194

Tim Laman is a field biologist, wildlife photographer and film-maker. He received his PhD from Harvard University, Massachusetts, USA, for his pioneering research on the rainforest canopy of Borneo, Indonesia and has participated in over one hundred scientific and photographic expeditions, primarily in Borneo and remote parts of New Guinea. He is best known for his long-term work with the Cornell Lab of Ornithology at Cornell University, New York, USA, documenting all the species of birds of paradise and his collaboration with his wife, scientist Cheryl Knott, on orangutan research and conservation. Tim is a contributing photographer for *National Geographic* magazine with twenty-three feature articles to his credit. He is an associate of Harvard University's Museum of Comparative Zoology, a fellow of the Explorer's Club and a founding member of the International League of Conservation Photographers and has garnered numerous international awards including Wildlife Photographer of the Year, World Press Photo and Prix de la Photographie, Paris.

Frans Lanting p. 46

Hailing from the Netherlands, Frans Lanting is a renowned photographer and naturalist whose work has frequently appeared in *National Geographic*, where he served as a photographer-in-residence. His work has covered endangered wildlife, ecological hot spots, global biodiversity and more and his key projects include *LIFE: A Journey Through Time* which examines life on earth from the Big Bang to the present and *Into Africa*, which explores Africa's natural heritage. He is the author of numerous books, including *Jungles*, *Okavango*, *Bonobo* and *Eye to Eye*. He has received numerous international awards and honours and was the first and only recipient of a Lifetime Achievement Award from the prestigious Wildlife Photographer of the Year competition. In 2001, he was inducted by HRH Prince Bernhard as a Knight in the Royal Order of the Golden Ark, the Netherlands' highest conservation honour.

jhenryfair.com
@jhenryfair

timlaman.com
@timlaman

lanting.com
@franslanting

Cristina Mittermeier p. 114

Cristina Mittermeier is a marine biologist and activist who pioneered the concept and field of conservation photography, founding the International League of Conservation Photographers in 2005 to provide a platform for photographers working on environmental issues. In 2015, she co-founded SeaLegacy, a non-profit organization dedicated to the protection of the ocean which uses the power of communications technology to educate and inform people about the world's oceans and the challenges they face through climate crisis. In 2020, on the fiftieth anniversary of Earth Day, she announced her most ambitious project yet: Only One, a collective of organizations that uses digital technology and visual storytelling with the goal of conserving the world's oceans for perpetuity. She is the recipient of many awards, including the Mission Award from the North American Nature Photography Association, the Smithsonian Conservation Photographer of the Year Award and the Imaging Award for Photographers Who Give Back and in 2018, was named one of *National Geographic*'s Adventurers of the Year.

Paul Nicklen p. 86

Paul Nicklen is a Canadian photographer and marine biologist specializing in the polar regions and their wildlife. In 2015, Nicklen co-founded SeaLegacy, a non-profit organization devoted to bringing the issue of ocean conservation onto the world stage through the use of visual storytelling, impact campaigns and the funding of sustainability projects. In 2020, on the fiftieth anniversary of Earth Day, Paul announced a flagship project: Only One, a web-based platform showcasing original content designed to drive people to take action and change their habits for the benefit of the ocean. He is also a fellow of the International League of Conservation Photographers and the National Geographic Society and has placed first in the World Press Photo's Nature Stories category four times. In 2012, he was named Wildlife Photographer of the Year and in 2019 was inducted into the International Photography Hall of Fame and appointed to the Order of Canada. He has also been recognized for his conservation efforts with the Natural Resources Defense Council BioGems Visionary Award.

Joel Sartore p. 264

Joel Sartore is an award-winning photographer, speaker, author, conservationist and the 2018 *National Geographic* Explorer of the Year. A fellow of both the National Geographic Society and the International League of Conservation Photographers, he is a regular contributor to *National Geographic* magazine and specializes in documenting endangered species and species in captivity around the world. He is the founder and head of the *National Geographic Photo Ark* project, a twenty-five-year project in collaboration with *National Geographic* to document and raise awareness for all known species living in captivity. Sartore's work has been the subject of many national broadcasts, including *National Geographic's Explorer*, *NBC Nightly News*, the *CBS Sunday Morning Show*, ABC's *Nightline*, NPR's *Weekend Edition*, *PBS Newshour*, *Fresh Air with Terry Gross* and *The Today Show*.

cristinamittermeier.com
@mitty

paulnicklen.com
@paulnicklen

joelsartore.com
@joelsartore

Richard John Seymour p. 242

British photographer, designer and filmmaker Richard John Seymour uses photography and film to explore the connections between cities, economies and landscapes in an effort to draw attention to the political, environmental and social issues that stem from human-made environments. His work has been featured by *The New Yorker*, the *Wall Street Journal*, *The Guardian*, *National Geographic*, CNN, BBC and more. He has received multiple awards, including the Tate Collective Emerging Artist award, the Royal Academy of Arts' British Institution Prize and the LensCulture Visual Storytelling Award. His 2016 film *Consumed*, which explored the consequences global mass consumption has had on China, was nominated for a BAFTA in the 2017 Short Film category.

Brian Skerry p. 16

Brian Skerry is a photojournalist with a focus on underwater environments and marine wildlife and is a lecturer on exploration, photography and conservation. His work has been featured in many publications and he has produced over twenty-five stories for *National Geographic* magazine. He has given lectures at major events including The World Economic Forum in Davos, Switzerland, the United Nations General Assembly, The Royal Geographical Society in London, England and the National Press Club in Washington, D.C., USA. He is a National Geographic Society Fellow, a founding member of the International League of Conservation Photographers and is explorer-in-residence at the New England Aquarium, USA. He has received many awards for his photography and is an eleven-time award winner in the prestigious Wildlife Photographer of the Year competition.

George Steinmetz p. 218

A regular contributor to *National Geographic* magazine, George Steinmetz's work has examined subjects ranging from global oil exploration and the latest advances in robotics, to the innermost stretches of the Sahara and the little-known tree house people of Papua, Indonesia. He has completed more than twenty major essays for *National Geographic* magazine, including five cover stories. He has received numerous awards including three prizes from World Press Photo, as well as the Pictures of the Year Environmental Vision award and a special citation from the Overseas Press Club. He is the author of five books: *African Air, Empty Quarter, Desert Air, New York Air* and *The Human Planet*.

richardjohnseymour.com
@richardjohnseymour

brianskerry.com
@brianskerry

georgesteinmetz.com
@geosteinmetz

Brent Stirton p. 132

Brent Stirton is a South African photographer and a senior staff photographer for Reportage by Getty Images, specializing in documentary work covering global topics including health, the environment and conflict. In 2007, his photograph of rangers carrying a dead mountain gorilla through Virunga National Park in the Democratic Republic of Congo (pp. 138–9) sparked an international outcry. His work has been published in the *New York Times Magazine* and *Time*, *Vanity Fair* and *National Geographic* magazines among others. He is a fellow of the National Geographic Society and works for numerous organizations focussed on conservation and human rights including the World Wild Fund for Nature, the Ford, Clinton and Gates Foundations and the Global Business Coalition on HIV/Aids, Tuberculosis and Malaria. In 2017, he was named Wildlife Photographer of the Year.

Ami Vitale p. 156

Ami Vitale is a photographer, film-maker, writer and explorer who tells stories about our fragile relationship with the natural world. She has worked in more than one hundred countries, surviving war zones and malaria and donning a panda suit in pursuit of her stories. In 2009, after photographing a story on the transport and release of one the world's last northern white rhinos, she shifted her focus from covering human conflict to today's most compelling wildlife and environmental stories. She is a five-time World Press Photo award winner, the recipient of the Daniel Pearl Award for Outstanding Reporting, International Photographer of the Year and was named Magazine Photographer of the Year by the National Press Photographers Association.

Steve Winter p. 178

Steve Winter has been a photographer for *National Geographic* for over two decades. He specializes in wildlife and particularly big cats. He is a *National Geographic* Explorer, has been named BBC Wildlife Photographer of the Year and BBC Wildlife Photojournalist of the Year and is a two-time winner of Picture of the Year International's Global Vision Award. He was awarded first prize in the Nature Story category of World Press Photo in 2008 and 2014 and second prize in the Contemporary Issues category in 2020. He has been featured on *60 Minutes*, *CBS Nightly News*, NPR, BBC, CNN, Nat Geo Wild and other media outlets. He speaks globally on big cats and conservation for *National Geographic Live*.

brentstirton.com
@brentstirton

amivitale.com
@amivitale

stevewinterphoto.com
@stevewinterphoto

Acknowledgements

We are tremendously grateful to the photographers who gave up their time to be part of this project and allowed their extraordinary images and words to grace these pages – thank you.

Thank you also to their kind and thoughtful colleagues for their assistance with a myriad of requests for files, information, captions, travel advice and cups of tea, all provided with unfailing professionalism and good humour: Kait Burgan, Christine Eckstrom, Kelly Hesburn, Talia Lipskind, Kerry McCarthy, Marcia Skerry, Rachel Woolfson and Rebecca Wright and the team at the *Photo Ark* studio.

A special thanks to Vince Musi, who generously opened his address book to introduce us to his colleagues.

As always, this book is the result of a group effort by the team at Blackwell & Ruth: Cameron Gibb, Nikki Addison, Olivia van Velthooven, Elizabeth Blackwell and Kate Raven – ngā mihi.

Geoff Blackwell and Ruth Hobday

Endnotes

1. Geoff Blackwell, *I know this to be true – Greta Thunberg on truth, courage & saving our planet* (San Francisco: Chronicle Books in association with Blackwell & Ruth, 2020).

2. Gerardo Ceballos, Paul R. Ehrlich and Rodolfo Dirzo, 'Biological annihilation via the ongoing sixth mass extinction signaled by vertebrate population losses and declines', PNAS July 25, 2017 114 (30) pnas.org/content/114/30/E6089.

3. Edward O. Wilson, *Half-Earth: Half-Earth: Our Planet's Fight for Life* (New York: Liveright Publishing Corporation, a division of W.W. Norton, 2017).

4. Giving USA, 'Giving USA 2018: Americans Gave $410.02 Billion to Charity in 2017, Crossing the $400 Billion Mark for the First Time', 13 June 2018, givingusa.org/giving-usa-2018-americans-gave-410-02-billion-to-charity-in-2017-crossing-the-400-billion-mark-for-the-first-time.

5. Gerardo Ceballos, Paul R. Ehrlich and Rodolfo Dirzo, 'Biological annihilation via the ongoing sixth mass extinction signaled by vertebrate population losses and declines', PNAS July 25, 2017 114 (30) pnas.org/content/114/30/E6089.

6. *Pollution Control Act of 13 March 1981 No.6 Concerning Protection Against Pollution and Concerning Waste*, regjeringen.no/en/dokumenter/pollution-controlact/id171893.

7. David Wallace-Wells, *The Uninhabitable Earth: A Story of the Earth* (London: Penguin Books, 2019).

8. Business Roundtable, 'Statement on the Purpose of a Corporation signed by 181 CEOs who commit to lead their companies for the benefit of all stakeholders – customers, employees, suppliers, communities and shareholders', 19 August 2019, businessroundtable.org/business-roundtable-redefines-the-purpose-of-a-corporation-to-promote-an-economy-that-serves-all-americans.

Captions

Front endpaper: An ice fissure on Lacul Morii [Mill Lake], the largest lake in Bucharest, Romania. Covering over 600 square miles [155,000 square hectares], it was artificially constructed in 1986 to protect the city against flooding.

Pp. 2–3: An aerial view of the border fence and poacher access points on the Mozambique-South Africa border in Kruger National Park, the epicentre of the rhino poaching.

Pp. 6–7: Farmlands in Eastern Cape, South Africa damaged by suspected arson.

Pp. 12–3: A fishing festival in Sanjou, Pendjari National Park, Benin. The park is the largest remaining intact ecosystem in West Africa.

Back endpaper: A flock of birds settles on the frozen surface of Lacul Morii [Mill Lake] on the outskirts of Bucharest, Romania.

First published in the United States of America
in 2020 by Chronicle Books LLC.

Produced and originated by
Blackwell and Ruth Limited
Suite 405, Ironbank, 150 Karangahape Road
Auckland 1010, New Zealand
www.blackwellandruth.com

Publisher: Geoff Blackwell
Editor in Chief: Ruth Hobday
Design Director: Cameron Gibb
Designer & Production Coordinator: Olivia van Velthooven
Publishing Manager and Project Editor: Nikki Addison
Digital Publishing Manager: Elizabeth Blackwell

Original interviews by Geoff Blackwell
Introduction by Nikki Addison
Text copyright © 2020 Blackwell and Ruth Limited
Layout and design copyright © 2020 Blackwell and Ruth Limited

The publisher is grateful for literary permissions to reproduce items subject
to copyright which have been used with permission. Every effort has been
made to trace the copyright holders and the publisher apologizes for any
unintentional omission. We would be pleased to hear from any not acknowledged
here and undertake to make all reasonable efforts to include the appropriate
acknowledgement in any subsequent edition.

Images used with permission of the following copyright holders: pp. 2–3, 6–7 and
132–55 copyright © Brent Stirton/Getty Images; pp. 16–45 copyright © Brian
Skerry; pp. 46–63 copyright © Frans Lanting; pp. 64–85 copyright © J Henry Fair;
pp. 86–113 copyright © Paul Nicklen; pp. 114–31 copyright © Cristina Mittermeier;
pp. 156–77 copyright © Ami Vitale; pp. 178–93 copyright © Steve Winter/*National
Geographic*; pp. 194–217 copyright © Tim Laman; pp. 218–41 copyright © George
Steinmetz; pp. 242–63 and endpapers copyright © Richard John Seymour;
pp. 264–693 copyright © Joel Sartore/*National Geographic Photo Ark*; portraits
of the photographers on pp. 296–9 copyright © Geoff Blackwell, except image
of Richard John Seymour by Richard John Seymour.

All rights reserved. No part of this publication may be reproduced, stored in
a retrieval system, or transmitted in any form or by any means, electronic,
mechanical, photocopying, recording, or otherwise, without prior consent
of the publishers.

The views expressed in this book are not necessarily those of the publisher.

Library of Congress Cataloguing-in-Publication Data available.

ISBN 978-1-7972-0591-5

Chronicle Books LLC
680 Second Street
San Francisco, CA 94107
www.chroniclebooks.com

10 9 8 7 6 5 4 3 2 1

Manufactured in China by 1010 Printing Ltd.

This book is made with FSC®-certified paper and other
controlled material and is printed with soy vegetable inks.
The Forest Stewardship Council® (FSC®) is a global, not-
for-profit organization dedicated to the promotion of
responsible forest management worldwide to meet the social,
ecological and economic rights and needs of the present
generation without compromising those of future generations.
The shrink-wrap is one hundred per cent recyclable via
certified soft plastics recycling programmes.

FSC
www.fsc.org

MIX
Paper from
responsible sources
FSC® C016973

FEB 1 5 2022